MW00805671

FOUL PLAY!

THE ART AND ARTISTS OF THE NOTORIOUS 1950s E.C. COMICS!

· GRANT GEISSMAN ·

HARPER
DESIGN

An Imprint of HarperCollinsPublishers

FOUL PLAY! THE ART AND ARTISTS OF THE NOTORIOUS 1950s E.C. COMICS!

The E.C. Logo is a registered trademark belonging to William M. Gaines, Agent, Inc.
and is used with permission
Copyright © 2005 by William M. Gaines, Agent, Inc.
Text copyright © 2005 by Grant Geissman

First published in 2005 by:
Harper Design,
An Imprint of HarperCollins*Publishers*
10 East 53rd Street
New York, NY 10022
Tel: (212) 207-7000
Fax: (212) 207-7654
HarperDesign@harpercollins.com
www.harpercollins.com

Distributed throughout the world by:
HarperCollins International
10 East 53rd Street
New York, NY 10022
Fax: (212) 207-7654

HarperCollins books may be purchased for educational, business, or sales promotional use.
For information please write: Special Markets Department, HarperCollins*Publishers* Inc.,
10 East 53rd Street, New York, NY 10022.

Front cover painting by Johnny Craig
Back cover painting by Graham Ingels

Associate Publisher: Harriet Pierce
Editorial Consultant: Alison Hagge
Associate Director of Production: Karen Lumley
Production Manager: Kimberly Carville
Production Associate: Ilana Anger
Production Editorial Assistant: John Easterbrook
Indexer: Bob Zolnerzak
Designer: Grant Geissman

Title page image by Johnny Craig, a detail from the cover of The Haunt of Fear *#15 (#1), 1950*
Page two image by Harry Harrison and Wallace Wood, from "Dream of Doom," Weird Science *#12 (#1), 1950*
Page five image by Johnny Craig, from "Easel Kill Ya!," The Vault of Horror *#31, 1953*
E.C. artist cameos on pages six and seven hand colored especially for this book by Marie Severin

Library of Congress Cataloging-in-Publication Data

Geissman, Grant.
Foul play : the art and artists of the notorious 1950s E.C. comics! /
by Grant Geissman.-- 1st ed.
p. cm.
Includes index.
ISBN 0-06-074698-X (pbk. with flaps)
1. E.C. Publications Inc. 2. Comic books, strips, etc.--United
States--History and criticism. 3. Cartoonists--United
States--Biography. I. Title.
PN6725.G45 2005
741.5'0973'09045--dc22
2004007032

All rights reserved. No part of this book may be used or reproduced in any manner whatsoever without written
permission except in the case of brief quotations embodied in critical articles and reviews. For information,
address Harper Design, 10 East 53rd Street, New York, NY 10022.

FIRST EDITION

Printed in China
1 2 3 4 5 6 7 / 10 09 08 07 06 05

First Printing, 2005

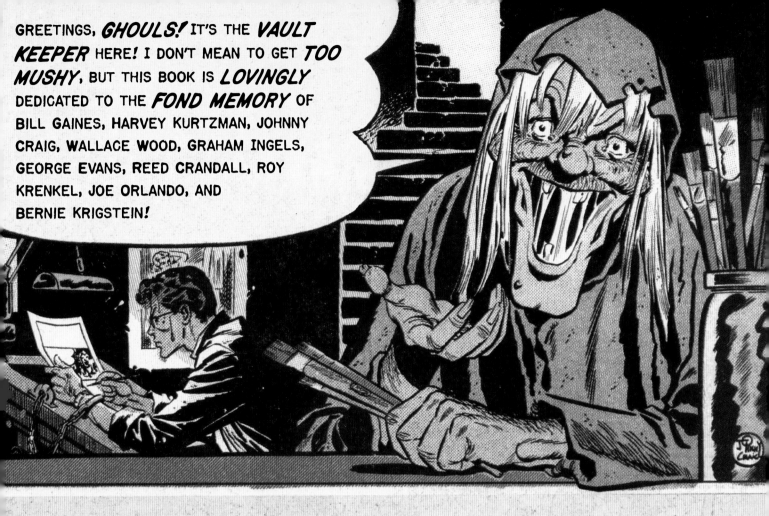

GREETINGS, *GHOULS!* IT'S THE *VAULT KEEPER* HERE! I DON'T MEAN TO GET *TOO MUSHY*, BUT THIS BOOK IS *LOVINGLY* DEDICATED TO THE *FOND MEMORY* OF BILL GAINES, HARVEY KURTZMAN, JOHNNY CRAIG, WALLACE WOOD, GRAHAM INGELS, GEORGE EVANS, REED CRANDALL, ROY KRENKEL, JOE ORLANDO, AND BERNIE KRIGSTEIN!

WITH VERY SPECIAL THANKS TO:

Wendy Gaines Bucci and family for their gracious hospitality and generosity, and for opening up the Gaines family archives for this project; Nancy Gaines; Cathy Gaines Mifsud; Dorothy Crouch; Jack Albert; Harriet Pierce and Ali T. Kokmen at HarperCollins*Publishers*; Alison Hagge; Nick Meglin; Al Feldstein; Marie Severin; Angelo Torres; Russ Cochran and Charles Kochman (for great help with the manuscript in its earliest form); Jim Halperin and Heritage Comics, for many of the E.C. original art images; Glenn Bray; Jerry Weist; Ron Parker; Greg Sadowski; Bob Barrett; Roger Hill; Steve Geppi, John Snyder, and Joe McGuckin at Diamond International Galleries; J.C. Vaughn; Chris Wrenn; Ted and Laura Cohen; Q Siebenthal at American Photo Repro; Bob Meyer at Color Trend; Coco Shinomiya, Beth Escott, and Amy McFarland; Chuck Lorre, Lee Aronsohn, Eddie Gorodetsky, Dennis C. Brown, and all of the *Two and a Half Men* family; Michael Mignola; Van Dyke Parks; John Shirley; Robt. Williams; and Lydia and Greer Geissman.

CONTENTS!

E.C. publisher Bill Gaines!

INTRODUCTION!

WHAT ARE THE VERY BEST COMIC BOOKS EVER CREATED?

Which comics have the best artwork, the best stories? Would it be the D.C. family of comics, which encompasses such venerable and enduring characters as Superman, Superboy, Batman, and Wonder Woman, to name but a few? Is it Marvel Comics, whose Marvel Universe has recently enjoyed a very successful—not to mention lucrative—translation to the silver screen with such titles as *X-Men*, *Spider-Man*, *Daredevil*, and *The Hulk*? Are they the notorious Underground Comix of the 1960s, best typified by Robert Crumb with his *Zap Comics*, *Fritz the Cat*, *Mr. Natural,* and "Keep on Truckin'"? Or is it the more recent Japanese comic-book style known as Manga, with its provocatively rendered women, erotic content, and often-violent storylines?

If you ask any E.C. Fan-Addict, that rabid group—now three generations strong—of dyed-in-the-wool fans of the comic books published by the E.C. Comics Group, there can be but one answer: "It's E.C. for me, see?!"

The comic-book company referred to as "E.C." had some very unlikely beginnings to have inspired such extreme fanaticism. Founded in 1945 by comics pioneer M.C. Gaines, the letters "E.C." originally stood for "Educational Comic," reflecting Gaines's firm belief in the notion of comic books as an educational medium.

Back in the early 1930s, as a salesman for Eastern Color Press, Gaines had been instrumental in the formation of the early comic-

book industry. The earliest comic books were actually giveaway items, or "premiums," given away as an inducement to buy other products. Gaines was in on the ground floor of these, arriving on the scene just after the 1933 appearance of what is widely considered to be the first modern comic book, *Funnies on Parade*, a premium done for Proctor and Gamble. Based on the success of this title, Gaines helped put together deals for additional premium comics, including *Skippy's Own Book of Comics* for Philip's Toothpaste, and *Famous Funnies* as a giveaway for various companies, including Wheatena, Milk-O-Malt, Kinney Shoes, and the John Wanamaker department store. Based on the demand for these books, Gaines came to believe that consumers would actually pay money for a comic book, but he was greeted with much skepticism by his co-workers at Eastern. As a test, he put "10¢" stickers on a stack of issues of his latest premium, *Famous Funnies: A Carnival of Comics*

Above: Two of the earliest comic books, from 1933.

Left: E.C. artist/writer Al Feldstein (left) and E.C. publisher Bill Gaines in a detail from "Horror Beneath the Streets!," illustrated by Feldstein (*The Haunt of Fear* #17, September–October 1950).

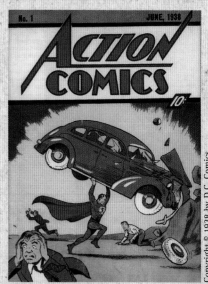

Below: The first appearance of "Superman," *Action Comics* #1, June 1938.

and placed them on some local newsstands in New York. Gaines was vindicated—the stickered comics sold out, and newsstand versions of *Famous Funnies* soon followed, priced at 10¢ each. Eastern rewarded the visionary Gaines by summarily dismissing him.

He aligned himself with the McClure Syndicate, who had acquired a couple of two-color presses from *The New York Graphic*, a defunct newspaper. Gaines had the two presses hooked together to make one four-color press, and he convinced Dell Publishing to release *Popular Comics*, which featured the first comic-book appearances of various newspaper comic strips, including *Gasoline Alley*, *Dick Tracy*, *Terry and the Pirates*, and *Little Orphan Annie*, among others. He was back in the game.

Desiring to keep McClure's presses rolling, Gaines was also handling the printing for a publisher friend of his named Harry Donenfeld. In December of 1937, Gaines was approached by two young men with a feature that had previously been turned down by every publisher in town. They were shopping the feature to McClure as a syndicated comic strip, but McClure was firmly not interested. The young men were named Jerry Siegel and Joe Shuster, and Gaines thought that their feature, which they called "Superman," was something that Donenfeld should publish as a comic book. Donenfeld wasn't sure, but on Gaines's strong recommendation, he published "Superman" as the lead feature in *Action Comics* #1, cover dated June 1938. It was an immediate hit, spawning countless spin-offs and imitations.

Donenfeld wisely kept *Superman* all to himself at his own D.C. Comics, but formed a partnership with Gaines to create a sister company called All-American Comics. Things functioned smoothly—not to mention profitably—between the two companies for quite some time, but their relationship

began to go south when Donenfeld, in an act of extreme largess, gave half of his share in the company to Jack Liebowitz, his accountant. Gaines regarded Liebowitz as a noncreative type bent on wringing every last nickel from the business. Liebowitz's insistence on adding more pages of advertising to the books was the last straw. In the early part of 1945 Gaines threw out an ultimatum: "You buy me out or I'll buy you out," and he was subsequently bought out of his share of the All-American–D.C./National partnership. For his stake in the company Gaines received $500,000, free and clear after taxes. As part of the deal, he released ownership of his All-American superhero characters such as Wonder Woman, The Flash, and Hawkman to D.C., but he took with him the rights to the *Pictures Stories from the Bible* series.

Gaines announced his retirement, but he was back in business just two weeks later. He formed E.C. Comics, publishing out of the

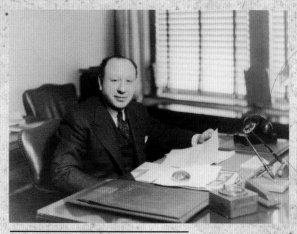

Above: M.C. Gaines in his office.

Above: *Famous Funnies* began as a "giveaway" comic, then graduated into a newsstand book, selling for 10¢.

Copyright © 1938 by D.C. Comics

Below: Two issues of *Picture Stories from the Bible*, and a "house ad" for M.C. Gaines's line of E.C. comics.

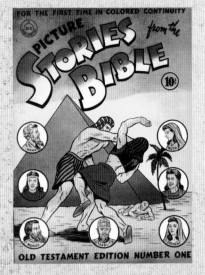

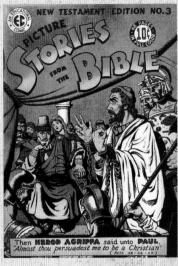

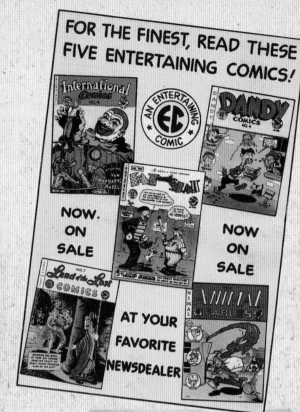

Left: A young Bill Gaines.

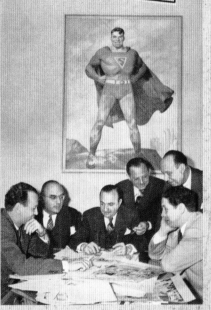

Above: A business meeting in the D.C. Comics offices. In the center is Harry Donenfeld. At the top right is M.C. Gaines, and below him is Jack Liebowitz.

same spartan downtown New York City offices (located at 225 Lafayette Street) as he had his All-American Comics. The first material to be issued by the new company (published under an E.C. logo that read "An Educational Comic") consisted of reprints of *Pictures Stories from the Bible*, adorned with new covers. Gaines soon expanded the *Picture Stories* series to include *Picture Stories from American History*, *Picture Stories from Science*, and *Picture Stories from World History*.

Announced as "in preparation" were *Picture Stories from Geography*, *Picture Stories from Mythology*, and *Picture Stories from Natural History*. He also added a line of comic books intended for younger readers, including such titles as *Tiny Tot Comics*, *Animal Fables*, *Dandy Comics*, and *Land of the Lost Comics*, based on a popular radio show. Most of these he published under an E.C. logo that read "An Entertaining Comic." How entertaining they actually were may be open to debate, but one thing is certain: they didn't exactly fly off the nation's newsstands.

The company was limping along when M.C. Gaines was drowned in a motor boating accident on Lake Placid, New York on August 20, 1947. Responsibility for the company fell to his son, William M. Gaines. Bill, who had been studying to become a chemistry teacher, was extremely reluctant to step into his father's shoes; he did so only at his mother's insistence. He had essentially inherited a line of comic-book titles that seemed as though they were in competition to see which one could lose the most money. At the time of his father's death, E.C. was running about $100,000 in the red.

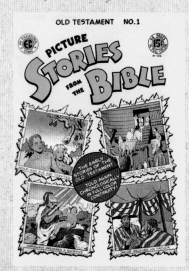

OLD TESTAMENT NO. 1

PICTURE STORIES FROM THE BIBLE

Picture STORIES FROM AMERICAN HISTORY

PART ONE—
The Period of
Discovery and Exploration

NO. 5 WINTER

TINY TOT COMICS

YOUR FIRST COMIC MAGAZINE!

NO. 1 JULY-AUG

The Funniest Animals Of All Appear

IN ANIMAL FABLES

DANDY COMICS

No. 1 SPRING

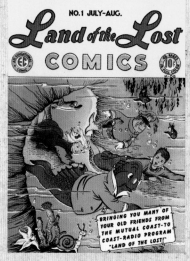

NO. 1 JULY-AUG.

Land of the Lost COMICS

BRINGING YOU MANY OF YOUR OLD FRIENDS FROM THE MUTUAL COAST-TO COAST-RADIO PROGRAM "LAND OF THE LOST"!

The younger Gaines was not thrilled with his new position. "In the beginning," Bill wrote, "I hated the business so much that I visited the office only once a week to sign the payroll checks." As he began feeling his way through the ins and outs of being a publisher, his attitude began to change. "First thing I knew, I had to read our comics. Next thing I knew, I was in love with them."

As Bill began to assemble a new and younger staff (notably artist/writers Al Feldstein, Harvey Kurtzman, and Johnny Craig), he also began replacing his father's well-intentioned (but lackluster) titles with new (but highly

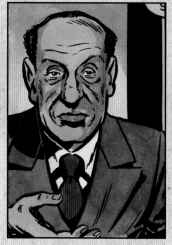

Above: M.C. Gaines, drawn by Al Feldstein and colored by Marie Severin.

derivative) ones. E.C.'s comics at the time were inferior knock-offs of whatever was the hot trend, with titles like *Saddle Justice* and *Gunfighter* (western), *Saddle Romances* (western love), *Crime Patrol* and *War Against Crime!* (crime), *Moon Girl* (a kind of *Wonder Woman* knock-off), and *Modern Love* (more love). After several years of playing "follow the leader" and trying to keep up with the ever-changing trends in the comic-book industry, E.C. tried out some experimental horror stories in the final two issues of *Crime Patrol* and *War Against Crime!* These stories proved to be quite popular, and they soon dropped their other titles and replaced them with horror. Almost overnight, E.C.'s horror titles, *Tales from the Crypt*

Top: A sampling of the E.C. comics published in the 1940s by M.C. Gaines. *Above:* Early logos for the "educational" and "entertaining" versions of E.C.'s comics.

Above: The first E.C. title to break away from M.C. Gaines's previous line of comics, *Saddle Justice* #3 (Spring 1948). *Below: Moon Girl* was E.C.'s attempt to create another *Wonder Woman.* Shown is issue #3, Spring 1948. After eight issues *Moon Girl* became *A Moon, a Girl . . . Romance.*

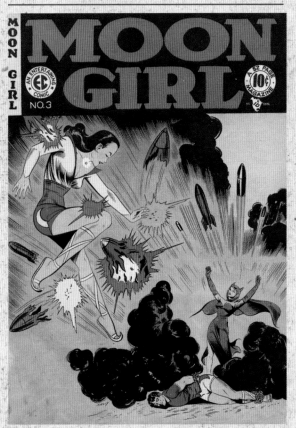

(formerly *The Crypt of Terror*), *The Vault of Horror,* and *The Haunt of Fear,* had become the flagships of the line. This time, however, it was E.C.'s turn to be imitated, and other companies flooded the newsstands with competing horror titles.

E.C.'s small—but influential—"New Trend" line of comics consisted not only of horror, but also included science fiction (*Weird Science* and *Weird Fantasy,* which eventually merged into *Weird Science-Fantasy,* and finally became *Incredible Science Fiction*) crime (*Crime SuspenStories*), shock (*Shock SuspenStories*), war (*Two-Fisted Tales* and *Frontline Combat*), adventure (*Piracy*), and eventually even humor comics (*MAD* and *PANIC*). The list of freelance artists that regularly did work for E.C. reads like a "who's who" of comic book and magazine illustration in the mid-twentieth century: Jack Davis, Wallace Wood, Will Elder, Reed Crandall, Frank Frazetta, Graham Ingels, Al Williamson, Joe Orlando, Jack Kamen, George Evans, Bernie Krigstein, and John Severin. Bill, whose father told him that he would never amount to anything, had been able to do what even his father could not do: make E.C. a success.

There was, however, an ominous cloud on the horizon. Armed with his 1954 book *Seduction of the Innocent,* an ambitious psychologist named Dr. Fredric Wertham had mounted a highly publicized campaign against horror and crime comics. *Seduction of the Innocent* was touted as being based on case histories of children who had been adversely affected by comic books. But because Wertham worked only with highly disturbed children, he essentially was engaging in pseudo-science, as there was no control group against which to balance his research. His theories basically boiled down to this: because juvenile delinquents read comic books, comic books cause juvenile delinquency.

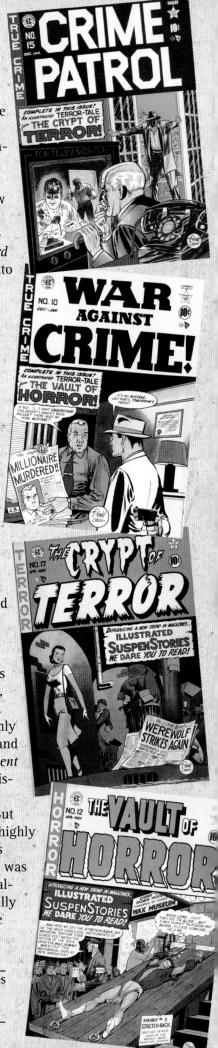

Far right: Gaines and Feldstein tried out some experimental horror stories in the last two issues of *Crime Patrol* and *War Against Crime!* They liked the result so much that they morphed the books into *The Crypt of Terror* (later titled *Tales from the Crypt*) and *The Vault of Horror.*

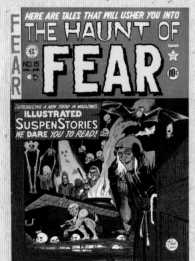

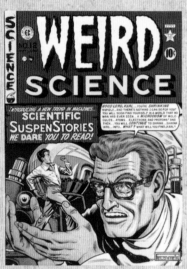

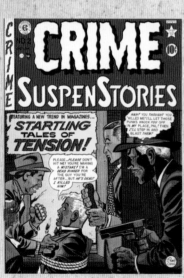

By publishing inflammatory articles against the comics in such publications as *Ladies' Home Journal*, *Reader's Digest*, and even *Scouting* (the house organ of the Boy Scouts of America), Wertham whipped the nation's mothers and other guardians of morality to a frenzy.

All of this led in 1954 to a full Senate Subcommittee investigation of the alleged (but never proven) link between comic books and juvenile delinquency. Gaines asked to appear before the Subcommittee to defend his comics. His prepared statement to the Subcommittee (written by Gaines and his business manager, Lyle Stuart) was brilliant, but as a result of the Subcommittee's subsequent pummeling, Gaines inadvertently became the personification of the irresponsible horror comic publisher. Although there was little actual legislation against the comics (what there was was unenforced and would likely not have stood up to legal challenge on First Amendment grounds), the damage was done.

Gaines appealed to the other publishers to join together, commission their own study to determine if there really *was* a link between comics and juvenile delinquency, hire a public relations firm to untarnish their image, and work to protect themselves against the censorship of comics material, which Gaines considered to

be a freedom of the press issue. Gaines hired a hall and issued an open invitation to the other publishers to join in the discussion. By the fourth meeting they had elected a chairman and appointed an official board. They also voted to ban the words "horror," "terror," and "crime" from the covers of comic books. "This isn't what I had in mind," said Gaines, and he walked out of his own meeting. The publishers also voted to establish the Comics Code Authority, an independent body that would draft a set of standards for what could and could not appear in Code-approved comics. This was all voluntary, but the message was clear: comics that did not bear the Code seal just might not get on the newsstands.

Forced to "clean up" his comics or go out of business, Gaines dropped most of his titles, and in 1955 began a "New Direction" in comics, emphasizing that these would be a "clean, clean line." These titles (*Impact, Valor, Aces High, Extra!, Psychoanalysis,* and *M.D.,*

Above: The infamous anti-comics manifesto *Seduction of the Innocent,* along with a photo of the author, Dr. Fredric Wertham. *Below:* Anti-comics diatribes by Dr. Fredric Wertham from *Ladies' Home Journal* (November 1953), *Scouting* (September 1954), and *Reader's Digest* (June 1954).

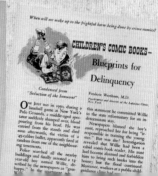

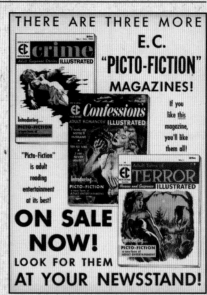

along with *Piracy, PANIC,* and the re-titled *Incredible Science Fiction,* carried over from the New Trend comics) ran into retailer and distributor resistance, and much of the print run never even made it onto the news-stands. Many news-dealers were sending back anything that had an E.C. logo on it. Needless to say, they were a money-losing proposition. A magazine-sized experiment for adult readers (*Shock Illustrated, Crime Illustrated, Terror Illustrated,* and *Confessions Illustrated*), dubbed "Picto-Fiction," was also attempted; this too proved to be unsuccessful. The end was near; E.C. was hemorrhaging red

ink. By 1956, the E.C. comics were no more. (For his part, Fredric Wertham—not content with having caused the complete evisceration of the comics industry—was still running around from the late 1950s until well into the 1960s pontificating about how comic books were *still* the root cause of juvenile delinquency.)

Fortunately for Bill Gaines, he had an ace up his sleeve with *MAD,* which he had just turned into a magazine format to pacify *MAD* creator/writer Harvey Kurtzman. Gaines put all his remaining eggs in the *MAD* basket, and fortunately for the company, *MAD*ness prevailed.

After Kurtzman abruptly departed from *MAD* in 1956 (taking with him most of the magazine's artists), Gaines got Al Feldstein to be the magazine's editor. Gathering together a new staff (mixed in with some familiar faces from the E.C. days), Gaines and Feldstein would, over the course of the next several decades, turn *MAD* Magazine into an American icon. Asked numerous times in later years, however, if he would ever consider going back to publishing his much-beloved comic-book line, the by-then-very-successful Gaines always replied, "No. Not unless I could do it the way we did it back then."

Gone but not forgotten, E.C.'s flame has been kept burning over the years by its most ardent fans through a long series of high-quality reprints and high-profile spin-offs (like HBO's *Tales from the Crypt* series).

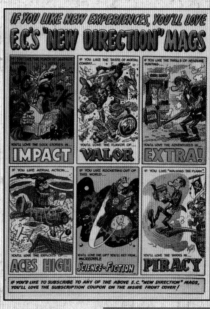

Below: Jack Davis ad for the E.C. Fan-Addict Club, 1954.

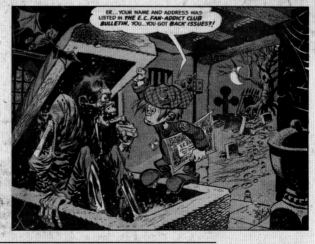

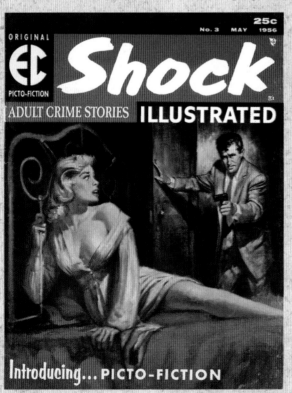

Above: The rarest E.C., the Picto-Fiction magazine *Shock Illustrated* #3 (Spring 1956). The full run of 250,000 copies was sitting on the press, but with no money to bind them, Gaines ordered the run destroyed. Saved were 100 to 200 copies that were hand-bound for the files, and to give to the artists or to fans who requested the issue.

15

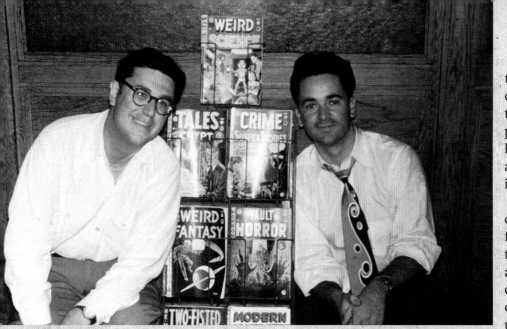

Above: Bill Gaines and Al Feldstein in the E.C. offices in 1950. *Right:* Bill and Nancy Gaines, circa 1958. *Below:* A detail from "Horror Beneath the Streets!" (*The Haunt of Fear #17*, September–October 1950), which reveals why Gaines and Feldstein published horror comics.

All of this is the stuff of legend for E.C.'s die-hard fans, but why should anyone else really care at this late date? Simply put, because day after day, month after month, issue after issue, E.C.'s little staff of artists and writers produced some of the best comic books ever published. With regard to comic art, we live in a very different age today, a time when there is a section designated for "graphic novels" in most major bookstores, and high-quality coffee-table books reprinting the best comics of the Golden and Silver Age are readily available. In the 1950s, however, comic books were considered by many to be a bottom-feeder's form of entertainment. Art Spiegelman wrote in his book *Jack Cole and Plastic Man* (Chronicle Books, 2001) that "In the hierarchy of the applied arts, the comic book has been near the bottom—above only tattoo art and sign painting—and every commercial artist has been as aware of these unspoken aesthetic ranks as any American who isn't white has been of race."

And the poor fans who loved and cherished the material when it was first issued didn't fare much better: they were often thought to be illiterate, childish, or worse. Noted Disney collector Malcolm Willits wrote, "A classic period is rarely appreciated until it's over. Then people look back and say: 'Wasn't that wonderful!' This usually coincides with the first stirrings of monetary value in material from the period. If something is worth money, people feel it *must* be good. Dealers and investors move in, and fairly soon the rich feel comfortable in announcing they collect it too. So the field is off and running, thanks only to the poor laughed-at saps who loved the

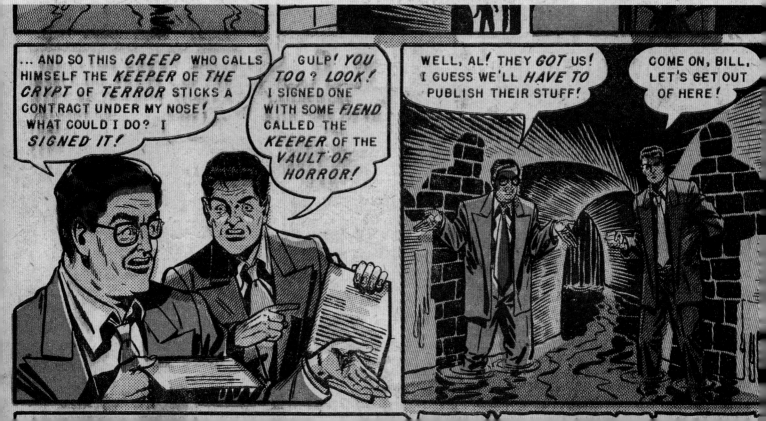

... AND SO THIS *CREEP* WHO CALLS HIMSELF THE *KEEPER* OF *THE CRYPT* OF *TERROR* STICKS A CONTRACT UNDER MY NOSE! WHAT COULD I DO? I *SIGNED IT!*

GULP! *YOU TOO? LOOK!* I SIGNED ONE WITH SOME *FIEND* CALLED THE *KEEPER* OF THE *VAULT OF HORROR!*

WELL, AL! THEY *GOT* US! I GUESS WE'LL *HAVE TO* PUBLISH THEIR STUFF!

COME ON, BILL, LET'S GET OUT OF HERE!

Above: Bill Gaines on the roof at 225 Lafayette Street, circa 1951.

And if we define "art" as a thing that has the capacity to evoke a response in human beings—whatever that response might be—then the material on the following pages surely qualifies.

WARNING! READ FURTHER AT YOUR OWN **PERIL**, FOR THE **E.C. COMICS** ARE HIGHLY **ADDICTIVE!** YOU MIGHT BECOME A **FAN-ADDICT** YOURSELF AFTER JUST **ONE** OR **TWO** HITS!

material *during* the classic period and protected it until it was acceptable."

Original E.C. comics *are* worth money today—absolutely mint copies can be worth a *lot* of it—but we focus here on the "classic period" itself and the creators who made that period happen. Not all of the E.C. artists did what they did for the same motivation. Some worked in comics because they found it was a way to make a steady paycheck, something that is always important, but was especially so to these children of the depression. Some drew comics because drawing comics was as important to them as eating or breathing; some thought comics were even *more* important.

But whatever the motivation, collectively they turned out a staggering amount of enormously high-quality material, on demand and (for the most part) on deadline. Not every single stroke or word of it was brilliant or even inspired, but the best of it bested the competition by a mile. It withstands the test of time.

JOLTING TALES OF **TENSION** IN THE EC **TRADITION!**

This page and opposite page, top left: Unpublished Allen Simon covers to *Picture Stories from Science* #3 and 5, and *Picture Stories from World History* #3. Although the series was abruptly stopped when M.C. Gaines was killed (only two issues of each title were released), the company was very far ahead in the inventory of material for further issues, including several finished covers, stories, and scripts yet to be assigned artists. These covers suggest that the company was striving to make the further material more exciting for the readers; note especially the cover for *Picture Stories from Science* #5 (opposite).

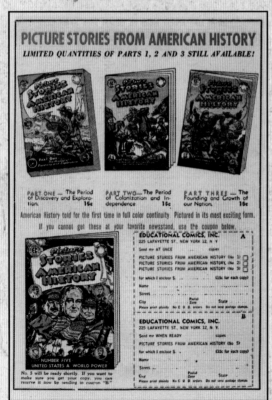

Above: E.C. house ad from Summer 1947 for the *Picture Stories from American History* series, showing the cover to the never-published issue #5.

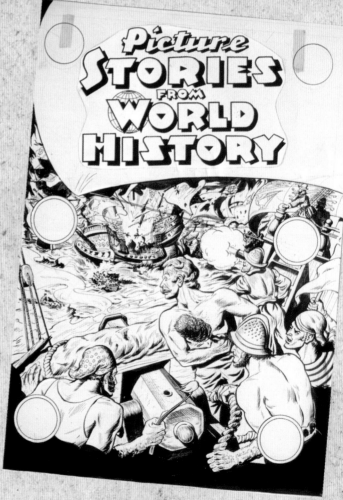

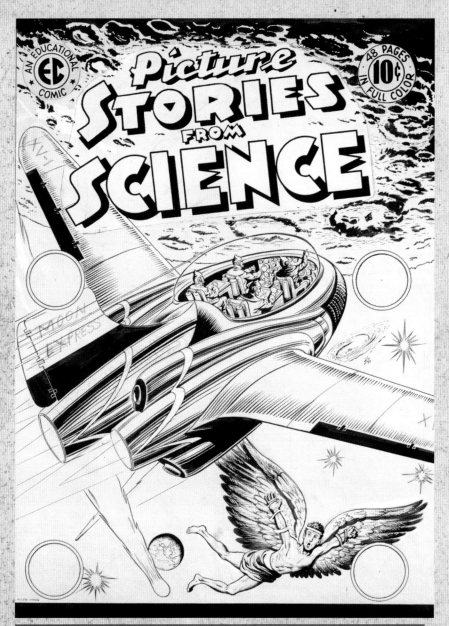

EDUCATIONAL COMICS, INC.

M. C. GAINES, President

PUBLISHERS OF

PICTURE STORIES from the BIBLE
"COMPLETE OLD TESTAMENT" and
"LIFE OF CHRIST" Editions

225 LAFAYETTE ST. . . . Telephone CAnal 6-1594-5 . . . NEW YORK 12, N. Y.

February 26, 1946

Editorial Advisory Council
for the Bible Series

DR. WILLIAM WARD AYER
Pastor Calvary Baptist Church
New York City

*DR. ALEXANDER M. DUSHKIN
Executive Director
Jewish Education Committee of
New York

RAIMUNDO deJOYES
Dean-Cathedral of St. Philip
Atlanta, Ga.
Author of "The Church and the Children"

*DR. ISRAEL GOLDSTEIN
Rabbi of Congregation B'nai Jeshurun
and former President of the Synagogue
Council of America

PROF. SAMUEL L. HAMILTON
Chairman Dept. Religious Education
New York University
Chairman Committee of Research
International Council of Religious Education

FRANK S. MEAD
Editor, The Christian Herald
Author of "The March of Eleven Men"
and "See These Banners Go"

DR. J. QUINTER MILLER
Associate General Secretary
Federal Council of the Churches of
Christ in America
In Charge of Field Work

*RABBI AHRON OPHER
Hebrew Tabernacle, New York City
Assistant to the President of
the Synagogue Council of America

DR. NORMAN VINCENT PEALE
Minister, Marble Collegiate Church,
N. Y.
Author of "The Art of Living" and Other books

DR. FRANCIS C. STIFLER
Secretary for Public Relations
American Bible Society and
Coast-to-Coast Broadcaster on the Bible

EDWARD L. WERTHEIM
Former President Bible School
Superintendent's Union of N. Y.

*Dr. Dushkin, Dr. Goldstein and Rabbi
Opher serve on the Advisory Council for the
Old Testament only.

Dear Mr. Wholesaler:

No doubt you have already received the announcement from
SHAP, that beginning with PICTURE STORIES FROM AMERICAN
HISTORY - Part Two, MACFADDEN PUBLICATIONS, INC. begins
the distribution of my publications. PICTURE STORIES FROM
AMERICAN HISTORY - Part Two is to be placed on sale Wednes-
day, March 13. PICTURE STORIES FROM THE BIBLE - New Testa-
ment #3 and TINY TOT COMICS #1 will be released shortly.

I recently organized EDUCATIONAL COMICS, INC., after disposing
of my interest in All-American Comics to my former associates
of the Independent News. The All-American line had been
founded by me seven years ago. EDUCATIONAL COMICS, INC.,
will publish only that type of comic magazine which will not
only be immune from all criticism, but will be good, steady
profit-makers for independent distribution for years to come.

May I ask the same full-hearted cooperation on my new titles
being distributed through MACFADDEN PUBLICATIONS, INC.,
that you have given me on my ten All-American Comic titles
during the past seven years?

Very sincerely yours,

M. C. Gaines, Pres.
Educational Comics, Inc.

P. S. I enclose herewith a cover of PICTURE STORIES FROM
AMERICAN HISTORY - Part Two. You will note that it contains
56-pages in keeping with my pledge to give top values in
every regard. Please be good enough to read the foreword
on the inside covers.

ALSO "PICTURE STORIES FROM AMERICAN HISTORY"
PART ONE, THE PERIOD OF DISCOVERY AND EXPLORATION, AND PART TWO,
THE PERIOD OF COLONIZATION AND INDEPENDENCE, NOW AVAILABLE.

Top right: Original February 26, 1946 letter from M.C. Gaines to whole-
salers announcing that Macfadden Publications would begin distributing
the new E.C. line of comics. *Right and below:* The original logo trademark
certificates from the U.S. Patent Office for a number of E.C. titles. Only the
Moon Girl and the Prince, Tiny Tot, and *Picture Stories from American
History* logos were ever used.

UNITED STATES PATENT OFFICE

M. Charles Gaines, New York, N. Y.

Act of 1946

Application July 7, 1947, Serial No. 529,096

MOON GIRL and The Prince

(Statement)
M. Charles Gaines, a citizen of the United

1947, and first used in commerce among the sev-
eral States which may lawfully be regulated by

UNITED STATES PATENT OFFICE

M. Charles Gaines, New York, N. Y.

Act of 1946

Application July 7, 1947, Serial No. 529,097

PRINCE MENGU and Moon Girl

(Statement)
M. Charles Gaines, a citizen of the United
States of America, residing at 16 Colonial Road,
White Plains, New York, and doing business at

1947, and first used in commerce among the a
eral States which may lawfully be regulated
Congress on June 26, 1947.

(Declaration)

UNITED STATES PATENT OFFICE

M. Charles Gaines, New York, N. Y.

Act of March 19, 1920

Application October 23, 1945, Serial No. 490,378

UNITED STATES PATENT OFFICE

Max C. Gaines, New York, N. Y.

Act of March 19, 1920

Application November 22, 1941, Serial No. 443,828

COMIC Digest

UNITED STATES PATENT OFFICE

M. Charles Gaines, New York, N. Y.

Act of February 20, 1905

Application May 3, 1941, Serial No. 443,227

STATEMENT

UNITED STATES PATENT OFFICE

M. Charles Gaines, New York, N. Y.

Act of March 19, 1920

Application October 25, 1945, Serial No. 490,483

UNITED STATES PATENT OFFICE

M. Charles Gaines, New York, N. Y.

Act of February 20, 1905

Application May 3, 1941, Serial No. 443,225

UNITED STATES PATENT OFFICE

M. Charles Gaines, New York, N. Y.

Act of March 19, 1920

Application October 25, 1945, Serial No. 490,485

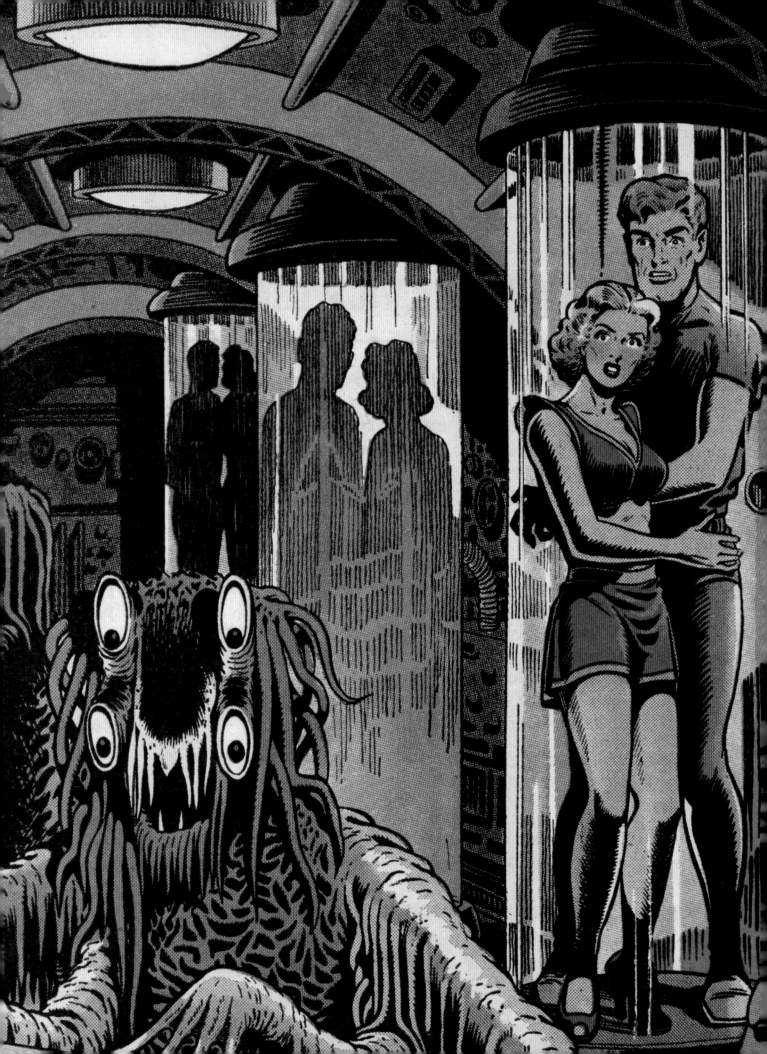

AL FELDSTEIN!

"AL AND I HAVE HAD A *LONG, INCREDIBLE* ASSOCIATION. WE ALMOST KNOW WHAT THE OTHER'S *THINKING!*" —BILL GAINES

Early February, 1948: cavorting right in front of Bill Gaines's eyes were the most luscious, well-endowed women he had ever seen. The fact that they were merely two-dimensional representations of females did little to dampen his enthusiasm for either the figures he was looking at, or the young artist who had drawn them. The artist's name was Al Feldstein, and Gaines—in his first real executive decision since taking over the family comic-book business—decided then and there that he should hire him. And thus, on the basis of some short skirts and very ample "headlights," one of the most successful associations in publishing was born.

Albert B. Feldstein was born in Brooklyn, New York on October 24, 1925, to (as he later described them) a "Russian immigrant" father and a "domineering" mother. By age seven or eight he was making little newspaper-style comics, drawing on his father's shirt cardboards. His mother encouraged him in his interest in art, taking him to museums and galleries. Feldstein's father, who owned his own dental lab until he lost his business in the depression, was more distant. But Feldstein was also encouraged by an elementary school teacher, Mrs. Kingsland, who had him enter an art contest held by the John Wanamaker department store in New York

Al Feldstein

City. He won a third prize medal for a drawing of a circus scene. In 1938, Mrs. Kingsland again encouraged him to enter a contest, this time the World's Fair Poster Contest, where he also won an award. At the end of eighth grade, Mrs. Kingsland asked him what he wanted to do with his life. Feldstein had actually wanted to become a doctor, but times were tough and family finances completely ruled that out. She encouraged him to choose art as a career path, and to apply to the High School of Music and Art, where he was accepted. "I don't know where I would have ended up, if it weren't for Mrs. Kingsland pushing me into art," Feldstein has said.

By the end of high school, Feldstein heard through a classmate that you could make $25 a page drawing for comic books. "I had never read a comic book; who had the dime?," Feldstein recalled. "So I borrowed a couple of comics and made up a portfolio, very crude." On the strength of this

Copyright © 1948 by Fox Feature Syndicate

Above: A pair of "headlights," a detail from the cover of *Junior* #16, July 1948.

Left: Detail from Feldstein's cover to *Weird Fantasy* #8, July–August 1951.

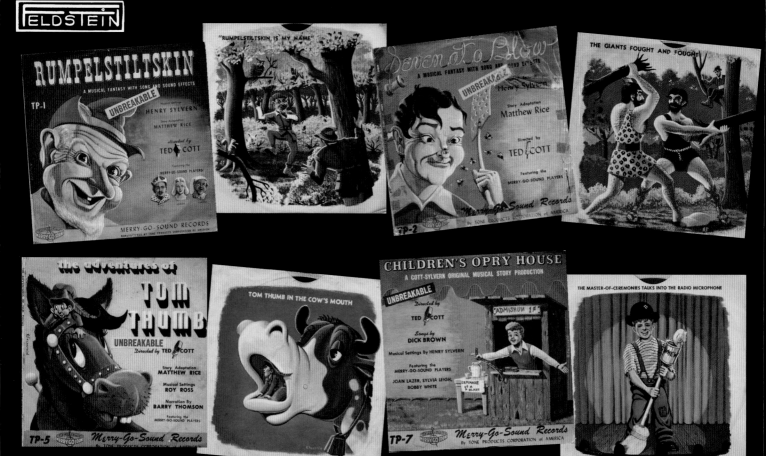

Above: Feldstein album covers for a series of children's records for a company called Merry-Go-Sound, circa late 1940s. If Feldstein's children's record career had taken off, this would most likely be a *very* different book!

AN ENTERTAINING COMIC • EC

22

Below: Al Feldstein self-portrait, done in 1941 at the age of sixteen.

Feldstein landed a part-time job with S.M. Iger, a kind of comic-book sweatshop. The studio was begun by Jerry Iger and Will Eisner (creator of *The Spirit*), but the partnership had just broken up. "Jerry Iger was running this thing, and he had some slaves shackled to the boards. Great artists, too; Reed Crandall, Rafael Astarita, Bob Webb. They were just so great. I just idolized them, and all I did was clean their pages. I used to erase the pencils, and run errands for Jerry," said Feldstein. As he began learning the ropes, Feldstein began to do some finish work on the pages as well, starting with inking in the leopard spots on the skimpy costume on *Sheena, Queen of the Jungle.* He also began doing backgrounds, which usually

Right: Among Feldstein's earliest work in comics was painting leopard spots on the skimpy costume of Sheena, Queen of the Jungle.

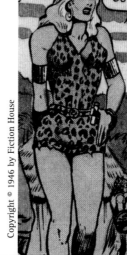

Copyright © 1946 by Fiction House

consisted of jungles, palm trees, and leafy plants. "Finally I got to the point where he let me pencil my first story, and eventually I was doing the whole job for him like everyone else."

After attending Brooklyn College by day and attending night classes at the Art Students League, Feldstein entered into the military, serving in the Air Corps. On the basis of his artistic ability, he was assigned to the Special Forces as an artist, where he worked on informational posters and slides, painted service club murals, and drew a base comic strip called "Bafy." He also had a thriving business on the side, painting custom designs on pilot's flight jackets.

After his discharge in 1945, he decided that he

HOW TUNNELS ARE CONSTRUCTED

Copyright © 1946 by Humor Publications

Above and below: Early Feldstein splash pages, from *Science Comics* #3, May 1946, and *Crown Comics* #7, November 1946.

MICKEY MAGIC

Copyright © 1946 by Home Guide Publications

would go back to college, get his degree, and become an art teacher. If he became an art teacher, he reasoned, he not only would have a steady paycheck but he would also have holidays and his summers open to paint. While waiting for a slot to open up at Columbia University he returned to Jerry Iger's shop, where he soon was making more money than he would ever make as a teacher. He decided to remain in the comic-book business. He stayed briefly with Iger, and then moved to break away and start freelancing. He found an opening at Fox Feature Syndicate. "They were looking for someone to package books," Feldstein has said, "and I lied to them about my wife being a writer." He wrote, drew, and packaged for Fox such teenage titles as *Junior*, *Sunny*, and *Meet Corliss Archer*.

Fox used a machine lettering service on their comics called Leroy lettering; E.C. comics used the same system, and also the same lettering service: Jim Wroten and Wroten Lettering. Feldstein heard through Wroten that E.C. was looking to do teenage books, so the ever-ambitious artist gathered up his portfolio and went down to meet Bill Gaines, who had just taken over the company after the death of his father. "Bill and I hit it off," Feldstein has said, and they drew up a contract (dated February 13, 1948) for Feldstein to package a teenage comic to be called *Going Steady with Peggy*. Feldstein recalled that "I had a piece of the profits, and I was really looking forward to doing that, because that was the first time I'd have a piece of something." Feldstein got as far as penciling the cover and the first story when Gaines called him in to say that the teenage market had collapsed and

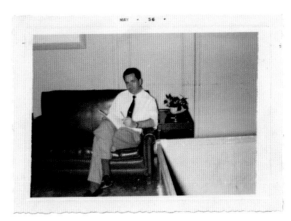

Above: Al Feldstein in the E.C. offices, reading a copy of the E.C. fanzine *HOOHAH!* in May 1956.

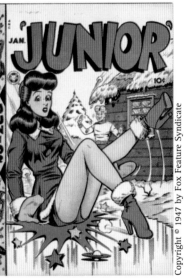

Copyright © 1947 by Fox Feature Syndicate

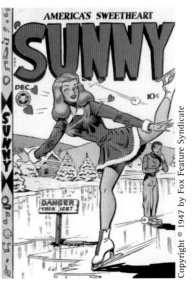

Copyright © 1947 by Fox Feature Syndicate

Above right: Feldstein covers from *Junior* #11, January 1948, and *Sunny* #11, December 1947.

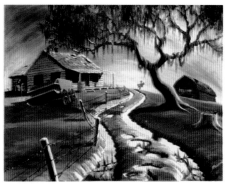

Above: Arkansas Farm, painted by Feldstein in 1947 while still in the service.

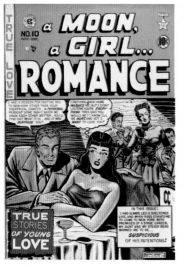

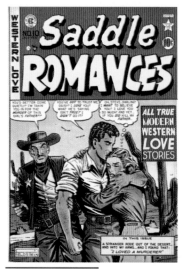

Above: Two of Feldstein's E.C. romance covers, 1949–1950.

Right: The unused, penciled cover to *Going Steady with Peggy,* 1948.

Peggy wasn't going to be published. Feldstein offered to tear up the contract if Gaines would offer him other steady work, to which Gaines happily agreed. His first work for E.C. was illustrating stories for such titles as *Saddle Justice, Crime Patrol,* and *War Against Crime!*

Within a short time Feldstein realized that he could write stories that were better than the scripts he was being given, and he began to both write and draw his own stories. Gaines (who by all accounts was a very paternalistic figure) and Feldstein developed both a close working relationship and a close friendship. Feldstein, whose father never encouraged him in his art or outwardly showed affection, found a kind of surrogate father figure in Gaines. Feldstein recalled: "He was three years older than me, which wasn't that much older, but I guess it was an explanation of why I wanted to please him. I never felt that I had pleased my father, because he was never very vocal about whether he thought I did good artwork or anything like that." In *The MAD World of William M. Gaines,* Feldstein elaborated: "When I wrote a script, my first and foremost motivation was for Bill to read it and enjoy it. Bill supplied my need for a father. For this I did all I could to earn his love." Regardless of the reasons why, the two enjoyed a rare, open relationship between employer and employee.

Coming from the uncertain world of the freelance artist, Feldstein insisted that E.C. pay their freelancers when their completed jobs were delivered, a rarity in the comics game that inspired loyalty in their stable of artists. (Gaines would follow this practice to the end of his

life.) Feldstein also hated companies that forced their artists to work in a "house style" (like Fox), and instead encouraged his artists to work with their own "voice." In the course of their many discussions about how to

Above and right: The original contract for *Going Steady with Peggy,* dated February 13, 1948.

Below left and right: Examples of Feldstein's romance, science fiction, and horror covers.

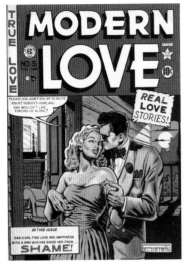

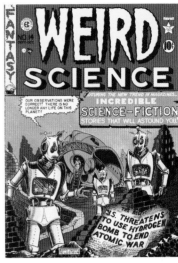

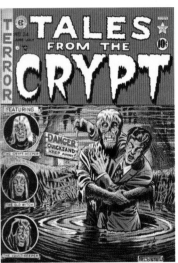

improve E.C.'s comics, Feldstein opined that they not continue to play follow the leader, jumping on whatever the perceived hot "trend" in the industry was, but rather go off in their own direction. The pair both loved scary stories like they used to hear on the old radio shows such as *Inner Sanctum, The Witches Tale*, and Arch Oboler's *Lights Out*, so they decided to insert some horror stories into their two crime comics (*Crime Patrol* and *War Against Crime!*) and test the waters. They liked the result so much that with the May–June 1950 issues they changed *Crime Patrol* into *The Crypt of Terror* (which was changed three issues later into *Tales from the Crypt*) and *War Against Crime!* into *The Vault of Horror*. A month later they changed *Gunfighter* into *The Haunt of Fear*.

Feldstein wrote (and drew) the earliest stories on his own, but Gaines was soon staying up half the night reading pulps and collections of horror stories to get plot ideas he could bring in to Feldstein. Gaines scribbled down these little plot ideas on scraps of paper he called "springboards," which he would bring in to Feldstein the next morning. Although these were the inspiration for many of E.C.'s stories, the pair would invariably change the plots, in some cases making a far better yarn than the original inspiration was. Feldstein was soon editing seven E.C. titles, adding *Weird Science, Weird Fantasy, Crime SuspenStories*, and *Shock SuspenStories* to the three horror comics.

Feldstein's art—which he himself dismisses as "stiff"—nonetheless has a visceral, immediate style that contributed much to what is often referred to as "the E.C. mystique." And *The World Encyclopedia of Comics* entry on Feldstein states that "his depiction of 'static horror'—freezing a single action in time—has never been successfully duplicated in comics."

Writing, editing, and drawing covers and stories for all of these books soon proved to be a bit much, and Feldstein dropped his drawing duties to concentrate on just writing the stories from Gaines's springboards. An incredibly proficient worker, Feldstein would write a story a day from Monday through Thursday, and use Friday to put together the letter pages and catch up on any other editing work that needed to be done. He would also squeeze in occasional cover art to keep his hand in that part of the process. The following Monday he would turn his attention to another E.C. title, and the process would begin all over again.

Unlike other comic-book script writers, there never was a typewritten script for any of Feldstein's E.C. stories; he would write them in pencil directly on the boards that would be given to the artists. About this system of writing, Feldstein said in an April 1996 interview (published in *Tales of Terror! The E.C. Companion*) that "I always used to amaze myself that I got to the end at the end. I had a great sense of timing as I went

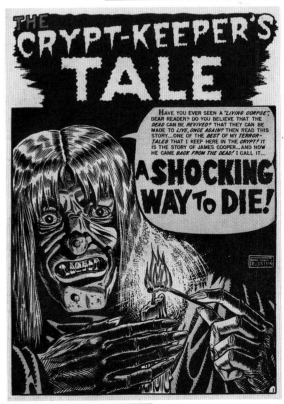

Above: A dramatic rendering of the Crypt-Keeper, from *Tales from the Crypt* #21 (December 1950–January 1951).

8. You may assign this agreement, but notwithstanding such right you shall continue principally liable.

Your acceptance upon the second copy shall constitute our agreement.

Very truly yours,

Albert B. Feldstein
ALBERT B. FELDSTEIN

Accepted,
TINY TOT COMICS, INC.,
By *William M. Gaines*
Vice-Pres.

Right: Ray Bradbury's original letter to E.C., dated April 19, 1952, asking for royalty payments.

Below: Feldstein cover to *PANIC* #1, February–March 1953.

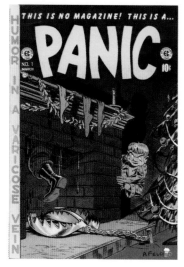

Above: An anaglyph made by Feldstein as a test for E.C.'s 3D comics. Amusingly, he used the main character from *Going Steady with Peggy* as the test subject.
Right: Feldstein in his office at *MAD* in the mid-1960s.

along. If I was on a six-pager, if I was on page five and a half I knew that I had to get started downhill to the end. It just worked."

Since Gaines supplied the springboards, Feldstein usually didn't know where the original inspiration for the plots came from. In one case the pair combined two of Ray Bradbury's stories ("Kaleidoscope" and "The Rocket Man") into one story in *Weird Fantasy* #13 (May–June 1952), which they called "Home to Stay!" Bradbury found out about it, but rather than make a big brouhaha he simply asked for a $25 payment for each story, and went on to suggest that there were many other Bradbury stories that might benefit by a translation into comics form. Gaines and Feldstein were thrilled. Feldstein said in the *Tales of Terror! The E.C. Companion* interview that "This became the love of my life, adapting Ray Bradbury into comics. That was where I think my writing really started to improve, because I was immersed in his writing–much to the detriment of the artists. The old joke was that I got to writing such heavy captions and balloons that all the characters had to be drawn with a hunchback." Bill Gaines concurred in a 1973 interview (published in the E.C. fanzine *Squa Tront* #9, 1983): "Feldstein developed a Ray Bradbury–ish style of using words. He got all carried away with the words, and so did I. I loved Al's words. We were using first-rate artists, because why not use first-rate artists? They can only enhance what we're doing. But Al would write such heavy

captions, and such heavy balloons on occasion, there really was no room for the artist to work." This is, of course, an exaggeration, but the point is well taken that E.C.'s comics were not just great stories or just great art, but a spectacular combination of the two elements.

When the *MAD* comic book took off in popularity, E.C. did the standard thing that is done in most commercial enterprises: do more of it. E.C.'s companion to *MAD* (edited by Feldstein) was titled *PANIC*. Feldstein wrote all the stories in *PANIC*'s first six issues, and then decided he could use some help, so Jack Mendelsohn was brought in to write the last six issues. Fleagle Gang member (and future *MAD* Magazine staffer) Nick Meglin also contributed several story ideas. Feldstein told comics historian John Benson in 1981 that "I always felt badly about *PANIC*, in that it was one of six books that I was doing while Harvey [Kurtzman] was doing just *MAD*. I always felt that if I had had the time to spend like he spent on *MAD* that I could have done a better job. But it was just a one-week book for me."

Nonetheless, *PANIC* has its fans, and some very good work appeared there.

Below: The original art to the splash page of "Death Must Come!" (*The Crypt of Terror* #17, April–May 1950).

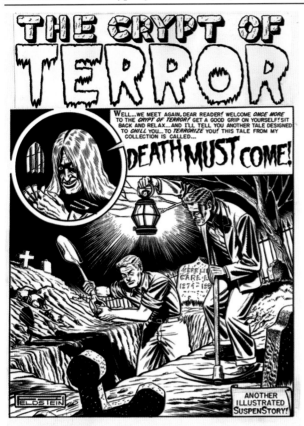

After Gaines was forced to drop his horror and crime comics, Feldstein helmed the transition into E.C.'s New Direction and Picto-Fiction titles. While these were noble experiments, the books failed for a variety of reasons—not the least of which was wholesaler and retailer resistance to anything published by E.C. Out of money and with no marketable property in his line except for Harvey Kurtzman's *MAD* Magazine, Gaines was forced to let Feldstein go in early 1956, along with any E.C. artists who were not contributing to *MAD*. This was a tough time for Feldstein. He was back pounding the pavement, looking for work. "It's amazing how people perceive you when you have been part of something that has been getting bad press," he said recently. In other words, he was not welcomed with open arms in many publishing houses. He did write some *Yellow Claw* scripts for Stan Lee at Atlas Comics, but after all his successes at E.C. he hated going back to the freelance world. Of this period, Feldstein said "I typed up the script and I brought it in and got paid whatever it was, seven dollars a page or some ridiculous thing. I said, 'God, what am I doing?'"

Feldstein was at liberty for several months, and had finally gotten a publisher interested in some concepts he was pitching. Unbeknownst to Feldstein, Kurtzman had just staged an unsuccessful power play at *MAD*, and had abruptly departed the magazine, taking with him most the artists. On the advice of several people, including E.C.'s business manager, Lyle Stuart, Gaines's wife, Nancy, and former E.C. artist Joe Orlando, Gaines met Feldstein at the train station in Merrick (as he was returning home from a pitch meeting) and asked him to to take over the job as *MAD*'s editor. And as of that Friday evening, *MAD* had a new editor: Al Feldstein.

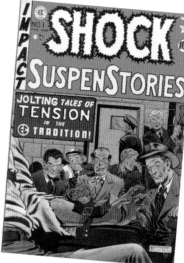

Left: Feldstein's "shocking" cover to *Shock SuspenStories* #1 (February–March, 1952).

In *The MAD World of William M. Gaines*, Frank Jacobs notes that "Feldstein took over the editorship [of *MAD*] with the zeal of a lineman coming off the bench." Feldstein said in the *Tales of Terror! The E.C. Companion* interview that "I don't know how the first few issues got done, but they got done. It was just one incident of serendipity after another. All these talented people were walking into the office, not aware that there's been this terrible change—that Harvey had left and taken all the artists with him. I don't think they knew that there was a new editor there who was on his knees praying for artists and writers to help him do his job." Among the artists answering his prayers: Don Martin, George Woodbridge, Mort Drucker, Norman Mingo, Kelly Freas, Bob Clarke, and Dave Berg, all of whom became founding members of "The Usual Gang of Idiots."

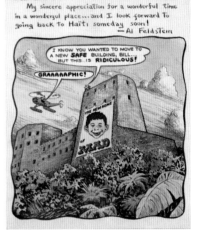

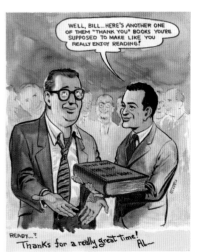

Above right: Bill Gaines organized yearly trips to exotic locales for his regular *MAD* contributors, and as a special "thank you," after each one the *MAD*-men gave Gaines what was called a "*MAD* Trip Book." Shown are Feldstein's contributions to the 1960 and 1961 books.

Copyright © 1956 by E.C. Publications

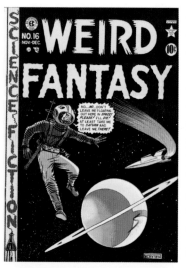

Right: Original art to the "headlight" cover of *Weird Fantasy #7* (May–June, 1951).

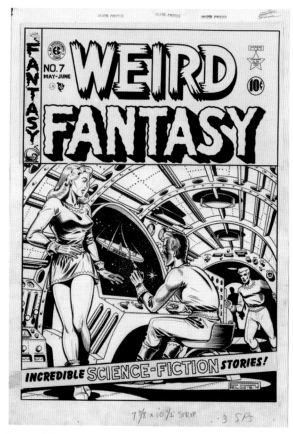

Feldstein, who was nothing if not a pragmatist, got *MAD* back on track and back on deadline. With a regular schedule and what was arguably a more accessible package, circulation began to increase. By the end of 1958, *MAD* could boast of a million copies sold per issue.

Because *MAD* was begun by Harvey Kurtzman, a brilliant satirist (but a poor businessman), there developed what came to be known as the "Kurtzman Cult," a group of aficionados wildly devoted to Kurtzman's *MAD*, and for whom the later Feldstein-edited version was entirely unpalatable. In truth, while Kurtzman more than pointed the way, many of the features and artists that are now so indelibly identified with *MAD* were developed under Feldstein's editorship. Indeed, many of what have become *MAD*'s most popular features (including Dave Berg's "Lighter Side," Al Jaffee's "Fold-Ins," Mort Drucker's movie parody caricatures, Sergio Aragonés's "marginals," and Antonio Prohias's "Spy vs Spy") were not so much as a gleam in their creator's eyes in the 1950s—these features didn't even begin to appear until the early 1960s, years after Kurtzman jumped ship. And while it's true that the Kurtzman-edited version of *MAD* planted the seeds of anarchy in the Underground Comix creators of the 1960s, the Feldstein-edited version of *MAD* has had an equally profound effect upon *its* readership as an indispensable rite of passage, a sort of primer into the adult world. Indeed, for all but the oldest among the Baby Boomers (that now-graying but eternally Peter Pan generation), there has always

been *MAD*, just as there has always been Rock 'n' Roll, television, and Walt Disney.

Probably because of his experiences growing up in the depression, Feldstein possesses both a thriftiness and a canny way with money that earned him the envy—as well as the ire—of his co-workers. And unlike Kurtzman, he has a good head for business as well. After Gaines sold *MAD* in 1960 (with a deal that allowed him to stay on as publisher), Feldstein negotiated with Gaines a percentage of the magazine's gross profits. Feldstein went in and told Gaines "I'm not Harvey Kurtzman. I didn't want 51%, but I sure would have liked a piece of this thing because I got it going again for you." In 1960 this percentage deal resulted in a nice raise, but as *MAD*'s circulation grew and grew over the years it made Feldstein, as Gaines loved to boast, "the highest paid editor in the world." Feldstein was a ferocious worker who usually worked through his day in the freewheeling *MAD* offices with his door closed, discouraging visits from fans of either *MAD* or of the E.C. comics. This was in stark contrast to Gaines, who loved reminiscing about the old E.C. days and was interviewed countless times about them. Feldstein regards his prior lack of visibility as something of a mistake, and he

Above: The Feldstein original cover (and the printed cover) to *Weird Fantasy #16* (November–December 1950), and *MAD #29* (September 1956), the first Feldstein-edited issue.

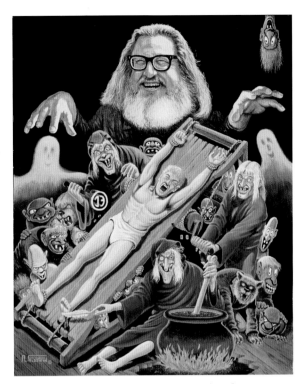

Far left and left:
Two of Feldstein's "E.C. Revisited" paintings, *Tales of Terror annual, 1953–Revisited* (2002), and *Weird Fantasy #20–Revisited* (2002). *Below: A Moon, a Girl . . . Romance #10–Revisited* (2003). The "GG" logo on the drum head is a nod to the author of this book.

now regularly appears at comic-book conventions as a featured guest.

As the years went on, Gaines and Feldstein's initial close friendship cooled off, but the two maintained a very successful working relationship for thirty-six years, until Feldstein decided at the end of 1984 it was time to step down from his post. "There were things I felt we should be doing [with the magazine] to avoid just atrophying of old age," Feldstein has said. Gaines was reluctant to make changes; interestingly, just about all of the things Feldstein thought should be done with the magazine—including a *MAD* TV show, inserting color pages, and taking advertising—have come to pass in recent years.

Feldstein sold his home in Connecticut and, with his new wife, Michelle, moved initially to Jackson Hole, Wyoming. There he finally began to indulge his life-long dream of becoming a fine artist, painting numerous canvases of the fast disappearing cowboys and ranchers he observed in the area. He ultimately relocated to a more remote location in Livingston, Montana, on a 270-acre property they christened Deer Haven Ranch. In this tranquil setting (with the Yellowstone River running through the property), Al paints in a studio adjoining the house. He has won numerous awards for his "fine art" paintings

in recent years. At the request of long-time E.C. fan (and Sotheby's consultant) Jerry Weist, starting in 1991 Feldstein began creating "E.C. Revisited" paintings to be offered at auction by the tony auction house. He has also accepted numerous private commissions for his "E.C. Revisited" paintings, which are exquisitely rendered and quite popular with the E.C. fans.

In 1999, he was awarded an honorary Doctorate of the Arts degree by Rocky Mountain College in Billings, Montana. And finally fulfilling another longtime dream, Al Feldstein was inducted into the Will Eisner Hall of Fame in 2003. •

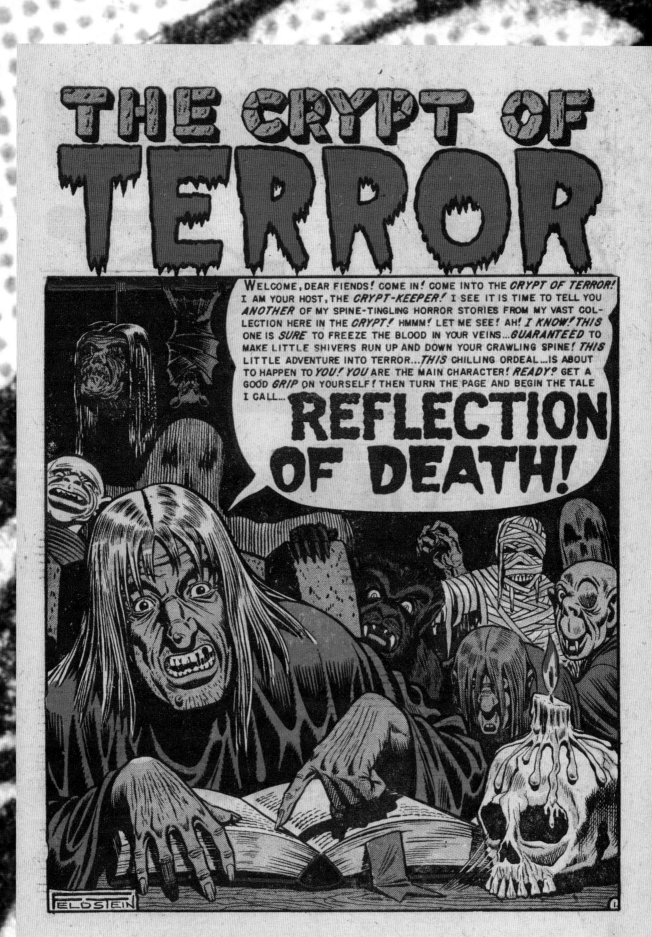

"Reflection of Death!," from *Tales from the Crypt* #23 (April–May 1951). Illustrated by Al Feldstein. Written by Bill Gaines and Al Feldstein.

AHEAD OF YOU, THE WHITE LINE THAT DIVIDES THE ROAD STRETCHES INTO THE DARKNESS BEYOND YOUR HEADLIGHT BEAM! BESIDE YOU, CARL SITS PUFFING ON A CIGARETTE...

GETTING PRETTY COLD, ISN'T IT, CARL?

YEAH! AND THE HEATER'S ON THE FRITZ, TOO! IT'S GOOD WE WORE WARM CLOTHES!

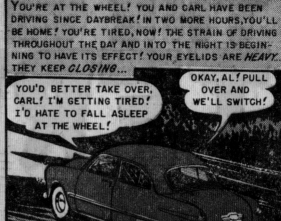

YOU'RE AT THE WHEEL! YOU AND CARL HAVE BEEN DRIVING SINCE DAYBREAK! IN TWO MORE HOURS, YOU'LL BE HOME! YOU'RE TIRED, NOW! THE STRAIN OF DRIVING THROUGHOUT THE DAY AND INTO THE NIGHT IS BEGINNING TO HAVE ITS EFFECT! YOUR EYELIDS ARE *HEAVY*...THEY KEEP *CLOSING*...

YOU'D BETTER TAKE OVER, CARL! I'M GETTING TIRED! I'D HATE TO FALL ASLEEP AT THE WHEEL!

OKAY, AL! PULL OVER AND WE'LL SWITCH!

YOU STOP THE CAR AND CARL GETS OUT! YOU SLIDE ACROSS THE SEAT AND CARL SLIPS BEHIND THE WHEEL...

WHY DON'T YOU TAKE A SNOOZE, AL? I'LL WAKE YOU UP WHEN WE GET TO TOWN!

MAYBE... MAYBE I WILL, CARL!

YOU DRAW YOUR COAT UP TIGHT AROUND YOU...PULL YOUR HAT DOWN...REACH INTO YOUR POCKET FOR YOUR GLOVES...

YOU STARE OUT THROUGH THE WINDSHIELD! THE ROAD COMES OUT OF THE DARKNESS AT YOU AND SLIDES BENEATH THE CAR...UNENDING...FASTER...FASTER! CARL BEGINS TO WHISTLE AN OFF-KEY TUNE! THE MOTOR PURRS... THE ROAD COMES ON...ON...

YOUR HEAD BEGINS TO NOD! CARL'S WHISTLING CONTINUES...FLAT...UNMELODIC! SUDDENLY HE GASPS! YOU LOOK UP! A PAIR OF HEADLIGHTS...BRIGHT...BLINDING...HURTLES AT YOU FROM THE DARKNESS! CARL SHOUTS! YOU TRY TO SCREAM BUT IT CHOKES UP IN YOUR THROAT...A RATTLING COUGH...

LOOK OUT...AL...WE'RE GOING TO HIT...

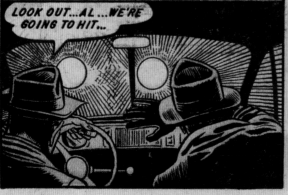

THERE IS A SPLINTERING SHRIEKING CRASH OF METAL AND GLASS AND SQUEALING BRAKES...

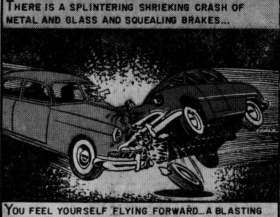

YOU FEEL YOURSELF FLYING FORWARD...A BLASTING LIGHT...THE PAIN...THE COLD...AND THEN THE VELVET NIGHT CLOSES IN! ALL IS QUIET, EXCEPT FOR A DISTANT ...FAR AWAY...WHIMPERING...

②

THE BLACKNESS IS EMPTY... ETERNAL! YOU FLOAT IN IT... TURNING...TWISTING...FALLING...THEN RISING AGAIN! THE PAIN IS GONE...EVERYTHING IS GONE...ONLY THE DARKNESS...ON...ON...DARK... BLACK...EMPTY...

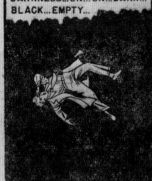

YOU OPEN YOUR EYES! TINY PINPOINTS OF LIGHT BLINK BRIGHT AND DIM BEFORE YOU! A LEAF FLUTTERS... THEN GLIDES AT YOU! YOU ARE ON YOUR BACK...GAZING UP AT THE NIGHT SKY...

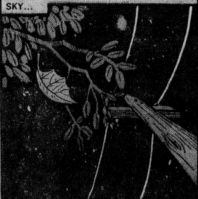

YOU RAISE YOUR HEAD AND LOOK ABOUT! YOU ARE LYING AT THE EDGE OF A ROAD! YOU REMEMBER NOW! THE HEADLIGHTS...THE CRASH...THERE MUST HAVE BEEN A COLLISION! BUT THE WRECK...THERE'S NO SIGN OF IT...

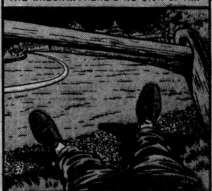

YOU GET TO YOUR FEET! YOUR CLOTHES ARE TORN AND DIRTY! THERE IS A SMELL...A SICKENING SMELL! YOU LOOK UP AND DOWN THE ROAD! NO SMASHED GLASS! NO TWISTED METAL! NOTHING! JUST A ROAD... CLEAN...WHITE...REACHING INTO THE NIGHT...

A CAR IS COMING! YOU STUMBLE OUT ONTO THE CONCRETE! YOU RAISE YOUR GLOVED HAND AS THE CAR BEARS DOWN UPON YOU! ITS WAILING BRAKES BRING IT TO A STOP...

CRAZY FOOL! DO YOU WANT TO GET YOURSELF KILLED? I...I..

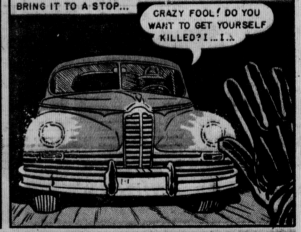

YOU STEP CLOSE TO HIM! YOU BEGIN TO ASK HIM IF HE'LL DRIVE YOU INTO TOWN...THAT THERE'S BEEN A WRECK! SUDDENLY YOU SEE THE WILD LOOK IN HIS EYES! A LOOK OF *STARK TERROR!* HE STARES AT YOU AND *SHRIEKS*...

YAAAAAAAAAAH!

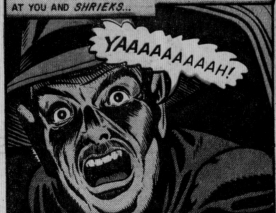

THE CAR MESHES GEARS AND ROARS AWAY! YOU CAN HEAR HIM SCREAMING! YOU CANNOT UNDERSTAND! THEN YOU LAUGH TO YOURSELF! OF COURSE! YOU MUST HAVE BEEN CUT IN THE ACCIDENT! MAYBE THE SIGHT OF BLOOD SCARED HIM! YOU START DOWN THE ROAD... TOWARD TOWN...TOWARD HOME...

THEN YOU SEE IT! THE FIRE! SOME-ONE UNDER THE ROAD-BRIDGE... COOKING! YOU MOVE TOWARD HIM! PERHAPS HE HEARD THE CRASH... SAW THE ACCIDENT...

IT IS A HOBO... A TRAMP HUDDLED NEAR THE FIRE! HE STIRS SOME-THING IN A CAN HUNG OVER THE FLAMES! HE LOOKS UP AS YOU APPROACH...

WELCOME, PARDNER! IF YOU'RE HUNGRY, SET YOURSELF DOWN! THE STEW'S JUST ABOUT DONE!

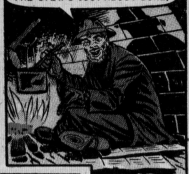

YOU MOVE INTO THE FIRELIGHT! HE LOOKS INTO THE CAN...STIRS IT A BIT... THEN TURNS TOWARD YOU! SUDDENLY THE BLOOD DRAINS FROM HIS UNSHAVEN FACE! HE CRINGES...

K...K...KEEP AWAY...I...I AAAAAGH!

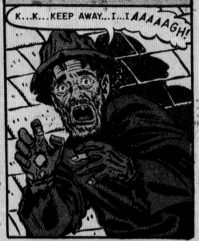

THE TRAMP CLAWS HIS WAY UP TO THE EMBANKMENT AND RUNS, SHRIEKING, DOWN THE ROAD! YOU WATCH HIM AS HE VANISHES INTO THE NIGHT...

NO..NO...EEEEEEEEEEEE!

YOU CONTINUE ON TOWARD TOWN! YOU'VE GOT TO GET HELP! THEN YOU STOP! YOU, LOOK DOWN! A PIECE OF A NEWSPAPER IS UNDER YOUR FOOT! YOU READ THE DATE...

IT CAN'T BE! FEBRUARY 26TH, 1951! IMPOSSIBLE! THAT'S ALMOST TWO MONTHS FROM NOW! TODAY...TODAY IS JANUARY 1ST! YOU AND CARL HAD BEEN RETURNING FROM A NEW YEARS EVE PARTY! YOU HAD BEEN DRIVING ALL DAY...NEW YEARS DAY! NOW IT'S NEW YEARS NIGHT! OR IS IT? ANOTHER CAR IS COMING! YOU PUT THE PAPER IN YOUR POCKET AND STEP OUT ONTO THE ROAD...

SHE'S FRIGHTENED! WHAT WOMAN WOULDN'T BE? A LONELY ROAD AT NIGHT! YOU...A STRANGE MAN... STEPPING OUT IN FRONT OF HER CAR...FORCING HER TO STOP OR HIT YOU! OF COURSE SHE'S FRIGHTENED...

WHAT...WHAT DO YOU WANT?

4

YOU ARE ABOUT TO TELL HER NOT TO BE AFRAID... THAT YOU MEAN NO HARM! BUT THERE IS NO TIME! SHE LOOKS AT YOU...HER EYES ROLL...SHE GURGLES A FAINT GROAN AND FAINTS...

U-U-U-G-H-H!

YOU GET INTO HER CAR! YOU DRIVE IT INTO THE OUTSKIRTS OF TOWN AND LEAVE IT...THE WOMAN UNCONSCIOUS BEHIND THE WHEEL! YOU MAKE YOUR WAY HOME...*HOME!* BUT WHEN YOU REACH IT...

THE WINDOWS ARE BOARDED UP! YOU CANNOT UNDERSTAND! THERE IS A SIGN TACKED TO THE HOUSE! YOU MOVE CLOSER...TO READ IT...

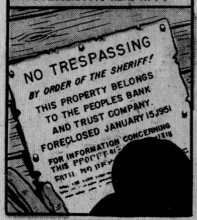

NO TRESPASSING
BY ORDER OF THE SHERIFF!
THIS PROPERTY BELONGS TO THE PEOPLES BANK AND TRUST COMPANY.
FORECLOSED JANUARY 15,1951
FOR INFORMATION CONCERNING THIS PROPERTY...

FORECLOSED! ON JANUARY 15,1951! BUT TODAY IS...OR IS IT? THE NEWSPAPER YOU FOUND! REMEMBER? HAVE YOU BEEN UNCONSCIOUS FOR ALMOST *TWO MONTHS?* YOU TURN AWAY FROM THE HOUSE! A LONE FIGURE APPROACHES ON THE DESERTED DARK STREET...

YOU WALK TOWARD HIM! YOU WANT TO ASK HIM THE DATE! HE COMES CLOSER! THEN HE SEES YOU...

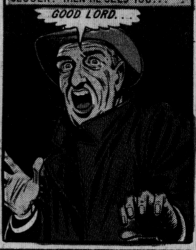

GOOD LORD...

HE BEGINS TO RUN FROM YOU! YOU RUN AFTER HIM! YOU ONLY WANT TO ASK HIM A *QUESTION!* WHY DOES EVERYONE *STARE* AT YOU *WIDE-EYED...FAINT... SCREAM...RUN* FROM YOU? *WHY?* CARL'S HOUSE! YOU'RE IN FRONT OF CARL'S HOUSE NOW! CARL...WHO WAS WITH YOU...WHEN THE ACCIDENT HAPPENED! YOU GO UP THE STEPS...STAND BEFORE THE DOOR...RING THE BELL...

HEAVY FOOTSTEPS APPROACH! THE DOOR OPENS! CARL STARES OUT AT YOU! YOU WAIT FOR HIM TO SCREAM... TO RUN...WAIT FOR THAT LOOK OF HORROR...BUT NOTHING HAPPENS...

CARL! LET ME COME IN! YOU'VE GOT TO HELP ME!

I...I...DON'T.

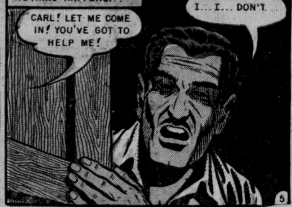

5

YOU RUSH INTO HIS APARTMENT! IT IS DARK! CARL OBJECTS! YOU TELL HIM THE STORY! YOU BLURT IT OUT... EVERYTHING! THE CRASH... HOW YOU WOKE UP... THE PEOPLE THAT SCREAMED WHEN THEY SAW YOU! EXCEPT CARL... CARL DID NOT SCREAM! CARL... YOUR FRIEND...

YOU JOKE WITH ME... WHOEVER YOU ARE...

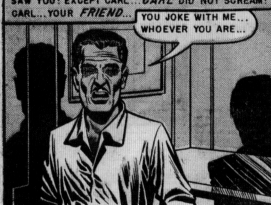

HE STARES AT YOU, BLANKLY! THERE IS NO RECOGNITION! 'DON'T YOU KNOW ME, CARL? DON'T YOU RECOGNIZE YOUR OLD FRIEND... AL?', YOU SAY! HE SHAKES HIS HEAD AND TURNS AWAY...

YOU'RE FOOLING! THIS IS SOME SORT OF A GAG! SURELY YOU KNOW THAT AL AND I WERE IN AN ACCIDENT ALMOST TWO MONTHS AGO... THAT AL WAS KILLED... HORRIBLY MANGLED...

...AND I LOST MY SIGHT! THAT I AM TOTALLY BLIND!

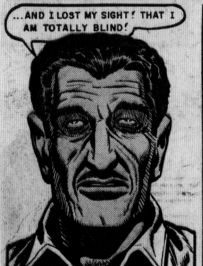

YOU, DEAD! YOU GASP! YOU LOOK AROUND! A MIRROR! YOU GET UP... STAGGER TOWARDS IT...

...AND LOOK IN!

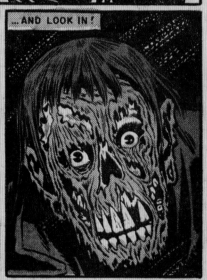

YOU SCREAM! YOU OPEN YOUR ROTTED, TORN, DECOMPOSED MOUTH AND SCREAM!

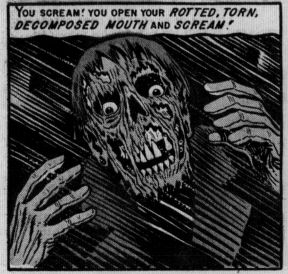

CARL IS AT YOUR SIDE SHAKING YOU... SHAKING YOU...

AL... AL... AL...!

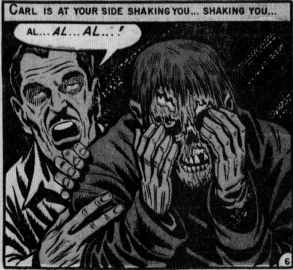

6

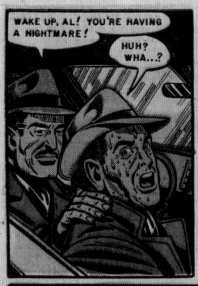

WAKE UP, AL! YOU'RE HAVING A NIGHTMARE!

HUH? WHA...?

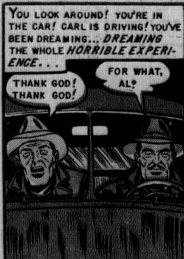

YOU LOOK AROUND! YOU'RE IN THE CAR! CARL IS DRIVING! YOU'VE BEEN DREAMING... *DREAMING* THE WHOLE *HORRIBLE EXPERIENCE...*

THANK GOD! THANK GOD!

FOR WHAT, AL?

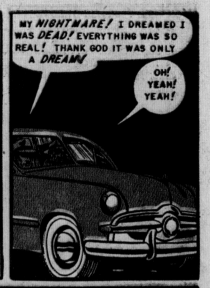

MY *NIGHTMARE!* I DREAMED I WAS *DEAD!* EVERYTHING WAS SO REAL! THANK GOD IT WAS ONLY A *DREAM!*

OH! YEAH! YEAH!

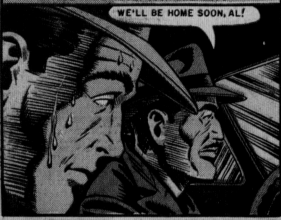

YOU WATCH THE ROAD AS IT UNFOLDS BEYOND THE HEADLIGHT GLOW AND RUSHES TOWARD YOU AND UNDER THE SPINNING WHEELS! YOU WONDER IF YOU SHOULD TELL CARL ABOUT YOUR DREAM...

WE'LL BE HOME SOON, AL!

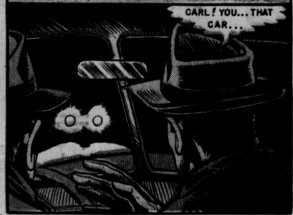

YOU STARE OUT OF THE WINDSHIELD! FAR AWAY THE HEADLIGHTS OF AN APPROACHING CAR KNIFE THROUGH THE DARKNESS! ICY FINGERS GRIP YOUR HAMMERING HEART! THEY'RE COMING AT YOU NOW... FAST...

CARL! YOU... THAT CAR...

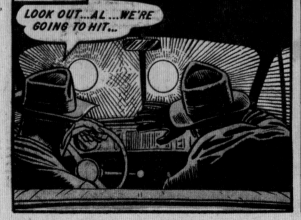

YOU TRY TO MOVE! YOU'RE PARALYZED! THE DREAM! IT'S SO MUCH LIKE THE DREAM! YOU TRY TO SCREAM BUT NOTHING COMES OUT! CARL GASPS... THEN SHOUTS...

LOOK OUT... AL ... WE'RE GOING TO HIT...

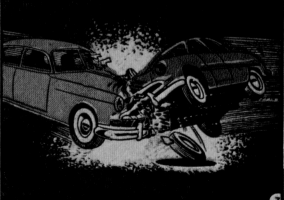

THERE IS A SQUEAL OF BRAKES... AND THE IMPACT OF TEARING METAL AND SHATTERING GLASS:...

YOU FEEL YOURSELF THROWN FORWARD...A BLINDING LIGHT...A SHOOTING PAIN! THEN THE DARKNESS CLOSES IN...AND YOU'RE FLOATING IN A SEA OF VELVET BLACK...

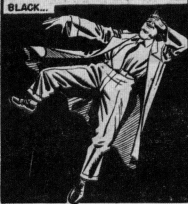

YOU OPEN YOUR EYES! YOU CAN SEE THE STARS...ABOVE YOU... TWINKLING! A LEAF FLOATS FROM THE TREE OVERHEAD TO EARTH! YOU ARE LYING AT THE SIDE OF THE ROAD...

YOU LIFT YOUR HEAD AND GAZE DOWN TOWARD YOUR FEET! THE DREAM...SO MUCH LIKE THE DREAM...

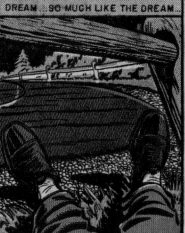

YOU STRUGGLE TO YOUR FEET! THE ROAD IS BARE! THERE IS NO SIGN OF THE WRECK! FROM FAR OFF... THE SOUND OF A MOTOR TELLS YOU OF AN APPROACHING CAR! YOU STEP OUT INTO THE ROAD...

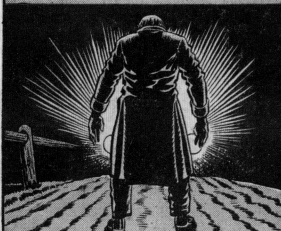

THE SMELL...THE SICKENING SMELL OF ROTTED FLESH BURNS YOUR NOSTRILS! SO MUCH LIKE THE DREAM...ONLY NOW YOU *KNOW* WHAT THE STENCH IS! THE CAR STOPS! YOU MOVE TOWARD IT...

CRAZY FOOL! DO YOU WANT TO GET YOURSELF KILLED?

THE DREAM IS *REAL!* YOU *KNOW* WHAT'S ABOUT TO HAPPEN! HE SEES YOUR FACE! YOU STEEL YOURSELF FOR HIS REACTION! IT COMES! A *HAUNTING TERRIFIED SCREAM*...

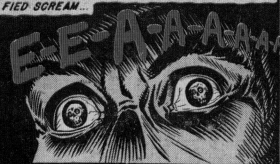

E-E-A-A-A-A-H!

YOU'RE *DEAD!* YOU *KNOW* IT, *NOW! DEAD!* AND *THIS* TIME, IT *ISN'T* A DREAM...

THE END

HEH, HEH! WELL, KIDDIES! THAT'S IT! LIKE IT? LIKE BEING A *CORPSE?* WELL, YOU MIGHT AS WELL GET *USED* TO IT! IT'S *BOUND* TO *HAPPEN... EVENTUALLY.* OH, COME, COME! WHY THE *GRAVE* LOOK? YOU'VE GOT TIME! HEH, HEH! MAYBE YOU'LL KNOW IT'S COMING BY HAVING A DREAM LIKE POOR AL IN THIS STORY! IF YOU DO, YOU'LL HAVE SOMETHING TO LOOK FORWARD TO! IN THE MEANTIME, YOU CAN LOOK FORWARD TO SOME MORE CHILLING TALES IN THIS BOOK! COMPOSE YOURSELF! READY? O.K. THEN, I'LL TURN YOU OVER TO *THE OLD WITCH!*

8

HARVEY KURTZMAN!

"HEY, I *LOVE* THIS GUY! I REALLY *DO!*" –ROBERT CRUMB

Harvey Kurtzman was born in Brooklyn, New York on October 3, 1924. He was attracted to cartooning at a very young age. Among his earliest work was a comic strip of his own invention entitled *Ikey and Mikey*, which he drew on the streets of Brooklyn in chalk every afternoon after school. The ultimate in ephemera, the strip would be gone by the next morning, washed away by the rain or by the city sanitation trucks. "Cartoons were my first love as a child," he wrote. "Sometime between elementary and high school, I got the urge to be a professional cartoonist. I wanted it to be my job, my life." At the end of eighth grade, Kurtzman was accepted at the High School of Music and Art in Manhattan. Here he came in contact with several young artists with whom he would later form working relationships, including Will Elder, Al Jaffee, Harry Chester, and Al Feldstein. After high school he was awarded a scholarship to Cooper Union art school, where he studied painting, sculpture, and lettering. His time at Cooper proved to be unrewarding, and he left after about a year. "All I really wanted to do was draw cartoons," he wrote.

Kurtzman found his first job in the industry at age eighteen, as an assistant to Louis Ferstadt, a fine artist who also did work in the comics. By 1943, Kurtzman was illustrating various second-tier superhero features for Ace Publications, including *Lash Lightning* and *Magno*. Not long after, Kurtzman was drafted into the Army, where he drew for the base newspapers where he was stationed, and contributed three cartoons to *YANK*, the official Army magazine.

After his discharge from the service in 1945, Kurtzman returned to comics, illustrating such features as "Black Venus" and "The Black Bull." He found more steady employment with Stan Lee at Timely Comics (later to become Atlas, and then Marvel), where he wrote and drew a series of humorous one-page "fillers" titled "Hey Look!" The strips were well received, especially among his peers, and Kurtzman later wrote, "It was my first merit badge as a professional, my first success with work that was all my own." He worked for several years doing "Hey Look!," until the powers that be at Timely abruptly decided that one-page fillers had gone out of style.

Undaunted, Kurtzman now had a substantial body of work to show for his time at Timely, as well as something else: his new wife, Adele, who was a proofreader there. With his portfolio of "Hey Look!" pages under his arm, Kurtzman began pounding the pavement looking for work. He had heard that there was an outfit downtown that published educational comics, and–hoping to do something more uplifting–he set out for the E.C. offices. There

Below: The young Kurtzman was awarded a dollar for this cartoon he sent in to *Tip Top Comics*, published in issue #36 (April 1939). Kurtzman later said "That was the first dollar I ever earned, and probably the sweetest."

Harvey Kurtzman
2166 Clinton Ave.
Bronx, New York

Copyright © 1939 by United Features Syndicate

Left: Kurtzman's cover to *Two-Fisted Tales* #18 (November–December 1950), which is actually the first issue.

Right: Two Kurtzman cartoons from high school.

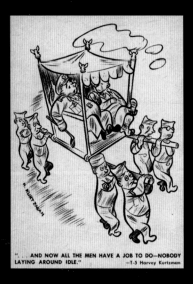

"... AND NOW ALL THE MEN HAVE A JOB TO DO—NOBODY LAYING AROUND IDLE."
—T-5 Harvey Kurtzman

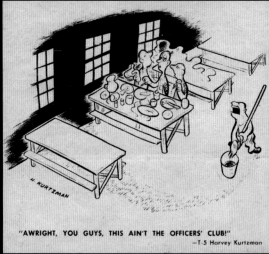

"AWRIGHT, YOU GUYS, THIS AIN'T THE OFFICERS' CLUB!"
—T-5 Harvey Kurtzman

"Aaaah—quit yer bitchin'! You never had it better in yer life!"
—T-5 Harvey Kurtzman, Fort Bragg, S. C.

Above: Kurtzman cartoons from his Army days, from *YANK: The Army Weekly,* November 16, 1945; November 23, 1945; and December 7, 1945.

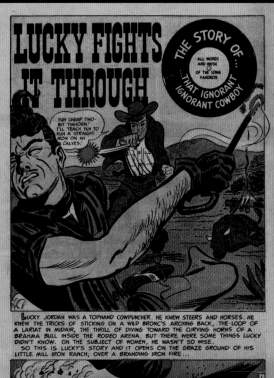

Left and above: Kurtzman's first job for E.C. was *Lucky Fights It Through,* a 1949 educational pamphlet about venereal disease.

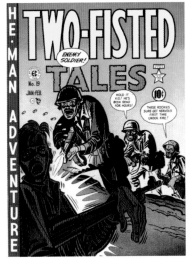
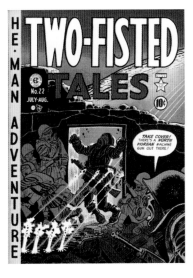
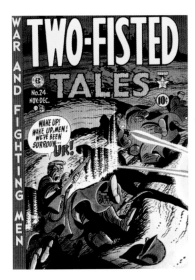
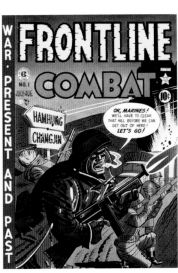
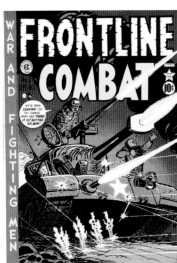
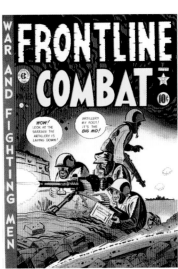

H. Kurtz.

Above: Kurtzman's E.C. covers were models of economy in line. He usually worked with bold, curvaceous lines that exaggerated—and heightened—the reality of the scene, but never in a "cartoony" way.

he met publisher Bill Gaines and artist/writer Al Feldstein, who immediately loved "Hey Look!" Bill and Al weren't working on educational comics, but Bill's uncle David was. They recommended Kurtzman for *Lucky Fights It Through*, a 1949 educational pamphlet published out of the E.C. offices by David Gaines.

Soon thereafter Kurtzman did his first story for E.C. proper, "House of Horror" (*The Haunt of Fear* #15, May–June 1950; this was actually the first issue). Kurtzman recalled in 1984 that "'House of Horror' was an ass-breaker. It was the effort that got me the E.C. account." Although they weren't exactly his

cup of tea, Kurtzman did a number of early horror and science fiction stories for E.C. The very earliest ones were from scripts that E.C. provided, but it wasn't long before Kurtzman was writing as well as drawing his own stories. Very soon after, Gaines gave Kurtzman a shot at editing his own comic book.

Always a fan of adventure and mystery stories, Kurtzman proposed a "he-man adventure" comic called *Two-Fisted Tales*; the first issue appeared in November–December 1950. But the Korean War had

Copyright © 1946 by Aviation Press

Above: Kurtzman "Black Venus" splash page, from *Contact Comics*, March 1946.

41

broken out, and the book was immediately changed into a war comic. Kurtzman wanted this war comic to be different. "I wanted my war stories to have some purpose. I wanted to do a war comic that told the truth. I wanted stories to show that all people are pretty much the same, and that all soldiers had the same problems, no matter who they were fighting for." A companion title, *Frontline Combat*, appeared in 1951. These highly regarded books were the very first true-to-life war comics.

Kurtzman was a slow, meticulous worker who not only wrote the stories, but also provided detailed tissue-paper layouts of each panel for the artists to follow. To go substantially off of Kurtzman's vision was *not* encouraged. Kurtzman also felt that he couldn't write until he had all the background

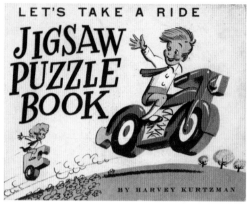

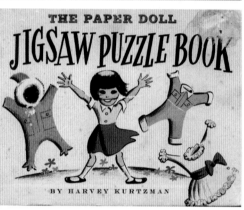

Above: Two 1949 children's books, part of a series of "jigsaw puzzle books" written and illustrated by Kurtzman just prior to his coming to E.C.

Right: Kurtzman was just as meticulous in answering letters from fans as he was in his actual work.

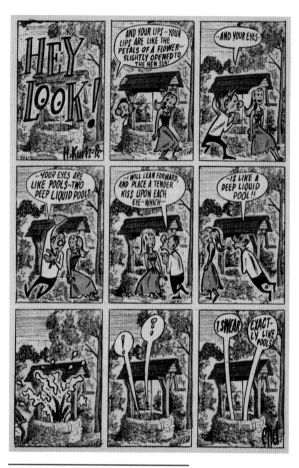

Above: "Hey Look!" page from *Patsy Walker* #20, January 1949.

material together, a process that included talking to war veterans, reading historical accounts, going up on a test flight, and even sending assistant Jerry DeFuccio down in a submarine for a first-hand account. Every detail had to be accurate, right down to the buttons on uniforms. Needless to say, this process could—and did—take weeks.

Kurtzman was producing work that was unsurpassed in the comic-book field, then or now. The downside was that he was running himself ragged and was barely making enough money to support his family. By contrast, Feldstein could write a horror story in a day (usually from a plot provided by Gaines), but with Kurtzman's method there was no way he could up his output. He appealed to Gaines for a raise, but Gaines was caught in a conundrum. Feldstein was turning out seven books to Kurtzman's two, and payment was calculated by the number of books, not by the time it took to turn one out. And although *Two-Fisted Tales* and *Frontline Combat* were

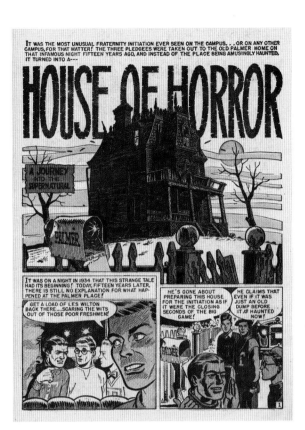

Above: "House of Horror" splash page, from *The Haunt of Fear* #15, May–June 1950. *Below:* "Lost in the Microcosm" splash page, from *Weird Science* #12, May–June 1950.

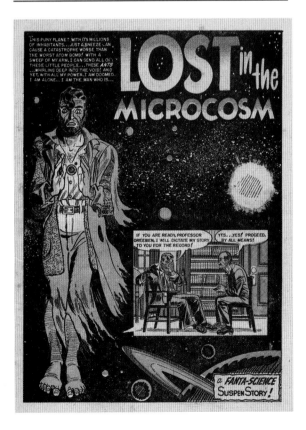

the best books of their kind, they were only moderately profitable compared with E.C.'s flagship horror titles.

Gaines told comics historian John Benson in 1973 that "Harvey felt that he was doing a better job than Al, which he was, intrinsically. On the other hand I kept pointing out that Al's books were selling better than his, which they were. So it was kind of a stand-off." The solution? Gaines suggested that if Harvey could sandwich in another book between the ones he was already doing, his income would go up by 50%. And what kind of book might that be? Remembering the "Hey Look!" pages that they had loved on first meeting Harvey, Gaines and Feldstein suggested that Kurtzman do a humor book. And thus, out of a simple (yet pressing) need for more income, *MAD*, a publication destined to become an American institution, was born.

The attendees present at *MAD*'s birth are in disagreement. All concerned agree upon the reason *MAD* was created, but the facts beyond that vary depending upon whose camp you are in. Gaines always insisted that it was he who proposed that the new endeavor be humorous, since the first material in Kurtzman's portfolio that he and Feldstein saw (and that got him hired at E.C.) were the comedic and surreal "Hey Look!" pages Kurtzman had done for Stan Lee at Timely. Kurtzman always insisted that *he* proposed a humor book, since humor continuities were something he had done before and enjoyed. Also open to debate is who coined the title "*MAD*." Kurtzman maintained that it was his title and his alone, but Gaines and Feldstein lay

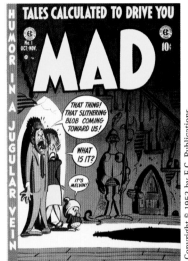

Above: *MAD* #1 (October–November 1952).

Copyright © 1952 by E.C. Publications

Copyright © 2000 by E.C. Publications

Above right: Gaines meets Kurtzman in this illustration by contemporary *MAD* artist Drew Friedman.

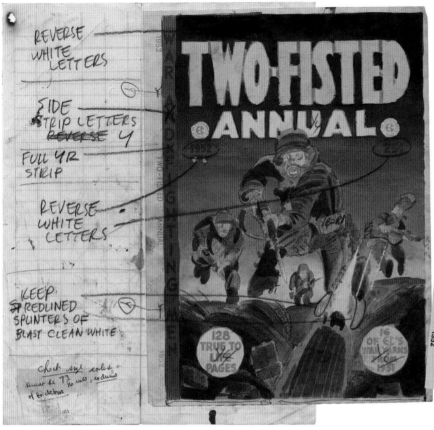

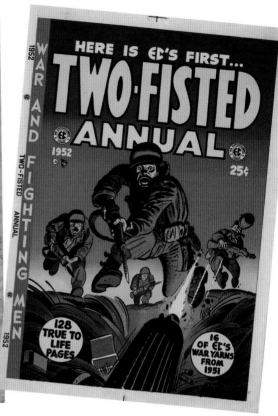

H. Kurtz

Above: Kurtzman's original hand colored and notated silver print to the 1952 *Two-Fisted Tales* annual, along with a printed proof of the final cover.

Above: Kurtzman cover for *Three Dimensional E.C. Classics*, Spring 1954.

claim to wanting to call the publication "E.C.'s MAD Mag.," which was a phrase the Crypt Keeper often used in the E.C. horror comics. According to Feldstein, Kurtzman came back with, "Well, *MAD* sounds better than "E.C.'s MAD Mag." "And that," Feldstein has said, "was *it.*"

Feldstein also recalls a friendly competition around the E.C. offices, with the editors trying to outdo each other, and sometimes even pitching ideas around for each other's projects. It was in this spirit that artist-writer-editor Johnny Craig suggested the comic book's early subtitle: "Humor in a Jugular Vein." Beyond this, the "real" story of the origin of *MAD* will likely never be untangled. It really matters not, because the creative genius behind all the material in the early *MAD* was Harvey Kurtzman. And about that there is no dispute.

The first issue of *MAD* (a 10¢ comic book) was cover-dated October–November 1952 but was on news-stands in August. The initial concept was to satirize the kinds of stories that E.C. had been churning out: horror, crime, science fiction, and even the not-so-dearly-departed romance comics. The artists that were to grace *MAD*'s pages were simply the same group of artists that had been working on Kurtzman's war books: Jack Davis, Wallace Wood, Will Elder, and John Severin. The stories, while comedic, were aimed at an older, more sophisticated reader than the average "funny book."

As Kurtzman struggled through *MAD*'s birth pangs, Gaines was facing another kind of a struggle. Comic-book industry pundits thought Gaines was crazy to invest money in what was quite obviously a losing proposition. Conventional wisdom was that comic books appealed to children, not adults. In a 1954 *Writer's Digest* article, Gaines wrote: "So they were right. *MAD* #1 lost money. My editor, Harvey Kurtzman, looked at me mournfully. I looked at him mournfully. *MAD* #2 lost money. *MAD* #3 lost money. *MAD* #4 lost money. Kurtzman and I were not looking at each other at all when the sales reports

began to come in on *MAD* #5. With a bang, we had done it!"

Convinced Kurtzman was on to something, Gaines carried the book at a loss until it found its audience—a rarity in comics. While *MAD* #4 may have lost money, it contained the infant publication's first bona fide classic, "Superduperman!," written by Kurtzman and illustrated by Wallace Wood. *MAD* had found its voice, satirizing not just comic-book *styles*, but specific comic book and comic strip features. He began taking on movies, television, politics, and various other aspects of popular culture. The pundits were

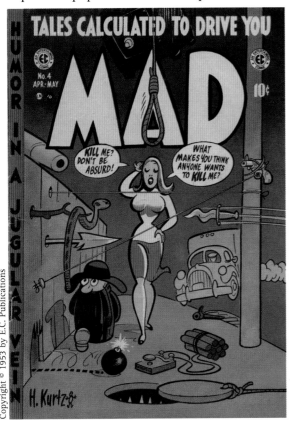

proved wrong: the comic-book *MAD* was a hit, even spawning a host of mediocre (and short-lived) imitations.

Fast-forward to 1955. *MAD* had been a comic book for three years. For all of *MAD*'s success, Kurtzman was still not satisfied. Kurtzman had been doing incredible, groundbreaking work in *MAD*, but after three years he had grown restless and was unsatisfied with the limitations of comic books. As brilliant as the work was, he still felt he was slumming in the world of comics. What he had been longing to do was to get out of the

comic-book game and work in the world of magazines—or "slicks," as they were known in the trade. Kurtzman had been entertaining an offer from an editor friend of his at *Pageant*, a highly regarded digest-sized slick. He told Gaines that he was seriously considering accepting the offer and moving on. Gaines, who was firmly convinced that without Kurtzman there could be no *MAD*, made Kurtzman an offer that he ultimately could not refuse: stay, and he could turn his *MAD* baby into a 25¢ slick.

MAD graduated to the magazine format with its twenty-fourth issue in July 1955, selling for "25¢—Cheap!" This was a thrilling time for Kurtzman. He told *MAD* writer Frank Jacobs in the book *The MAD World of William M. Gaines* that "the next day was one of the most exciting times in my life. I ran down to the newsstand and bought a bunch of slick magazines to see what other people were doing. I was scared to death when we abandoned the comic format, and I couldn't sleep wondering whether *MAD* would succeed in

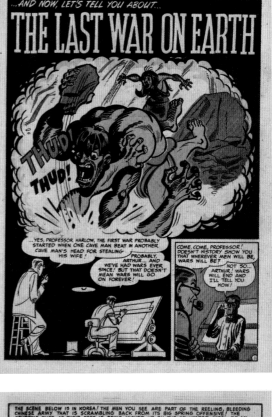

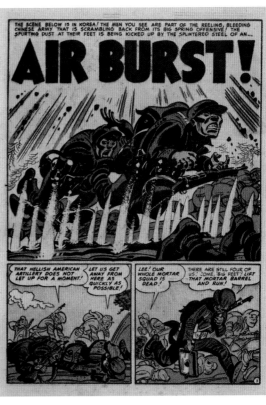

Above left: Kurtzman's cover to *MAD* #4 (April–May 1953). *Above right:* Examples of Kurtzman's E.C. science fiction and war splash pages: "The Last War on Earth," *Weird Science* #5 (January–February 1951) and "Air Burst!," *Frontline Combat* #4 (January–February 1952).

its new format." About this period, Gaines told comics historian John Benson, "I don't think there was the kind of excitement over the [*MAD*] comic book that there was later on when Harvey put out issue #24, the first 25¢ book. That made such a splash that we actually went back to press. It wasn't a good idea to go back to press [because of the lag time involved], but the very fact we did it indicates how well the book did."

For all the excitement, though, there were problems. *MAD* was officially a bimonthly, but the time between issues began stretching out to be much longer; the perfectionist Kurtzman just could not seem to stay on top of his deadlines, often insisting that artists draw and re-draw otherwise "finished" articles. And

Copyright © 1955 by E.C. Publications

Above: MAD #24, the first magazine-sized issue (July 1955).

he was pressuring Gaines for more money: not for himself, but to spend on the magazine. Unfortunately, it was money that Gaines didn't have, due to the outcry against horror and crime comics in the mid-1950s and the subsequent collapse of the comic-book market. Kurtzman's demands for money coupled with his deadline problems did not sit well with *MAD*'s publisher, and the formerly very friendly relationship began to develop severe frostbite.

It all came to a head in 1956 on what Gaines would later refer to as the "fateful Friday." Several days prior, Kurtzman had come to Gaines and demanded a stock interest in the company in order for him to remain on as *MAD*'s editor. Gaines wrestled with this, but ultimately decided to offer Kurtzman a 10% stake in what had always been a family owned business. He relayed this to Kurtzman's right-hand man Harry Chester, and was quickly put on notice that this was not the magic number—Kurtzman wanted control of the magazine. "Fifty-one percent of the stock?" Gaines asked incredulously. "Yes," replied Chester. In a 1962 letter to the satire fanzine *Smudge*, Gaines wrote, "I immediately called Harvey at his home, repeated my conversation with Chester, and asked if this correctly represented his feelings."

"'Yes,' said Harvey.

"'Fifty-one percent of the stock?,' said I.

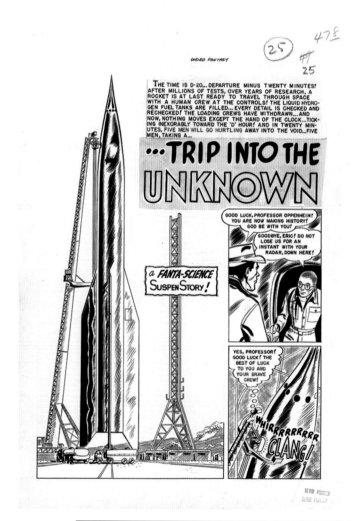

Above: The original art to Kurtzman's splash page to the science fiction story ". . . Trip into the Unknown," *Weird Fantasy* #13, May–June 1950.

Above: Gaines as devil, done in 1953 by Kurtzman as a gift to Gaines.

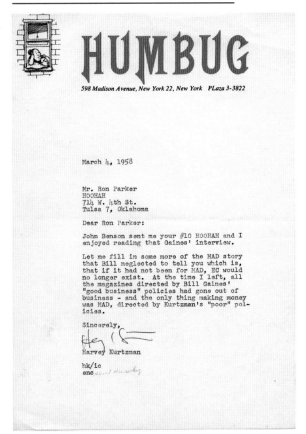

Copyright © 1957 by Humbug Publishing

Copyright © 1958 by Humbug Publishing

Copyright © 1957 by Ballantine Books

"'Yes,' said Harvey.

"'Goodbye, Harvey,' said I.

"'You'll be sorry, Bill,' said Harvey.

"'Goodbye, Harvey,' said I.

"'You don't know what you're doing, Bill,' said Harvey.

"'Goodbye, Harvey,' said I for the third time, and hung up. As of Friday evening, *MAD* had a new editor: Al Feldstein."

Gaines was profoundly hurt over Kurtzman's power play, and to add insult to injury Kurtzman ended up taking with him most of *MAD*'s artists (including Will Elder and Jack Davis) to go start a competing humor magazine for *Playboy* publisher Hugh Hefner. This project, called *Trump*, proved to be a high-quality but ultimately star-crossed experiment, failing after only two issues. Although wildly successful with *Playboy*, Hefner had expanded his empire too fast and overextended himself; something had to give, and one of the things was *Trump*. Harvey's wife, Adele, remembers Hefner coming to the hospital right after their third child, Elizabeth, was born, to tell them that he had to pull the plug on the project. Adele—who has a sense of humor some think is even more wicked than Harvey's—later said, "I never liked that third child. A bad reminder!"

After the abrupt demise of *Trump*, Kurtzman and his merry band of men—including Will Elder, Jack Davis, Arnold Roth, and Al Jaffee—decided they would pool their (meager) resources and publish their own magazine, which was called *Humbug*. Although Kurtzman and company did some of their best work in *Humbug*, it had some inherent flaws that would ultimately prove fatal, including a small size that made it hard to find in a magazine rack, and distribution problems. They

Above: The first and last issues of *Humbug* (August 1957 and October 1958), and *The Humbug Digest* paperback, released by Ballantine Books in December 1957.

Above: A 1958 letter from Kurtzman to Ron Parker, publisher of the E.C. fanzine *HOOHAH!* Kurtzman always hated E.C.'s horror comics, and felt that *MAD* carried the company when they were dropped. But it was the profits from the horror comics that permitted *MAD* to operate at a loss for its initial issues.

Copyright © 1960 by Warren Publishing

published nine issues in the small format, and as a last-ditch effort released two issues in *MAD* Magazine size. In an editorial in the final issue, a clearly demoralized Kurtzman wrote: "Satire has got us beat. 1952—We started *MAD* for a comic-book publisher and we did some pretty good satire and it sold very well. 1956—We started *Trump* magazine and we worked much harder and we sold much worse. 1957—We started *Humbug*

Above: HELP! #1, August 1960.
Right: Kurtzman stars in a TV commercial and print ad for Scripto pens, early 1970s. Far right: Fast-Acting HELP! was a collection of the best of Kurtzman's *HELP!* magazine. *HELP!* regularly featured early work by future Underground Comix creators such as Robert Crumb, Skip Williamson, and Gilbert Shelton.

magazine and we worked hardest of all and turned out the very best satire of all, which of course sells the very worst of all."

In 1960, Kurtzman and *Famous Monsters of Filmland* publisher James Warren teamed up to produce *HELP!*, a humor magazine that was clearly aimed at an older audience. "There wasn't much money," wrote Kurtzman. "We had to constantly come up with creative ways to fill the pages without spending a lot." One of these money-saving devices was the use of "fumettis," whereby one captioned existing photographs with humorous word balloons. Although low-budget, *HELP!* had a definite hipness factor, and it regularly featured in its pages and on its covers such notables as Dick Van Dyke, Woody Allen, Sid Caesar, Ernie Kovacs, Jackie Gleason, Jerry Lewis, Jonathan Winters, and many others. Cartoonists who had early work published in *HELP!* included such future Underground Comix creators as Robert Crumb, Skip Williamson, Jay Lynch, and Terry Gilliam.

Also in *HELP!* was a feature that many Kurtzmaniacs consider to be his finest, "Goodman Beaver." Kurtzman wrote and laid out the stories, and the actual finished drawings were done by Will Elder. Kurtzman later described Goodman Beaver as a "totally innocent young man and a good guy," who inevitably had terrible things happen to him "because of his innocence and his ignorance of the world around him." In one classic story, "Goodman Meets S*perm*n," Kurtzman examines the typical superhero and essentially asks, "If he never gets rewarded for the good he does, why should he continue to do

H.Kurtz

Copyright © 1972 by HMH Publishing

good?" In another story, "Goodman Goes Playboy," Kurtzman presents a thinly veiled Hugh Hefner, whom he portrays as having sold his soul to the devil to have gotten all that he has. The end of the story finds Goodman wondering if he should remain virtuous, or just go ahead and sign away his soul as well. (Hefner loved this story.)

Speaking of Hefner, he and Kurtzman had remained in contact after the failure of *Trump*, and Kurtzman had pitched numerous feature humor concepts to Hefner, none of which quite suited Hef. At one point, Hefner tried to encourage an obviously dejected Kurtzman with the following: "The only real problem with the work you've submitted to us is that it hasn't been funny. And in a more critical time, you would have recognized that yourself, I'm sure. I feel certain, too, that with things moving ahead now for you, the old sharpness will return. I think I have proven that I dig your work by investing $100,000 in it [in *Trump*]. I bow to no one in my appreciation for H. Kurtzman."

While still working on *HELP!* for James Warren, Kurtzman began developing a feature that ultimately would fit in perfectly with Hefner's *Playboy*, entitled "Little Annie Fanny." "Little Annie Fanny" was essentially

Goodman Beaver with a sex change; like Goodman she was an innocent trying to understand the world. "Little Annie Fanny" debuted in the October 1962 issue of *Playboy*, and was an immediate success with the readers. The strip is widely regarded as the most finely detailed comic strip ever done, and over the course of its run featured work by Frank Frazetta, Jack Davis, Al Jaffee, and Arnold Roth. (Kurtzman and Elder were always the main artists.) It also is one of the longest running; the final episode written by Kurtzman appeared in the September 1988 issue of *Playboy*.

In his later years, Kurtzman taught at the School of Visual Arts and worked or collaborated on numerous projects, including *From Aargh to Zap!* (a history of the comics), *Harvey Kurtzman's Strange Adventures* (featuring new stories written by Kurtzman and illustrated by a host of excellent artists), and his own 1988 autobiography (aimed at younger readers), *My Life as a Cartoonist*. He was also a revered guest at comic conventions, where he was virtually canonized by the fans. Largely because he made himself available, he became, as comics historian John Benson puts it, "the most interviewed man in comics."

Despite the old wounds, in later years Gaines and Kurtzman managed to bury the hatchet to some extent. Kurtzman and Will Elder even came back and did some work for *MAD* in the mid-1980s, producing numerous interior pieces and several front and back covers.

With his humor work, Kurtzman planted the seeds of anarchy in such future underground cartoonists as Robert Crumb, Gilbert Shelton, Bill Griffith, and Rick

Left: After Harvey Kurtzman left *MAD* in 1956, he wrote and edited a variety of humor publications, including *Trump*, *Humbug*, and *Help!* While all were artistically successful, none thrived on the newsstand. He finally settled in for a long run with Hugh Hefner's *Playboy*, writing and doing the layouts for "Little Annie Fanny," which is widely regarded as the lushest and most finely detailed comic strip ever done.

Copyright © 1962 by HMH Publishing

Above: The first "Little Annie Fanny," *Playboy*, October 1962.

H.Kurtz

Copyright © 1976 by Harvey Kurtzman

Copyright © 1973 by Kitchen Sink Press

Above left: A Kurtzman convention sketch. *Above middle:* **Kurtzman Komix**, a 1976 collection of "Hey Look!" pages and other early work, with a Robert Crumb introduction (Kitchen Sink Press). *Above right:* Kurtzman cover to *Bijou* #8, a 1973 Underground Comix homage to *MAD* comics, edited by Jay Lynch (Kitchen Sink Press).

Above: Kurtzman's cover for *Kar-tūnz'* #1, done when he was teaching at the School of Visual Arts, 1975.

Griffin, as well as in future *Monty Python* member/visionary film director Terry Gilliam. Because of his profound influence, in his later years he came to be regarded as the father of the 1960s Underground Comix movement. True to form, Kurtzman demanded a "blood test." Kurtzman, who died on February 21, 1993, once told comics historian John Benson that "I don't regard myself as the satirist/philosopher of the Western world. All I'm really trying to do is to entertain people and remind them how the world really is." He has done just that for more than fifty years, and—with the help of projects like this one—is likely to do it for another fifty as well. Harvey Kurtzman was inducted into the Will Eisner Hall of Fame in 1989. •

Photo by Barbara Boatner

Above: Harvey Kurtzman, February 11, 1976.
Right: Image from "Air Burst!," *Frontline Combat* #4 (January–February 1952).

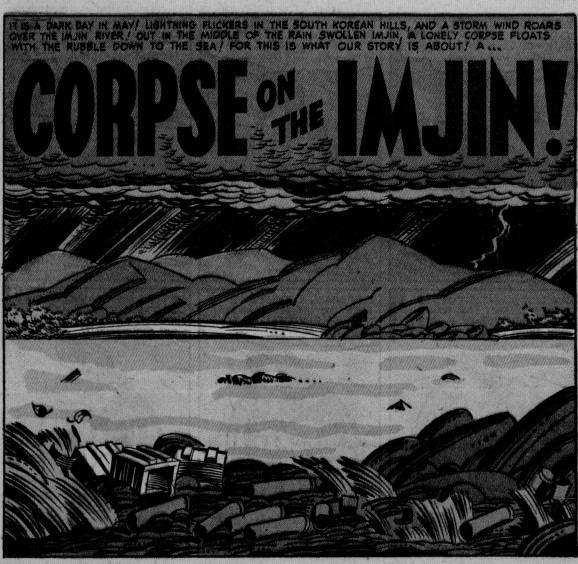

IT IS A DARK DAY IN MAY! LIGHTNING FLICKERS IN THE SOUTH KOREAN HILLS, AND A STORM WIND ROARS OVER THE IMJIN RIVER! OUT IN THE MIDDLE OF THE RAIN SWOLLEN IMJIN, A LONELY CORPSE FLOATS WITH THE RUBBLE DOWN TO THE SEA! FOR THIS IS WHAT OUR STORY IS ABOUT! A...

CORPSE ON THE IMJIN!

BUT MANY THINGS FLOAT ON THE IMJIN! DRIFTWOOD, AMMUNITION BOXES, RATION CASES, SHELL TUBES!

...WE IGNORE THE FLOATING RUBBLE! WHY THEN, DO WE FASTEN OUR EYES ON A LIFELESS CORPSE?

...THOUGH WE SOMETIMES FORGET IT, LIFE *IS* PRECIOUS, AND DEATH IS UGLY AND *NEVER* PASSES UNNOTICED!

"Corpse on the Imjin!," from *Two-Fisted Tales* #25 (January–February 1952). Written and illustrated by Harvey Kurtzman.

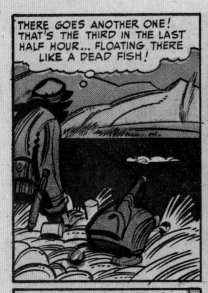

THERE GOES ANOTHER ONE! THAT'S THE THIRD IN THE LAST HALF HOUR... FLOATING THERE LIKE A DEAD FISH!

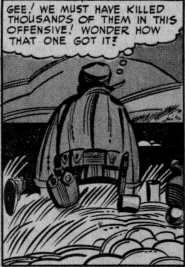

GEE! WE MUST HAVE KILLED THOUSANDS OF THEM IN THIS OFFENSIVE! WONDER HOW THAT ONE GOT IT?

PROBABLY GOT HIT BY THE BOMBERS WHEN HE WAS TRYING TO CROSS FARTHER UPSTREAM THERE!

MAYBE IT WAS THE F-51's! I SURE WOULDN'T LIKE TO BE CAUGHT SITTING BY F-51's... WITH THEM 5 INCH ROCKETS!

THEN AGAIN, IT COULD HAVE BEEN THE 155 MM CANNONS! THEM SELF-PROPELLED 'LONG TOMS' ARE MURDER!

OR DID A RIFLEMAN CATCH HIM? COULD'VE BEEN A SHARP SHOOTER WITH A TELESCOPIC SIGHT SPRINGFIELD!

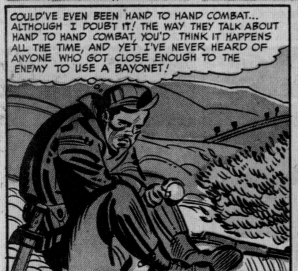

COULD'VE EVEN BEEN HAND TO HAND COMBAT... ALTHOUGH I DOUBT IT! THE WAY THEY TALK ABOUT HAND TO HAND COMBAT, YOU'D THINK IT HAPPENS ALL THE TIME, AND YET I'VE NEVER HEARD OF ANYONE WHO GOT CLOSE ENOUGH TO THE ENEMY TO USE A BAYONET!

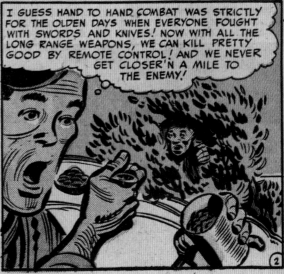

I GUESS HAND TO HAND COMBAT WAS STRICTLY FOR THE OLDEN DAYS WHEN EVERYONE FOUGHT WITH SWORDS AND KNIVES! NOW WITH ALL THE LONG RANGE WEAPONS, WE CAN KILL PRETTY GOOD BY REMOTE CONTROL! AND WE NEVER GET CLOSER'N A MILE TO THE ENEMY!

CORRECTION, SOLDIER! NOT CLOSER THAN *FIFTEEN FEET*... FOR THE ENEMY IS WATCHING YOU EAT YOUR C-RATIONS NOT FIFTEEN FEET FROM YOUR RIFLE!

HE IS WET AND SCARED AND HUNGRY, AND HIS EYES GO FROM YOUR C-RATION CAN TO YOUR RIFLE! THE WIND HIDES ALL SOUND *AS HE SPRINGS!*

 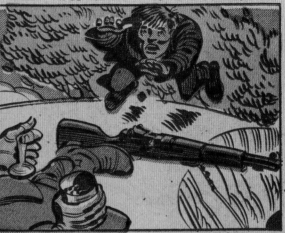

YOU SEE HIM OUT OF THE CORNER OF YOUR EYE AND YOU KICK OUT WITH BOTH YOUR FEET!

YOU KICK CLUMSILY AT YOUR RIFLE, BECAUSE THAT IS ALL YOU CAN DO TO GET IT OUT OF HIS REACH!

THE RIFLE TUMBLES OVER THE BANK AND INTO THE IMJIN RIVER! AND THEN THERE'S JUST THE SOUND OF THE WIND!

WHERE ARE THE WISECRACKS YOU READ IN THE COMIC BOOKS? WHERE ARE THE FANCY RIGHT HOOKS YOU SEE IN THE MOVIES? HE PICKS UP A BROKEN STICK!

HE'S A LITTLE FELLOW AND HE GRINS AS HE CIRCLES YOU WITH HIS STICK! YOU WIPE AT YOUR NOSE, AND THEN YOU REMEMBER YOUR BAYONET!

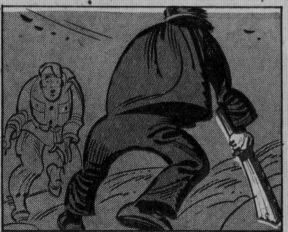 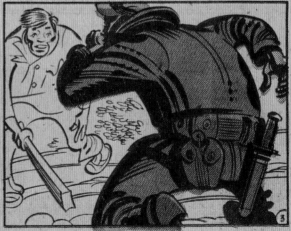

YOU GRIP YOUR BAYONET TIGHT... *TIGHT!* DEEP INSIDE, YOU DON'T *REALLY* BELIEVE YOU CAN STICK A KNIFE INTO A HUMAN BEING! IT'S ALMOST SILLY...

THEY SAY THE MAN WHO MOVES FIRST HAS WON HALF THE BATTLE, AND THE LITTLE GUY STRIKES OUT AT YOU WITH THE STICK... *CRACKS YOUR FINGERS!*

 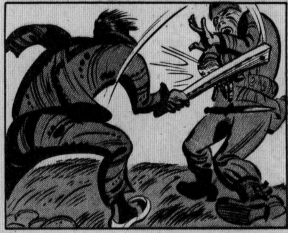

YOU'VE LOST THE BAYONET AND NOW YOU'RE HURT! HE CLUBS YOU ON THE ARMS, THE SHOULDERS...

BUT THE PAIN MAKES YOU *REACT...* YOU FEEL A SURGE OF FEAR... HATE... ENERGY... TINGLING IN YOUR MUSCLES...

YOU SHRIEK AND CHARGE LIKE A CRAZY BULL TO ESCAPE THE STINGING CLUB! YOU CLUTCH AT HIM!

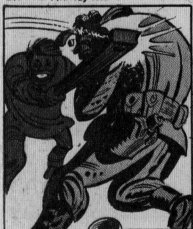

HE'S REALLY HURT YOU AND YOUR LEGS ARE WOBBLY AND HE STRIKES AND STRIKES AND STRIKES!

YOU OUTWEIGH HIM THOUGH, AND WITH ALL THE STRENGTH YOU CAN MUSTER, YOU PUSH HIM TO THE RIVER...

...AND YOU BOTH FALL! YOU RELAX AND YOU FALL! YOU NEVER KNEW FALLING COULD BE SO PLEASANT!

HE KICKS TO STAY UP, BUT YOU ARE HEAVIER AND YOU **PRESS HIM UNDER!**

IT REMINDS YOU OF SOMETHING...AND YOU **PRESS HIM UNDER!**

LIKE DUNKING, WHEN YOU WENT SWIMMING! YOU **PRESS HIM UNDER!**

YES... YES... LIKE DUNKING AT THE SWIMMING HOLE... YOU DUNK...**DUNK... DUNK...**

HIS HANDS HAVE STOPPED CLAWING AT THE AIR...HIS FEET HAVE STOPPED THRASHING...

...BLOOD AND BUBBLES ARE COMING TO THE SURFACE AND THE MAN YOU ARE HOLDING RELAXES!

IT SEEMS LIKE HOURS HAVE GONE BY! THE BUBBLES ARE BARELY TRICKLING UP AND ALL IS STILL!

SUDDENLY, YOUR MIND IS QUIET, AND YOUR RAGE COLLAPSES! THE WATER IS VERY COLD!

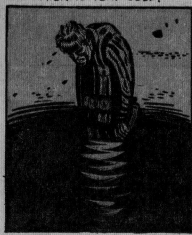

YOU'RE TIRED... YOUR BODY IS GASPING AND SHAKING WEAK... AND YOU'RE ASHAMED!

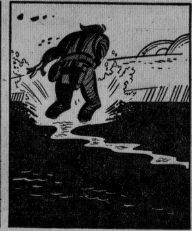

YOU STUMBLE AND SLOSH OUT OF THE RIVER AND RUN...RUN AWAY FROM THE BODY IN THE WATER!

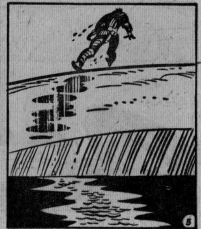

56

THE WIND IS RUSHING FITFULLY OVER THE IMJIN! IT STIRS THE HAIR ON THE BACK OF THE DEAD MAN'S HEAD!

THE WATER RIPPLES BEFORE THE WIND... LAPS AT THE SHORE...SWAYS THE BODY FROM SIDE TO SIDE!

THE FLOWING RIVER GENTLY SWINGS THE BODY OUT AWAY FROM THE BANK AND INTO THE CURRENT!

AND NOW THE CURRENT, WEAK NEAR THE SHORE, SLOWLY TURNS THE BODY AROUND AND AROUND...

...AND IT IS AS IF NATURE IS TAKING BACK WHAT IT HAS GIVEN! HAVE PITY! HAVE PITY FOR A DEAD MAN!

FOR HE IS NOW NOT RICH OR POOR, RIGHT OR WRONG, BAD OR GOOD! DON'T HATE HIM! HAVE PITY...

...FOR HE HAS LOST THAT MOST PRECIOUS POSSESSION THAT WE ALL TREASURE ABOVE EVERYTHING... HE HAS LOST HIS *LIFE!*

LIGHTNING FLASHES IN THE KOREAN HILLS, AND ON THE RAIN SWOLLEN IMJIN, A CORPSE FLOATS OUT TO SEA.

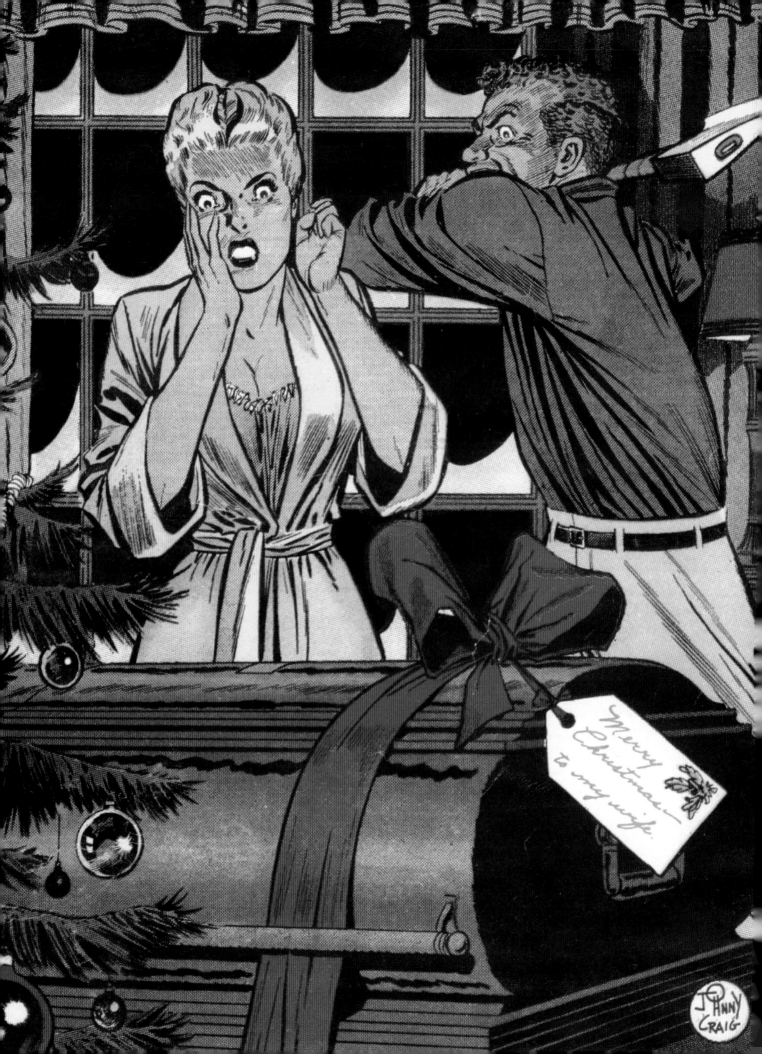

JOHNNY CRAIG!

"I ALWAYS *ADMIRED* JOHNNY'S WORK. HE WAS THE *ULTIMATE* COMIC ARTIST AS FAR AS I WAS CONCERNED." —AL FELDSTEIN

Johnny Craig was one of the first artists to work for the E.C. Comics group, and by all accounts he was one of the nicest. As Bill Gaines said of Craig in *E.C. Lives!*, "John was, and is, a prince."

Craig was born in Pleasantville, New York, on April 25, 1926. His family moved to the Washington Heights section of New York City when he was three, and he was raised there. Craig's first professional work in the industry (at the age of twelve) was in 1938 as an assistant to All-American Comics artist Harry Lampert, ruling pages and doing lettering; for this he was paid the munificent sum of one dollar a week. (This was the sister company to D.C., with M.C. Gaines publishing out of the 225 Lafayette Street offices.) Craig worked for Lampert for about a year and a half or so, until Lampert went into the Army. The editor at All-American, Sheldon Mayer, then took Craig under his wing and had him work part time as the letterer on his *Scribbly* feature. During the next summer, Mayer hired Craig full time as a staff artist, where he did paste-ups, corrections, and lettering.

Craig joined the Merchant Marine and then the Army, where he was stationed in Germany. After being wounded, he returned home in 1946, and after a short time freelancing for such companies as Lev Gleason, Magazine Enterprises, and Fox he went back to work for M.C. Gaines. This time, however, the comics he was working on weren't D.C./All-American, they were E.C. comics. Craig told E.C. art collector and historian Roger Hill in 1969 that "It was about this time that I started doing covers and art work for this new line, and only shortly after this that M.C. Gaines passed away." Craig's first covers for the company appeared on the one-shot *Blackstone* #1 and *Moon Girl and the Prince* #1, both dated Fall 1947. Craig became a very valuable asset to the outfit, contributing numerous stories and covers to *Gunfighter, Saddle Justice, Crime Patrol, War Against Crime!*, and *Moon Girl*.

Craig was a slow, meticulous craftsman who was very rarely satisfied with his first attempt to draw anything. "I was forced at a very early age to learn drawing by continually searching for flaws in my own work, and then drawing it again and again to try to correct those flaws," Craig told Hill. "I was supposed to do three stories a month. I was lucky if I did *one*." Wally Wood said in *E.C. Lives!* that "It was hard for him to draw; it was painful watching him work. He was struggling with it all the time. He had a very exact way of working." Al Williamson said

Left: Detail from Craig's cover to *The Vault of Horror* #35, March 1954.

Right: Craig's first covers for E.C., *Blackstone* #1 and *Moon Girl and the Prince* #1 (both dated Fall 1947).

59

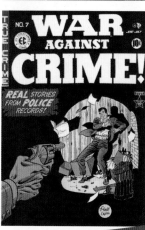

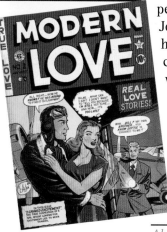

of Craig in *The Art of Al Williamson* that "Johnny Craig should have gotten much more recognition at E.C., because his stuff was really good. In his own right, he was as good as Harvey Kurtzman, because he wrote good stories and drew them well, and knew how to entertain you." Feldstein said in *E.C. Lives!* that "Johnny was extremely talented, but he had no real drive, either monetarily or from the ego point of view. He was slow in his artwork, and therefore his income was limited."

For a time, Craig and Feldstein worked together in an attempt to up Craig's output; they signed these collaborations "F.C. Aljohn," which they derived by combining <u>F</u>eldstein, <u>C</u>raig, <u>Al</u>, and <u>John</u>. "I penciled and John would ink," Feldstein has said. "He would straighten out my lousy drawing and I, at least, was going hell bent ahead on the drawings, doing the breakdowns in my very simple interpretations of the story." After a while the experiment was abandoned. "It didn't help much and sort of petered out," said Feldstein.

Gaines told *The Comics Journal*, "Al was doing seven books, Johnny Craig was of course doing a book, and I used to work with Johnny in the evenings. But Johnny was slow, so slow. He would take an entire month to write and draw one story. It was just his nature. A lot of guys in comics bat stuff out; Johnny never did. Everything had to be perfect." And Gaines told John Benson, "I always had a theory that John had some kind of computer working in his head—that he wasn't even aware of—that prevented him from making more than X dollars a year. As the rates went up, his production went down."

Craig was in on the ground floor with Gaines and Feldstein in developing the E.C. horror titles *Tales from the Crypt*, *The Vault of Horror*, and *The*

Above: Moon Girl, as rendered by Johnny Craig.

Haunt of Fear. Craig told Hill that "It was mostly Feldstein's idea, I believe, but there were three-way conferences in and around that office all the time." And with characteristic modesty Craig added, "But I give credit to Al and Bill for getting the brainstorm." Because Craig also wrote the stories he drew (with very few exceptions), Gaines, Feldstein, and Craig formed E.C.'s horror triumvirate. Craig's art often exhibited a film-noir kind of a look. He came by this naturally, as his prime influences in comic art were the work of Will Eisner (creator of *The Spirit*) and Milton Caniff (the main artist on *Terry and the Pirates*), both specialists in moodily lit, atmospheric panels.

Craig didn't go for horror stories with an overt amount of grue. "I always preferred the voodoo type of story, or the haunted house type, or a story with a mystical theme, rather than a tale that had its impact relying on blood and gore," Craig told Hill. Craig's stories tended to be peopled with vampires, zombies, and the walking dead. Wallace Wood said in *E.C. Lives!* that Craig drew the "cleanest horror stories you ever saw." Indeed, most of the gruesome scenes in Craig's stories took place "off-camera," allowing the reader to visualize the scene. Craig also raised the depiction of sweat running down the face of an antagonist to the level of high art.

The irony here is that Fredric Wertham singled out one of Craig's E.C. covers (*Crime SuspenStories #20*, December 1953–January 1954) in his infamous *Seduction of the Innocent*, pictured with the caption "Cover of a children's comic book." Another Craig cover (*Crime SuspenStories #22*, April–May 1954) was held up at the Senate Subcommittee hearings, with Senator Kefauver asking Gaines, "This seems to be a man with a bloody ax holding a woman's head up which has been severed from her body. Do you think that is in good taste?" To which Gaines replied, "Yes, sir, I do, for the cover of a horror comic." (What Gaines knew and Kefauver did *not* know was

Above: Four of Craig's E.C. Pre-Trend covers. (The term "Pre-Trend" was coined by collectors to describe the early E.C. comics that were published before the company launched the New Trend line.) The *Modern Love #2* cover, signed "F.C. Aljohn," is a collaboration between Craig and Al Feldstein.

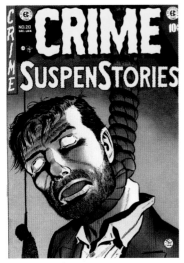

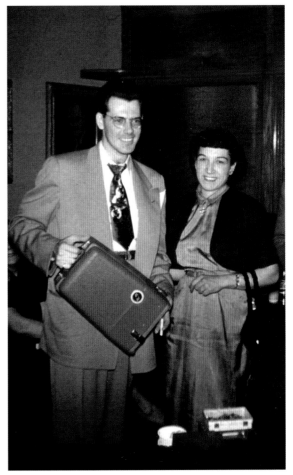

that the cover, when originally conceived, had the head lifted up a bit higher so that blood could be seen dripping from the neck. So, naturally, the printed cover *was* in good taste compared to the original version.)

While Feldstein drew the earliest appearances of the Vault-Keeper, it was Craig who refined the character's countenance. Once Craig established the look, even when other artists drew a story that was "hosted" by the Vault-Keeper, a stat of a Johnny Craig version was usually used. He also drew the covers for all twenty-nine issues of the Vault-Keeper's comic book, *The Vault of Horror.*

In 1950, E.C.'s office boy Paul Kast got the idea of making up 5 x 7 "photos" of the horror hosts, the three GhouLunatics, to be sold through the mail to E.C.'s readers. The photos were actually heavily retouched shots of Craig in a wig and makeup, applied by Al Feldstein. Gaines turned the proceeds of the sale of the photos over to Kast, which helped pay his way through law school.

When *Crime SuspenStories* was added to the E.C. line at the end of 1950, Craig was able to fully indulge his film-noir tendencies; many aficionados feel that much of Craig's finest work is to be found here, both in the interior stories and in the many covers he contributed for the title.

In early 1954, Craig became the editor of what was to be the final six issues of *The Vault of Horror,* and in the last four issues he introduced "Drusilla," the hostess of the Vault of Horror. When asked why this was done, Craig told Hill that "Anytime there's a chance to draw a

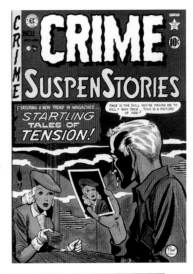

Above: Craig cover to *Crime SuspenStories* #1 (October–November 1950).

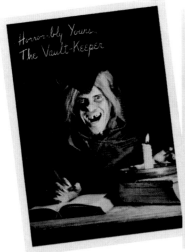

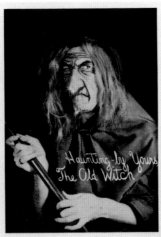

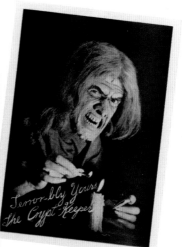

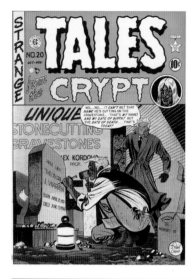

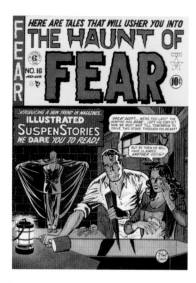

Above: Three of Craig's E.C. horror covers, 1950–1951. *Below:* Craig covers to the New Direction comics *Extra!* #3 (July–August 1955) and *M.D.* #1 (April–May 1955).

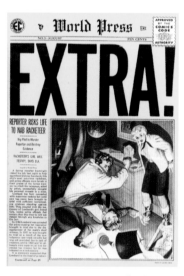

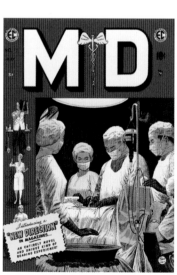

pretty girl, I'm not sure I have to *have* a reason. Eventually, if she became popular enough, Drusilla may have taken charge of the book, or possibly may have been given a book of her own. Who knows?"

Alas, it was not to be, as Gaines announced the discontinuation of his horror and crime comics in a press conference held on September 14, 1954. When Gaines launched the New Direction line, Craig edited the newspaper/adventure comic called *Extra!* Along with his editing duties, Craig wrote and drew two stories in each issue, and all five of the book's covers. He told Hill, "I liked it because it was a clean type of story, and clean type of book, and it had many advantages for me as an editor. It had an engaging character [newspaper reporter Keith Michaels], someone whom I could develop and build on. It gave me the chance to take him anywhere in the world, and do any kind of story that I felt like writing. It was great." As great as it was for him, the plug was pulled on *Extra!* after only five issues. Craig also illustrated all five covers of the E.C. medical comic *M.D.*

Right: Detail from Craig's cover to *The Vault of Horror* #30, April–May 1953. Note the "Stomach Upset?" advertisement.

For the Picto-Fiction magazines Craig did some superlative art, often working in richly hued pencils. "It was a very fine experience," Craig told Hill, "and something which I think most of the artists welcomed because it made us feel we were advancing and doing a better grade of art work—a more illustrative type of art work. I'm sorry it didn't go over better than it did."

When E.C. dropped its comics and was publishing only *MAD*, Craig left the comic-book field entirely for a new career working at an advertising agency. He worked his way up the ranks, becoming Art Director for one firm, and then Art Director and Vice President

THE BLOODY AXE STOOD IN THE HALLWAY, LEANING AGAINST THE WALL BETWEEN THE TWO BEDROOMS. AND IF YOU WERE TO PEEK INSIDE THE CLOSED BEDROOM DOORS, YOU WOULD SEE AMY IN HER BED, CARESSING *HER* SIDE OF EDWIN, AND SUSAN DOING LIKEWISE WITH *HER* SIDE OF HIM! FOR THE *VERY FIRST TIME* THE TWO SHY, INNOCENT TWINS WERE ABLE TO ENJOY THE COMPANY OF THEIR HUSBANDS AT THE *SAME TIME!* FOR, IN THEIR UNBALANCED STATE, THEY HAD *SPLIT HIM IN TWO, RIGHT DOWN THE MIDDLE!*

THE END.

Left: Panel from "Split Personality!," *The Vault of Horror* #30 (April–May 1953). As with most of Craig's work, the actual horror of the scene is not shown. *Below:* "Drusilla," mistress of The Vault of Horror.

for an agency based in Pennsylvania. He stayed with that firm for seven or eight years, but found that he didn't care for the "extreme deadline pressure," and spending so much time doing everything but art. Around the end of 1963, he decided that it was time to leave the advertising agency world behind and go back to freelancing. He still kept his hand in advertising illustration, but began to work once again in comics. His first effort upon his return to comics was for American Comics Group (A.C.G.), a story called "The People vs. Hendricks!" in *Unknown Worlds* #36, December 1963– January 1964. Drawn in a style not dissimilar to his *Extra!* work, the story was later voted the "most popular A.C.G. story ever" by the comic's readers.

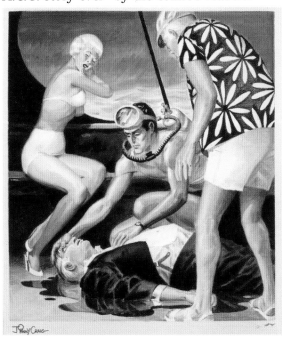

Above: Craig's painted cover for *Extra! #1,* March–April 1955.

Craig was also writing and drawing some very attractive stories for James Warren's *Creepy* and *Eerie* around this period; he signed these stories with the pen name "Jay Taycee" in case his advertising clients should stumble across the work.

In 1967, Craig was assigned to pencil a Batman/Hawkman team-up story for an issue of D.C.'s *The Brave and the Bold.* Still struggling with deadlines, he handed the story in quite late. Once in, the powers that be decided that the drawing style wasn't quite right for D.C., and the inker left little of Craig's style intact. He didn't fare much better at Marvel, where in 1968 he was assigned penciling and/or inking chores on the newly launched *Iron Man* comic. Again deadlines were a problem, and Stan Lee ultimately didn't think the art had the right look for Marvel. He was utilized only as an inker after that. First-generation-E.C.-fan-turned-comics-professional Archie Goodwin said of Craig that "he couldn't draw super-heroes the way they wanted, and he couldn't hit the deadlines. I don't know how he made a living in comics. His work was so good, but every page took him forever."

Craig soldiered on, inking for both D.C. and Marvel, but by the early 1980s he had had it with deadlines and editorial demands and stopped working in comics. Craig spent the rest of his life in semi-retirement, but

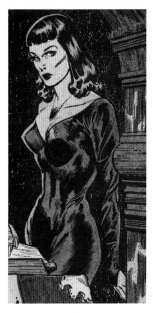

 Above: Johnny and Toni Craig at home in 1975, with some of Johnny's paintings.

Photo by Charlie Roberts

AN ENTERTAINING EC COMIC

HER HUSBAND WAS DEAD, AND IT WAS THE BEST CHRISTMAS PRESENT SHE'D EVER HAD! SHE STOOD OVER THE LIFELESS BODY SPRAWLED AT HER FEET AND SMILED...

HA, HA! *MERRY CHRISTMAS,* JOSEPH! YOU'RE SLEEPING SO PEACEFULLY! DREAMING OF *SANTA CLAUS?*

these commissions, and there was but one stipulation: there was to be no deadline of any kind on the work. He would complete it in his own time, and in his own way. Fortunately for his fannish patrons, the work he did for them was lovingly rendered and quite well crafted. Craig put the same energy and focus into these private commissions that he put into his "professional" work. Regarding one such commissioned painting, the always gracious and ever-humble Craig wrote "I only worry, as always, that the result will not equal my hopes. I will promise to do my best, and I do thank you for considering me." About another painting he wrote, "the painting has turned out better than expected. And I always enjoy the doing."

happily, he had plenty to keep him busy, for E.C. fans began requesting special commissions of E.C.-related artwork. Often these were oil paint re-creations of his classic E.C. covers, or new scenes that featured various combinations of the GhouLunatics, and even Drusilla. Craig greatly enjoyed working on

Johnny Craig passed away on September 13, 2001 (just two days after the World Trade Center came down). On that day, the comics world lost not just a gifted and well-respected artist, but a truly humble, kind, and considerate soul. •

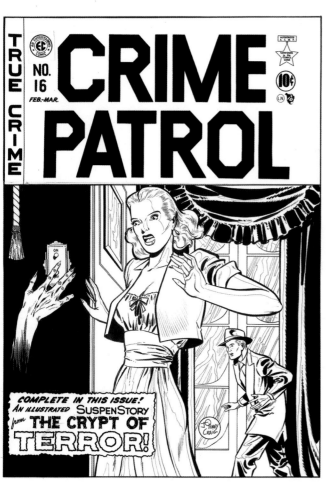

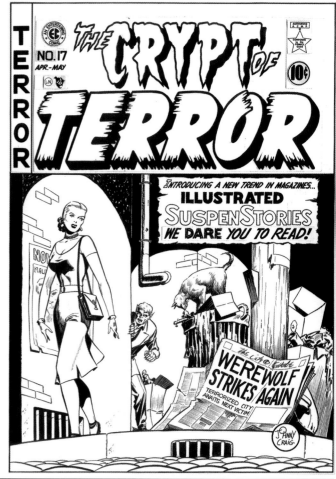

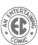
Above: Craig covers were employed for E.C.'s transition from crime to horror. Shown is the original cover art from *Crime Patrol #16* (February–March 1950), which became *The Crypt of Terror* with #17 (April–May 1950).

Below: Craig's 1987 oil paint re-creation of his 1952 cover to *Crime SuspenStories* #9.

Photo by Charlie Roberts

Above: Craig in 1975, posing with a commissioned painting.

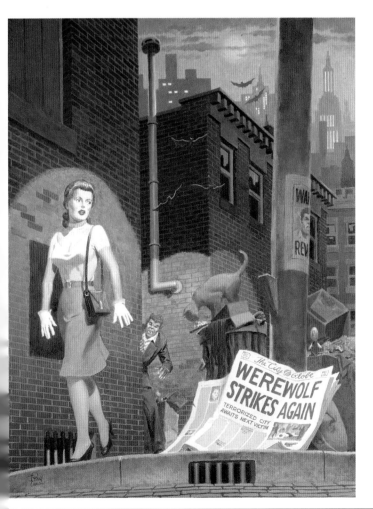

Above left: Craig's November 2000 oil paint re-creation of his 1950 *The Crypt of Terror* #17 cover.
Above right: Craig's February 2001 oil paint re-creation of his 1950 *The Haunt of Fear* #15 cover.

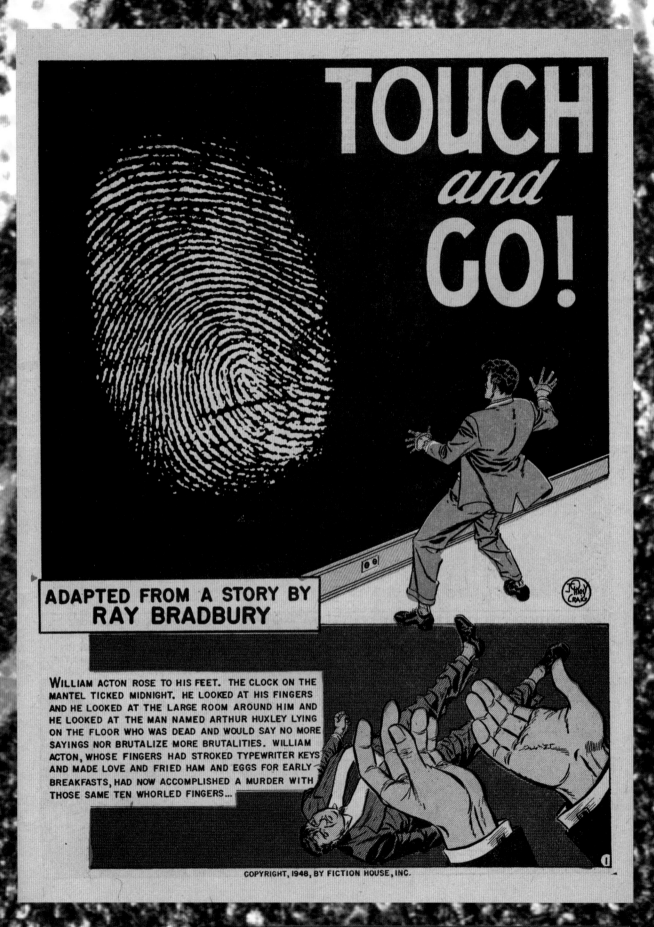

TOUCH and GO!

ADAPTED FROM A STORY BY
RAY BRADBURY

WILLIAM ACTON ROSE TO HIS FEET. THE CLOCK ON THE MANTEL TICKED MIDNIGHT. HE LOOKED AT HIS FINGERS AND HE LOOKED AT THE LARGE ROOM AROUND HIM AND HE LOOKED AT THE MAN NAMED ARTHUR HUXLEY LYING ON THE FLOOR WHO WAS DEAD AND WOULD SAY NO MORE SAYINGS NOR BRUTALIZE MORE BRUTALITIES. WILLIAM ACTON, WHOSE FINGERS HAD STROKED TYPEWRITER KEYS AND MADE LOVE AND FRIED HAM AND EGGS FOR EARLY BREAKFASTS, HAD NOW ACCOMPLISHED A MURDER WITH THOSE SAME TEN WHORLED FINGERS...

COPYRIGHT, 1948, BY FICTION HOUSE, INC.

"Touch and Go!," from *Crime SuspenStories* #17 (June–July 1953).
Story by Ray Bradbury. Adapted and illustrated by Johnny Craig.

NOW WHAT? HIS EVERY IMPULSE EXPLODED HIM IN A HYSTERIA TOWARD THE DOOR. GET OUT, GET AWAY, RUN, NEVER COME BACK, BOARD A TRAIN, GET A TAXI, GET, GO, RUN, WALK, SAUNTER, BUT GET THE BLAZES *OUT* OF HERE...

HIS HANDS HOVERED BEFORE HIS EYES, FLOATING, TURNING. IT WAS NOT THE HANDS AS HANDS HE WAS INTERESTED IN, NOR THE FINGERS AS FINGERS. HE FOUND INTEREST ONLY IN THE *TIPS* OF HIS FINGERS. THE CLOCK TICKED UPON THE MANTEL...

HE KNELT BY HUXLEY'S BODY, TOOK A HANDKERCHIEF FROM HUXLEY'S POCKET AND BEGAN METHODICALLY TO SWAB HUXLEY'S THROAT WITH IT. HE BRUSHED AND MASSAGED THE FACE AND THE BACK OF THE NECK WITH A FIERCE ENERGY...

HE STOPPED. THERE WAS A MOMENT WHEN HE SAW THE ENTIRE HOUSE, THE HALLS, DOORS, FURNITURE; AND AS CLEARLY AS IF IT WERE BEING REPEATED WORD FOR WORD, HE HEARD HUXLEY TALKING AND HIMSELF TALKING JUST AS THEY HAD TALKED ONLY AN HOUR AGO...

I WANT TO SEE YOU, HUXLEY. IT'S IMPORTANT.

OH! IT'S *YOU*, ACTON. I DON'T SEE...WELL, ALL RIGHT. COME IN. WE CAN TALK IN THE LIBRARY.

HE HAD *TOUCHED* THE LIBRARY DOOR. HE HAD *TOUCHED* THE BOOKS AND THE LIBRARY TABLE AND *TOUCHED* THE BURGUNDY BOTTLE AND BURGUNDY GLASSES...

NOW, SQUATTING ON THE FLOOR BESIDE HUXLEY'S COLD BODY WITH THE POLISHING HANDKERCHIEF IN HIS FINGERS, HE STARED AT THE HOUSE, THE WALLS, THE FURNITURE, STUNNED BY WHAT HE REALIZED. HE SHUT HIS EYES, WADDING THE HANDKERCHIEF IN HIS HANDS, BITING HIS LIPS WITH HIS TEETH, PULLING IN ON HIMSELF! THE FINGERPRINTS WERE EVERYWHERE!

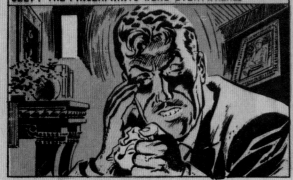

A PAIR OF GLOVES. BEFORE HE DID ONE MORE THING, BEFORE HE POLISHED ANOTHER AREA, HE MUST HAVE A PAIR OF GLOVES. HE PUT HIS HANDS IN HIS POCKETS, WALKED TO THE HALL UMBRELLA STAND, THE HATRACK, HUXLEY'S OVERCOAT. HE PULLED OUT THE OVERCOAT POCKETS. NO GLOVES...

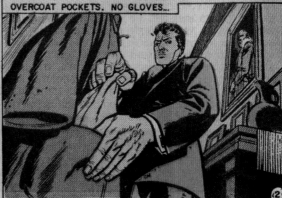

HIS HANDS IN HIS POCKETS AGAIN HE WALKED UPSTAIRS. HE UNTIDIED SEVENTY OR EIGHTY DRAWERS IN SIX UPSTAIRS ROOMS, LEFT THEM WITH TONGUES HANGING OUT. AT THE BOTTOM OF THE EIGHTY-FIFTH DRAWER HE FOUND GLOVES...

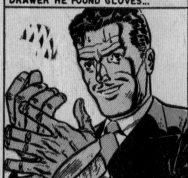

DOWN ONTO THE HARDWOOD FLOOR HAD DROPPED MR. HUXLEY, WITH WILLIAM ACTON AFTER HIM. THEY HAD ROLLED AND TUSSLED AND CLAWED AT THE FLOOR PRINTING IT WITH THEIR FINGERTIPS!

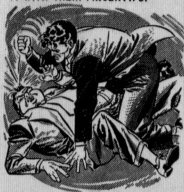

GLOVED, WILLIAM ACTON RETURNED TO THE ROOM AND LABORIOUSLY BEGAN SWABBING EVERY INFESTED INCH OF THE FLOOR. INCH BY INCH, HE POLISHED TILL HE COULD MOST SEE HIS INTENT SWEATING FACE IN IT...

THEN HE CAME TO A TABLE AND POLISHED THE LEG OF IT, ITS SOLID BODY, AND ON TOP, AND HE CAME TO A BOWL OF WAX FRUIT AND HE PLUCKED OUT THE WAX FRUIT AND POLISHED THEM, LEAVING THE FRUIT AT THE BOTTOM UNPOLISHED...

I'M *SURE* I DIDN'T TOUCH *THEM!*

AFTER RUBBING THE TABLE, HE CAME TO A PICTURE FRAME OVER IT...

AND I'M CERTAIN I DIDN'T TOUCH *THAT!*

HE SHINED THE DOORKNOBS, CURRIED THE DOORS FROM HEAD TO FOOT. HE WENT TO ALL THE FURNITURE AND WIPED THE CHAIRS AND RUBBED THE FABRIC. FINGERPRINTS CAN BE FOUND ON FABRIC. HE WENT TO THE BODY, TURNED IT NOW THIS WAY, NOW THAT, AND BURNISHED EVERY SURFACE OF IT. HE EVEN SHINED THE SHOES, CHARGING NOTHING...

WHILE SHINING THE SHOES HIS FACE TOOK ON A LITTLE TREMOR OF WORRY, AND AFTER A MOMENT HE GOT UP AND WALKED OVER TO THAT TABLE. HE TOOK OUT AND POLISHED THE WAX FRUIT AT THE *BOTTOM* OF THE BOWL...

3

HE WENT BACK TO THE BODY. BUT AS HE CROUCHED OVER IT, HIS EYELIDS TWICKED AND HIS JAW MOVED FROM SIDE TO SIDE AND HE DEBATED... THEN HE GOT UP AND WALKED ONCE MORE TO THE TABLE. HE POLISHED THE PICTURE FRAME...

WHILE POLISHING THE PICTURE FRAME HE DISCOVERED... *THE WALL!*

THAT... IS *SILLY.*

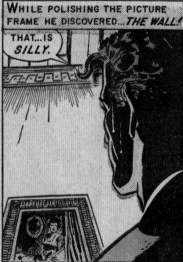

HUXLEY HAD GIVEN HIM A SHOVE AS THEY STRUGGLED. HE HAD FALLEN AGAINST ONE WALL, GOTTEN UP, *TOUCHING* THE WALL...

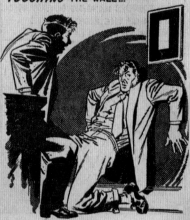

HE GLANCED AT THE FOUR WALLS...

RIDICULOUS.

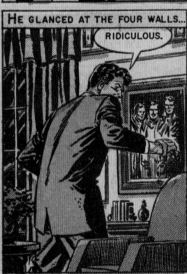

FROM THE CORNERS OF HIS EYES HE SAW SOMETHING ON ONE WALL...

I REFUSE TO PAY ATTENTION. THE NEXT ROOM, NOW. I'LL BE METHODICAL. LET'S SEE, WE WERE IN THE HALL, THE LIBRARY, *THIS* ROOM, THE DINING ROOM AND THE KITCHEN.

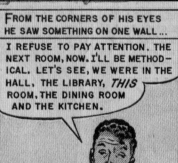

THERE WAS A SPOT ON THE WALL BEHIND HIM...

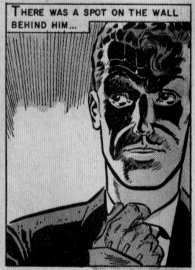

WELL, *WASN'T* THERE?

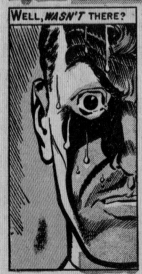

HE TURNED, ANGRILY, AND HE WENT OVER AND HE COULDN'T FIND ANY SPOT. OH, A *LITTLE* ONE, YES, RIGHT. *THERE.* HE DABBED IT. IT WASN'T A FINGERPRINT ANYHOW!

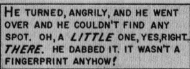

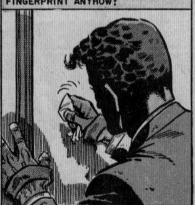

HE LOOKED AT THE WALL AND THE WAY IT WENT OVER TO HIS RIGHT AND OVER TO HIS LEFT AND HOW IT WENT DOWN TO HIS FEET AND UP OVER HIS HEAD AND HE SAID SOFTLY...

NO.

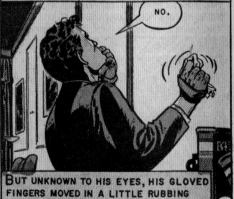

BUT UNKNOWN TO HIS EYES, HIS GLOVED FINGERS MOVED IN A LITTLE RUBBING RHYTHM ON THE WALL.

4

HE PEERED AT HIS HAND AND THE WALLPAPER. HE LOOKED OVER HIS SHOULDER AT THE OTHER ROOM. HIS FACE HARDENED. WITHOUT A WORD HE BEGAN TO SCRUB THE WALL, UP AND DOWN, BACK AND FORTH, UP AND DOWN, AS HIGH AS HE COULD STRETCH AND AS LOW AS HE COULD BEND...

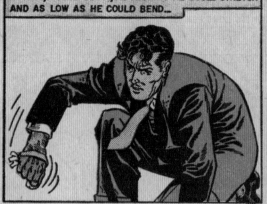

HE GOT ONE WALL FINISHED, AND THEN...HE CAME TO ANOTHER WALL. HE LOOKED AT THE MANTEL CLOCK. AN HOUR GONE. IT WAS FIVE AFTER ONE. HE TURNED AWAY FROM THIS NEW FRESH WALL...

SILLY. IT'S FLAWLESS. I *WON'T TOUCH* IT.

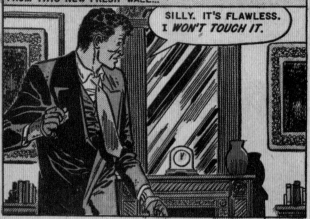

FROM THE CORNERS OF HIS EYES HE SAW THE LITTLE WEBS. WHEN HIS BACK WAS TURNED THE LITTLE SPIDERS CAME OUT OF THE WOODWORK AND SPUN THEIR LITTLE FRAGILE HALF-INVISIBLE WEBS UPON THE THREE WALLS AS YET UNTOUCHED. EACH TIME HE STARED DIRECTLY AT THEM, THE SPIDERS POPPED BACK INTO THE WOOD-WORK ONLY TO SPINDLE OUT AS HE RETREATED...

THOSE WALLS ARE ALL *RIGHT!* I WON'T TOUCH *THEM!*

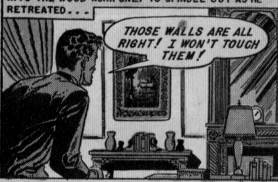

HE WENT TO A WRITING DESK AT WHICH HUXLEY HAD BEEN SEATED EARLIER. HE OPENED A DRAWER AND TOOK OUT WHAT HE WAS LOOKING FOR. A LITTLE MAG-NIFYING GLASS HUXLEY SOMETIMES USED FOR READING. HE TOOK THE MAGNIFIER AND APPROACHED THE WALL UNEASILY...

FINGERPRINTS!

BUT THOSE AREN'T *MINE!* I *DIDN'T* PUT THEM THERE! I'M *SURE* I DIDN'T! A SERVANT, A BUTLER, OR A MAID PERHAPS!

THE WALL WAS FULL OF THEM...

LOOK AT THIS ONE HERE, LONG AND TAPERED, A WOMAN'S, I'D BET ON IT!

WOULD YOU? I WOULD!

ARE YOU CERTAIN?

YES!

POSITIVE?

WELL...YES.

ABSOLUTELY?

YES, YES!

WIPE IT OUT, ANYWAY!

OH, ALL RIGHT!

IN A RAGE HE BEGAN TO SWEEP THE WALL UP AND DOWN AND BACK AND FORTH WITH HIS GLOVED HANDS, SWEATING, GRUNTING AND SWEARING, BENDING AND RISING AND GETTING REDDER OF FACE...

HE FINISHED THE WALL AT TWO O'CLOCK. HE TOOK OFF HIS COAT AND PUT IT ON A CHAIR. HE WALKED OVER TO THE BOWL AND TOOK OUT THE WAXED FRUIT AND POLISHED THE ONES AT THE BOTTOM AND POLISHED THE PICTURE FRAME. HE LOOKED UP AT THE CHANDELIER...

HIS FINGERS TWITCHED AT HIS SIDES. HIS MOUTH SLIPPED OPEN AND THE TONGUE MOVED ALONG HIS LIPS AND HE LOOKED AT THE CHANDELIER AND LOOKED AWAY AND LOOKED BACK AT THE CHANDELIER AND LOOKED AT HUXLEY'S BODY AND THEN AT THE CRYSTAL CHANDELIER WITH ITS LONG PEARLS OF RAINBOW GLASS...

HE GOT A CHAIR AND BROUGHT IT OVER UNDER THE CHANDELIER AND PUT ONE FOOT UP ON IT AND TOOK IT DOWN AND THREW THE CHAIR, VIOLENTLY, LAUGHING, INTO A CORNER. THEN HE RAN FROM THE ROOM LEAVING ONE WALL AS YET UNWASHED...

IN THE DINING ROOM HE CAME TO A TABLE. HE PAUSED OVER THE TABLE WHERE THE BOXES OF CUTLERY WERE LAID OUT, HEARING ONCE MORE HUXLEY'S VOICE...

LOOK AT THIS SILVER, ACTON. EXQUISITE CRAFTSMANSHIP. *LOOK* AT IT!

NOW ACTON WIPED THE FORKS AND SPOONS AND TOOK DOWN ALL THE PLATES AND SPECIAL CERAMIC DISHES FROM THE WALL SHELF... REMEMBERING ALL THE TOUCHINGS AND GESTURINGS...

HERE'S A LOVELY BIT OF CERAMICS BY GERTRUDE AND OTTO NATZLER, ACTON. ARE YOU FAMILIAR WITH THEIR WORK?

PICK IT UP. TURN IT OVER. SEE THE FINE THINNESS OF THE BOWL, THIN AS EGGSHELL. INCREDIBLE. HANDLE IT, GO AHEAD. I DON'T MIND.

HANDLE IT! GO AHEAD! PICK IT UP!

6

ACTON SOBBED UNEVENLY. HE HURLED THE POTTERY AGAINST THE WALL. IT SHATTERED AND SPREAD, FLAKING WILDLY, UPON THE FLOOR...

AN INSTANT LATER, HE WAS ON HIS KNEES. EVERY PIECE, EVERY SHARD OF IT, MUST BE REGAINED. FOOL, FOOL, FOOL, HE CRIED TO HIMSELF. FIND EVERY PIECE, YOU IDIOT...NOT ONE FRAGMENT OF IT MUST BE LEFT BEHIND. HE GATHERED THEM...

ARE THEY ALL HERE? HE LOOKED UNDER THE TABLE AGAIN AND UNDER THE CHAIRS AND FOUND ONE MORE PIECE BY MATCH-LIGHT AND STARTED TO POLISH EACH LITTLE FRAGMENT AS IF IT WERE A PRECIOUS STONE...

HE TOOK OUT THE LINEN AND WIPED IT AND WIPED THE CHAIRS AND TABLES AND DOORKNOBS AND WINDOW-PANES AND LEDGES AND DRAPES AND WIPED THE FLOOR AND FOUND THE KITCHEN, PANTING, BREATHING VIO-LENTLY, AND TOOK OFF HIS VEST AND ADJUSTED HIS GLOVES AND WIPED THE GLITTERING CHROMIUM...

AND HE WIPED ALL THE UTENSILS AND THE SILVER FAUCETS AND THE MIXING BOWLS, FOR NOW HE HAD FORGOTTEN WHAT HE HAD TOUCHED AND WHAT HE HAD NOT. HUXLEY AND HE HAD LINGERED HERE, IN THE KITCHEN, THEY HAD IDLED, TOUCHED THIS, THAT, SOME-THING ELSE, THERE WAS NO REMEMBERING WHAT OR HOW MUCH OR HOW MANY...

AND HE FINISHED THE KITCHEN AND CAME THROUGH THE HALL INTO THE ROOM WHERE HUXLEY LAY. HE CRIED OUT. HE HAD FORGOTTEN TO WASH THE FOURTH WALL OF THE ROOM. AND WHILE HE WAS GONE, THE LITTLE SPIDERS HAD COME OUT OF THE FOURTH UNWASHED WALL AND SWARMED OVER THE ALREADY CLEAN WALLS, DIRTYING THEM AGAIN! ON THE CEIL-INGS, THE CHANDELIER, IN THE CORNERS, ON THE FLOOR A MILLION LITTLE WHORLED WEBS HUNG BILLOWING AT HIS SCREAM...

TINY, TINY LITTLE WEBS, NO BIGGER THAN, IRONICALLY, YOUR...FINGER! AS HE WATCHED, THE WEBS WERE WOVEN OVER THE PICTURE FRAME, THE FRUIT BOWL, THE BODY, THE FLOOR. PRINTS WIELDED THE PAPER KNIFE, PULLED OUT DRAWERS, TOUCHED THE TABLE-TOP...TOUCHED, TOUCHED, TOUCHED EVERYTHING EVERYWHERE...

HE POLISHED THE FLOOR WILDLY, WILDLY. HE ROLLED THE BODY OVER AND CRIED ON IT WHILE HE WASHED IT AND GOT UP AND WALKED OVER AND POLISHED THE FRUIT AT THE BOTTOM OF THE BOWL. HE PUT A CHAIR UNDER THE CHANDELIER AND GOT UP AND POLISHED EACH LITTLE HANGING FIRE OF IT, SHAKING IT LIKE A CRYSTAL TAMBOURINE UNTIL IT TILTED BELLWISE IN THE AIR. THEN HE LEAPED OFF THE CHAIR AND GRIPPED THE DOORKNOBS AND GOT UP ON ANOTHER CHAIR AND SWABBED THE WALLS HIGHER AND HIGHER AND RAN TO THE KITCHEN AND GOT A BROOM AND WIPED THE WEBS DOWN FROM THE CEILINGS AND POLISHED THE BOTTOM FRUIT OF THE BOWL AND WASHED THE BODY AND DOORKNOBS AND SILVERWARE AND FOUND THE HALL BANISTER AND FOLLOWED THE BANISTER UPSTAIRS...

THREE O'CLOCK! THERE WERE TWELVE ROOMS DOWNSTAIRS AND EIGHT ABOVE. ONE HUNDRED CHAIRS, SIX SOFAS, TWENTY-SEVEN TABLES, SIX RADIOS. AND UNDER AND ON TOP AND BEHIND. HE YANKED FURNITURE OUT AWAY FROM WALLS AND, SOBBING, WIPED THEM CLEAN OF YEARS-OLD DUST, HANDLING, ERASING, RUBBING, POLISHING, AND NOW IT WAS FOUR O'CLOCK! AND HIS ARMS ACHED AND HIS EYES WERE SWOLLEN AND STARING AND HE MOVED SLUGGISHLY ABOUT, ON STRANGE LEGS, HIS HEAD DOWN, HIS ARMS MOVING, SWABBING AND RUBBING, BEDROOM BY BEDROOM, CLOSET BY CLOSET...

THEY FOUND HIM AT SIX-THIRTY THAT MORNING. IN THE ATTIC, THE ENTIRE HOUSE WAS POLISHED TO A BRILLIANCE. THEY FOUND HIM IN THE ATTIC, POLISHING OLD TRUNKS AND OLD FRAMES AND OLD CHAIRS AND TOYS AND VASES AND ROCKING HORSES AND DUSTY CIVIL WAR COINS. HE WAS HALF THROUGH THE ATTIC WHEN THE POLICE OFFICER WALKED UP BEHIND HIM WITH A GUN...

ON THE WAY OUT OF THE HOUSE, ACTON POLISHED THE FRONT DOORKNOB WITH HIS HANDKERCHIEF, AND SLAMMED IT IN TRIUMPH!

THE END.

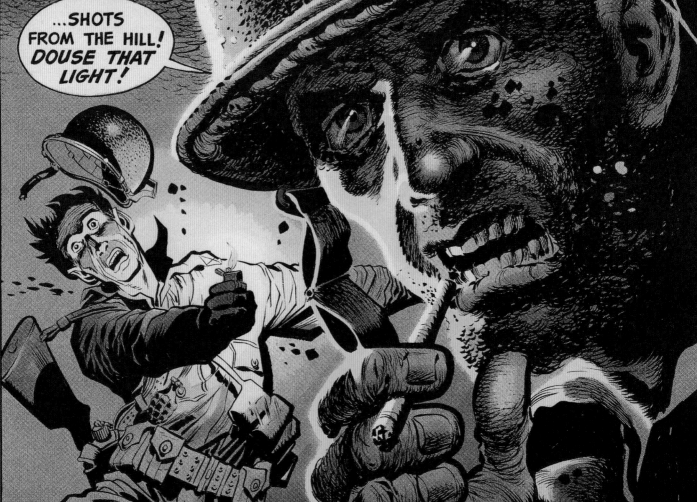

JACK DAVIS!

"THE *CONSUMMATE SOUTHERNER*, AND THE *CONSUMMATE PROFESSIONAL!*" —AL FELDSTEIN

Jack Davis joined the E.C. staff towards the end of 1950. Both incredibly fast on the draw and extremely versatile, Davis immediately became an important member of E.C.'s stable.

Jack Burton Davis, Jr. was born on December 2, 1924 in Atlanta, Georgia, the only offspring of Jack Davis, Sr. and Callie Davis. He gravitated towards art at a very early age, and by the time he was in grammar school he was copying comic strips such as *Henry*, *Popeye*, and *Mickey Mouse*. His first published work (appearing just four issues before Harvey Kurtzman's winning entry) appeared in *Tip Top Comics* #32, December 1938. Davis had sent in a drawing to "Buffalo Bob's Cartoon Contest," which was awarded the then-princely sum of one dollar. "I was so excited," Davis said later. "I was about twelve years old and it was the first thing I'd ever had printed." In high school, Davis regularly contributed illustrations to the school newspaper and to the yearbook.

With World War II in full swing, upon graduation from high school Davis enlisted in the Navy rather than get drafted. He was first sent to Pensacola, Florida, where he created a character named "Seaman Swabby," a thinly veiled knock-off of George Baker's *Sad Sack*. He was then sent to Norwalk, Virginia, and later to a nine-month stay in Guam, where "Seaman Swabby" reappeared as "Boondocker." "Boondocker" proved to be

quite popular, and appeared in the *Navy News* for the entire time Davis was stationed there.

After his discharge from the Navy, Davis returned to Atlanta to study at the University of Georgia, which he attended on the G.I. Bill. While there Davis was a regular contributor to the college newspaper, *The Red and Black*, where he again reinvented "Seaman Swabby," this time as "Georgiae," a student at the University who had recently served in the Navy. Davis and some of his fraternity brothers also put out several issues of an off-campus humor magazine called *Bullsheet*. "The fraternity brothers would get out and hawk them on the street corners," said Davis in *The Art of Jack Davis!* (Stabur Press, 1987). "The ads paid for the printing and we kept the rest."

In 1947, Davis spent a summer assisting Ed Dodd on the syndicated newspaper strip "Mark Trail." Dodd recognized Davis's potential and encouraged him to go to New York to study at the Art Students League, but finances prevented such a big move at that time.

Below: "Boondocker," *Navy News,* December 21, 1945.

BOONDOCKER by JACK DAVIS

"I can hardly wait to go back to school and start studying again."

Left: Davis's cover to *Two-Fisted Tales* #30 (November–December 1952), a masterpiece of shadow and light.

Copyright © 1949 by Coca-Cola

In 1949, Davis was hired by the Coca-Cola Company in Atlanta to illustrate an in-house instructional booklet called *Here's How*. It was Davis's first professional assignment, and with it he made enough money to buy a car and make the move to New York. Following up on Ed Dodd's suggestion, Davis enrolled at the Art Students League, which he attended at night while looking for work during the day. He made the rounds at both the newspaper syndicates and the comic-book publishers, with no luck.

Finally, through a notice placed at the school, Davis landed a job with the *New York Herald Tribune* doing inking on the syndicated strip "The Saint." The artist on the strip was Mike Roy, whom Davis described as being "fantastic with a brush." Davis worked on the strip for about a year and learned a lot, but then in 1950 the *New York Herald Tribune* closed its doors.

Davis did several issues of a digest-sized, 5¢ western comic book called *Lucky Star*, but apart from this nothing much was happening for him. He was about ready to throw in the towel and head back to Atlanta when he decided to give it one more try. He copied down E.C.'s address from the indicia inside one of their comics, and he and his portfolio headed down to 225 Lafayette Street. Davis met with Al Feldstein, who looked through his portfolio, and then simply handed him a story. Davis was both surprised and relieved. Feldstein was an immediate fan, and he said recently, "I don't know where Davis had been before he came to see us, but I really can't believe that no one hired him. And I made it a point—like I did with all the artists—to make sure he didn't try to change

his style. Each artist should have his own handwriting." Davis's first story for E.C. was "The Living Mummy" in the fourth issue of *The Haunt of Fear* (November–December 1950); his scratchy, cartoony style proved to be a perfect foil to the often gruesome E.C. horror stories. He came by it naturally. In an interview published in the *The Comics Journal*, Davis said, "As a kid, I loved ghost stories. I loved *Frankenstein*; that scared the hell out of me, and I love that. So I learned to draw it. It comes out that way: gruesome. I've never been one to draw romantic things, or sweet or nice things. I've always drawn grotesque things."

Davis was good, but he was also fast—an incredibly valuable asset in the comics game, where slow and steady did *not* win the race. "Jack was very, very fast," said Bill Gaines in the 1972 fanzine *E.C. Lives!* "He could turn out a seven- to eight-page story in two to three days if he really wanted to." (It is little wonder why a caricature of Davis done for one of E.C.'s Christmas parties depicted Davis turning the handle of a machine labeled the "Jack Davis mechanical high-speed comic-book artist," literally cranking it out!) Feldstein took it a step further in the same publication: "He was a professional from the outset, from the very beginning. He took a script and added to it all the wild techniques that Jack was famous for. He really brought the thing to life in the Jack Davis style."

Davis also was an important contributor to E.C.'s war comics, *Two-Fisted Tales* and

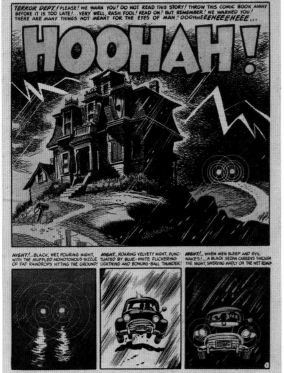

Copyright © 1952 by E.C. Publications

Left: The splash page from Davis's first story for E.C., "The Living Mummy" (*The Haunt of Fear* #4, November–December 1950).

Frontline Combat, written by Harvey Kurtzman. Here Davis's speed was both a blessing and a curse, for while it allowed him to get the work out on time, it sometimes raised the ire of the perfectionist Kurtzman, who insisted that all the details be correct, right down to the buttons on the uniforms. As one might imagine, Davis didn't always take the time to work on these small details. Still,

his work on those titles was very effective, and his scratchy, cross-hatched style was well suited to showing the horrors of war.

In 1952, Kurtzman launched a new addition to the E.C. line, with the full title of *Tales Calculated to Drive You MAD*. Davis occupied the opening slot in the very first issue with a story called "HOOHAH!," which was a parody of the kinds of horror stories he had been doing for E.C.'s horror comics. The respite from horror and war was most welcome, and with *MAD* Davis finally got a chance to fully indulge his humorous side. Davis was present in nearly every issue of the *MAD* comic book, and also contributed the cover for *MAD*'s second issue (December 1952–January 1953). Shortly after *MAD* became successful, E.C. launched a sister publication called *PANIC* (edited by Al Feldstein), and Davis was an important contributor to this book as well, appearing in every issue, as well as contributing a suitably manic cover to the final issue, #12 (December 1955–January 1956).

Davis worked steadily for E.C. all through the mid-1950s. When the company discontinued their New Trend comics and embarked on the New Direction and Picto-Fiction experiments, Davis smoothly made those transitions. He also was present for the earliest issues of the 25¢, black-and-white, magazine-sized version of *MAD*.

Having become a close friend of Harvey Kurtzman's, Davis followed Kurtzman when he departed *MAD* to create *Trump* for Hugh Hefner. "Harvey was the originator of *MAD*, and I thought he was very talented and could lead us. At the time it seemed very glamorous—I met Hefner and all—everything looked great, but deadlines got missed. It took so long to produce an issue, it never really had a chance. We enjoyed working on it, but financially it wasn't profitable," said Davis in *The Art of Jack Davis!* Davis did some absolutely spectacular color work for *Trump*, but Hefner

Above: Jack Davis at the 1951 E.C. Christmas party.

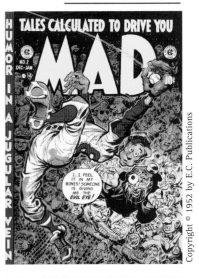

Copyright © 1952 by E.C. Publications

Copyright © 1952 by E.C. Publications

Above: The splash page from Davis's story in *MAD* #1, "HOOHAH!" (October–November 1952).

Above: Davis covers to *MAD* #2 (December 1952–January 1953) and *PANIC* #12 (January 1956).

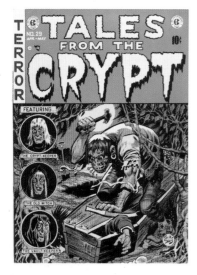

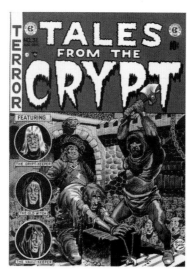

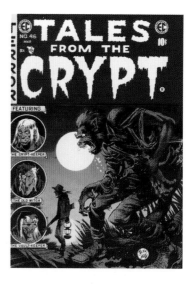

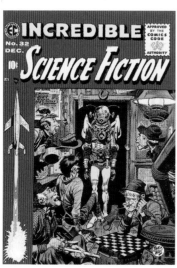

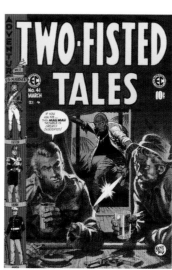

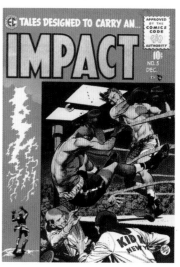

Above: No matter what the subject matter, Davis's art has a mischievous quality that comes through, which renders even the most horrific scenes palatable.

Below: Davis self-portrait from *Humbug* #1, August 1957.

had over-extended himself and had to pull the plug on the project after only two issues. Kurtzman and the *Trump* artists decided to stay and create *Humbug*, which they published themselves. Davis again followed Kurtzman, but had to insist on a salary rather than the percentage deal that was offered to the other artists to make sure he could still support his family. *Humbug* lasted eleven issues, running from August 1957 to August 1958. In *The Art of Jack Davis!*, Davis said, "It wasn't distributed well and eventually it, too, folded. But I was really pleased with a lot of the work that I did for *Humbug*."

Davis had entered a period where he took work wherever he could get it. He had been

doing occasional one-page cartoons for *Playboy*, and he did fifteen of these between September 1956 and May 1963. He also started branching out into other kinds of illustration, including record album covers, magazine covers, book covers, as well as comic-book work, primarily for Atlas. Some of the work was low-paying, but Davis was working his way up the ladder as an illustrator. He was shut out of *MAD* for a time, but

Copyright © 1958 by Humbug Publishing

Above: Davis cover from *Humbug* #6, January 1958.

The Entertaining Comics Group
225 LAFAYETTE STREET, NEW YORK 12, N. Y., CAnal 6-1994-5

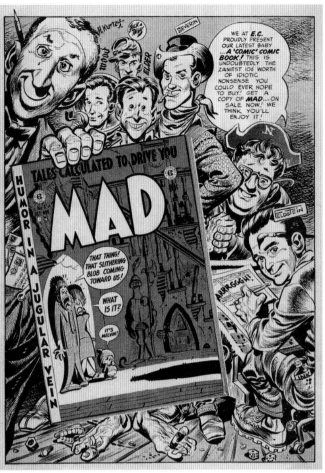

Above: A sheet of E.C. stationary with Davis art, and Davis's E.C. "house ad" for *MAD* #1 (from *Weird Fantasy* #15, September–October 1952), featuring caricatures of most of the E.C. staff.

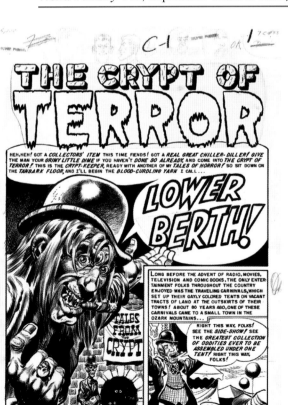

Davis did a substantial amount of work for various *MAD* imitators, including *Cracked* and *SICK*. "I did most of those in the lean years," said Davis. "They were just imitators, but you had to pay the bills." He did several hundred illustrations for various humorous bubble gum cards issued by Topps. He also did work for another Kurtzman-edited publication, *HELP!*, a low-budget (but hip) humor magazine published by James Warren.

Davis eventually became one the most in-demand illustrators of the 1960s, 1970s, and 1980s, creating a long line of covers for such high-profile publications as *Time* and

Copyright © 1962 by HMH Publishing

"Sis must like you — she's wearing her big chest tonight."

Above: From *Playboy*, October 1962.

Left: Original Davis art to the splash page of "Lower Berth!," *Tales from the Crypt* #33, December 1952–January 1953.

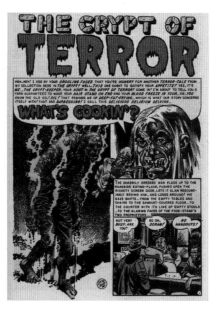

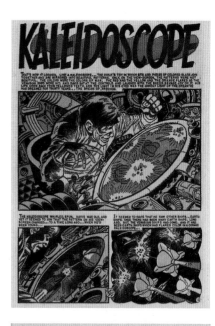

Right and below: A sampling of Davis's E.C. splash pages.

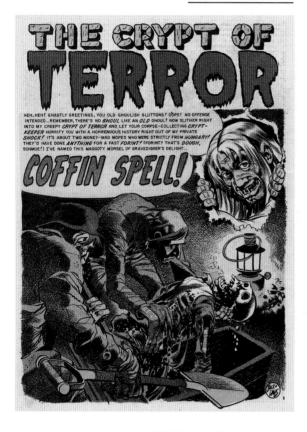

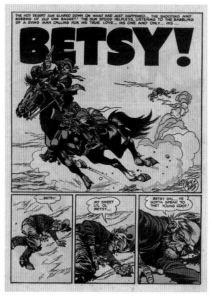

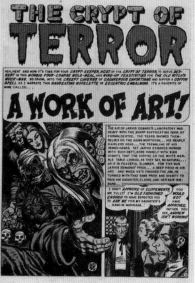

Photo by Charlie Roberts

Above: Jack Davis at the 1972 E.C. Fan-Addict Convention in New York City.

TV Guide. He also did work for a wide range of other products, including greeting cards, game box covers, lunch boxes, and coloring books. He returned to *MAD* in 1965, and remained a regular contributor–despite an increasingly busy (not to mention more lucrative) schedule of other work. As Gaines said of Davis in a 1969 fanzine interview with Rich Hauser: "He's working for *MAD* again, and he doesn't do nearly enough. He can do about twenty pages a year, and that's all we can get from him." But the *MAD* men were happy to have him for as much or as little as they could get him. Davis continued to work for his old friends at *MAD* until 1997, when a dictate for a "new, edgier" *MAD* came down from its corporate owners. Finding the raunchier material the magazine began

running distasteful, Davis reluctantly bid adieu to his oldest account.

With an absolutely staggering body of work behind him, Jack Davis today is arguably the most-published cartoonist of our time. A dyed-in-the-wool southerner, he is now semi-retired, living on an island off the coast of Georgia in a lovely home designed especially for him by his

Copyright © 1974 by Time

Copyright © 1978 by TV Guide

Right: Davis covers to *Time* (July 1, 1974) and *TV Guide* (July 29, 1978).

Above and right: Davis covers from two low-wattage competitors to *MAD* magazine, *Cracked* #12 (January 1960) and *SICK* #34 (February 1965), the Davis cover to James Warren's *Creepy* #1 (1964), and a selection of various Davis book and magazine covers.

architect son, Jack Davis III. In an interview published in 1992 in *The Comics Journal*, Davis offered this: "The main thing is to enjoy. I love to make other people laugh and see them enjoy what I do, too. I get a kick every time something of mine is printed." Jack Davis was inducted into the Will Eisner Hall of Fame in 2003. •

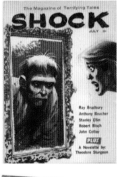

Above: Jack Davis in Monte Carlo, October 1993, on the final *MAD* trip.

Above: Jack Davis hand-drawn Christmas card, circa 1960s.

Copyright © 1959 by Major Magazines

Copyright © 1965 by Headline Publications

Copyright © 1964 by Warren Publishing

Photo by Irving Schild

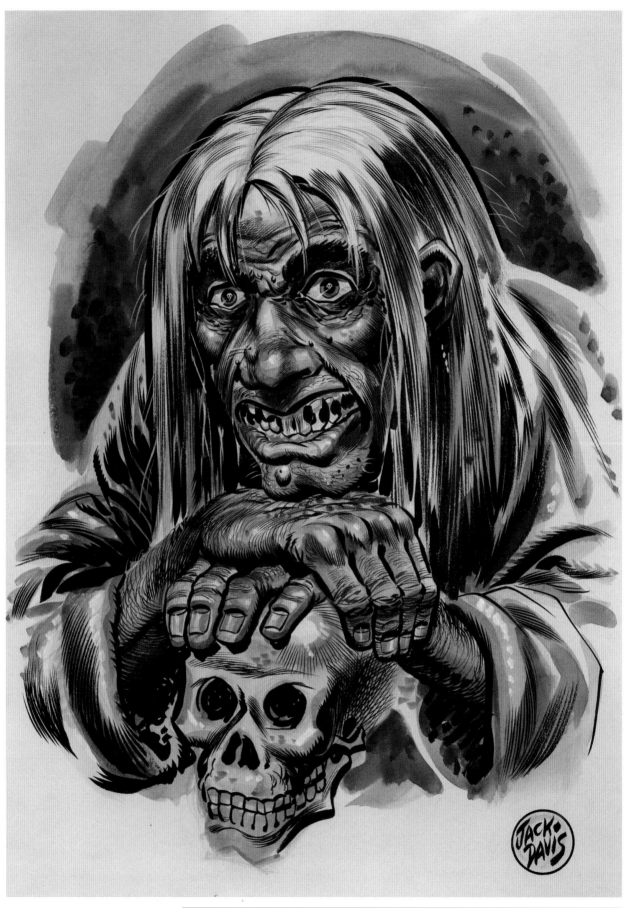

Above: "The Crypt-Keeper," done by Jack Davis in 1954 as a gift for Bill Gaines. This artwork hung in the E.C./*MAD* offices until Gaines's death in 1992.

THE CRYPT OF TERROR

HEH, HEH! AH... *SPRING* IS HERE, EH, FIENDS? IT'S *BASEBALL TIME* AGAIN. WELL, I'VE GOT A *BASEBALL HORROR YARN* THAT WILL DRIVE YOU *BATTY.* SO CREEP INTO THE *CRYPT OF TERROR,* SETTLE DOWN ON THAT *SACK,* AND YOUR *CRYPT-KEEPER* WILL *PITCH* YOU THE *BLOOD-CURDLING, SPINE-TINGLING, FEARFUL FUNGO-FABLE* I CALL...

FOUL PLAY!

IT IS MIDNIGHT... THE EVE OF OPENING DAY. CENTRAL CITY'S BUSH-LEAGUE BALL PARK LIES IN DARKNESS. THERE IS A SMELL OF FRESHLY PAINTED SEATS AND RAILS AND HOT-DOG STANDS HANGING IN THE COOL NIGHT AIR. THE CHAMPIONSHIP PENNANT SAGS LIMPLY FROM THE NEW-WHITENED FLAGPOLE IN THE OUTFIELD, LIFTING SADLY NOW AND THEN TO FLAP IN THE SOFT BREEZE THAT SWEEPS IN AND ACROSS THE SILENT DESERTED GRANDSTANDS. BUT DOWN ON THE GREEN PLAYING FIELD, ILLUMINATED BY THE COLD MOONLIGHT, ARE FIGURES... FIGURES IN BASEBALL UNIFORMS... EACH IN ITS POSITION... WAITING... WAITING FOR THE WORDS...

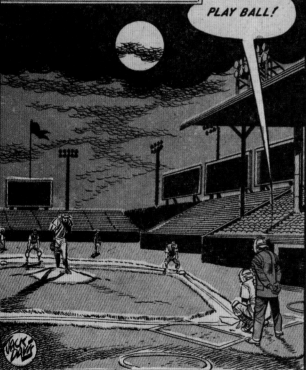

PLAY BALL!

WHAT GOES ON, YOU ASK? WHY THIS MIDNIGHT GAME IN THE MOONLIT CENTRAL CITY BALL PARK? COME BACK WITH ME TO LAST SEASON... TO THE FINAL DAYS OF THIS BUSH-LEAGUE PENNANT RACE... TO A BRISK SEPTEMBER AFTERNOON. DRY BROWNED LEAVES, CHASED BY A FALL WIND THAT CARRIED A PREVIEW OF WINTER WITH ITS CHILL, TUMBLED ACROSS *BAYVILLE'S* BALL PARK AS CENTRAL CITY'S STAR PITCHER STRODE TO THE PLATE...

C'MON, HERBIE! LET'S GET SOME *RUN-INSURANCE!*

GET ON *BASE,* HERBIE BOY!

"Foul Play!," from *The Haunt of Fear* #19 (May–June 1953). Illustrated by Jack Davis. Written by Bill Gaines and Al Feldstein.

IT WAS THE PLAYOFF GAME BETWEEN CENTRAL CITY AND BAYVILLE. THE TWO TEAMS HAD ENDED THE SEASON TIED FOR FIRST PLACE AND THIS GAME WOULD DECIDE THE PENNANT WINNER. VISITING CENTRAL CITY WAS LEADING THEIR BAYVILLE HOSTS BY ONE PRECIOUS RUN IN THE FIRST OF THE NINTH. THERE WERE TWO OUT AS HERBIE SATTEN CAME TO BAT...

PUT IT IN HERE, BOY. *DOWN* THE ALLEY...

EASY OUT, BOYS... AN' WE GOT OUR *POWER* COMING UP LAST OF THE NINTH.

LET'S GO, HERBIE...

BAYVILLE'S HURLER WOUND UP. BIG HERBIE WATCHED AS THE PITCH CAME STEAMING IN...

LOOK OUT, HERBIE...

THE PITCH WAS INSIDE. HERBIE MOVED TOWARD IT, THEN TURNED AWAY. THE BALL STRUCK HIS ELBOW...

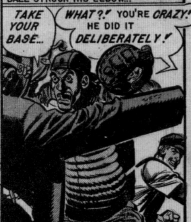

TAKE YOUR BASE...

WHAT?! YOU'RE *CRAZY!* HE DID IT *DELIBERATELY!*

THE BAYVILLE TEAM CROWDED AROUND THE UMPIRE, PROTESTING HIS CALL...

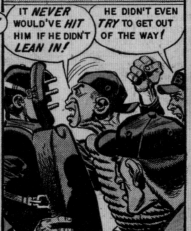

IT *NEVER* WOULD'VE *HIT* HIM IF HE DIDN'T *LEAN IN!*

HE DIDN'T EVEN *TRY* TO GET OUT OF THE WAY!

THE UMPIRE JUST SHOOK HIS HEAD. HIS DECISION STOOD. HERBIE TROTTED DOWN TO FIRST, AND CENTRAL CITY'S LEAD-OFF MAN CAME TO THE PLATE...

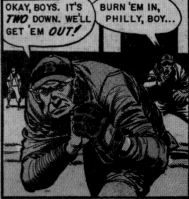

OKAY, BOYS. IT'S *TWO* DOWN. WE'LL GET 'EM *OUT!*

BURN 'EM IN, PHILLY, BOY...

BAYVILLE'S PITCHER, PHIL BRADY, WOUND UP. SUDDENLY, HERBIE, ON FIRST, DID SOMETHING STRANGE FOR A BIG HULKING GUY. HE MADE A BREAK FOR SECOND BASE...

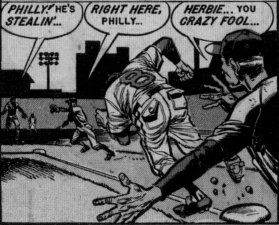

PHILLY! HE'S *STEALIN'*...

RIGHT HERE, PHILLY...

HERBIE... YOU *CRAZY FOOL*...

PHIL SPUN AROUND AND LET GO. JERRY DEEGAN, BAYVILLE'S SECOND BASEMAN AND STAR PLAYER, LEAGUE LEADER IN HITS AND HOME RUNS, WAS COVERING. THE PEG WAS WAY AHEAD OF HERBIE, BUT HERBIE CAME IN SLIDING, SPIKES HIGH...

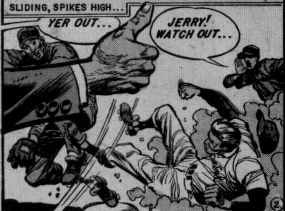

YER OUT...

JERRY! WATCH OUT...

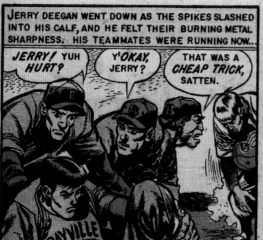

JERRY DEEGAN WENT DOWN AS THE SPIKES SLASHED INTO HIS CALF, AND HE FELT THEIR BURNING METAL SHARPNESS. HIS TEAMMATES WERE RUNNING NOW...

JERRY! YUH HURT?

Y'OKAY, JERRY?

THAT WAS A CHEAP TRICK, SATTEN.

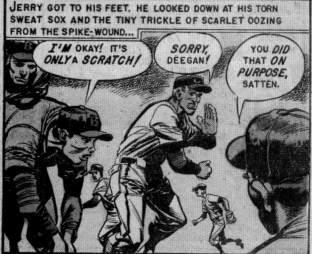

JERRY GOT TO HIS FEET. HE LOOKED DOWN AT HIS TORN SWEAT SOX AND THE TINY TRICKLE OF SCARLET OOZING FROM THE SPIKE-WOUND...

I'M OKAY! IT'S ONLY A SCRATCH!

SORRY, DEEGAN!

YOU DID THAT ON PURPOSE, SATTEN.

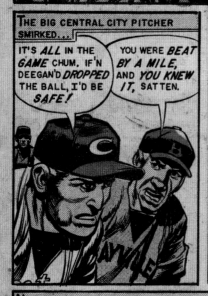

THE BIG CENTRAL CITY PITCHER SMIRKED...

IT'S ALL IN THE GAME CHUM. IF'N DEEGAN'D DROPPED THE BALL, I'D BE SAFE!

YOU WERE BEAT BY A MILE, AND YOU KNEW IT, SATTEN.

THE UMPIRES CALLED 'PLAY BALL' AND THE GAME RESUMED. CENTRAL CITY, STILL LEADING BY ONE RUN, TOOK TO THE FIELD. CENTRAL'S FIRST BASE COACH WALKED SATTEN TO THE MOUND...

I DIDN'T GIVE YOU NO STEAL SIGN, SATTEN! WHAT WAS THE IDEA?

MY IDEA, EDDIE! DON'T WORRY ABOUT IT! THE PENNANT'S AS GOOD AS OURS!

IN BAYVILLE'S DUGOUT, DOC WHITE CLEANED DEEGAN'S SPIKE WOUND AND TAPED IT...

IS HE OKAY, DOC? WILL HE BE ABLE TO BAT?

SURE! JUST A SLIGHT CUT!

OKAY, BAYVILLE. LET'S GET A BATTER OUT HERE.

NOW IT WAS THE LAST OF THE NINTH. A HOME RUN WOULD TIE THE GAME FOR BAYVILLE, AND WITH ONE ON, IT WOULD MEAN VICTORY AND THE PENNANT, AND JERRY DEEGAN WAS DUE TO BAT FOURTH. THE FIRST BATTER STRODE TO THE PLATE...

GET ON, AL! JUST GET ON. JERRY'LL PUT ONE INTO THE STANDS!

YEAH, BOY! I FEEL IT...

BUT AL GROUNDED SADLY TO SHORT. ONE OUT. THE SECOND BATTER MOVED INTO THE BOX...

WAIT 'IM OUT, BILL! HE'S TIRIN'!

S'MATTER, JERRY?

HUH? OH... NUTHIN'!

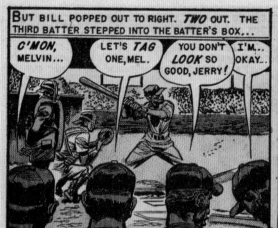

BUT BILL POPPED OUT TO RIGHT. *TWO* OUT. THE THIRD BATTER STEPPED INTO THE BATTER'S BOX...

C'MON, MELVIN...

LET'S *TAG* ONE, MEL.

YOU DON'T *LOOK* SO GOOD, JERRY!

I'M.. OKAY..

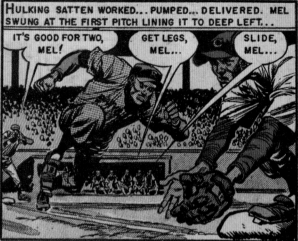

HULKING SATTEN WORKED... PUMPED... DELIVERED. MEL SWUNG AT THE FIRST PITCH LINING IT TO DEEP LEFT...

IT'S GOOD FOR TWO, MEL!

GET LEGS, MEL...

SLIDE, MEL...

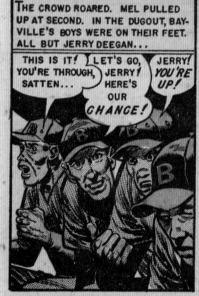

THE CROWD ROARED. MEL PULLED UP AT SECOND. IN THE DUGOUT, BAYVILLE'S BOYS WERE ON THEIR FEET. ALL BUT JERRY DEEGAN...

THIS IS IT! YOU'RE THROUGH, SATTEN...

LET'S GO, JERRY! HERE'S OUR *CHANCE!*

JERRY! *YOU'RE UP!*

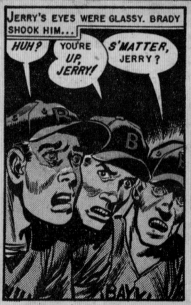

JERRY'S EYES WERE GLASSY. BRADY SHOOK HIM...

HUH?

YOU'RE UP, JERRY!

S'MATTER, JERRY?

JERRY GOT TO HIS FEET... SLOWLY. THE DUGOUT STEPS REELED AS HE STUMBLED UP...

I'M.. *I'M OKAY!* JUST... FELT A LITTLE... DIZZY...

BLAST ONE INTO THE BLEACHERS, JERRY!

JERRY MOVED TO THE BAT RACK... SLOWLY... PAINFULLY. HE SQUINTED HARD, SEARCHING...

SOMETHING'S *WRONG* WITH HIM!

HE CAN'T EVEN FIND HIS BAT...

LET'S GO, BATTER...

FINALLY, FINDING HIS FAVORITE WOOD, JERRY MOVED INTO THE BATTER'S BOX. HE STARED OUT AT SATTEN WHO WAS PUMPING... DELIVERING...

ST-E-E-RIKE ONE!

ATTA BOY, HERBIE!

C'MON, JERRY...

PLOP

JERRY HADN'T EVEN SEEN THE PITCH SPEED PAST HIM... 4

86

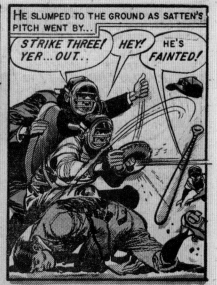

FOR A MOMENT, IT WAS SO QUIET IN THE BAYVILLE DRESSING ROOM, YOU COULD HEAR A PIN DROP. THEN...

SATTEN! HERBIE SATTEN.

HE KNEW THAT IF JERRY CAME UP IN THE NINTH, IT WOULD MEAN THE GAME!

THAT CRAZY MOVE! THAT STEAL! HE HAD NO CHANCE TO MAKE IT...

SATTEN SPIKED JERRY DELIBERATELY!

MURDERED HIM... WITH...

POISONED SPIKES!

THE VISITING TEAM LOCKER ROOM WAS DESERTED. CENTRAL CITY'S BOYS, INCLUDING SATTEN, HAD GONE. ONLY THE TRAINER WAS LEFT...EMPTYING THE LOCKERS, AND PACKING THE EQUIPMENT AWAY...

WHICH LOCKER'D HERBIE SATTEN USE, MOE?

THAT ONE. HIS STUFF'S STILL IN IT...

WHILE THE OTHER PLAYERS KEPT MOE, THE TRAINER, BUSY, DOC WHITE MADE A FAST CHECK ON SATTEN'S SPIKES. LATER, BACK AT THE BAYVILLE DRESSING ROOM...

THERE'S NO DOUBT ABOUT IT! SATTEN'S OUR MURDERER. TRACES OF THE POISON ARE STILL ON HIS SPIKES.

THIS IS A JOB FOR THE POLICE.

NO! WAIT! LET'S TAKE CARE OF HIM OURSELVES... OUR WAY...

YES, FIENDS. HERBIE SATTEN HAD SO WANTED TO WIN THE PENNANT, NOT FOR CENTRAL CITY BUT FOR HIS OWN FAT EGO, THAT AT THE BEGINNING OF THE NINTH, WHILE HIS TEAM WAS AT BAT, HE'D PAINTED HIS SPIKES WITH THE FAST-ACTING POISON. HE'D CARRIED THE POISON WITH HIM FOR JUST SUCH AN OCCASION. GETTING HIT WITH THE PITCH WAS EASY. THE SLIDE, EASIER. AND THE JOB WAS DONE. AND ALL LAST WINTER, HERBIE'D THOUGHT HE'D GOTTEN AWAY WITH IT. HE'D PITCHED HIS TEAM TO VICTORY AND THE PENNANT. HE'D BEEN DECLARED A HERO. SOON IT WOULD BE THE BIG-LEAGUES FOR HIM. SOON, HE'D BE FAMOUS. HE'D HAVE A NAME. A NAME IMMORTALIZED IN THE ANNALS OF BASEBALL. THAT'S WHY, ON THE DAY BEFORE OPENING DAY...

...WHEN THE LETTER ARRIVED, HE FELL FOR THE INVITATION...

DEAR MR. SATTEN,
WE ARE A GROUP OF YOUR MOST AVID FOLLOWERS. IT IS OUR PLAN TO PLACE IN CENTRAL CITY BALL PARK A PLAQUE, CARRYING YOUR NAME, TO HONOR YOU AND YOUR ACHIEVEMENTS IN BASEBALL. PLEASE MEET US TONIGHT AT ELEVEN P.M. AT THE FIELD TO HELP DECIDE UPON WORDING AND PLACEMENT OF SAID TABLET.
THE HERBERT SATTEN COMMEMORATION COMMITTEE

HERBIE WENT. WHY NOT? THIS WAS WHAT HE WANTED ABOVE ALL ELSE. THIS WAS WHAT HE'D MURDERED FOR. HONOR. PRESTIGE. AT 11:00 P.M., HE WAS IN THE DESERTED BALL PARK, ON THE MOONLIT FIELD, WAITING.

HELLO, HERBIE...

WHAT THE...? BRADY! DOC WHITE! THE BAYVILLE TEAM. WHAT'S THIS ALL ABOUT?

So *NOW* you *KNOW*, FIENDS. NOW YOU KNOW *WHY* THERE IS A BALL GAME BEING PLAYED IN THE MOONLIGHT AT MIDNIGHT IN THE DESERTED CENTRAL CITY BALL PARK. LOOK *CLOSELY*. *SEE* THIS *STRANGE BASEBALL GAME!* SEE THE LONG STRINGS OF PULPY INTESTINES THAT MARK THE BASE LINES. SEE THE TWO LUNGS AND THE LIVER THAT INDICATE THE BASES...THE HEART THAT IS HOME PLATE. SEE DOC WHITE BEND AND WHISK THE HEART WITH THE MANGY SCALP, YELLING ...

PLAY BALL... BATTER UP!

LET'S *GO* PHILLY, BOY! *PITCH IT IN*...

SEE THE BATTER COME TO THE PLATE SWINGING THE LEGS, THE ARMS, THEN THROWING ALL BUT ONE AWAY AND STANDING IN THE BOX WAITING FOR THE PITCHER TO HURL THE HEAD IN TO HIM. SEE THE CATCHER WITH THE TORSO STRAPPED ON AS A CHEST-PROTECTOR, THE INFIELDERS WITH THEIR HAND-MITS, THE STOMACH-ROSIN-BAG, AND ALL THE OTHER PIECES OF EQUIPMENT THAT ONCE WAS CENTRAL CITY'S STAR PITCHER, HERBIE SATTEN...

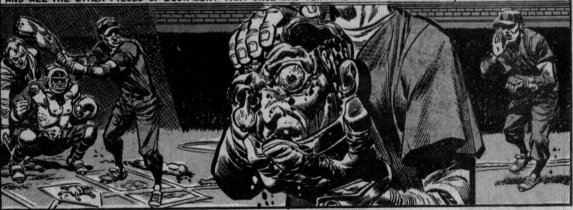

AND IN THE MORNING, WATCH THE FACES OF THE FANS AS THEY PACK THE PARK AND SEE THE GREEN GRASS NOW STAINED RED, AND SEE THE HASTILY SUBSTITUTED PITCHER STEP TO THE RUBBER AND STARE DOWN AT THE STONE PLAQUE EMBEDDED THERE WITH THE ENGRAVED WORDS MEMORIALIZING THE GORY REMAINS BURIED BENEATH THE *PITCHER'S MOUND*...

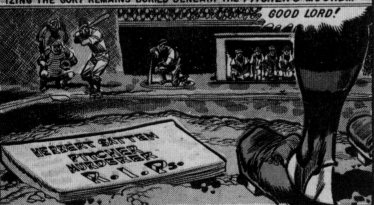

GOOD LORD!

HERBERT SATTEN PITCHER MURDERER R. I. P.

HEH, HEH! SO THAT'S MY *YELP-YARN* FOR THIS ISSUE, KIDDIES. HERBIE, THE PITCHER, WENT TO *PIECES* THAT NIGHT AND WAS TAKEN *OUT*...OUT OF *EXISTENCE*, THAT IS! THE *PLAQUE* TURNED OUT TO BE HIS *GRAVE STONE*, AND THE *PITCHER'S MOUND* HIS *GRAVE*. OH, BY THE WAY. NEXT TIME YOU GO SEE CENTRAL CITY PLAY, BE CAREFUL WHERE YOU SIT. THAT NIGHT ONE OF BAYVILLE'S BOYS HIT A HOMER, INTO THE STANDS. THEY NEVER FOUND THE ... HEH, HEH... 'BALL'! 'BYE, NOW. WE'LL ALL SEE YOU NEXT IN *MY* MAG, *TALES FROM THE CRYPT!*

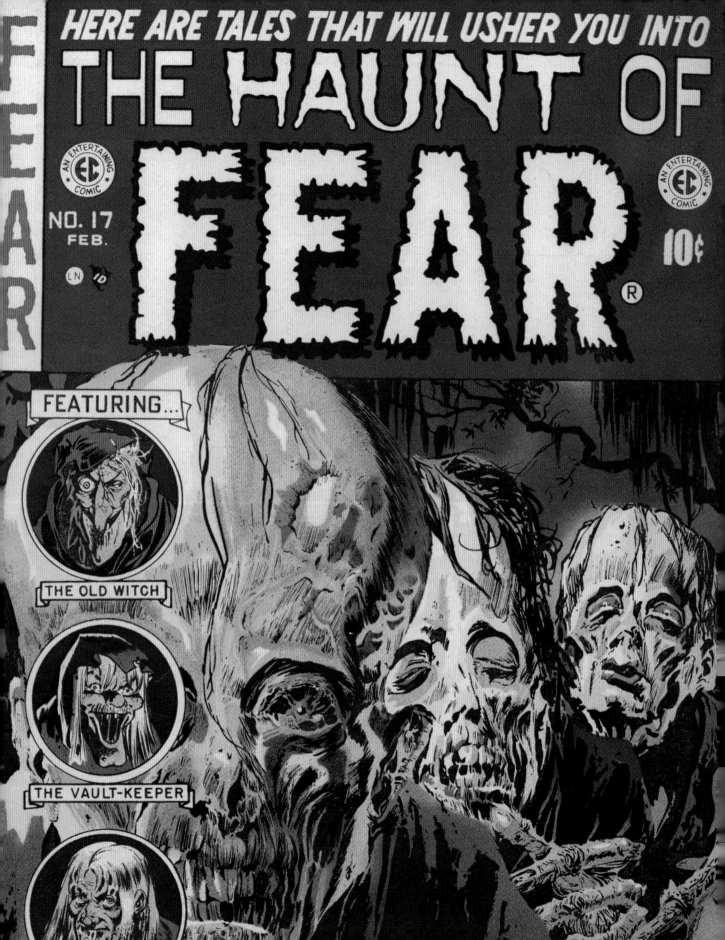

GRAHAM INGELS!

"IT DIDN'T TAKE US VERY LONG TO *REALIZE* THAT INGELS WAS *'MR. HORROR'* HIMSELF!" —BILL GAINES

Graham Ingels, who after the end of 1951 signed most of his E.C. work with the pen name "Ghastly," joined E.C. at the beginning of 1948 not to work on horror, but rather on the company's early western and crime comics.

Graham Ingels was born on June 7, 1915 in Cincinnati, Ohio. Details are somewhat sketchy about his early life, and what little is known can be gleaned from the "E.C. Artist of the Issue" biography on him that ran in several issues of the E.C. comics in 1952. His father was a commercial artist, and he encouraged his son's artistic talents. In 1927, when Ingels was twelve, his family moved to Georgia, and finally relocated to New York, where Ingels was schooled in Yonkers and later in Long Island. His father was killed in 1929, and at the age of fourteen Ingels had to take various jobs—including window washing—to help support the family. By age sixteen he was working creating theater displays. Ingels received no formal training in art in his early years; what education he had was picked up from other artists he had come in contact with that worked in both commercial and fine art.

He began freelancing as an artist at the age of twenty, but details on exactly what kind of work it was are unavailable; it is fairly certain, however, that it was not in the comic-book industry. Around this time, Ingels took a wife, named Gertrude, and they would

produce two offspring: Deanna and Robie. (Deanna was fourteen and Robie was five in 1952 when the Ingels E.C. biography was published.)

His earliest known published work appeared in 1943, interior illustrations for various pulp magazine titles published by Fiction House, including *Planet Stories*, *Jungle Stories*, *Wings Comics*, and *Action Stories*. For the comic-book division of Fiction House, Ingels also did various installments of "The Lost World" and "Auro, Lord of Jupiter" in *Planet Comics*.

Ingels joined the Navy in 1943 but saw no action, spending most of his tour of duty in a "quonset hut on the sand dunes of Long Island." He did do some artwork for the Navy, including a mural for the United Nations, but the exact location of this work is unknown. It also appears that he was able to keep doing some work for Fiction House's pulps during his time in the service, including interior illustrations and an oil paint illustration that was used for the cover for the Spring 1944 issue of *Planet Stories*.

After his discharge, Ingels returned to freelancing. He apparently was unsuccessful in securing further magazine illustration

GRAHAM INGELS

Copyright © 1947 by Famous Funnies

Above: A pre-E.C. Ingels painted cover to *Heroic Comics #41,* March 1947.

Left: Ingels's classic cover to *The Haunt of Fear #17,* February 1953.

91

Copyright © 1944 by Planet Stories

Copyright © 1944 by Planet Stories

Counter-clockwise from above: One of Ingels's first professional jobs was illustrating for the pulp magazines. Pictured at left is his only pulp magazine cover, *Planet Stories*, Spring 1944; it was universally panned by the vociferous letter hacks in subsequent issues. Ingels also illustrated two interior stories in that same issue, "The Avenger" and "Wanderers of the Wolf Moon."

Copyright © 1944 by Planet Stories

Copyright © 1947 by Better Publications

Above: A similar pose to the *Planet Stories* cover, but Ingels added the bondage element on this pre-E.C. cover to *Wonder Comics* #12, June 1947.

assignments, and he reportedly turned to comic-book work as a last resort. He freelanced for a variety of comic-book publishers, including Magazine Enterprises and Famous Funnies, for whom he did a handsome painted cover to *Heroic Comics #41*.

He eventually landed a job as an editor for Ned Pines at the Better-Standard-Nedor comic company, and while there he produced a number of covers and stories for both *Wonder Comics* and *Startling Comics*. He left this position after a year or so, and began freelancing for a number of companies, including Fiction House, Avon, Western Comics/Youthful, and E.C.

Ingels's first job for E.C. was "Smokin' Six-Guns!" in *War Against Crime! #1*, Spring 1948. From then on, he regularly appeared in both *Crime Patrol* and *War Against Crime!* He also regularly worked in *Gunfighter* and *Saddle Justice*, and contributed a number of covers for both of those titles. While his cover work for these titles is generally highly regarded, his interior stories were merely competent, at best. When asked about Ingels's early work, Al Feldstein didn't mince words: "When he was trying to do straight comic art, he was bad, like I was bad, but in his own way." Asked why Ingels was kept on while other artists were given tryouts and then let go, Feldstein said, "Bill was fiercely loyal to everybody. Unless there was a definite reason to get rid of somebody, he would give them a chance. And it may very well be that Ingels

needed some help, and Bill just kept him on."

Bill Gaines stated in *E.C. Lives!*, "In the early days of E.C. we had Graham typecast into the Western books, and when we started the love books we used him there for a few stories, but he didn't seem to fit. When we started the horror titles, we didn't use Graham because we thought he'd be *good* at it, we used him because whenever an artist came into the fold we had to use him for *something*. So we stuck him in the horror books, and it didn't take us very long to realize what had happened: that Graham Ingels was 'Mr. Horror' himself." He was soon signing his work with the pen name "Ghastly," and began specializing in what Bill Gaines biographer Frank Jacobs once famously referred to as "cadaverous inkings." Ingels's horror tableaus were swampy, oozing, decaying, and fetid, and in the depiction of the rotting, shambling corpse he was second to none. He was also famous for his interpretation of the grinning visage of the Old Witch, one of E.C.'s three GhouLunatics, the horror hosts that bookended each story.

Longtime E.C. fan Stephen King paid tribute to Ingels in an early short story called "The Boogeyman," originally published in the March 1973 issue of *Cavalier* (and collected in King's 1978 anthology *Night Shift*). Here is the Ingels-related passage: "I had a dream," Billings said. "I was in a dark

Above left and above right: Ingels's covers to *Gunsmoke* (Western Comics/Youthful), out around the same time as his various E.C. covers to *Gunfighter*, surely caused confusion on the newsstand: they are interchangeable.

Above: Ingels's first E.C. job, from *War Against Crime! #1*, Spring 1948.

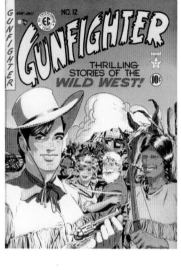

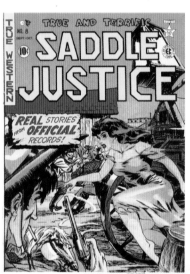

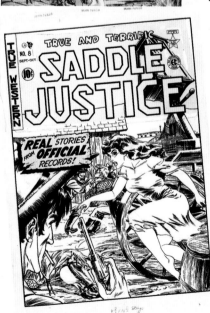

room and there was something I couldn't . . . couldn't quite see, in the closet. It made a noise . . . a squishy noise. It reminded me of a comic book I read when I was a kid. *Tales from the Crypt*, you remember that? Christ! They had a guy named Graham Ingels; he could draw every god-awful thing in the world—and some out of it."

There has been much speculation about exactly what forces were at work that made Ingels the definitive horror artist. Some theorize that he was putting his own inner demons out there on the art board. Will Elder has said, "I always felt there was something deeper in his work than was actually on the paper." Al Feldstein seemed to second this notion, saying, "Graham Ingels's work stands out because of his technique, which was a product of his total makeup . . . his physical, psychological, emotional makeup." Harvey Kurtzman said of Ingels that he was "very philosophical, always concerned with the deeper meaning of life. There was an honesty about Graham that was very refreshing. Unfortunately, Graham had weaknesses and I think his weaknesses won out, but his intentions were good."

One of Ingels's weaknesses was alcohol; indeed, he would probably rank as the "poster boy" among the E.C. regulars who had substance-abuse problems with liquor. Comic artist Howard Nostrand knew Ingels in the 1950s, and he said in an interview in Bill Spicer's *Graphic Story Magazine* that "he had this booze problem. He'd be all right if he drank beer, but if he got into anything else, he'd turn into something fierce." George Evans lived near Ingels on Long Island at this time, and the two spent a fair amount

of time together, even gathering their families for occasional backyard barbeques. Evans recalled that "Old Graham, he'd keep the drinks coming—and coming. Before we started eating I would be so bleary from drinking that I wouldn't know what I was finally eating."

Although he was very fast with a brush and a pen, Ingels became known at E.C. for missing deadlines. It wasn't because he couldn't turn out the work, it was because he would head out from home with the completed job in his portfolio, stop off somewhere for a quick one on the way in, and show up at the E.C. offices, as Gaines once said, "four days later with his mind a complete blank." Gaines and Feldstein quickly sized up the situation, and began giving Ingels artificially early due dates, so even if the job came in "late," it was actually on time. "He was—or is—an extremely nice man, but he was an alcoholic," Gaines told E.C. fan Rich Hauser in 1969. "Consequently, he'd go along fine and then he'd fall over the edge and disappear from sight—he couldn't be found. One thing I'll say about him is that no matter what dreadful business he was involved in, and most of the times we didn't know, he never lost a job, and he never got a job dirty."

In spite of Ingels's problem, he was able to turn out a remarkable amount of material, and he had stories in nearly every issue of E.C.'s three horror titles, *Tales from the Crypt*, *The Haunt of Fear*, and *The Vault of Horror*, as well as in many issues of both *Crime SuspenStories* and *Shock SuspenStories*. He also did every cover of *The Haunt of Fear* from the eleventh issue on, eighteen covers in all. In a really quite remarkable statement from a publisher, Bill Gaines told Hauser that "Graham Ingels's covers never sold as much as Craig's or Davis's,

Above left and above right: Examples of Ingels's Pre-Trend western covers.

under a dialog balloon that reads, "You know, sometimes those stories make me *sick!*"

Unlike many comic book artists, Ingels loved painting in oils, which he would do when not working on paid assignments. He reportedly painted various kinds of subject matter, including landscapes, still lifes, and portraiture. Jack Davis once said of Ingels that "He was such a great painter. I think he was a better painter than he was a cartoonist. Most people never knew how fantastically Ingels could paint." Nostrand felt that "Graham was a frustrated fine artist." This painterly quality is actually very evident in his E.C. art; there is a lushness and depth there that betrays the heart of a painter. E.C. colorist Marie Severin once said, "I remember Ingels sent in a couple of cover color guides that were gorgeous and really moody, but his watercolors were so muddy that we knew the separators would never follow them. I really worked on following his style."

Ingels had a long, successful run with E.C., which lasted until well after Gaines dropped his horror and crime comics. The very loyal Gaines kept Ingels working on the New Direction comics; there are Ingels stories in *Piracy*, *Impact*, *Valor*, and *M.D.* The "Ghastly" moniker was gone, and so was the the perfect fit that Ingels enjoyed in the horror books. Although Ingels's art during this period was good, he was back to his pre-E.C. problem of trying to connect his style with the material. He fared somewhat better in the Picto-Fiction magazines, because the subject matter was more like what he had previously done in the horror and crime titles. The drawing technique required was also a throwback to the black-and-white art he used to do for the pulp magazines.

Above: Marie Severin's caricature of Ingels, done for the 1952 E.C. Christmas party.

as much as I love Graham's work. We just ran them because we loved them. His [cover] work, brilliant as it was, was not very saleable. *The Haunt of Fear*s with his cover work never sold well."

Feldstein feels that Ingels was held back by the other editors he had worked with before he got to E.C.; that he was forced to subjugate his natural style to fit in the accepted comic technique. "When he came to E.C.," Feldstein has said, "we didn't set up those limitations. We encouraged him to develop his own screwball, hairy, black-and-white style. That's why he developed the way he did, and that's why his work [at E.C.] stands out." Interestingly, Ingels—a devout Catholic—had more than a few qualms about the horror material he was so brilliantly illustrating. In fact, one of the caricatures done for an E.C. Christmas party pictures Ingels

Above: Detail from "Blood Type V," *Tales from the Crypt #22*, February–March 1951. Note the unusual "by G. I." signature.

Above: Graham Ingels at the 1951 E.C. Christmas party.

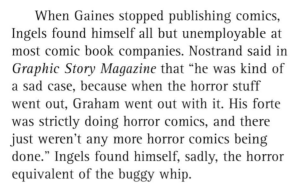

When Gaines stopped publishing comics, Ingels found himself all but unemployable at most comic book companies. Nostrand said in *Graphic Story Magazine* that "he was kind of a sad case, because when the horror stuff went out, Graham went out with it. His forte was strictly doing horror comics, and there just weren't any more horror comics being done." Ingels found himself, sadly, the horror equivalent of the buggy whip.

To help make ends meet, Ingels taught painting classes for a time out of his studio in Long Island, but it was, as Nostrand said, "a tough buck to make, teaching old ladies to paint." His friend George Evans arranged for Graham to ink Evans's pencils on some *Classics Illustrated* stories, which led to Ingels doing some

adaptations for the company on his own, but the work was low paying and clearly a step down. He also did some stories for *Treasure Chest* comics, published by the Catholic Church. His work for *Classics Illustrated* and *Treasure Chest* was Ingels's last work in comics.

Things improved somewhat for Ingels when he took a job at the Famous Artists School in Westport, Connecticut. It was a steady paycheck, and by most accounts Ingels enjoyed teaching others, even though the actual instruction was conducted through the mail. Nostrand put a more negative spin on it in *Graphic Story Magazine*, however, saying "It's a factory. There are all these guys, over-the-hill artists or illustrators who can't quite make it any more, sitting around there correcting all this garbage that comes in, and painting little things to show the students."

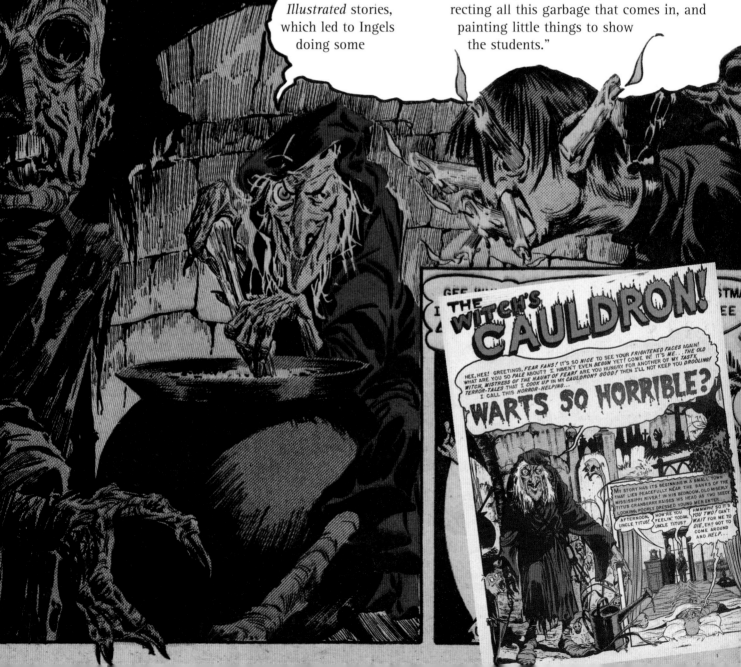

Below: Ingels in the E.C. offices in 1951.

Details are sketchy about this particular time, but apparently Ingels's home life was in shambles, very likely due to his alcohol problem. So one day around 1962, Ingels did something that would be unthinkable to most people with a family, even given all the problems: he simply disappeared. Vanished. For years none of his associates, including Bill Gaines, knew what became of him, or even if he were alive or dead. He had dropped off the face of the earth.

Finally, at the 1972 E.C. Fan-Addict Convention in New York City, it was revealed that Ingels was indeed alive, and had been living in Florida. Gaines said at the convention that Ingels "doesn't want it known where he is in Florida, and I don't know where he is in Florida. I did talk to him twice by telephone. He won't tell me what he's doing, and he won't tell me where he is, and all he says is that he's very happy." That weekend, Ingels was voted "Favorite E.C. Horror Artist," and selected as the "Best E.C. Horror Story" was Ingels's "Horror We? How's Bayou?" from *Haunt of Fear* #17, January–February 1953. (This story appears in its entirety at the end of this chapter.) Gaines accepted the awards on Ingels's behalf. Ingels was clearly a hero among the cognoscenti, and many convention goers were observed wearing buttons that read "Ghastly Lives."

In early 1978, E.C. aficionado and fanzine publisher Bill Spicer attempted to contact Ingels about securing an interview with him. In a letter to Bill Gaines, dated January 12, 1978, Ingels wrote:
"Dear Bill,

I really appreciate your consideration. I'm not a total recluse but avoid public contact as much as possible, particularly relating to the past.

My work these days requires a certain amount of publicity and promotion beneficial mainly to other interests. Obviously I have many good reasons to constantly discourage the image-making attempts of well-intentioned followers.

I am here during the winter months only, so their projected visit would be pointless. Even so, I would regard the intrusion with great hostility, and believe me it would avail them nothing. This guy Spicer comes on in a crude fashion, and he does *not* have my address. My attorney handles all.

I will be most grateful if you block any further inquiry and *appreciate so much* your concern and the trouble you've taken.

Best wishes and happiness, thanks,

Graham

P.S. Regards to the old gang! I have many gratifying thoughts of our relationship, Bill, and your graciousness at Christmas time."

Ingels had in fact settled in Lantana, Florida, and had been instructing the art of oil painting to talented local students out of his home. He had also been concentrating on a series of fine art paintings depicting South Florida, including five large-scale murals depicting the area's history (commissioned by the Bank of Belle Glade) and nine historical paintings of the area for an intended limited edition. (Only one such print was released.) One of Ingels's

Below: The original art to Ingels's splash page from the horror story "Horror! Head . . . It Off!," *Tales from the Crypt* #27 (December 1951–January 1952).

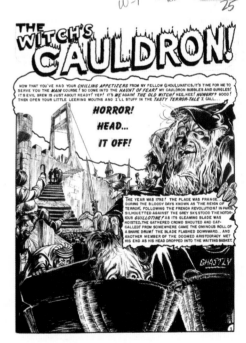

Left: Detail from "Shoe-Button Eyes!," from *The Vault of Horror* #35 (February–March 1954). *Inset:* "Warts So Horrible?" splash page, from *The Haunt of Fear* #9 (September–October 1951).

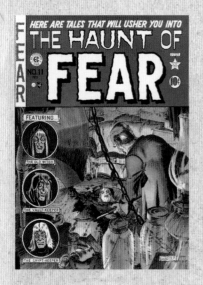
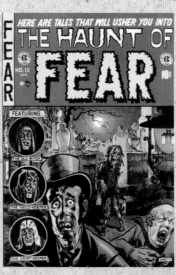
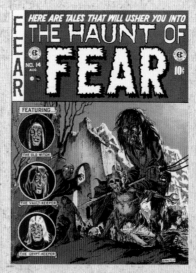

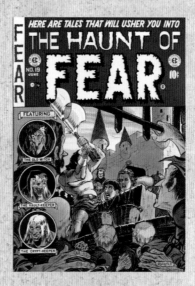

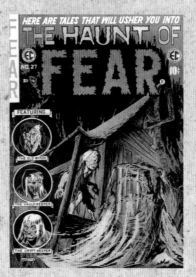
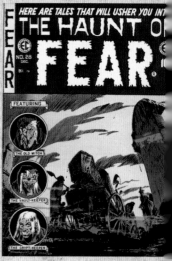

Above: A selection of "Ghastly" Graham Ingels's covers for *The Haunt of Fear*. To this day, the moody, visceral nature of Ingels's E.C. covers has never been equalled.

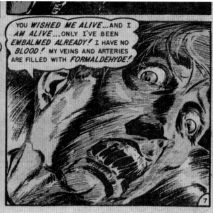

Florida students, Ann Tyler, told Don Vaughan in an in-depth 1996 article on Ingels that appeared in *Outre* that "there wasn't anything Graham couldn't draw. He was a master. His talent was limitless." (Tyler—who spent twenty-five years studying with Ingels—is now a very successful fine artist in her own right.)

Bill Gaines had been slowly selling off the original art done for the E.C. comics through a regular series of auctions conducted by E.C. reprint publisher and art dealer Russ Cochran; by the late 1980s most of the New Trend art had been sold. Although he was under no obligation to do so, Gaines had been splitting the proceeds with the original artists, and these sums sometimes were up into the thousands of dollars. Ingels at first refused the money, until Gaines protested that it would "crap up his books" if he didn't send Ingels his share. Gaines suggested that if Ingels wasn't comfortable keeping the money for himself, that he at least take it, and then if he wanted to, do something like give it over to charity. Ingels relented, but he had made it clear that he had no love for the comic-book field he had left behind, although he did have warm feelings for Gaines and many of his old E.C. associates. He also wanted no part of well-meaning fans seeking to interview him about his past.

In early 1989, Cochran had written to Ingels about the possibility of having him do some new oil paintings of the Old Witch to be sold through Cochran's auctions. After calling Gaines to "check out Russ Cochran," Ingels gave Cochran a call. Cochran's secretary told Russ that a "Mr. Ingels" was on the phone for him, and thinking it was one of his friends pulling a prank, Cochran picked up the phone and purred, "Hello, Ghastly." A rich baritone voice answered back, "Hello, this is Graham Ingels calling." Cochran sputtered out an apology and an explanation, and after some lengthy conversations Ingels agreed to the plan. He made it clear, however, that he would tolerate little interference in his work. He also told Cochran that the Old Witch's shawl, which had been red in the comics, would now be a purple magenta, as he said red hurt his eyes. After Cochran protested, Ingels told him "Would you rather have an Old Witch with a purple dress, or no Old Witch?" Cochran quit pushing him. Ingels also reluctantly agreed to the concept of an interview to help promote the endeavor, but quickly put the stipulation on it that prying questions about his personal life were out.

The paintings, both the small studies and the large finals, were quite lovely, with moody lighting

Left and above: Splash page and panel from "Wish You Were Here," *The Haunt of Fear* #22 (November–December 1953).

Above: Two of Ingels's Old Witch oil paintings, sold through Russ Cochran's Comic Art Auctions.

and a rich-but-subdued palate. A total of four large finished paintings and ten smaller studies were sold though Cochran's auctions between October 1989 and February 1991, at prices ranging from $1,000 to $2,000 for the smaller studies and $5,000 to $7,500 for the large, finished paintings, and Ingels was reportedly very happy with the results of the sales. "Sadly," Russ Cochran told Don Vaughan, "by the time we had some momentum up and people were aware of the fact that he'd been found again, and that he was doing E.C.-style paintings, he got sick." Ingels, complaining of stomach pains, had

checked into a local hospital, where he was soon diagnosed with advanced stomach cancer. Graham Ingels died very shortly after, on April 4, 1991. No interview of him was ever conducted, so there is nothing on the record of the man himself discussing his work. But he left behind him a sizable body of classic, highly visceral images and a legion of adoring fans, not to mention a number of adoring students.

Farewell, Ghastly. Farewell, Graham. •

Right: Detail from "The Prude," *The Haunt of Fear* #28 (November–December 1954). *Below:* Panel from "Reunion!," *The Vault of Horror* #19 (June–July 1951).

Left: Ingels study of the Old Witch, sold through Russ Cochran's Comic Art Auction in 1989.

THE WITCH'S CAULDRON!

HEE, HEE! I SEE YOU'RE *HORROR-HUNGRY* AGAIN... BACK FOR MORE *SAVORY SERVINGS* OF *SCREAMS* FROM MY *CAULDRON!* WELL, *GOOD!* WELCOME TO *THE HAUNT OF FEAR!* THIS IS YOUR *DELIRIUM-DIETICIAN, THE OLD WITCH,* COOKING UP ANOTHER *REVOLTING RECIPE!* READY? GOT YOUR *DROOL CUPS* FASTENED UNDER YOUR *DRIBBLING CHINS?* GOT YOUR *SHROUDS* TIED NEATLY AROUND YOUR *NECKS?* THEN I'LL BEGIN DISHING OUT THE *TERROR-TIDBIT* I CALL...

HORROR WE? HOW'S BAYOU?

THE MOSS-LADEN CYPRESS TREES THAT LINE THE RUTTED BAYOU ROAD SEEM TO PART... AND AN OLD PLANTATION HOUSE, WEATHERBEATEN AND FADED, LOOMS UP IN THE CAR'S HEADLIGHT BEAMS! ITS COLUMNED PORTICO LEERS OMINOUSLY, LIKE SOME GIGANTIC FANGED MONSTER SQUATTING IN THE ROAD, BLOCKING THE AUTOMOBILE'S FURTHER PROGRESS! OFF IN THE DISTANCE A SWAMP BIRD SCREAMS INTO THE NIGHT, AS IF LAUGHING AT THE DRIVER'S DISCOMFORT...

BLAST IT! THIS ROAD *ENDS* HERE! BUT I'M *SURE* THAT *SIGN* BACK THERE POINTED *THIS WAY...*

GHASTLY

"Horror We? How's Bayou?," from *The Haunt of Fear* #17 (January–February 1953). Illustrated by Graham Ingels. Written by Bill Gaines and Al Feldstein.

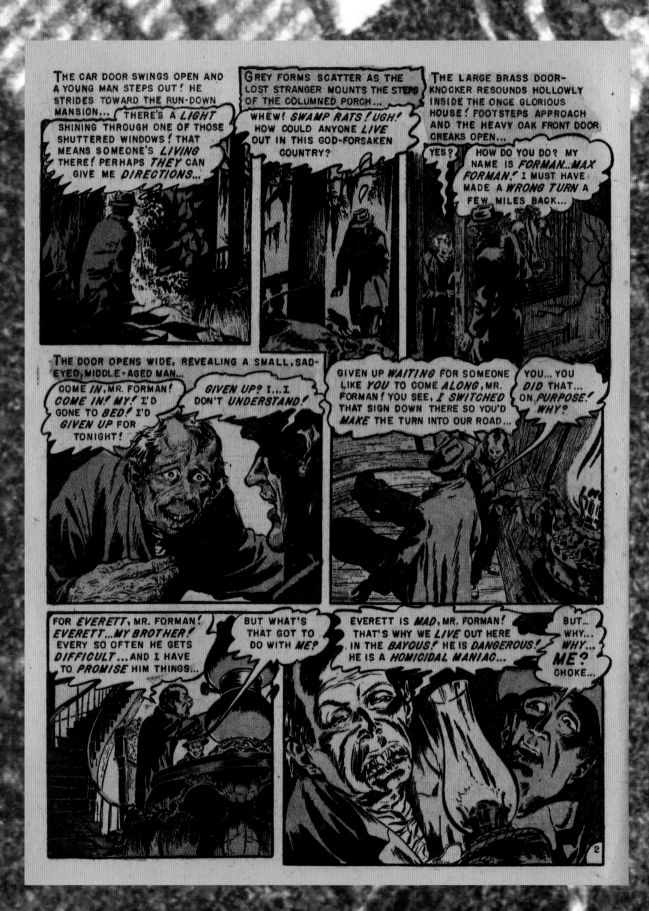

LATER, THE DOOR TO THE OLD PLANTATION HOUSE OPENS AND THE ELDER BROTHER COMES OUT...

NOW TO GET *RID* OF THE *CAR*...

THE CAR LEAPS FORWARD WITH A LOUD GRINDING OF GEARS, DOWN AN OVERGROWN PATH, FINALLY STOPPING BEFORE A SHIMMERING YELLOW POOL...

THE *QUICK-SAND POOL* WILL SWALLOW UP ALL TRACES OF IT...

RELEASING THE EMERGENCY BRAKE, THE ELDER BROTHER LEAPS OUT, AND THE CAR ROLLS FORWARD INTO THE SUCKING BOG.. SINKING SLOWLY FROM SIGHT! BEYOND, FROM THE MANSION, A SICKENING SHRIEK OF LAUGHTER ECHOES INTO THE BAYOU NIGHT.

POOR EVERETT. WELL, PERHAPS THIS WILL *SATISFY* HIM... FOR A *WHILE*, AT LEAST!

FINALLY THE CAR HAS DISAPPEARED BELOW THE SURFACE OF THE ROLLING QUICKSAND POOL! THE ELDER BROTHER MOVES BACK THROUGH THE BAYOU OVER-GROWTH TO THE MANSION! EVERETT STANDS IN THE OPEN DOORWAY, BREATHING HEAVILY! HIS HANDS ARE BLOTCHED RED

I'M *FINISHED*, SIDNEY! COME...*SEE*!

N-NO, THANK YOU, EVERETT! JUST PUT WHAT'S LEFT OF HIM IN THE *SACK*, AS USUAL

EVERETT LUMBERS OFF AND RETURNS SHORTLY AFTER, A LARGE BLOOD-STAINED SACK SWUNG OVER HIS SHOULDERS...

HE... HE WAS A *DOCTOR*, SIDNEY! I FOUND HIS *CARD*! I DON'T *LIKE* DOCTORS!

THROW WHAT'S *LEFT* OF HIM IN THE *QUICKSAND POOL*, EVERETT... WITH THE *OTHERS*!

EVERETT'S STUPID FACE BRIGHTENS! HE GRINS IDIOTICALLY...

REMEMBER THE *OTHERS*, SIDNEY? THE *FAT SALESMAN*... AND THE *WOMAN*...

YES, EVERETT! I REMEMBER! *GO AHEAD, NOW! IN THE QUICK-SAND POOL*...

THE WOMAN WAS *NICE*! HER *FLESH* WAS SO *SOFT*! WHEN I CUT...

EVERETT!

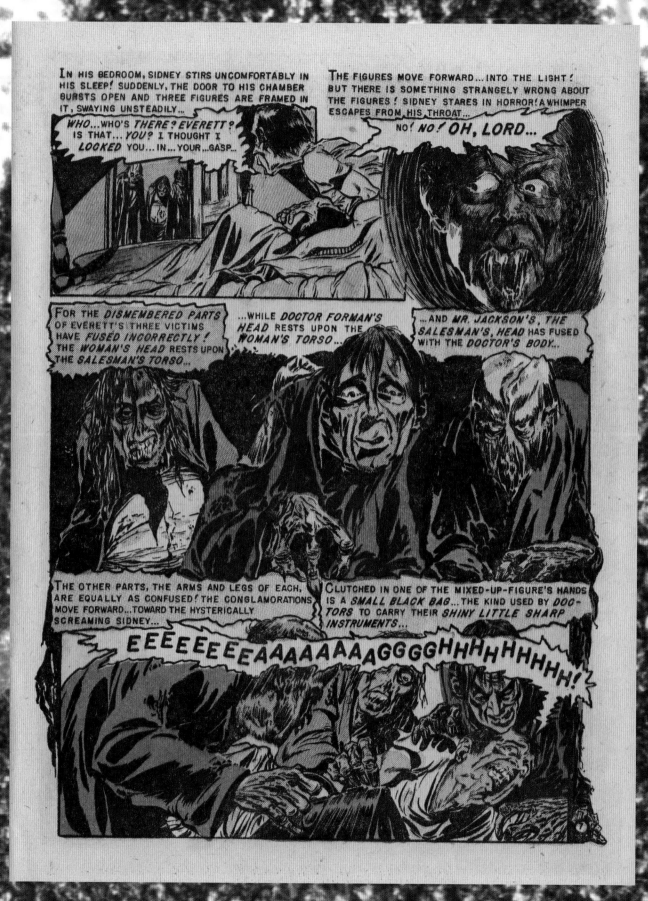

IN HIS BEDROOM, SIDNEY STIRS UNCOMFORTABLY IN HIS SLEEP! SUDDENLY, THE DOOR TO HIS CHAMBER BURSTS OPEN AND THREE FIGURES ARE FRAMED IN IT, SWAYING UNSTEADILY...

WHO...WHO'S *THERE*? EVERETT? IS THAT...*YOU*? I THOUGHT I *LOCKED* YOU...IN...YOUR...GASP...

THE FIGURES MOVE FORWARD...INTO THE LIGHT! BUT THERE IS SOMETHING STRANGELY WRONG ABOUT THE FIGURES! SIDNEY STARES IN HORROR! A WHIMPER ESCAPES FROM HIS THROAT...

NO! NO! *OH, LORD*...

FOR THE *DISMEMBERED PARTS* OF EVERETT'S THREE VICTIMS HAVE *FUSED INCORRECTLY*! THE *WOMAN'S HEAD* RESTS UPON THE *SALESMAN'S TORSO*...

...WHILE *DOCTOR FORMAN'S HEAD* RESTS UPON THE *WOMAN'S TORSO*...

...AND *MR. JACKSON'S*, THE *SALESMAN'S*, HEAD HAS FUSED WITH THE *DOCTOR'S BODY*...

THE OTHER PARTS, THE ARMS AND LEGS OF EACH, ARE EQUALLY AS CONFUSED! THE CONGLAMORATIONS MOVE FORWARD...TOWARD THE HYSTERICALLY SCREAMING SIDNEY...

CLUTCHED IN ONE OF THE MIXED-UP FIGURE'S HANDS IS A *SMALL BLACK BAG*...THE KIND USED BY *DOCTORS* TO CARRY THEIR *SHINY LITTLE SHARP INSTRUMENTS*...

EEEEEEEEAAAAAAAAAGGGGGHHHHHHHH!

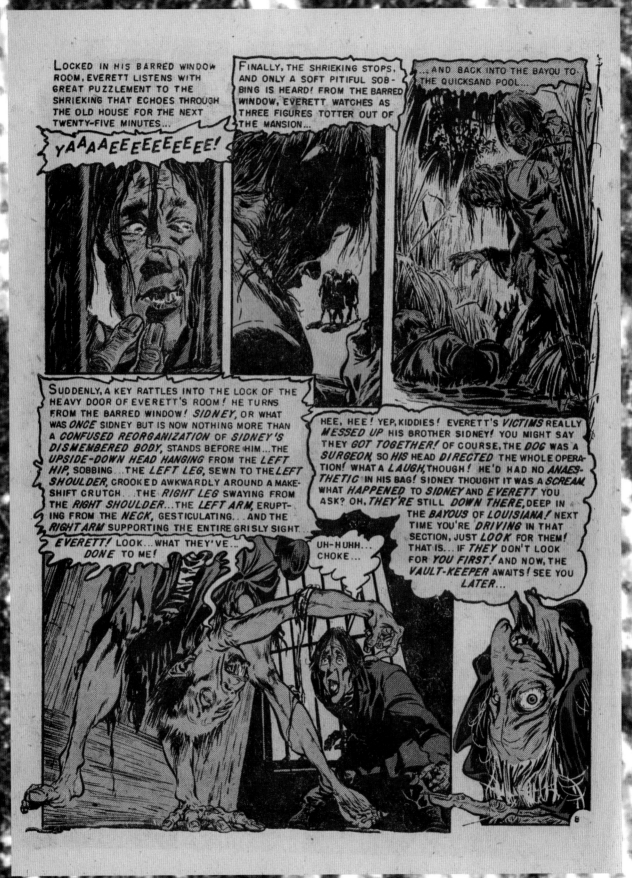

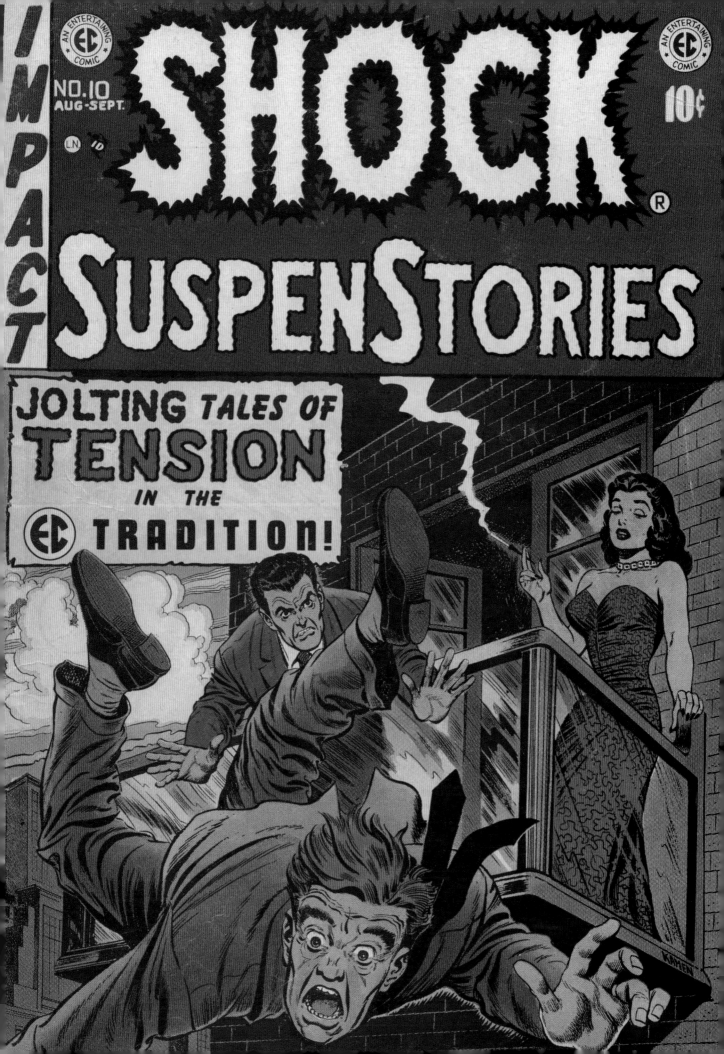

JACK KAMEN!

"HIS *PRISTEEN* QUALITIES LENT A DELIGHTFUL CONTRAST TO THE *DREADFUL* THINGS THAT WERE GOING TO HAPPEN!" —BILL GAINES

Jack Kamen was brought into the E.C. fold by Al Feldstein, who had known Kamen from back in the S.M. Iger shop days. Kamen's initial E.C. work appeared in the first issues of the two science fiction magazines, *Weird Science* and *Weird Fantasy*, cover dated May–June 1950. (Knowing that Kamen's forte was drawing pretty girls, however, Gaines and Feldstein routinely shied away from giving him sci-fi stories that needed an abundance of machinery or technical equipment.) Over the next few months he would also be appearing in *Modern Love* (the final two issues, cover dated June–July 1950 and August–September 1950), *The Vault of Horror, Tales from the Crypt, The Haunt of Fear*, and *Crime SuspenStories*. Feldstein said of Kamen in the *Tales of Terror! The E.C. Companion* interview that "Jack was a professional. He had no qualms about being an 'artist,' or having a cult following, or anything like that. He was a dependable artist that did a good job on whatever he was assigned."

Kamen became almost immediately famous among E.C. fans for what came to be called "Kamen girls:" women who were beautiful, voluptuous, and all too often cold and calculating. Interestingly, Kamen's art was not a favorite among many of the readers. His pristeen, slick style was markedly different

from Wallace Wood's or Graham Ingels's, artists who could readily inspire rabid hero worship. Gaines elaborated in *E.C. Lives!*: "To many people, he was not their favorite artist, but I think Jack was a good workman-like artist; he was a real pro. Jack was almost as fast as Davis. He never missed a deadline and was there when we needed him. I always felt that Jack was a very important cog in the E.C. machinery, and I'm glad we had him."

Jack Kamen was born on May 29, 1920 in Brooklyn, New York. Kamen recalls "always drawing pictures," but he had no formal art training until high school, where he was enrolled in the Art Students League in New York City. His first paying job was as an assistant to a sculptor who was doing a heroic statue of Texas Governor P.H. Bell for the Texas Centennial. He paid for his classes at the Art Students League and the Grand Central Art School by sculpting, painting theatrical scenery, decorating fashion manikins, and doing window displays. Kamen was really interested in fine art, but he had lost his father at age fourteen and went into comic books strictly as a way to help out

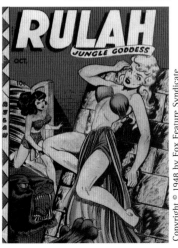

Below: A pre-E.C. Kamen "good-girl art" cover to *Rulah* #19, October 1948, Fox Publications.

Copyright © 1948 by Fox Feature Syndicate

Left: Kamen's femme-fatale cover to *Shock SuspenStories* #10, August–September 1953.

Above: One of Kamen's early professional jobs was illustrating the "Inspector Dayton" daily strip, which was produced through the S.M. Iger shop.

Photo by Larry Stark/Fred von Bernewitz collection

with the family finances. He spent a few years cutting his teeth in the Harry Chesler comic-art shop, and then decided to try his hand at freelancing. He found work at Fawcett and Harvey Comics, and also did some black-and-white illustrations for Better Publications, working in their western and detective pulp magazines. He ultimately hooked up with Jerry Iger's shop.

Kamen was drafted in 1942, and he served four years in the Army. When he got out, he went back to see Iger. "Jerry Iger was very glad to see me again and hired me immediately," Kamen told Ken Smith in a 2002 *Comics Journal* interview. "I stayed with him a couple of years, and that's where I met Al Feldstein." For Iger, Kamen regularly worked on *Blue Beetle, Jo-Jo Congo King,*

Rulah, and on the various romance titles the shop was turning out for Fox.

When Kamen left Iger, Feldstein recommended him to Bill Gaines. Kamen said in the *Comics Journal* interview: "I was delighted, because Bill Gaines was always Bill Gaines, and Al was my friend. So I got the work. I was glad to get it." Quickly seeing that Kamen was a very useful asset, Gaines offered to up Kamen's rates and make him exclusive to the company, to which Kamen readily agreed. Unlike the other E.C. artists, Kamen rarely went into New York City to go to the E.C. offices. Because Kamen and Feldstein lived just one stop apart on the Long Island Railroad, Kamen would journey only as far as Feldstein's house. "What he would do is bring the script home and we would discuss it," Kamen told *The Comics Journal.* "I would pencil it and give him the pencils. He would take it back to the city and get it lettered. It was always a rotation. I'd be going to Al's house and reading the script, or getting my work back to ink."

When Gaines and Feldstein would plot their stories each morning, they always did so

Above: Kamen nude, painted as a gift to Bill Gaines. The painting hung in Gaines's office at E.C. for many years, but its current whereabouts are unknown.

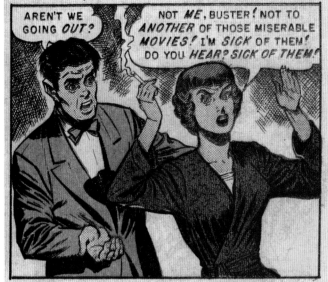

Left: Gaines always called the types of stories they gave to Kamen "Buster stories," because the femme fatale would often exclaim something like, "Listen, Buster!"

Direction offerings, *Psychoanalysis.* Gaines and Feldstein were both in analysis at the time, so they got the idea to do a comic book of stories following people's progress in their analysis. "We had this idea that we were gonna put out this proselytizing comic book called *Psychoanalysis* and tell people what it was all about," said Feldstein in *Tales of Terror! The E.C. Companion.* "I don't know why we ever thought it would sell, when I think about it!"

Unusual as the book might have been, Kamen did some excellent work in *Psychoanalysis,* including what many people consider his best cover, done for issue #3. Work on *Psychoanalysis* segued directly into E.C.'s next experiment, the Picto-Fiction magazines. What would have appeared in comic-book form as *Psychoanalysis* #5 was reworked by Gaines and Feldstein into the first issue of the new magazine-sized Picto-Fiction title *Shock Illustrated,* which was drawn entirely by Kamen. And echoing back to his "romance comic" roots, Kamen also had stories in another Picto-Fiction title, *Confessions Illustrated.* Kamen adapted well into the more illustrative, black-and-white demands of the Picto-Fictions, and he was sorry to see them not succeed. Of the Picto-Fiction experiment, Kamen told *The Comics Journal,* "If it had continued and caught on, I would have stayed with it because I loved doing that stuff. If you look at it, you'll see a lot of pen work and atmosphere. To me, that was the most enjoyable time. I was so sorry to see that go."

Around the end of the E.C. comics, Gaines, Feldstein, and Kamen tried to offer a syndicated strip based on *Psychoanalysis.* They worked up samples of

with a specific artist in mind. Feldstein said in *E.C. Lives!* that "When we sat down to do a Jack Kamen script, we did a story that was slick, modern, and up-to-date to fit his style, which was a slick, modern, 'cold' style. His style was slick and controlled, and yet personally he was a very loose, free, wild guy." With Kamen, Gaines told *The Comics Journal* in 1983, "you're looking for something light, humorous, pretty women, a little sex, a little double entendre." Gaines always called the types of stories they gave to Kamen "Buster stories," because oftentimes the femme fatale would get fed up with her hapless suitor or philandering husband and exclaim something like, "Look, Buster!"

When *Shock SuspenStories* was added to the E.C. line, Kamen had stories in every issue of that title; he also contributed covers for issues #10, #13, and #15. Kamen also drew covers for the final three issues of *Crime SuspenStories,* #25, #26, and #27.

Kamen also drew most of the installments of the "Grim Fairy Tale!" feature that was sprinkled around various E.C. comics between 1952 and 1954. These fairy tales were tongue-in-cheek send-ups of various classic children's stories—done with an E.C. twist ending, naturally.

When E.C. dropped their horror and crime comics, Kamen drew the covers and all the stories in all four issues of one of E.C.'s more unusual New

Right: Psychoanalysis #3, July–August 1955.

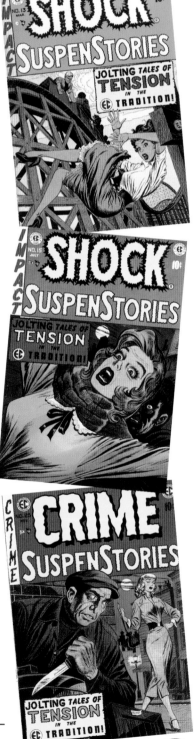

Above right: Shock SuspenStories #13 and #15, and *Crime SuspenStories* #25, 1954.

Below: Crime SuspenStories #26 and #27, and Shock Illustrated #1, 1954–1955.

Below: Kamen babes adorn this splash page from "Beauty and the Beach!" (Shock SuspenStories #7, February–March 1953).

the strip and even a précis of the story line, shopping it around to King Features and United Features, but they never succeeded in placing the strip.

About the final days of E.C., Kamen said in the E.C. fanzine *Horror from the Crypt of Fear* that "I knew the bad publicity was preventing distribution of the books, but Bill felt a responsibility to a family man with four children like myself, and paid me for three months of [Picto-Fiction] art that would probably never get printed." Gaines and Feldstein had Kamen do two stories for the early *MAD* Magazine, "Make Your Own Love-Story Comic" and a panel in "Real Estate Ads" (*MAD* #29, September–October 1956). In truth, Kamen's art didn't possess quite the right humorous touch for *MAD*. It was just as well, for in the interim Kamen had been finding work in the higher-paying field of advertising.

"At that time, my [advertising] rates were exceedingly higher than comic-book pay, but I shall never forget that they tried to tailor material for me that could fit the format," Kamen said in *Horror from the Crypt of Fear*. He hooked up with an agency, and began illustrating black-and-white print ads for such companies as Vick's (doing ads for their cough drops), Playtex, U.S. Steel, and Reynolds Aluminum. As the years went on, Kamen became very successful in advertising, and he did color paintings that advertised such high-profile products as Esquire shoe polish, Kent cigarettes, Mack trucks, and Smith Corona typewriters.

Around 1961, Kamen was approached to be the art director of a children's encyclopedia. According to Kamen, every page was designed to look like a *Ripley's Believe It or Not* panel. There were two editions of it, one published by Harwyn (*Harwyn Picture Encyclopedia*), and

another endorsed by Art Linkletter, entitled *Art Linkletter's Picture Encyclopedia for Boys and Girls*. Kamen immediately asked his fellow former E.C. artists to contribute, and the series is filled with wonderful full-color illustrations by the likes of Wallace Wood, George Evans, and Al Williamson.

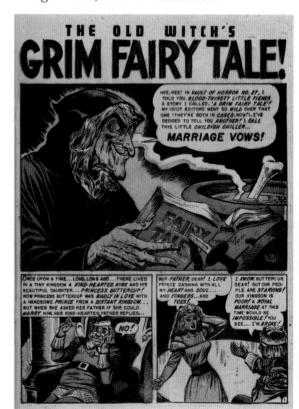

Right: Splash page from a Kamen "Grim Fairy Tale!" (from *The Haunt of Fear* #15, September–October 1952).

Below: Kamen cover to the comic art version of Stephen King's *Creepshow*, 1982.

Copyright © 1994 by Cahners Publishing

In 1982, Stephen King (a longtime E.C. fan) contacted Bill Gaines to try to get an E.C. artist to illustrate the movie poster for King's feature film *Creepshow*, a homage to the E.C. horror comics. King's first choice was Graham Ingels, who immediately refused. Gaines then suggested Kamen, who was happy to do the assignment. Kamen's art appeared on the one-sheet movie poster, and also on the cover of the graphic novel version of *Creepshow*. (This book had interior work by Bernie Wrightson, a younger artist who, fittingly, was heavily influenced by the E.C. comics.)

One of Kamen's sons, Dean (who was just a baby during the time of the E.C. comics), grew up to be a very successful inventor of various medical devices, specializing in remaking them in a much smaller, portable size for home use. "Dean has sixty patents in the medical field. Every one of them is operating today, and every one of them pays a royalty. Needless to say, he's a very wealthy young man," said Kamen in *The Comics Journal*. At Dean's request, Kamen would help in the product design by working up renderings of Dean's various inventions, even doing detailed diagrams for the Patent Office. Kamen also invested in some of Dean's early patents, mortgaging his house to come up with the money. Dean was only sixteen or seventeen years old at the time. "Everybody said I was crazy," Kamen told *The Comics Journal*. "We hocked everything. As it turned out, it was one of the best investments we ever made." More recently, Dean has received tremendous media coverage as the inventor of the Segway. Dean is also perhaps the biggest collector of Kamen's original art, and owns the artwork to many of Jack's E.C. stories and covers.

Jack Kamen is now basically retired from art as a profession (except for what Dean asks him to do), and now paints for his own enjoyment. As Kamen told *The Comics Journal*: "You're looking at a very happy man." •

Above: Kamen-illustrated cover to the March 7, 1994 issue of *Design News*, featuring his inventor son, Dean.
Below: Feldstein and Kamen at Bill and Nancy Gaines's wedding reception, November 17, 1955.

Above: "Make Your Own Love-Story Comic," *MAD* #29, September–October 1956).

Above: Sea Siren, 1995.

THE DEN OF INIQUITY!

HO, HO! FOND FELICITATIONS, FANS! YEP, IT'S US... *THE DEN-KEEPERS*...YOUR EDITORS, *BILL* AND *AL!* IN THIS ISSUE OF *TALES FROM THE CRYPT*, THE *CRYPT-KEEPER* HAS CHEERFULLY (*THAT'S* A LAUGH! WE HAD TO THREATEN TO CUT OFF HIS SUPPLY OF *CADAVERS!*) CONSENTED TO OUR APPEARING IN THE FLABBY FLESH TO PERSONALLY TELL YOU OUR VERY OWN HORROR STORY! SO COME CLOSER TO THE ELECTRIC-HEATER... SIT YOURSELF DOWN ON THAT ROTTED OLD TEXT-WRITER...AND WE'LL HAND OUT A YARN FROM OUR TRASH-BASKET (ALL OF OUR STORIES ARE TRASH!) THAT WE AFFECTIONATELY CALL...

KAMEN'S KALAMITY!

OUR STORY BEGINS BACK IN THE DAYS WHEN E.C. WAS JUST A BUDDING ORGANIZATION BUSILY ENGAGED IN PUBLISHING LOVE MAGAZINES FOR ROMANCE-STARVED WOMANHOOD! IN *THOSE* DAYS OUR MOTTO WAS *"SIGH"!* NOW... IT'S *"UGH"!* ONE DAY, AS BILL WAS BUSY CHASING SUZY, OUR SECRETARY, AROUND THE OFFICE, ATTEMPTING TO GATHER MATERIAL...

I *BEG* YOUR PARDON! ARE *THESE* THE OFFICES OF THE *ENTERTAINING COMICS GROUP?*

GOOD LORD! JACK KAMEN...

I'M GETTIN' OUT OF HERE!

BY Jack Kamen (WHO ELSE??)

1

"Kamen's Kalamity!," from *Tales from the Crypt* #31 (August–September 1952). Illustrated by Jack Kamen. Written by Bill Gaines and Al Feldstein.

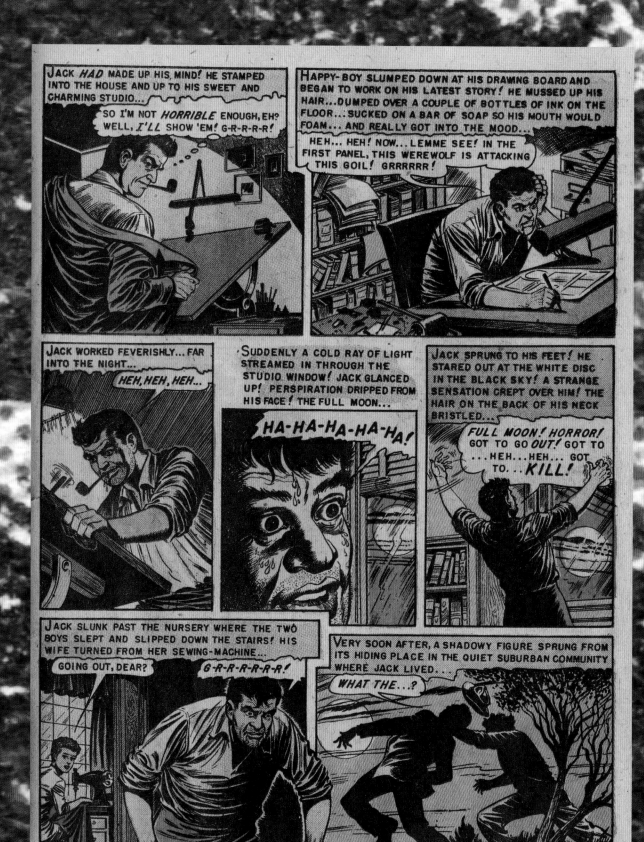

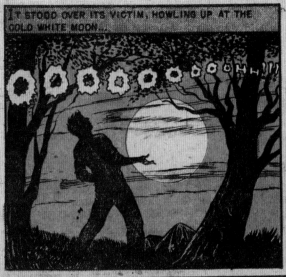

IT STOOD OVER ITS VICTIM, HOWLING UP AT THE COLD WHITE MOON...

OOOOOOOOHH!!

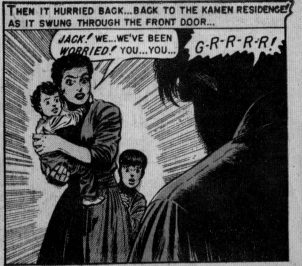

THEN IT HURRIED BACK...BACK TO THE KAMEN RESIDENCE! AS IT SWUNG THROUGH THE FRONT DOOR...

JACK! WE...WE'VE BEEN WORRIED! YOU...YOU...

G-R-R-R-R!

THEY STOOD THERE... THE THREE OF THEM...THE YOUNGER CHILD CRADLED IN HIS MOTHER'S ARMS...THE OLDER ONE TUGGING AT HER SKIRTS! THEY STOOD THERE WIDE-EYED...WATCHING THE BEAST CLOSE IN...

JACK! WHAT IS IT? WHAT'S WRONG WITH YOU? JACK!

AND THEN THEY SCREAMED...SCREAMED IN HORROR...

EEEEEEEEEEEEEEEE!!

THE SCREAM ECHOED THROUGH THE KAMEN HOME! JACK SAT UP STRAIGHT AT HIS BOARD...

HUH? WHA...WHA.. WHY, I'VE BEEN DREAMING! IT WAS NOTHING BUT A DREAM! BUT THAT SCREAM! EVELYN? DID YOU SCREAM?

YES, DEAR! I THOUGHT I SAW A MOUSE! DID I FRIGHTEN YOU?

AND THE NEXT DAY...

BUT JACK! YOU CAN'T QUIT! WE'LL DO ANYTHING... ANYTHING! WE'LL EVEN PAY YOU... IN MONEY FROM NOW ON!

YEAH! AND WE'LL EVEN LISTEN TO YOUR JOKES! GO AHEAD, TELL ONE!

WELL! LET'S SEE! D'JA EVER HEAR THE ONE...

HO, HO! YEP! JACK (HORROR-BOY) KAMEN GOT HIS TASTE OF HORROR THAT NIGHT! YOU CAN NOTICE IT IN HIS WORK! YOU WATCH CAREFULLY...THE NEXT TIME HE DRAWS A MOUSE! AND NOW...WE'LL TURN YOU OVER TO THE OLD WITCH, WHO'LL WIND UP THE CRYPT-KEEPER'S MAG! OH, BY THE WAY! IF YOU HAVEN'T SENT FOR YOUR ACTUAL PHOTO OF THOSE THREE CREEPS, THE GHOULUNATICS... DO SO! IT'LL HELP SEND OUR OFFICE BOY THROUGH COLLEGE! 'BYE!

6

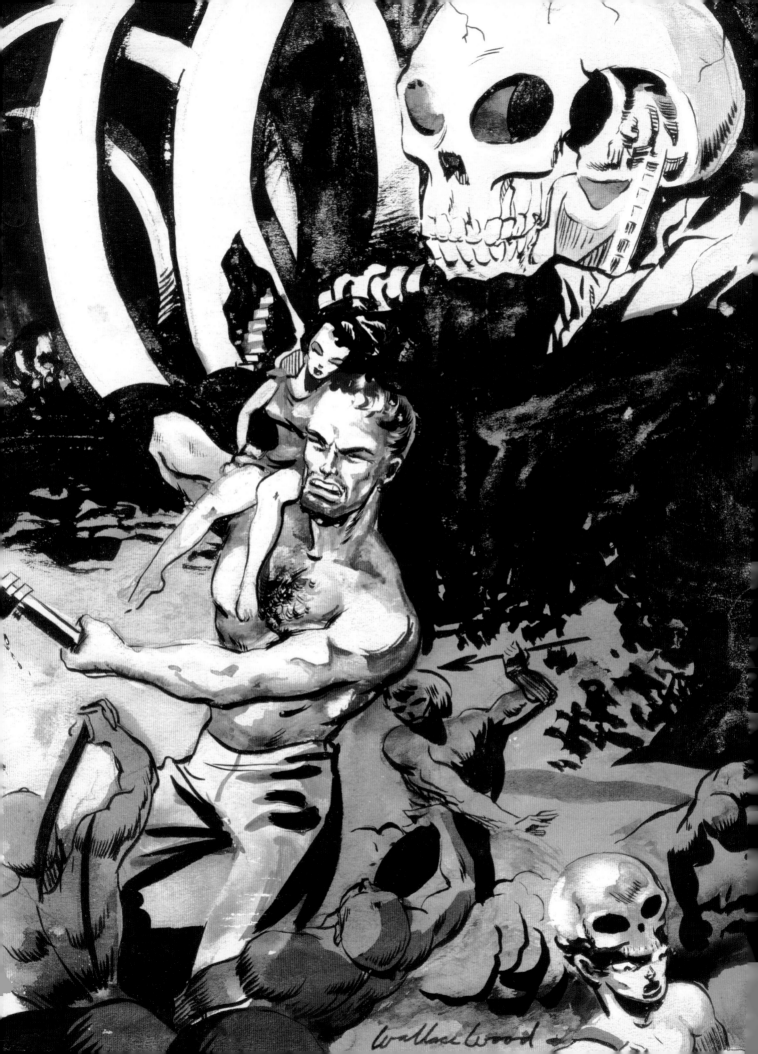

WALLACE WOOD!

"HE HAD THIS *ENORMOUS* TALENT, AND HIS CURSE WAS THAT HE WAS INTROVERTED . . . EVERYTHING WAS *BOTTLED UP!*"
—HARVEY KURTZMAN

Wallace "Wally" Wood, who came to be known as "the dean of science fiction artists," was born in Menahga, Minnesota on June 17, 1927. His mother was a school teacher and his father worked as a lumberjack, a job that caused him to be away from the family for weeks at a time.

Wood knew that he wanted to be a comic artist almost out of the chute, and he drew incessantly as a child, filling notebook after notebook with hundreds and hundreds of drawings, many with themes and characters he would use much later in life. In an interview done by Rick Stoner (published in *The Woodwork Gazette* #1, June 1978), Wood said, "I had a dream when I was about six, that I found a magic pencil. It could draw just like Alex Raymond. You know, I've been looking for that pencil ever since!"

Wood's father showed disdain for Wood's budding artistic talent, feeling that it was an endeavor only for sissies. His mother, however, encouraged him. By the age of nine, he was making his own crude comic books, which his mother would dutifully bind together on her sewing machine. On the cover of one such piece of juvenilia, *Different Comics* (published in the E.C. fanzine *Squa Tront* #9, 1983), Wood billed himself as "A

different artist! W. Alan Wood, 'The kid cartoonist.'"

To help make ends meet, as a young man Wood worked at a bewildering assortment of odd jobs, including as a busboy, movie-theater usher, dental lab assistant, printing plant apprentice, factory worker, lumberjack, stevedore, and as a pin boy in a bowling alley.

Wood had little formal art training as a young man, attending just one term at the Minneapolis School of Art.

During World War II, Wood joined the Merchant Marine, and his tour of duty took him to the Philippines, Guam, South America, and Italy. Upon his departure from the Merchant Marine, Wood joined the U.S. Army Paratroopers, and he was stationed in Japan while serving in the 11th Airborne.

He made his way to New York in 1948, attending one term at Burne Hogarth's Cartoonists and Illustrators School, where he met future E.C. artists John Severin and Roy Krenkel. He also met a young artist/writer named

Left: A previously unpublished, very early Wallace Wood ink and watercolor study, circa late 1940s.

Above: A very early Wood self-portrait.

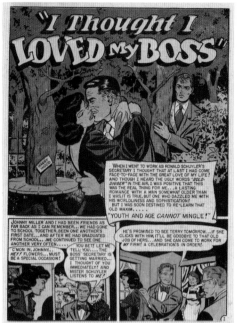

WOOD.

Below right: Original cover art to *Weird Science* #15, September–October 1952. Wood's art in *Weird Science* and *Weird Fantasy* earned him the title of "the dean of science fiction artists."

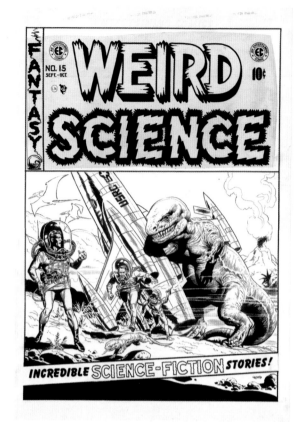

Above: Wood's first E.C. story (done with Harry Harrison), "I Thought I Loved My Boss" (*A Moon, a Girl . . . Romance* #10, November–December 1949).

Harry Harrison (who would go on in later years to become a science fiction author, famous for writing *The Stainless Steel Rat* and *Make Room!, Make Room!*). Wood and Harrison decided to create a partnership and look for work together; they found it at Fox. Harrison said in an interview in *Graphic Story Magazine* #15 (Summer 1953) that "we worked together because neither of us could hack it alone." Harrison went on to say that "anybody could work at Fox, whether they could draw well or not."

The pair would turn out a substantial amount of work for a variety of publishers, including Fox and Avon. In 1949, they made their way to E.C. Harrison recalled in *Graphic Story Magazine* that "we went down one day to meet Bill Gaines, [and it was] the first time we got any kind of really decent publisher."

Their first story for E.C. was a romance romp called "I Thought I Loved My Boss" in *A Moon, a Girl . . . Romance* #10 (November–December 1949). The duo immediately became E.C. regulars, and together they made the transition when E.C. launched the New Trend comics in 1950.

Harrison and Wood can lay claim to talking Gaines into publishing science fiction comics. "Somewhere along the line we talked Bill into trying to start a science fiction comic," said Harrison in *Graphic Story Magazine.* "I gave Gaines a lot of it to read. We just wanted to do a science fiction comic, since there was none of that kind at all at the time." Covering an event called the Fan-Vet Convention held in New York on April 19, 1953 (and attended by Gaines, Feldstein, and several of the E.C. artists), editor James Taurasi wrote in the fanzine *Fantasy-Comics* (May 1953): "Bill Gaines announced that he began the two magazines [*Weird Science* and *Weird Fantasy*] at the urging of Harry Harrison, now editor of *Rocket Stories*, in 1950."

Right: Wallace Wood in the E.C. offices in 1951, holding a page of his original art and flanked by issues of *Weird Science, Weird Fantasy,* and *Tales from the Crypt* that bear his cover art.

Harrison and Wood continued along doing stories for E.C. until they had a falling out, and they started working separately. Gaines told E.C. fan Rich Hauser in a 1969 interview (published in the E.C. fanzine *Spa Fon* #5) that "there was this combination of Harrison and Wood, and I didn't know who

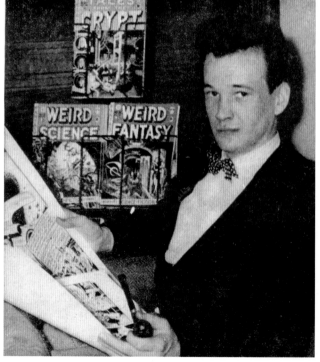

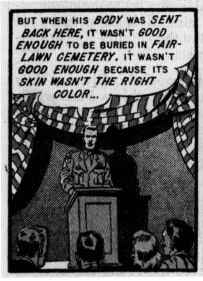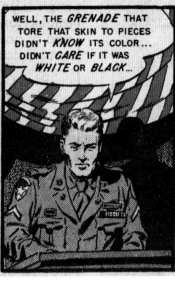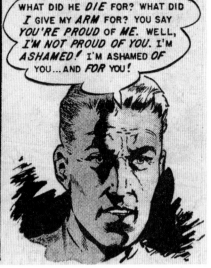

Left: Three Wood panels from an "E.C. Preachie" ("In Gratitude . . . ," *Shock SuspenStories* #11, October–November 1953).

did what. When they broke up, all of a sudden Harrison's art wasn't very good anymore, and I found out who did what." Harrison was out, but Wood was in.

After Wood and Harrison split up, Wood joined forces with Joe Orlando, and together they turned out a respectable amount of material for E.C., as well as for other companies like Avon, Fox, and Youthful Magazines. It wasn't long before Orlando became an E.C. artist in his own right.

Wood had art in all three of E.C.'s horror comics, work that was always solidly professional. Wood also made excellent contributions to Kurtzman's war comics *Two-Fisted Tales* and *Frontline Combat*. But it is the quality of the work he would do in E.C.'s science fiction comics, *Weird Science* and *Weird Fantasy*, that would earn him the title "the dean of science fiction artists." Wood essentially created a new visual vocabulary for science fiction art, with a propensity for depicting the ornate, complicated interiors of spaceships. Wood's figures often look as if they are defying gravity, carved out of plastic, and frozen in space. There is a three-dimensional quality to his work that few other artists have ever achieved. Also noteworthy are Wood's women, which are rivaled in raw sex appeal by few other cartoonists.

Wood was also the artist usually chosen to illustrate what Gaines and Feldstein called "E.C. Preachies," an unusual series of morality tales on racism, bigotry, and anti-Semitism that appeared in *Shock SuspenStories*.

When Kurtzman launched *MAD* in 1952, the ever-versatile Wood was one of the artists he hand-picked for the project. Actually, Kurtzman didn't have to look all that far; the artists he choose for *MAD* were the regular crew he used on his war comics: Wood, Jack Davis, John Severin, and Will Elder. With his

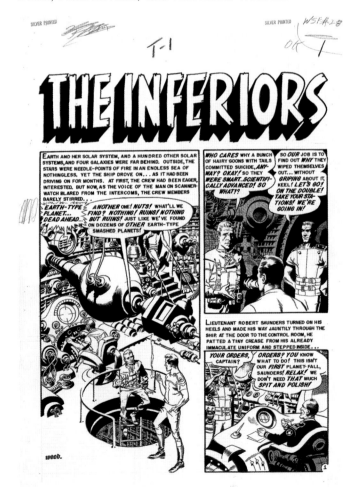

Left: Wood was expert in depicting the ornate, inscrutable interiors of spaceships. Shown is the original art to the splash page from "The Inferiors," *Weird Science-Fantasy* #28, March–April 1955.

usual attention to detail, Kurtzman provided tissue-paper layouts for all of the stories in *MAD*. As great as it is, Wood's art can sometimes have a tendency to be a little stiff; following Kurtzman's roughs gave Wood's art a suppleness and and sense of movement his work rarely had otherwise.

Early *MAD* stories were essentially Kurtzman parodies of generic comic-book features, including those published by E.C.

Right: Wood's splash panel from "Superduperman!," *MAD* #4 (April–May 1953).

Copyright © 1953 by E.C. Publications

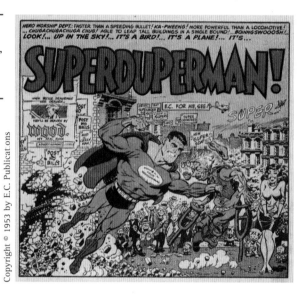

But with "Superduperman!" in *MAD* #4 (April–May 1953) both Kurtzman and Wood found the *MAD* tone. Wood supplied his share of background gags in this story, something that was normally a Will Elder trademark. Note the "when better drawrings are drawrn, they'll be drawrn by Wood" sign in the splash panel. The men in suits at D.C. were not at all amused, and threatened Gaines with legal action; he promised not to do it again, a promise he would break countless times over the years with features in *MAD*.

Gaines recalled an atmosphere of friendly competition among the artists at E.C. in the May 1983 issue of *The Comics Journal*: "They had tremendous admiration for one another. Wally Wood would come in with a story and three artists would crowd around him and *faint*, just poring over every brushstroke and every panel. And of course Wally, who's getting this adulation, sits there and loves it. Next time around it's his turn to adulate someone; Williamson comes in with his story and Wally Wood faints. And everybody tried to outdo each other, which is one of the reasons we got such incredibly good art."

Unfortunately, like several of the other E.C. artists, Wood had more than his share of inner demons, as well as problems with alcohol. Al Feldstein said of Wood in *Tales of Terror! The E.C. Companion* that "Wally made me uncomfortable a lot of the time. He was like a lit firecracker; I would be afraid when he might explode." Kurtzman said of Wood in the October 1981 issue of *The Comics Journal*, "I feel that Wally devoted himself so intensely to his work that he burned himself out. He overworked his body. Wally had a tension in him, an intensity that he locked away in an internal steam boiler, and I think it ate away his insides. The work really used him up."

Wood was a workaholic, often spending days and days at his art board. "I worked twelve hours a day, seven days a week for years," Wood told comics aficionado Shel Dorf. "Being a comic-book artist is like sentencing yourself to life imprisonment at hard labor in solitary confinement." Roy Krenkel said in *Against the Grain: MAD Artist Wallace Wood* that "you'd come to Wally's door, and you'd realize Wally had been up all night. The door finally, slowly, opens, and Wally stands there with an absolutely glazed look in his eyes, totally incapable of focusing. The guy was totally obsessed with work. Why it didn't kill him, I'll never know."

When Kurtzman left *MAD* in 1956, Wood decided not to go with him, and he was perhaps the most important early contributor to the Feldstein-edited version of

Above: A personal Wood Christmas card, 1960s.

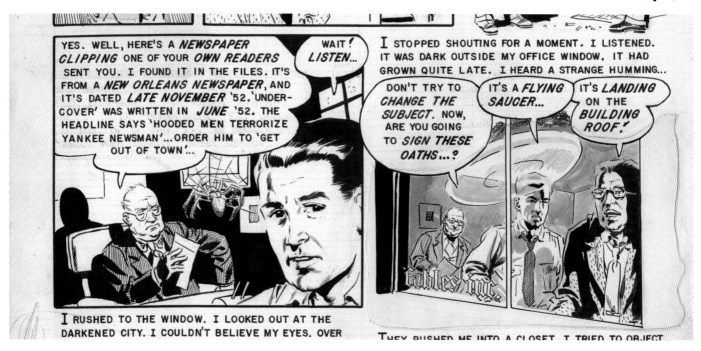

YES. WELL, HERE'S A *NEWSPAPER CLIPPING* ONE OF YOUR *OWN READERS* SENT YOU. I FOUND IT IN THE FILES. IT'S FROM A *NEW ORLEANS NEWSPAPER*, AND IT'S DATED *LATE NOVEMBER '52.* 'UNDER-COVER' WAS WRITTEN IN *JUNE '52.* THE HEADLINE SAYS 'HOODED MEN TERRORIZE YANKEE NEWSMAN'...ORDER HIM TO 'GET OUT OF TOWN'...

WAIT! LISTEN...

I STOPPED SHOUTING FOR A MOMENT. I LISTENED. IT WAS DARK OUTSIDE MY OFFICE WINDOW. IT HAD GROWN QUITE LATE. I HEARD A STRANGE HUMMING...

DON'T TRY TO *CHANGE THE SUBJECT.* NOW, ARE YOU GOING TO *SIGN THESE OATHS...?*

IT'S A *FLYING SAUCER...*

IT'S *LANDING* ON THE *BUILDING ROOF!*

I RUSHED TO THE WINDOW. I LOOKED OUT AT THE DARKENED CITY. I COULDN'T BELIEVE MY EYES. OVER

THEY RUSHED ME INTO A CLOSET. I TRIED TO OBJECT.

MAD Magazine. There was prime Woodwork in literally every issue of *MAD* Magazine from #24 (the first magazine issue, July 1955) to #86 (April 1964).

During this period, Wood contributed hundreds of black-and-white wash illustrations (and some color covers) for the science fiction digest *Galaxy*, and also contributed numerous one-page gag cartoons to various men's magazines, all second-tier knock-offs of *Playboy*. He also worked on a wide variety of assignments, including gum cards, album covers, book and magazine illustrations, and advertising work for Alka-Seltzer.

In 1960, Wood began experiencing what he described as "a constant headache," probably the result of years of bottled-up stress and the constant cycle of endless work, cigarettes, caffeine, and alcohol. He began drinking heavily in an effort to block the pain, and gradually his work began to suffer.

Consequently, Wood and *MAD* parted ways. Gaines told E.C. fan Rich Hauser in a 1969 interview (published in the E.C. fanzine *Spa Fon #5*) that "Wood and *MAD* parted under strange circumstances. Woody had gotten sick, and he had gotten very cantankerous. He had a headache for a long time, and that can make you cantankerous. His work had degenerated, and he took the criticism very badly. It got ooky there for a while, so he left."

In 1965, Wood created the *Thunder Agents* (and assorted spin-offs such as *Dynamo* and *No-Man*) for Tower Comics. These books, though highly regarded, suffered from distribution problems, and ultimately failed to compete with Marvel and D.C. in the marketplace.

In 1966, Wood embarked on a bold, self-published experiment called *Witzend*. Wood had this to say in the first

"Not much. Who's new with you?"

Above: A 1957 Wood cartoon from *The Gent*, a second-tier *Playboy* clone.

Copyright © 1957 by Excellent Publications

Above: Wood original art from "E.C. Confidential!" (*Weird Science #21*, September–October 1953), a story that featured the E.C. staff. *Below:* Wood cover on the Galaxy paperback novel *The Forever Machine* (1958).

GALAXY NOVEL NO. 35
The Forever Machine
MARK CLIFTON and FRANK RILEY
35¢

Copyright © 1958 by Galaxy Publishing

issue: "Our theory is that an artist is his own best editor, and, left to his own devices, will turn out his best work. Our only aim is to make this magazine the best, most entertaining one we possibly can. It is a comic book—and it is not. It is a platform, a vehicle for any idea in any form." Apart from Wood himself, *Witzend* featured work by established pros such as Al Williamson, Frank Frazetta, Harvey Kurtzman, Steve Ditko, and Reed Crandall, as well as more experimental pieces by the likes of Art Spiegelman, Roger Brand, Jeff Jones, and Vaughn Bodé. *Witzend* was a trailblazer on several levels, championing creator's rights (the artists retained ownership of all of their material) and foreshadowing the "anything goes," editor-free environment of the Underground Comix. Gaines told Hauser, "Funny thing; Wood never used to smile. He was never happy about anything he did. He's a lot happier now, I feel. And certainly the stuff he's doing in *Witzend* is so charming, so delightful."

Delightful it was, but a money maker it really wasn't. After several years of publishing, Wood stepped back from active participation in the magazine, turning the reins over to associates.

Wood continued to freelance for a variety of publishers, including Marvel, D.C., Charlton, and Warren, but he was getting more and more fed up with the business.

In 1978, Wood attempted to rally his troops with an official fan club called "Friends of Odkin." Members who joined early on received a membership certificate, an original Wood drawing, and a subscription to *The Woodwork Gazette*, a "what's new" newsletter. In an essay entitled "The

Copyright © 1968 by Mills Laboratories, Inc.

Above: An Alka-Seltzer ad illustrated by Wood, 1968.

Big Blue Pencil," published in *The Woodwork Gazette* #1 (June 1978), a disillusioned and cynical Wood wrote: "Don't be a creator. It's much more fun, and much more rewarding, to be a defacer with a title: 'Creative Director' or 'Assistant Associate Editorial Consultant.' If you're a creator—be it writer or artist—you'll find yourself in the position of being at the mercy of a kid fresh from writing dirty words on the walls, who will take the work you have spent hours and hours on and write the singularly revealing message 'KILL THIS' across it in bold strokes of his big blue pencil. So I repeat: do not seek to be a creative writer or artist. Do not *care* about doing anything

Copyright © 1966 by Wallace Wood

Above: Witzend #1, Summer 1966.

good. That will only put you at the mercy of those who will always hate you because you can do something that they can't."

Asked by Stoner in *The Woodwork Gazette* if he had any regrets about his career, Wood told him "if I had it to do over again, I wouldn't do it. And yet, I'm not sorry where I am." Kurtzman said of Wood in *The Comics Journal*, "I think he delivered some of the finest work that was ever drawn, and I think it's to his credit that he put so much intensity into his work, at great sacrifice to himself."

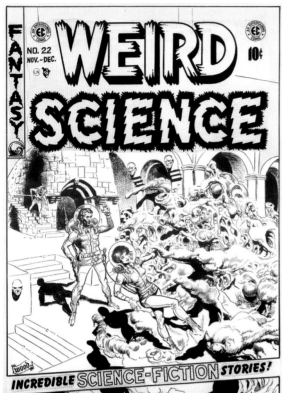

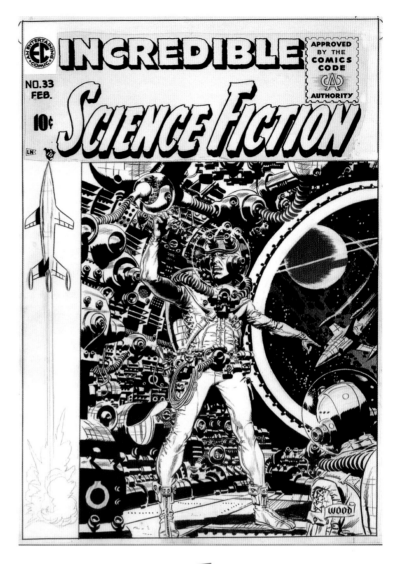

In January 1978, Wood began having vision problems with his left eye, which made it very difficult to draw. He also found out that he was suffering from extreme hypertension. Not long after this, Wood had the first of a series of small strokes. Later he discovered that his kidneys were failing, the result of years of hard drinking and over-working his body. He was told that he would need dialysis, and ultimately a kidney transplant. He told friends that he didn't want to live the rest of his life hooked up to a machine.

On Halloween night or shortly after in 1980, Wallace Wood went home, got out his gun, and shot himself to death. One often hears the old saw about artists "suffering" for their art, but few who knew him would dispute that Wood suffered for his. Wallace Wood was inducted into the Will Eisner Hall of Fame in 1992. •

Above and left: The original art to Wood's cover of the very last E.C. comic book, *Incredible Science Fiction* #33 (January–February 1956), along with the printed cover.

Above: The original art to Wood's spectacular cover of *Weird Science* #22 (November–December 1953), along with the printed cover.

129

THE PRECIOUS YEARS

SUNLIGHT STREAMED THROUGH THE TRANSPARENT METAL WALL, DANCING OVER THE INDESTRUCTIBLE SPUN-ALLOY RUG. IN ITS GOLDEN SHAFT OF LIGHT, NO SPECULES OF DUST DRIFTED LAZILY, FOR THERE WERE NONE TO DRIFT. THE ATMOSPHERE-FILTER MACHINES KEPT THE AIR FREE OF GERM-CARRYING DUST PARTICLES. BEYOND THE TRANSPARENT WINDOW-WALL, THE CITY BASKED IN THE MORNING SUN. SOMEWHERE INSIDE THE ROOM, WITHIN THE WALLS PERHAPS, RELAYS CLICKED, AND MUSIC BEGAN TO PLAY. THE FIGURE ON THE HUGE BED STIRRED AND SAT UP, RUBBING ITS EYES SLEEPILY. ELSEWHERE, OTHER MECHANISMS, AWAKENED BY THE FIGURE'S AWAKENING, CHATTERED AND WHIRRED. A REMINDER-ROBOT ERUPTED FROM ITS WALL NICHE, ROLLED FORWARD, AND RASPED...

TODAY IS *MAY 3RD, 4152.* TODAY IS YOUR *SHOT-DAY.* YOU WILL REPORT FOR YOUR *LONGEVITY-SHOT* AT PRECISELY 12:32 P.M., MEDICAL-CLINIC, MUNICIPAL LEVEL. YOUR *DIVORCE* IS FINAL TODAY. TODAY IS YOUR *NINTH WIFE'S BIRTHDAY*...

OH, SHUT UP, WILL YOU? *SHUT UP!*

THE REMINDER-ROBOT, UNCONCERNED, FINISHED OUT ITS MESSAGE AND POPPED BACK INTO ITS WALL-NICHE WHERE ITS TAPE RECEIVED THE NEXT DAY'S REMINDERS BY DIRECT WIRE FROM THE MAIN REMINDER-MECHANISM. MARTIN CURSED AFTER IT...

TODAY IS *THIS!* TODAY IS *THAT!* I *KNOW* WHAT DAY IT IS, @#*?!! *TODAY'S* THE DAY I GET *ANOTHER TEN YEARS* OF *THIS MADNESS*...

BREAKFAST, SIR? YOUR *ORDER?*

THE BREAKFAST-ROBOT GLIDED FORWARD SILENTLY, COFFEE BREWING WITHIN IT, TOAST BROWNING, PANCAKES FRYING, EGGS, JUICE... WAITING TO BE CALLED FORTH...

WILL IT BE THE *USUAL*, SIR? ANYTHING *SPECIAL* THIS MORNING, SIR? YOUR *ORDER*...

GET OUT OF HERE! GET OUT OF HERE BEFORE I *SMASH YOU TO BITS.*

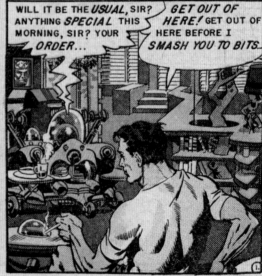

"The Precious Years," from *Weird Science* #19 (May–June 1953). Illustrated by Wallace Wood. Written by Bill Gaines and Al Feldstein.

RELAYS CLICKED. TAPES SPUN. THE BREAKFAST-ROBOT BACKED OFF TOWARD ITS WALL-HOUSING, APOLOGIZING. MARTIN GOT UP...

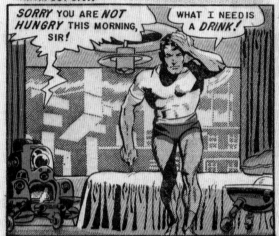

SORRY YOU ARE *NOT HUNGRY* THIS MORNING, SIR!

WHAT I NEED IS A *DRINK!*

MARTIN STRODE TO THE MECHANICAL BAR. SENSITIVE RADAR BEAMS, WARNED OF HIS APPROACH, SWUNG IT WIDE, REVEALING CRYSTAL GLASSES AND A PROUD COLLECTION OF AMBER BOTTLES. MARTIN POURED HIMSELF A STIFF DRINK AND TOASTED HIS REFLECTION IN THE MIRROR BEHIND THE BAR...

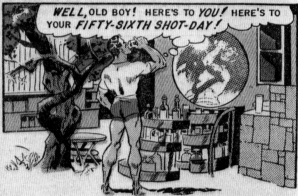

WELL, OLD BOY! HERE'S TO *YOU!* HERE'S TO YOUR *FIFTY-SIXTH SHOT-DAY!*

HE DRAINED THE GLASS DRY, SHIVERED AS IT BURNED DOWN, AND POURED ANOTHER...

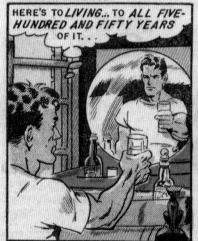

HERE'S TO *LIVING...* TO *ALL FIVE-HUNDRED AND FIFTY YEARS* OF IT...

THE SECOND ONE WENT DOWN SMOOTHER. MARTIN STARED AT HIS FACE IN THE MIRROR...

NOW WHAT, MARTIN DAKAN? *NOW WHAT?* WHAT HAVEN'T YOU *SEEN?* WHAT HAVEN'T YOU *DONE?* WHAT CAN YOU DO *TODAY* THAT YOU HAVEN'T DONE A *MILLION TIMES ALREADY...*

FIVE HUNDRED AND FIFTY YEARS OLD, MARTIN! AND YOU *STILL* LOOK *TWENTY-FIVE!* THEY'RE *WAITING,* MARTIN... WAITING TO GIVE YOU *ANOTHER* SHOT...WAITING TO *KEEP* YOU LOOKING TWENTY-FIVE...WAITING TO KEEP YOU *LIVING FOREVER...*

MARTIN PICKED UP THE BOTTLE AND FLUNG IT AT THE MIRROR, SHATTERING IT INTO A THOUSAND SHIMMERING PIECES, RIPPING HIS REFLECTION APART AND SENDING IT CASCADING TO THE FLOOR...

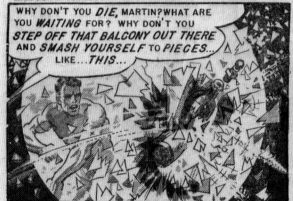

WHY DON'T YOU *DIE,* MARTIN? WHAT ARE YOU *WAITING* FOR? WHY DON'T YOU *STEP OFF THAT BALCONY OUT THERE* AND *SMASH YOURSELF TO PIECES...* LIKE...*THIS...*

HE STOOD THERE GASPING AS CLEANING-ROBOTS SCURRIED OUT FROM THEIR HIDING PLACES AND SWEPT UP THE MIRROR FRAGMENTS. SOMEWHERE A RELAY SENT ITS MESSAGE TO THE REPAIR-ROBOTS IN THE CELLAR FAR BELOW...

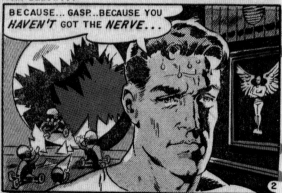

BECAUSE... GASP..BECAUSE YOU *HAVEN'T* GOT THE *NERVE...*

2

MARTIN DROPPED INTO A CHAIR, SHAKING HIS HEAD. HE SCARCELY LOOKED UP AS THE REPAIR-ROBOTS ENTERED WITH THE MIRROR REPLACEMENT...

SO YOU GO ON... DAY AFTER DAY... YEAR AFTER YEAR... UNTIL YOU'RE SO *BORED* WITH LIFE, YOU'RE READY TO GO *OUT OF YOUR MIND!* BUT YOU HAVEN'T THE *NERVE* TO END IT ALL!

THE ROBOTS SCURRIED ABOUT, REFASTENING THE NEW MIRROR INTO THE OLD BRACKETS...

AND YOU'RE AFRAID TO *STOP* TAKING THE REJUVENATION SHOTS BECAUSE YOU DON'T *WANT* TO GROW OLD AND *RHEUMATIC* AND *DRY* UP AND *DIE*. YOU WANT TO DIE QUICKLY...

THEN THE REPAIR-ROBOTS SCURRIED AWAY. MARTIN STARED AT HIMSELF IN THE NEW MIRROR...

LOOK AT YOU! YOU'VE HAD *ELEVEN* WIVES! YOU'VE *TASTED* OF LIFE UNTIL IT'S *SOURED* AND YOU'VE LOST YOUR APPETITE FOR IT. YOU'RE *BORED*, MARTIN DAKAN! *BORED SILLY!* WHY DON'T YOU QUIT?

MARTIN DRESSED SLOWLY. THE WARDROBE-ROBOT WAITED PATIENTLY UNTIL MARTIN TOOK EACH ARTICLE OF CLOTHING, THEN GLIDED AWAY AND RETURNED WITH MORE...

GET OUT OF HERE. I DON'T *WANT* A TOP-COAT!

THE *TEMPERATURE* IS 41°! A TOP-COAT IS *NEEDED*!

MARTIN SNEERED AND STARTED TOWARD THE DOOR. SOLENOIDS SNAPPED. MARTIN CURSED. THE DOOR WAS LOCKED...

THE *TEMPERATURE* IS 41°! A TOP-COAT IS *NEEDED*.

ALL RIGHT! ALL RIGHT!

MARTIN SNATCHED THE COAT. THE DOORLOCK RELEASED. MARTIN WENT OUT INTO THE HALL. THE VACUUM-LIFT SLID OPEN. A SENSITIVE BEAM FELT OF MARTIN AND A LOUDSPEAKER WITHIN THE LIFT-CAR DRONED...

GOOD MORNING, MR. DAKAN. MUNICIPAL. YOUR LEVEL, PLEASE?

MARTIN STEPPED INSIDE AND SAT DOWN ON THE PLUSH CHAIR. THE DOORS SLID SHUT AND THE LIFT-CAR HURTLED DOWNWARD. MUSIC PLAYED SOFTLY. THE VOICE ANNOUNCED...

THE TELE-THEATER IS FEATURING 'MY THIRD WIFE' AT EIGHT P.M. THE FIDELITY-CONCERT PLAYS AN ALL-WAGNER PROGRAM AT NINE. THE ROBOT-FIGHTS START AT TEN AT THE AMPHITHEATER. LUNCH IS NOW BEING SERVED IN ALL DINING HALLS...

HMMPH...

THE LIFT DOORS SLID OPEN. THE MUSIC FADED. THE VOICE WAS CURT...

MUNICIPAL LEVEL, MR. DAKAN.

THANKS...

THE MUNICIPAL LEVEL'S MOVING CORRIDORS WERE JAMMED WITH CHATTERING PEOPLE. MARTIN STEPPED TO THE WEST-BOUND BELT AND EYED A BLONDE. SOMEWHERE, DOWN DEEP, A SPARK TRIED TO IGNITE A FLAME THAT HAD LONG AGO FLICKERED AND DIED...

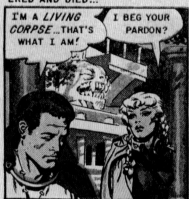

I'M A *LIVING CORPSE*...THAT'S WHAT I AM!

I BEG YOUR PARDON?

SHE SMILED AT HIM. A CENTURY OR TWO AGO, HER BEAUTY MIGHT HAVE MEANT SOMETHING TO MARTIN. BUT ONE TIRES OF EVERYTHING IN TIME. HE SHOOK HIS HEAD...

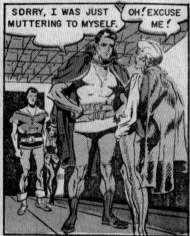

SORRY, I WAS JUST MUTTERING TO MYSELF.

OH! EXCUSE ME!

THE MEDICAL CLINIC RAMP SWEPT TOWARD THEM. THEY BOTH STEPPED OFF THE CORRIDOR BELT...

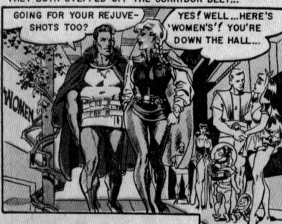

GOING FOR YOUR REJUVE-SHOTS TOO?

YES! WELL...HERE'S 'WOMEN'S'! YOU'RE DOWN THE HALL...

MARTIN WATCHED HER OPEN THE DOOR AND DISAPPEAR BEYOND IT. HE SHRUGGED. SHE WAS BEAUTIFUL ALL RIGHT, BUT WHAT WAS THE USE? IF HE'D MAKE A PLAY FOR HER, IT WOULD BE THE SAME...ALWAYS THE SAME. THE NOVELTY WAS GONE...

YOUR *NAME* AND *AGE*, PLEASE...

MARTIN DAKAN. FIVE-FIFTY.

THE ROBOT GOT UP...

FOLLOW ME, PLEASE.

BUT...

THE ROBOT LED MARTIN PAST THE SHOT-MACHINES TO A DOOR MARKED 'PRIVATE'. IT KNOCKED AND SWUNG IT OPEN...

GO AHEAD IN, MR. DAKAN!

WHAT'S THIS ALL ABOUT?

He sat at a desk piled high with records. He glanced up at Martin and motioned to a chair beside it.

SIT DOWN, MR. DAKAN.

WHAT *IS* THIS? I CAME FOR MY *REJUVE-SHOT!* WHY THE *INTERVIEW?*

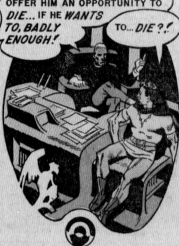

MR. DAKAN, WHEN A MEMBER OF OUR SOCIETY REACHES THE AGE OF FIVE HUNDRED AND FIFTY, WE OFFER HIM AN OPPORTUNITY TO *DIE*... IF HE *WANTS TO, BADLY ENOUGH!*

TO... *DIE?!*

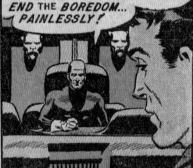

EXACTLY. WE HAVE FOUND, IN OUR EXPERIENCES THROUGH THE CENTURIES, THAT PEOPLE *ENDOWED* WITH *ETERNAL YOUTH* DIVIDE INTO *TWO CLASSES.* THOSE THAT *ACCEPT* AND *ENJOY* IT... AND THOSE THAT *TIRE* OF IT AND FIND IT, EVENTUALLY, *BORING* AND *DULL.* TO THE *LATTER,* WE OFFER A CHANCE TO *END* THE *BOREDOM*... *PAINLESSLY!*

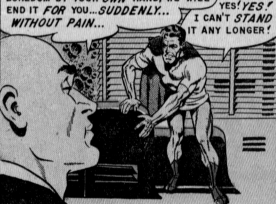

IF YOU'VE FOUND ETERNAL YOUTH IS *NOT* THE *UTOPIA* YOU'D *THOUGHT* IT WOULD BE... IF YOU'RE *BORED* WITH *LIVING,* YET HAVEN'T THE *NERVE* TO END YOUR BOREDOM BY YOUR *OWN* HAND, WE WILL END IT *FOR* YOU... *SUDDENLY... WITHOUT PAIN...*

YES! YES! I CAN'T *STAND* IT ANY LONGER!

UNDERSTAND *THIS,* MR. DAKAN. ONCE YOU *SIGN UP,* YOU *CANNOT BACK OUT.* THINK IT OVER *CAREFULLY.* YOUR *DECISION* IS *FINAL.* YOU MAY *LEAVE...* GO *BACK* TO YOUR *ETERNAL LIFE...* OR MAY *SIGN* THIS PAPER AND GO THROUGH THAT *DOOR.* WHAT AWAITS *BEYOND* IS THE *END OF ETERNAL LIFE...* THE *END* OF *BOREDOM...*

I'LL *SIGN!* I *WANT* TO! THERE'S NOTHING *LEFT* FOR ME...

The man at the desk slid the paper forward. He handed Martin the pen...

BE *SURE,* MR. DAKAN! THERE'S *NO BACKING OUT!*

I'M *SURE!* THERE...

Martin hesitated at the door. Was he to step into an abyss and plunge to his death. Was he to swing it open and be blasted to smithereens? What did it matter, anyway? This is what he wanted! He stepped inside ...

THE ROOM WAS DIMLY LIT. IT WAS EMPTY SAVE FOR A FIGURE SEATED IN ONE CORNER. MARTIN LOOKED AROUND. THE FIGURE LIFTED ITS HEAD AND LOOKED AT HIM. IT WAS THE BLONDE GIRL FROM THE CORRIDOR-BELT...

YOU...

HELLO! DID *YOU* SIGN UP, *TOO?*

MARTIN NODDED. SOMEWHERE DOWN DEEP, THE FLAME FLICKERED FAINTLY...

YES! BUT *WHY YOU?* YOU'RE...*BEAUTIFUL!*

WOULD MY *BEAUTY* MAKE MY LIFE ANY *MORE EXCITING!* WOULD IT *HELP* END *MY BOREDOM?*

MARTIN SHRUGGED...

I'VE HAD *SEVEN HUSBANDS.* I'VE *DONE* EVERYTHING... *SEEN* EVERYTHING... *LIVED* UNTIL *LIFE ITSELF* NO LONGER *MATTERED...*

I KNOW WHAT YOU *MEAN.* WELL...WHAT HAPPENS *NOW?*

SHE LOOKED AT HIM...

WE *DIE,* I GUESS! THAT'S WHAT WE *WANT,* ISN'T IT? WE WANT A *QUICK END* TO THIS *BOREDOM!*

YEAH. THAT'S WHAT WE *WANT!* FUNNY! FOR *CENTURIES* MANKIND HIS STRIVEN TO *ATTAIN* THIS PERFECT GOAL... *ETERNAL YOUTH...* AND NOW THAT *WE* HAVE IT...WE *DON'T* WANT IT!

DON'T YOU *SEE?* IN THE *OLD* DAYS, LIFE WAS A *CHALLENGE.* EVERY DAY WAS A *BATTLE* FOR *SURVIVAL.* PEOPLE HAD TO *WORK* TO *EAT.* *TODAY* EVERYTHING IS *DONE FOR US.* TODAY EVERYTHING IS *EASY.* LOOK WHAT HAS HAPPENED TO *LOVE...* TO *MARRIAGE...*

I *KNOW.* I'VE HAD *ELEVEN WIVES.* I *THOUGHT* I *LOVED* EACH OF THEM, BUT THE LOVE SOON *FADED.* WE WERE *DIVORCED.* ELEVEN TIMES... MARRIED AND DIVORCED.

LOVE ISN'T *ALL PHYSICAL.* THERE'S SOMETHING *MORE.* IT'S *TWO PEOPLE...* *BATTLING TOGETHER...FIGHTING FOR EACH OTHER...* FOR THE *RIGHT* TO ENJOY THE PHYSICAL. NO *BATTLE!* NO *ENJOYMENT!* THE THRILL OF THE CONQUEST IS *GONE,* TODAY!

I GUESS YOU'RE *RIGHT.* IN THE *OLD* DAYS A MAN AND WOMAN *MARRIED* AND *STAYED* TOGETHER UNTIL *DEATH...*

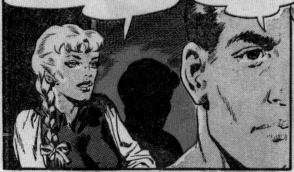

THAT'S BECAUSE DEATH WAS ALWAYS SO *CLOSE.* THE BATTLE *INCLUDED* DEATH. HOW LONG DID THEY *HAVE...* *FIFTY...SIXTY YEARS? A WHOLE* LIFE TOGETHER... TO LIVE IN *FIFTY OR SIXTY YEARS?* NO WONDER EACH MOMENT WAS SO *PRECIOUS.* *NO WONDER* THEY FOUGHT AND *SAVORED* EACH MINUTE... *LOVING* AND *ENJOYING* IT!

TODAY A MAN KNOWS THAT HIS YOUTH IS *ETERNAL.* THOSE *PRECIOUS MOMENTS DON'T EXIST...*

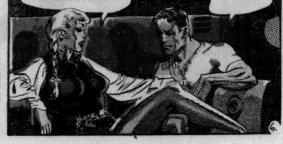

THEY SAT THERE IN THE DIMNESS AND THEY TALKED. AN HOUR PASSED. TWO. THE FLAME FLARED...

SHE MOVED CLOSER TO HIM FEELING HIS WARMTH...

WHAT ARE YOU SMILING AT MARTIN?

I'M SMILING AT *MYSELF*, JEAN. ONCE UPON A TIME, SOMETHING *DIED* INSIDE ME. I THINK IT WAS MY ABILITY TO EVER *LOVE SOMEONE* AGAIN...

AND NOW THAT SOMETHING HAS COME *ALIVE* AGAIN? *HAS* IT, MARTIN? BECAUSE THAT'S WHAT'S HAPPENED TO *ME*...

JEAN! I...I...

SUDDENLY THEY WERE IN EACH OTHER'S ARMS...

AND THEN SHE WAS CRYING AND LAUGHING AT THE SAME TIME...

DON'T YOU *SEE*, MARTIN? WE'RE GOING TO *DIE*! THAT'S WHY WE'VE *COME ALIVE AGAIN. INEVITABLE DEATH* MAKES YOU *WANT* TO *LIVE*!

WE'RE *NOT* GOING TO *DIE*, JEAN! NOT WHEN WE'VE *FOUND EACH OTHER*! THEY *CAN'T*...

'NO BACKING OUT'... REMEMBER? 'THE *END OF BOREDOM*.' DON'T *FIGHT* IT, MARTIN! IF WE GO BACK *THERE*, I'LL BE *NUMBER TWELVE* FOR YOU. THAT'S ALL...

I... I GUESS YOU'RE RIGHT!

THEY WERE IN EACH OTHER'S ARMS...DEFIANT...WHEN THE PANEL OPENED AND THE MAN FROM THE DESK STEPPED IN BRANDISHING THE STRANGE WEAPON...

THERE WAS A CLICK! THAT'S ALL! JUST A CLICK! AND THE DARKNESS CLOSED IN AS THEY SLUMPED TO THE FLOOR. THE MAN FROM THE DESK GRINNED...

I SEE YOU'RE READY NOW!

YES... YES...

THE END OF BOREDOM...

THEY AWOKE ALMOST THE SAME INSTANT...SIDE BY SIDE ...IN THEIR SHOCK COUCHES. THERE WAS A DEADLY SILENCE AROUND THEM. THEY LOOKED AT EACH OTHER...

MARTIN! DARLING!

JEAN! WE'RE *NOT* DEAD!

A RELAY CLICKED. A TAPE GLIDED THROUGH A HIDDEN MACHINE...

YOU ARE IN A *ROCKET SHIP*, MY CHILDREN. *YOUR DESTINATION HAS BEEN AUTOMATICALLY PRE-SET.* IT IS A *DISTANT COLONY* OF *EARTHS*... WILD AND UNTAMED...

THE BATTLE, MARTIN...

I HEAR IT, JEAN!

THE VOICE CONTINUED...

YOU WILL *LIVE* YOUR *LIVES OUT* ON THAT PLANET. YOUR *NATURAL* LIVES. YOU DID NOT *RECEIVE* YOUR *REJUVE-SHOTS* SO *AGE* WILL *COME* TO YOU...

DEATH, MARTIN! IT WILL *STILL* BE *INEVITABLE.*

YES, JEAN.

THERE IS MUCH *WORK* WAITING FOR YOU, MY CHILDREN! THE COLONISTS *NEED* YOU! THEY ARE *OTHERS*...WHO *DESIRED TO ESCAPE FROM BOREDOM!*

THE TAPE CLICKED OFF. SILENCE CLOSED IN. JEAN TURNED TO MARTIN...

DARLING. IT'S THE *CHALLENGE* I SPOKE ABOUT...THE *FIGHT* FOR THE *RIGHT* TO *ENJOY EACH OTHER*...

PRECIOUS MOMENTS TO *SAVOR* AND *ENJOY TOGETHER*...

THE SHIP ROARED ON OUT INTO SPACE. BEHIND IT, GREEN EARTH FADED. BEFORE IT, STARS TWINKLED IN THE BLACK GULF OF INFINITY. INSIDE THE SHIP, MARTIN AND JEAN HELD EACH OTHER CLOSE... READY FOR THE COMING STRUGGLE.

the end

JOE ORLANDO!

"JOE WAS A *DEADLINE LOVER'S* FOOL. HE WOULD *MAKE* A *DEADLINE* IF THEY HAD TO GET HIM BACK FROM THE *GRAVE!*" -ROY KRENKEL

Joe Orlando was born in Bari, Italy on April 4, 1927. His parents moved to the United States when he was two, settling in New York City. At the age of seven, Orlando began taking art classes offered through a boy's club in his neighborhood. He studied there until the age of fourteen, and won numerous prizes in competitions sponsored by the club. He also won a bronze medal in a contest held by the John Wanamaker department store in New York City. He furthered his study at the High School of Industrial Art. Upon graduation he was drafted into the Army, but unlike some of the other E.C. artists, the closest he got to doing art in the Army was "stencilling boxcars in Germany." Instead, Orlando served with the Military Police, and was stationed in France, Belgium, and Germany. Orlando was discharged in 1947, and he returned to New York to study at the Art Students League, where, he said, he was "exposed to different artistic points of view." His original plan was to become an illustrator in the mold of Norman Rockwell rather than a cartoonist, but a shift by the ad agencies away from illustration and towards photography caused him to change his focus.

Orlando's first work in comics was a feature entitled "Chuck White" in *Treasure Chest*, a comic book published by the Catholic Church. At the end of 1949, in the offices of Renaldo Epworth, an artist's agent who supplied art for Fox, Orlando met a young artist that would have a profound influence on him: Wallace Wood. "Wally and I met when we were both showing samples. We ended up collaborating because we liked each other and each other's work instantly," Orlando said in the *Wally Wood Sketchbook* (Vanguard, 2000). Wood was amazed at how fast Orlando could pencil a page, and Orlando loved Wood's inking over his pencils. "I was always impressed by what he was able to do with my drawing—he gave it a quality that I could never do for myself."

Orlando and Wood opened a studio together with several other young artists, including Sid Check and Harry Harrison, and began producing work together. Together they turned out a substantial amount of work for Fox on such titles as *Dorothy Lamour*, *Martin Kane*, *Frank Buck*, *Judy Canova*, and *Pedro*. With no warning, Fox suddenly went bankrupt in 1950, owing the artists about $6,000—a staggering sum of money at the time. There was little they could do to get what was owed to them. "We weren't

Below: Orlando/Wood cover to *Pedro* #1, June 1950.

Copyright © 1950 by Fox Feature Syndicate

Left: Detail from Orlando's cover to *Weird Fantasy* #19, May–June 1953.

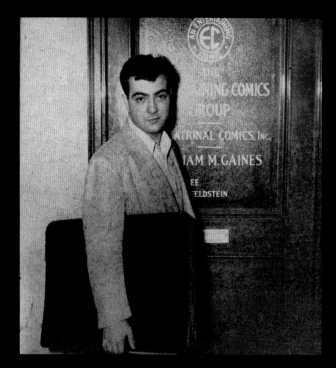

Joe Orlando

Copyright © 1951 by Avon Periodicals

Copyright © 1951 by Avon Periodicals

Copyright © 1951 by Master Comics

Above: Joe Orlando and his art portfolio outside of the E.C. offices in 1952.
Right: A selection of early 1950s Orlando/Wood covers.

Copyright © 1951 by Avon Periodicals

Above: Splash page from the Orlando/Wood classic "An Earth Man on Venus," Avon, 1951.

really business men, we were just young artists," Orlando has said.

Disgusted, Orlando quit comics entirely and took a job in the shipping department of a handbag manufacturer. "In the back of my mind I dreamed of becoming a handbag designer, starting at the bottom," said Orlando. He was putting on a brave face, but inside he was really miserable. He had worked there for about nine months when he got a call from Wood asking for some help on some work he had. Orlando said no, but Wood was persistent, and Orlando finally agreed to help out after hours. Orlando found that Wood did indeed have a lot of work lined up, primarily for Avon. The first job he started on with Wood when he came back was *An Earth Man on Venus*, an Avon comic that is now widely considered to be a classic.

Orlando began to absorb Wood's influence like a sponge. "It's not so much that I was trained by Wood, it's that I admired his inking so much that I changed my style to make it look more like how he inked my stuff," Orlando said in the *Wally Wood Sketchbook*. Orlando started to get more and more involved with comics, and finally got fired from his day job because he would work all night with Wood and then come dragging in to work the next morning. It was just as well, for by then he was making more doing comics.

Avon was run at the time by Sol Cohen, who had worked as E.C.'s circulation manager from about 1946 to 1949. Cohen kept Wood—and by extension Orlando—very busy. Together they worked on a number of comics for Avon that are considered to be classics, including *Strange Worlds*, *The Mask of Dr. Fu Manchu*, *Witchcraft*, and *With the U.S. Paratroops Behind Enemy Lines*. They also turned out work for other publishers, most

notably *Captain Science* for Youthful Magazines and *Dark Mysteries* for Master Comics. During this period, the pair worked like fiends in a tag-team arrangement. Orlando recalled: "I remember Wally and I would be exhausted, and we would be getting two-hour naps; he would sleep for two hours and then get back to work, I would sleep for two hours and then get back to work. I always took more work than we could handle."

Working solo, Wood had also been doing work for E.C., and he recommended Orlando when they were looking to add another artist. He worked up a penciled sample page and went down to E.C. "I got my first story on the basis of my penciling, and I really sweated that inking job. I hated my inking, and I was sure I would get fired when I brought it in," Orlando said in *The Amazing World of D.C. Comics* #6, May 1975, an issue that was devoted to him. "And I looked into Feldstein's face and he said, 'Terrific, we have another Wally Wood.' I

couldn't believe it." In the Orlando biography published in *Tales from the Crypt* #28 (February–March 1952) and also in *Weird Fantasy* #12 (March–April 1952), Gaines and Feldstein wrote, "Wally recommended Joe to us when we were searching for an addition to our overworked staff. You could've knocked us over with a feather when we saw his samples. 'Another Wood!' we shrieked! Joe's been with us ever since!"

Orlando's first story for E.C. was "A Mistake in Multiplication" in *Weird Fantasy* #9 (September–October 1951), and after that he missed appearing in only one issue of E.C.'s science fiction comics. He also regularly contributed to E.C.'s three horror comics, the *Crime* and *Shock* titles, and he also had a story in nearly every issue of *PANIC*, the sister publication to *MAD*. Many aficionados consider the series of "Adam Link" stories (about a robot teacher from Mars) that Orlando illustrated in *Weird*

Left: Joe Orlando and Wallace Wood work together to beat a deadline in this early 1950s caricature by Wood.

Above: Orlando splash pages from "A Mistake in Multiplication" (*Weird Fantasy* #9, September–October 1951), "This Is Your Strife" (*PANIC* #1, February–March 1954), and "I, Robot" (*Weird Science-Fantasy* #27, January–February 1955).

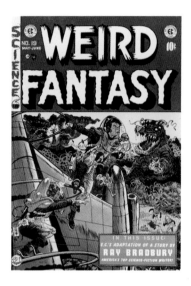
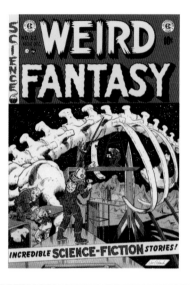
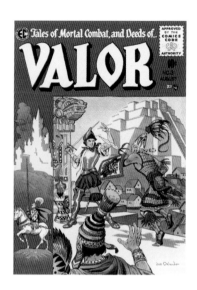

Above and below left: Orlando contributed only three covers to E.C.'s comics, and one for the Picto-Fiction magazines. It has been said that at any other comic book company, Orlando would have been the shining star; here, however, competition was fierce.

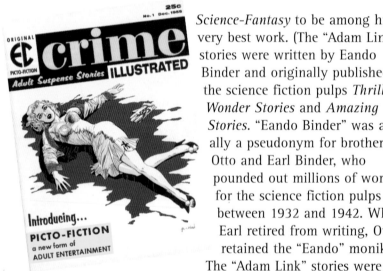

Science-Fantasy to be among his very best work. (The "Adam Link" stories were written by Eando Binder and originally published in the science fiction pulps *Thrilling Wonder Stories* and *Amazing Stories.* "Eando Binder" was actually a pseudonym for brothers Otto and Earl Binder, who pounded out millions of words for the science fiction pulps between 1932 and 1942. When Earl retired from writing, Otto retained the "Eando" moniker. The "Adam Link" stories were actually written by Otto alone, and were adapted into comics form for E.C. by Al Feldstein.) Orlando also contributed superlative art on several of the Ray Bradbury stories that were adapted by Feldstein for E.C., including "The Lake," "The Long Years!," "Outcast of the Stars," and "Judgment Day!" (This last story appears in its entirety at the end of this chapter.) In a February 3, 1953 letter to E.C., Bradbury wrote: "'Judgment Day!' should be required reading for every man, woman, and child in the United States. You've done a splendid thing here, and deserve the highest commendation."

When E.C. dropped its New Trend line and replaced them with the New Direction comics

in 1955, Orlando was a regular contributor to *Impact*, *Valor*, and *M.D.* He also worked on three of the four Picto-Fiction magazines: *Crime Illustrated*, *Terror Illustrated*, and *Confessions Illustrated*.

During his days at E.C., Orlando and Bill Gaines became very close friends. Orlando was there the night Kurtzman left *MAD*. "He came home and he was holding his head, he

Above: Splash page from E.C.'s Ray Bradbury adaptation "The Long Years!," *Weird Science* #17, January–February 1953.

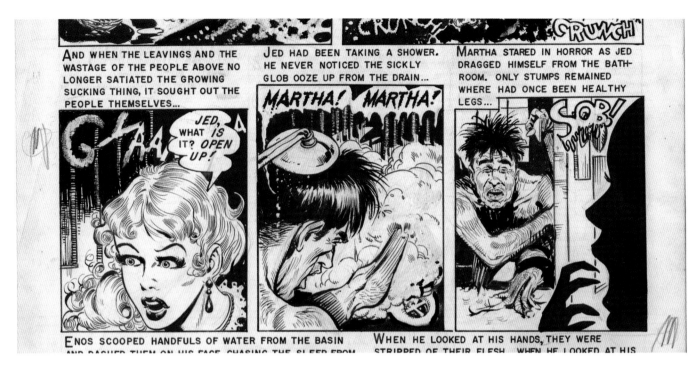

AND WHEN THE LEAVINGS AND THE WASTAGE OF THE PEOPLE ABOVE NO LONGER SATIATED THE GROWING SUCKING THING, IT SOUGHT OUT THE PEOPLE THEMSELVES...

JED, WHAT *IS* IT? OPEN UP!

JED HAD BEEN TAKING A SHOWER. HE NEVER NOTICED THE SICKLY GLOB OOZE UP FROM THE DRAIN...

MARTHA! MARTHA!

MARTHA STARED IN HORROR AS JED DRAGGED HIMSELF FROM THE BATHROOM. ONLY STUMPS REMAINED WHERE HAD ONCE BEEN HEALTHY LEGS...

ENOS SCOOPED HANDFULS OF WATER FROM THE BASIN AND DASHED THEM ON HIS FACE, CHASING THE SLEEP FROM

WHEN HE LOOKED AT HIS HANDS, THEY WERE STRIPPED OF THEIR FLESH. WHEN HE LOOKED AT HIS

was in a state of shock," Orlando said. "I actually heard him say that he would give Kurtzman 49% [of *MAD*], if he had just asked for 49% and not 51%." Orlando encouraged Gaines to hire Al Feldstein to replace Kurtzman as *MAD*'s editor, as did E.C. business manager, Lyle Stuart, and Gaines's wife, Nancy. Orlando also convinced Wallace Wood not to leave *MAD* and follow Kurtzman to *Trump*. "I played Wally like an instrument," said Orlando. He knew Wood was tired of following Kurtzman's layouts, and Orlando "played that card like you wouldn't believe."

He also helped to refine Gaines's legendary palate. Gaines, who in later years was well known as a wine connoisseur and collector, was actually introduced to fine wines by Orlando; prior to this, Gaines only liked Manischewitz.

When E.C. ceased publication of its comic books, Orlando was out of a job. "I had been working pretty extensively for E.C., but not for *MAD*, which was the only remaining mag there. So I went out with my portfolio, and I picked up assignments right away from *Classics Illustrated*," Orlando said in *The Amazing World of D.C. Comics*. He also found work with Stan Lee at Atlas (soon to become Marvel), working on their Comics Code-approved titles such

as *Astonishing* and *Mystic*. However, said Orlando, "The scripts, unfortunately, never had the quality that the E.C. stories did. Therefore, the art never made that much of an impact, proving to me that the scripting is more important than the art." He also did some advertising work during this time.

He was asked to work for *MAD* in 1957, taking over the "Scenes We'd Like to See"

Above: Detail from Orlando's original art to "The Meddlers!," *Shock SuspenStories* #9 (June–July 1953).

Above: The original art to the splash pages of two of Orlando's E.C. stories: "Why Papa Left Home" (*Weird Science* #11, January–February 1952) and "Bum Steer! (*The Haunt of Fear* #10, November–December 1951).

Joe Orlando

To Bill — THANK YOU for a wonderful TRIP! — Joe

Above: Bill Gaines organized yearly trips to exotic locales for his regular *MAD* contributors, and as a special "thank you," after each one the *MAD*-men gave Gaines what was called a "*MAD* Trip Book." In this Orlando piece from the 1960 Trip Book, Bill Gaines (in the safari hat at left) hawks busts of Alfred E. Neuman and back issues of *MAD* in a Haitian marketplace.

feature from Phil Interlandi, who had moved on to *Playboy*. Orlando's first "Scenes" page appeared in *MAD* #32, March–April 1957, and he became a regular contributor to the magazine.

In 1964, Orlando did some work at Marvel Comics for Stan Lee on *Daredevil*. He was also in on the early planning stages for James Warren's *Creepy*; besides contributing artwork, Orlando is given a "story ideas" credit in the first issue. He also contributed art and one cover to *Creepy*'s sister publication, *Eerie*.

Orlando also started working for D.C. Comics in 1966, doing art for titles like *Swing with Scooter* and

The Inferior Five. Two years later, Orlando's friend Carmine Infantino was bumped up into the position of Editorial Director, and he brought Orlando on as an editor. Infantino was ushering in a new era of artist/editors at D.C., also bringing in Dick Giordano from Charlton, and Joe Kubert, who had previously been working as an artist on D.C.'s war comics. "It was a very frightening experience," said Orlando. "It was like walking into a bank and getting a loan without any collateral. I'd hear whispered things like 'This won't last long.'" Fortunately, things worked out just fine. Orlando inherited two titles from departing editors, *Swing with Scooter* and *House of Mystery*. He immediately moved *House of Mystery* back to its original mystery/horror roots, even while working within

Above: Joe Orlando, circa 1962.

144

the limits of the Comics Code. "I worked within the Code by looking for its openings, not its restrictions, and gradually developed my own limits by starting with simple monster stories," said Orlando. "In fact, the first couple of issues we even used old D.C. reprints of

Copyright © 1967 by Warren Publishing

Above: Orlando cover to James Warren's *Eerie* #11, September 1967.

their very tame 1950s monster stuff." For *House of Mystery* he introduced two horror hosts reminiscent of E.C.'s three GhouLunatics: Cain and Abel. And *Swing with Scooter* he repositioned to compete with *Archie*, a move that "shocked the *Archie* people, because they thought they owned that particular style." Sales shot up on both books. Over the next few years, Orlando championed such successful D.C. titles as *Swamp Thing*, *Phantom Stranger*, and the *Sandman*. Of the books Orlando was doing for D.C., his old friend Bill Gaines said in 1969, "I

can see his fine Italian hand in their success."

In 1973, Orlando helped create *PLOP!*, a new D.C. humor title, which was also hosted by Cain and Abel and regularly featured covers by both Wallace Wood and Basil Wolverton. It also featured interior work by Sergio Aragonés, one of the most popular of the contemporary *MAD* artists. Also in the 1970s, Orlando contributed art to both the *National Lampoon* and to *Newsweek* magazine.

Orlando enjoyed a steady rise within the ranks at D.C., eventually becoming Vice President and Editorial Director for the company. After Bill Gaines died in 1992, corporate parent Time/Warner placed *MAD* under the wing of D.C., and Orlando was appointed the Associate Publisher of the magazine. "I'm sure Bill Gaines was rolling in his grave," joked Orlando. In later years, in addition to his duties at D.C., he also taught at the School of Visual Arts, where he loved interacting with the students and encouraging new talent.

Joe Orlando, who was often referred to by friends in the industry as the "Godfather of Comics," in deference to his soft-spoken, *Sopranos*-style manner of speaking, passed away on December 23, 1998. He worked in the industry he loved right until the end. D.C. Comics publisher Paul Levitz—who Orlando had originally hired at D.C. when Levitz was only sixteen—wrote, "Joe Orlando was an artist who conjured human emotion with his brush strokes. He loved to scare, to thrill, and to inspire, and most of all, to make people laugh. He taught a generation of us how to do our best work, and his creativity will live on in his students." •

Copyright © 1968 by D.C. Comics

Above: Orlando cover to *Swing with Scooter* #11, March 1967.

Copyright © 1967 by D.C. Comics

Copyright © 1976 by D.C. Comics

Above: Orlando covers to *Showcase* #62 (first "Inferior Five," September 1967), and *PLOP!* #21 (May–June 1976). *Below:* Joe Orlando in Monte Carlo, October 1993, on the final *MAD* trip.

Photo by Irving Schild

Above: "Funeral Procession," a 1953 painting done by Joe Orlando as a gift for Bill Gaines. The painting hung in the E.C. offices for a number of years.

JUDGMENT DAY!

THE MAN ROARED DOWN FROM THE NIGHT SKY. HE'D COME FROM THE INFINITE VOID OF SPACE... ACROSS THE ENDLESS COSMIC VACUUM. HE'D COME FROM THE PLANET EARTH. HE'D COME IN A SHIP OF GLEAMING ALLOYS... BELCHING BLUE FLAMES AND YELLOW CLOUDS OF ATOMIC DUST. AND HE'D COME ALONE. HE STEPPED TO THE PORT AMID THE CHEERS OF THE ROBOT POPULATION.

WELCOME! WELCOME, EARTHMAN, TO CYBRINIA... TO THE *PLANET OF MECHANICAL LIFE!*

THE MAN STEPPED FROM HIS GLEAMING SHIP. HE STEPPED INTO THE ARTIFICIAL SUNLIGHT THAT FLOODED THE LANDING SITE. HE EXTENDED HIS HAND...

I AM *TARLTON*... FROM 'EARTH COLONIZATION.' I AM HERE TO *INSPECT*. IF I FIND THAT YOU ARE *READY*...

WE ARE *READY!* WE HAVE LABORED LONG AND HARD TO PER-FECT OUR SOCIETY. WE HAVE *EXPERIMENTED* AND *DISCOVERED, PLANNED* AND *BUILT*... *ASKED* AND *ANSWERED. WE ARE READY*...

TARLTON MOVED FORWARD THROUGH THE CROWD OF ORANGE ROBOTS THAT PRESSED AROUND HIM. HE STOPPED AND QUESTIONED ONE...

DO YOU *KNOW* WHO I *AM?*

YOU ARE *TARLTON*... FROM *EARTH!* YOU ARE A *REPRESEN-TATIVE* OF OUR *ORIGINAL CREATORS!* IF YOU FIND THAT WE ARE *READY*, ALL OF THE *WONDERS* AND *GREATNESS* OF *EARTH* WILL BE *OURS.*

Joe Orlando

"Judgment Day!," from *Weird Fantasy* #18 (March–April 1953). Illustrated by Joe Orlando. Written by Bill Gaines and Al Feldstein.

TARLTON NODDED. THE ARTIFICIAL SUNLIGHT DANCED ON HIS SPACE HELMET...

QUITE RIGHT. THOUSANDS OF YEARS AGO, WE PLACED A *SMALL HANDFUL* OF YOU UPON THIS PLANET. THIS SMALL HANDFUL WAS GIVEN THE *KNOW-HOW* TO BUILD *MORE* OF YOU...

WE LEFT YOU TO *YOURSELVES.* WE HOPED THAT *IN TIME* YOU WOULD DEVELOP A SOCIETY WORTHY OF *INCLUSION* IN EARTH'S GREAT *GALACTIC REPUBLIC.* AT THAT TIME ALL OF OUR *SCIENTIFIC ADVANCES,* OUR *GLORY,* WOULD BECOME YOURS...

COME, TARLTON. LET US SHOW YOU WHAT WE HAVE ACCOMPLISHED! LET US SHOW YOU THAT WE ARE READY...

LEAD THE WAY...

THE SPACE-SUIT CLAD EARTH-MAN FOLLOWED THE ORANGE ROBOT PAST THE CROWD OF METAL ONLOOKERS TO A SLEEK-LOOKING LOW VEHICLE...

THIS IS KNOWN AS A MOBILE-CAR. IT WAS DEVELOPED QUITE SOME TIME AGO BY N-R-E-PHORD. IT OPERATES BY MEANS OF AN INTERNAL COMBUSTION ENGINE...

YES. GOOD! GOOD! *TWENTIETH CENTURY* LEVEL...

THE SPEEDY MOBILE-CAR SWEPT THE EARTHMAN THROUGH A SHINING CITY, ALONG STREETS JAMMED WITH CHEERING ORANGE ROBOTS...

THIS IS OUR CAPITOL CITY! THAT BUILDING *THERE* IS OUR *HOUSE OF DELEGATES...* ELECTED BY THE POPULACE...

HMMM. INTERESTING. DEMOCRATIC RULE. VERY GOOD. AND *THAT* BUILDING...

THE EARTHMAN POINTED TO A LONG LOW STRUCTURE...

THAT BUILDING IS OUR *CONSTRUCTION LINE* AND *ASSEMBLY PLANT* WHERE OUR *POPULATION* IS *MADE...*

STOP HERE. I WOULD LIKE TO *SEE* IT...

THE MOBILE-CAR PULLED UP BEFORE THE PLANT, AND THE EARTH-MAN GOT OUT. HE FOLLOWED HIS ORANGE ROBOT-GUIDE INTO THE BUILDING...

THIS IS THE *PARTS* DEPARTMENT, WHERE OUR *UNITS* ARE *CONSTRUCTED...*

I SEE ONLY *ORANGE* WORKERS! WHAT ABOUT THE *BLUE* ROBOTS...

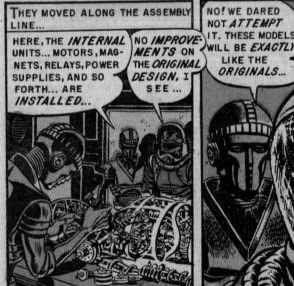

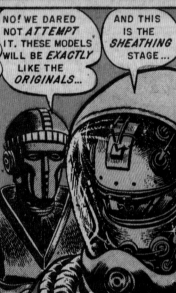

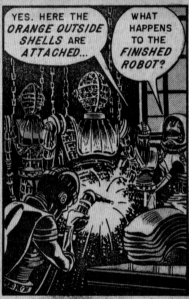

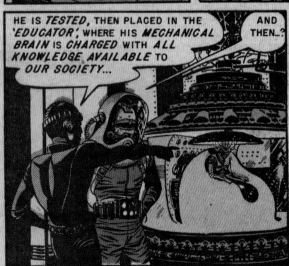

THEY MOVED OUT OF THE PLANT...

THEN he is FREE TO FOLLOW HIS CHOICE of ENDEAVOR...

A FREE ENTERPRISE SOCIETY?

OF COURSE! AFTER YOU...

NO! I...I'D RATHER WALK...

TARLTON WALKED ALONG BESIDE HIS ROBOT GUIDE SURVEYING THE SPARKLING CITY...

WHERE IS THE BLUE ROBOT ASSEMBLY PLANT?

THE BLUE ROBOTS? WELL...YOU'LL HAVE TO GO OVER TO BLUE TOWN...ON THE SOUTH SIDE OF THE CITY FOR THAT!

BLUE TOWN?

WELL. YOU KNOW. THEY ALL LIVE OVER THERE. WE CALL IT BLUE TOWN. IT'S JUST THE SECTION. WE'D BETTER TAKE A MOBILE-BUS. IT'S A LONG WALK...

THEY STOOD UNDER THE BUS STATION SHED, TARLTON SURVEYING THE TWO BENCHES...

YOU...DIFFERENTIATE BETWEEN BLUE ROBOTS AND ORANGE ROBOTS?

OF COURSE! OTHERWISE THERE'D BE TROUBLE! HAVE TO KEEP THEM IN THEIR PLACE, YOU KNOW...

BUS STO

ORANGE

BLUE

TARLTON NODDED. THE BUS ARRIVED. THEY BOARDED IT. TARLTON MOVED TOWARD THE BACK...

NO! UP HERE... IN FRONT!

OH! YES! I SEE...

BLUE

THE BUS ZOOMED OFF SOUTHWARD THROUGH THE CITY...

WHILE WE'RE RIDING, I COULD SHOW YOU SOME POINTS OF INTEREST...

I'D APPRECIATE IT...

THEY SPED PAST A LARGE IMPOSING STRUCTURE. OUTSIDE A LINE OF ORANGE ROBOTS WAITED PATIENTLY...

A *RECHARGING STATION!* THERE OUR POWER UNITS ARE SUPPLIED WITH *ENERGY* WHEN THEY *NEED* IT...

SIMILAR TO A *RESTAURANT* FOR HUMANS, I SEE...

ORANGE ONLY

G STATION

SOON THE MOBILE-BUS ENTERED A SEEDY SECTION OF THE CITY. THE BUILDINGS NO LONGER SHINED. THE STREETS WERE CROWDED WITH BLUE ROBOTS...

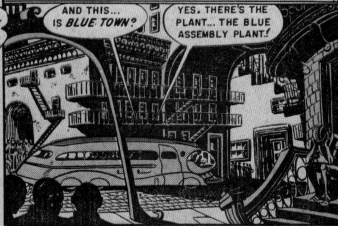

AND THIS... IS *BLUE TOWN?*

YES. THERE'S THE PLANT... THE BLUE ASSEMBLY PLANT!

TARLTON AND HIS ROBOT GUIDE ALIT FROM THE MOBILE-BUS AND IT SPED OFF...

YOU'D BETTER GO ON IN ALONE, TARLTON. I'LL WAIT OUT HERE!

HAVE YOU EVER BEEN *IN* THE BLUE PLANT?

THE GUIDE SHOOK HIS HEAD...

NO! I HARDLY EVER EVEN *COME* TO BLUE TOWN.

COME *IN* WITH ME. I *WANT* YOU TO. IT MIGHT PROVE *INTERESTING.*

TARLTON MOVED INTO THE BUILDING, HIS ORANGE GUIDE FOLLOWING SHYLY. A BLUE ROBOT CAME TO MEET HIM...

ALLOW ME TO APOLOGIZE FOR THE APPEARANCE OF OUR PLANT, TARLTON. OUR FUNDS ARE LIMITED.

I UNDER-STAND...

THE BLUE ROBOT GUIDED TARLTON INTO THE PARTS DEPARTMENT...

THIS IS WHERE OUR *UNITS* ARE *CONSTRUCTED.*

NOTICE, MY FRIEND. *THEY* USE THE *SAME ALLOY* IN *THEIR* PARTS AS *YOU* DO.

I... I SEE.

...THEN ON TO THE ASSEMBLY LINE...

NOTICE THE *INTERNAL UNITS,* MY FRIEND. THE *SAME DESIGNS,* THE *ORIGINAL* DESIGNS. NO *IMPROVEMENT!* NO *DIFFERENCE!* EXACTLY LIKE YOURS!

WE...WE *KNOW* THAT TARLTON...

I AM *SORRY* MY FRIEND! YES. I *KNOW* YOU ARE ONLY *ONE ROBOT.* THAT IS WHY I AM AFRAID THAT *CYBRINIA* IS NOT YET *READY* TO JOIN THE GREAT GALACTIC REPUBLIC...

NO. WAIT, TARLTON...

TARLTON MOVED OUT OF THE BLUE ASSEMBLY PLANT THROUGH BLUE TOWN. THE ORANGE ROBOT HURRIED AFTER HIM...

WHY, TARLTON? WHY AREN'T WE READY?

ASK *YOURSELF* THAT, MY FRIEND! TELL YOUR *FELLOW ROBOTS* TO ASK *THEMSELVES* THAT QUESTION!

TARLTON MOVED FAST. THE ROBOT CLANKED AFTER HIM...

IS...IS THERE ANY *HOPE,* TARLTON? FOR US?

OF COURSE THERE IS!

TARLTON STOPPED BELOW HIS GLEAMING ROCKET...

OF COURSE THERE'S *HOPE* FOR *YOU,* MY FRIEND. FOR A WHILE, ON *EARTH,* IT LOOKED LIKE THERE WAS *NO HOPE!* BUT WHEN MANKIND ON EARTH LEARNED TO *LIVE TOGETHER, REAL* PROGRESS FIRST *BEGAN.* THE *UNIVERSE* WAS *SUDDENLY OURS.*

...AND WHEN *WE* LEARN TO LIVE TOGETHER...

THE UNIVERSE WILL BE *YOURS TOO.* GOOD-BYE, MY FRIEND!

GOOD-BYE, TARLTON.

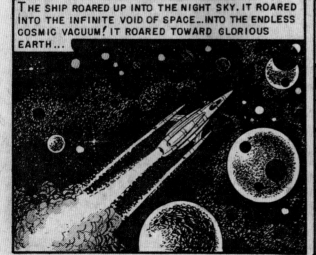

THE SHIP ROARED UP INTO THE NIGHT SKY. IT ROARED INTO THE INFINITE VOID OF SPACE...INTO THE ENDLESS COSMIC VACUUM! IT ROARED TOWARD GLORIOUS EARTH...

AND INSIDE THE SHIP, THE MAN REMOVED HIS SPACE HELMET AND SHOOK HIS HEAD, AND THE INSTRUMENT LIGHTS MADE THE BEADS OF PERSPIRATION ON HIS DARK SKIN TWINKLE LIKE DISTANT STARS...

THE END 7

WILL ELDER!

"WILL ELDER WAS UNQUESTIONABLY THE *NUTTIEST* GUY THAT *EVER* WALKED IN THE DOORS HERE!" —*BILL GAINES*

Will "Chicken Fat" Elder was born Wolf Eisenberg on September 22, 1921 in the Bronx, New York. (In his early days, he went by the name "Bill," but in later years he preferred to use "Will.") At a very early age he became fascinated with the Sunday Comics section, which, he told *The Comics Journal* in a 1995 interview, his Dad would drop on his bed. Elder would "rush out with a terrible hunger for looking at the comics. I wanted to get the most out of this world of imagination, and I loved it. I said, 'Someday I'll make my own comic strip.'"

Elder was the class clown, a natural comedian. There are enough stories about Elder's antics to fill a book. On one occasion, Elder and his friends were playing in a freight yard, and they got into a refrigerated boxcar full of meat. He and his friends collected some old clothes, gathered up some of the meat and spread it along the railroad tracks over about a mile or so. Elder then screamed at the top of his lungs, "Mikey fell! Mikey fell on the railroad tracks!" Finally, the police came and took the meat away, solemnly, to the morgue.

Another time, Elder wasn't present in class. At the end of the day, the kids opened the coat closet to retrieve their coats, and found Elder hanging there motionless, his face whitened with chalk dust. His teacher, of course, thought he had hung himself!

Yet another time, his mother was entertaining, and Elder decided to rip up his clothes and pour ketchup all over himself to make it look like he had been in some terrible accident. His hysterical mother called an ambulance, and Willy—now too afraid to fess up that nothing was wrong—was rushed to the hospital and examined by a doctor. Elder, naturally, was found to be in mint condition. If Elder were growing up today he would undoubtedly immediately be diagnosed with Attention Deficit Disorder, and placed on a high dosage of Ritalin—or worse. "I was a great practical joker, I just loved that," Elder told comics historian John Benson. "I always wanted to shock people; my parents, my relatives. I got a sort of macabre gleefulness out of seeing them suffer, for some reason or another. I was a deflator of authority, like the Marx Brothers—I loved them."

One Valentine's Day, Elder sent his wife Jean a real chicken heart with an arrow through it. E.C. colorist Marie Severin said of Elder in *E.C. Lives!* that "he was the type of

THIS *NUT* IS FOR THE *WALL!*

Below: "Rufus DeBree," which he both wrote and illustrated, was Elder's first professional work (from *Toytown* #5, December 1946).

Copyright © 1946 by Toytown Publications

Left: Detail from Elder's antic cover to *MAD* #5, June–July 1953, Elder's only solo cover effort for E.C.

person who would order some milk and cake, and if they took too long to serve him, he would mix the milk and cake in the glass when he got it to hurry things up. Anything to be funny. What a mind, or what an absence of a mind!" In later years, Elder was able to channel his antic energy in a more positive direction. "Now I sublimate my energies into my work," he has said. "Like many comedians and actors, they hide behind the character they play. In my case, I hide behind this zany cartoon, this zany thing on paper, which is very safe for me."

Like many of the E.C. artists, Elder attended the High School of Music and Art, where he first met Harvey Kurtzman. (Kurtzman was a junior, and Elder was a senior at the time.) Elder graduated in 1940, and in 1942 was drafted into the Army Air Corps, where his artistic talents were put to use as a map designer.

He was discharged in 1946, and he came back to New York and began looking for work. His first professional assignment appeared in 1946 in *Toytown Comics*, where he both wrote and drew a backup feature entitled "Rufus DeBree," about a garbage man who gets knocked unconscious and finds himself in a dream world with King Arthur's Knights of the Round Table.

After this, Elder did some advertising work for a publishing house. One day on the street he bumped into Harvey Kurtzman and another friend from the High School of Music and Art named Charlie Stern. Together they decide to pool their talents and open up a studio, which they called the Charles William Harvey Studio. "We had dreams like you wouldn't believe," Elder told *The Comics Journal*. The men took just about any kind of work they could to keep the wolves from the door. Harvey Kurtzman has said that "we decided we'd have an art studio that offered diverse services—paste-up, layout, illustration. We did everything but make money. God, how we starved." A lot of interesting people also shared space in the studio, including future E.C. artist John Severin and René Goscinny, a

French cartoonist who later became very famous in France for a popular character he co-created called *Asterix*.

In 1948, while still working out of the Charles William Harvey Studio, Elder and John Severin decided to team up. At the time, Elder was a very slow penciler but an ace inker, whereas Severin was fast with a pencil but less comfortable inking. The combination was a good one, and the duo began to get work, most notably a long run on *Prize Comics Western*, where they did many covers and a feature called "American Eagle."

Elder and Severin followed Harvey Kurtzman to E.C. at the very end of 1950, working together on Kurtzman's war comics. In truth, the war comics weren't really Elder's cup of meat, but he was refining his craft. "I did them because it was a living, it was a chance to get into the business and work at it, and develop techniques," Elder told comics historian John Benson. Of his collaboration with Severin, Elder said on a panel at the 1972 E.C. Fan-Addict Convention (held in New York City) that "John Severin was a remarkable artist as far as drawing uniforms, soldiers. I was more of a humorist; I never

Above: An unused sheet of office stationary from the Charles William Harvey Studio, circa 1948.

charles william harvey studio
1151 BROADWAY
NEW YORK 1, N. Y.
RM. 301 · MU 6-3064

Above: Severin/Elder "American Eagle" splash page, *Prize Comics Western* #85, January–Febuary 1951.

could get into that corner of it while working on the war stories. John at that time didn't have the ability to dramatize it in black and white, and I did. John was a marvelous artist, had great historical background, and drew very rapidly. I was very fast with the

in most of the subsequent issues of that title, as well as stories in ten of the fifteen issues of *Frontline Combat*.

Apart from their work on Kurtzman's war comics, Severin and Elder collaborated on several beautifully realized E.C. science fiction

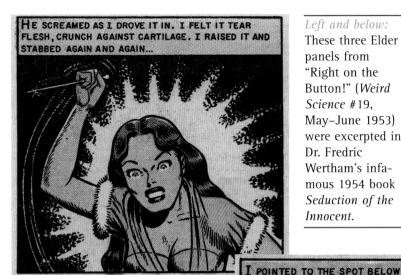

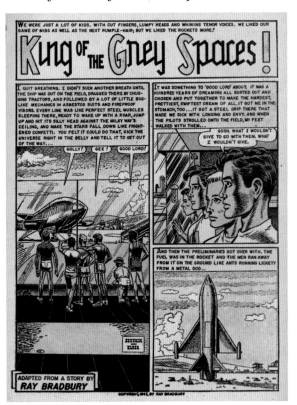

inking and dramatization of the stories, and together we seemed to work very well and very rapidly." Their first story for Kurtzman at E.C. was "War Story!," in the second issue of *Two-Fisted Tales* (cover dated January–February 1951). The pair had stories

stories, including two particularly lovely Ray Bradbury adaptations, "King of the Grey Spaces!" (*Weird Fantasy* #19, May–June 1953) and "The Million Year Picnic" (*Weird Fantasy* #21, September–October 1953). Bradbury himself, in a letter to E.C., had this to say about "King of the Grey Spaces!": "Severin and Elder, in 'King of the Grey Spaces,' have a very fresh technique, new and well handled. I certainly hope you'll have them work on some of my other stories."

Elder did a few science fiction stories on his own as well. One such story, "Right on the Button!" (*Weird Science* #19, May–June 1953), was singled out in Dr. Fredric Wertham's anti-comics diatribe *Seduction of the Innocent*. Three uncredited panels from the story were reproduced in that book, captioned "a young girl on her wedding night stabs her sleeping husband to death when she realizes that he comes from a distant planet and is a 'mammal.'"

Left and below: These three Elder panels from "Right on the Button!" (*Weird Science* #19, May–June 1953) were excerpted in Dr. Fredric Wertham's infamous 1954 book *Seduction of the Innocent*.

Above: Severin/Elder splash pages from "War Story!" (*Two-Fisted Tales* #19, January–February 1951) and "King of the Grey Spaces!" (*Weird Fantasy* #19, May–June 1953).

157

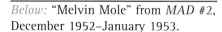

BILL
ELDER

Below: "Melvin Mole" from *MAD* #2, December 1952–January 1953.

Elder also did several horror stories for E.C., working solo. Although quite competent, the horror work wasn't really up his alley. "I think it was kind of against my grain," Elder has said. "I never dug that type of bag. So until *MAD* came along, which was just right for me, I worked in horror because it was making a living. It's as simple as that." Still, it wasn't an entirely imperfect fit: the old Elder story about spreading meat across the railroad tracks was used as the basis for one of the horror stories he illustrated, titled "Last Laugh" (*Tales from the Crypt* #38, October–November 1953, written by Bill Gaines and Al Feldstein).

Right: One of Elder's childhood hijinks was used as the basic for "Last Laugh," *Tales from the Crypt* #38 (October–November 1953).

MAD came along in 1952, and rather than keep the Severin/Elder duo together as he largely had on his war comics, Kurtzman wisely decided to split up the two artists for their *MAD* work, freeing up each one to follow his own muse. Elder's work sprang fully to life in *MAD*, where he could finally channel all his manic energy into the art. Elder told John Benson that "*MAD* gave me a tremendous license. I was thinking of pure, unadulterated humor, to get as crazy as I possibly could within the story limits." And while some of the other artists resented working with Kurtzman's tissue paper layouts, Elder saw no problem with it. "Willie was very agreeable, because he sensed that he did unique work, working with me," Kurtzman has said. "And it was true; his work became unique. He had done other things before—he'd done some horror stories, he'd done war sto-

ries with John Severin. But his stuff was never particularly unique in those formats. When he did *MAD* he became really good."

MAD #2 featured "Mole!," a character of Elder's that was fleshed out into a full story by Kurtzman, featuring a seemingly unstoppable bank robber. Melvin Mole's "dig, dig, dig, dig!" litany is fondly remembered by *MAD*'s early readership.

In *MAD* (and later carried over into the sister publication, *PANIC*), Elder was inspired to add to the stories in the form of crazy background gags and various signs on the walls—or just about anywhere else he could fit them. Kurtzman told John Benson that "he contributed much to the feel of the early *MAD*. He did a lot to make *MAD* the wild, irreverent thing it was, and I think Will's 'chicken-fat' humor was very necessary to the feeling that *MAD* generated. As a matter of fact, Will did much to set the cartoon approach that was used for years in *MAD*—the detail, the asides."

Some of those famous "asides" got Bill Gaines in some hot water, although the trouble came completely out of nowhere. "Outer Sanctum," (*MAD* #5, June–July 1953) was Kurtzman's parody of both the long-running radio thriller *Inner Sanctum* and of the stories in E.C.'s horror comics. In this classic story Elder manages to combine the look and feel of an E.C. horror tale with his own antic, signs-on-the-wall style. Elder had inserted a sign in the second panel that read "Nice, clean, fat, errand boy wanted—J. Ghoul." This got Gaines into a lot of trouble with his wholesalers. As Gaines recalled to comics historian John Benson: "You and I know what the nice, fat, errand boy was wanted for; he was wanted to be eaten. But not the wholesalers! They knew he was wanted for sexual perversion. They really believed it. What

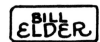

do wholesalers know about ghouls?"

Another parody that caused an uproar was Elder's version of "The Night Before Christmas," from *PANIC* #1 (February–March 1954). Gaines biographer Frank Jacobs said of this version that "never had Charles Clement Moore's classic been adorned with such unusual art, and the result was an outburst of indignation from the state of Massachusetts." Not only was the book banned in Boston, but Massachusetts State Attorney General George Fingold moved to stop the sale of all copies of *PANIC* #1 in the state. The odd thing is just what the uproar was about: Elder had depicted a "Just Divorced" sign on the back of Santa's sleigh, and a meat cleaver, ash can, and two daggers were tied to the rear of the sled. "What we didn't realize then," Gaines told Frank Jacobs, "is that Santa Claus is a saint. We put a 'divorced' sign on the back of his sleigh. Santa Claus couldn't have been married, although it runs to my mind that I've seen pictures of Santa and Mrs. Claus up in their workshop with the elves." Gaines was outraged, and after a fair amount of legal wrangling and a series of mostly negative newspaper articles, the "Santa Claus affair" ended up being not much more than a tempest in a teapot, but it was bad publicity E.C. didn't need at the time. ("The Night Before Christmas" appears in its entirety at the end of this chapter.)

Elder's art made a giant leap with the transition to the magazine version of *MAD*, where he did richly toned black-and-white interior art and some absolutely wonderful, fluid color paintings for *MAD*'s ad parodies that were barely even hinted at in his earlier work, most notably "Beer Belongs" (*MAD* #27, April 1956) and "Canadian Clubbed" (*MAD* #26, October–November 1955). This trend continued when Elder made the jump with Kurtzman

Left: Elder's offending panel from "Outer Sanctum" (*MAD* #5, June–July 1953).

to work on Hefner's *Trump*. Working mostly in color, Elder contributed some incredible work, including a spectacular panoramic centerfold for *Trump* #1, the "Epic of Man." A piece intended for the never-published *Trump* #3, a Norman Rockwell send-up called "A Day at Grandma's," rates in the minds of many fans as Elder's finest work. (This was issued as a signed, fine-art-style print in the 1980s by Stabur Press.)

After the demise of *Trump*, Elder became one of the principals on *Humbug* with Harvey Kurtzman, were he did some very strong work that was somewhat hampered by the book's small size and cheap printing.

After *Humbug* stopped publication in 1958, Elder spent several years freelancing, doing work both with Kurtzman and without. Like Jack Davis, Elder created work that can be found in early issues of *Cracked*, a *MAD* imitation. Elder also contributed the "Bridget Bardot" cover for *Cracked*'s tenth issue (August 1959). He also did some advertising work for a Christmas 1959 television spot for Page and Shaw Chocolates, as well as the poster art for the 1962 James Stewart film *Mr. Hobbs Takes a Vacation*.

Elder was an important contributor to Kurtzman's next humor magazine,

Above: Elder's Bridget Bardot cover to *Cracked* #10 (August 1959).

Above: Detail from the classic "Epic of Man," from *Trump* #1 (January 1957), and "A Day at Grandma's" by "Rockwill Elder," intended for the aborted *Trump* #3.

Copyright © 1962 by HELP! Magazine.

Below: Hateful Thoughts for Happy Occasions, an extremely rare 1963 joke book illustrated by Elder.

HELP!, begun in 1960. Elder became Kurtzman's main collaborator. Kurtzman stated that "the magic between me and Willie was, he could be inspired to go far beyond

Above: Detail from "Goodman Meets S*perm*n," HELP! #15 (August 1962). Kurtzman would write and lay out the stories, and Elder would do the finished art, adding an amazing amount of wild and crazy background detail.

my work. Willie would take my work and add twenty additional situations into the background. And he was funny; he was much funnier than I, certainly for that sort of thing. He would carry my stuff forward and enrich it by a multiple of five." In the pages of HELP!, Kurtzman and Elder developed what many feel is their crowning effort, "Goodman Beaver." Again working from Kurtzman's layouts, Elder created art for "Goodman Beaver" that has the quality of a fine woodcut engraving. Of "Goodman Beaver," Elder said in *The MAD Playboy of Art* (a coffee-table book on his work released in 2003) that "this was the greatest time of my life. Every panel was Fantasyland. It had unlimited freedom to express yourself without too many editors peering over your shoulder. 'Goodman Beaver' was our funniest effort."

Elder was also Kurtzman's chief collaborator on *Playboy*'s "Little Annie Fanny," which they began in 1962. The pair worked together on the strip until 1988, often bringing in old friends such as Jack Davis, Arnold Roth, Al Jaffee, and Frank Frazetta to help out.

Apart from their work on "Little Annie Fanny," Elder and Kurtzman did a series of print ads in the late 1970s for ABC-TV,

pushing made-for-TV movies such as *The Love Boat, Love Boat II, Three on a Date,* and *Make Me an Offer.* They also did print ads for two TV pilots, *The Beach Girls* and *Sorority '62.*

Elder and Kurtzman even went back to work on *MAD* in the mid-1980s, producing a number of interior pages and several front and back color covers for the magazine.

When Harvey Kurtzman died in 1993, Elder produced a charming full-page tribute to him that appeared in *The New Yorker.*

Will Elder today is basically retired, sketching and painting here and there just for the fun of it. About all the wonderful antic detail he has always infused into his art, Elder told *The Comics Journal:* "In a sense, I was really entertaining myself. And when people discover that outside of myself, that's just one more bonus for me." Will Elder was inducted into the Will Eisner Hall of Fame in 2003. •

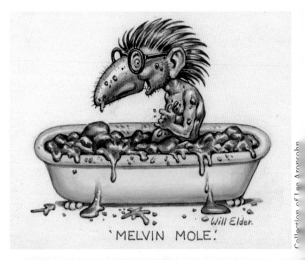

'MELVIN MOLE!'

Above right: A "Melvin Mole" commissioned piece.
Right: Will Elder and Harvey Kurtzman at the 1972 E.C. Fan-Addict Convention in New York City.

AN ENTERTAINING EC COMIC

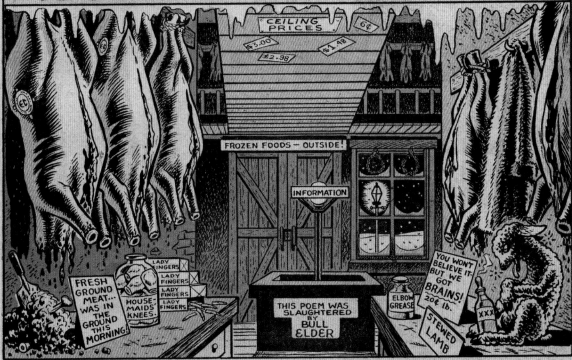

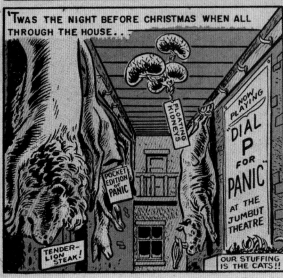

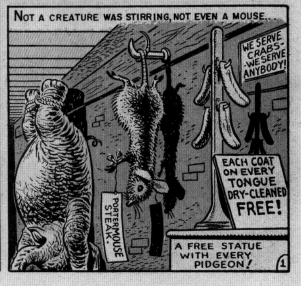

"The Night Before Christmas," from *Panic* #1 (February–March 1954).
Illustrated by Will Elder. Written by Charles Clement Moore.

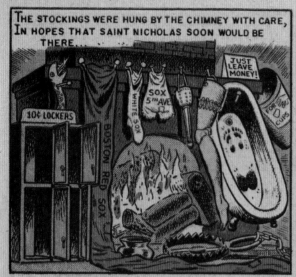

THE STOCKINGS WERE HUNG BY THE CHIMNEY WITH CARE, IN HOPES THAT SAINT NICHOLAS SOON WOULD BE THERE...

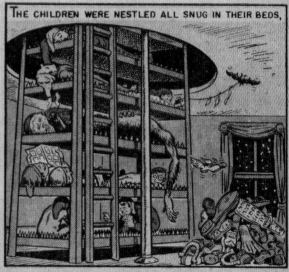

THE CHILDREN WERE NESTLED ALL SNUG IN THEIR BEDS,

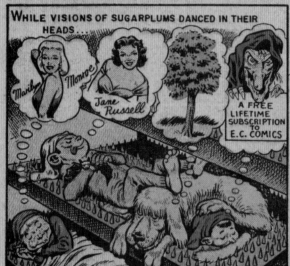

WHILE VISIONS OF SUGARPLUMS DANCED IN THEIR HEADS...

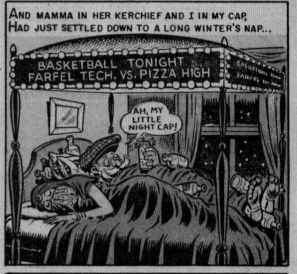

AND MAMMA IN HER KERCHIEF AND I IN MY CAP, HAD JUST SETTLED DOWN TO A LONG WINTER'S NAP...

WHEN OUT ON THE LAWN THERE AROSE SUCH A CLATTER, I SPRANG FROM MY BED TO SEE WHAT WAS THE MATTER...

AWAY TO THE WINDOW I FLEW LIKE A FLASH, TORE OPEN THE SHUTTERS AND THREW UP THE SASH...

THE MOON ON THE BREAST OF THE NEW-FALLEN SNOW,
GAVE A LUSTER OF MIDDAY TO OBJECTS BELOW,

WHEN WHAT TO MY WONDERING EYES SHOULD APPEAR,
BUT A MINIATURE SLEIGH, AND EIGHT TINY REINDEER;

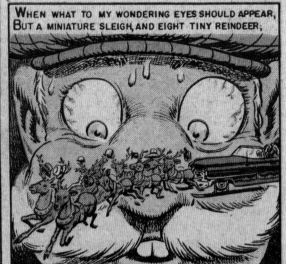

WITH A LITTLE OLD DRIVER, SO LIVELY AND QUICK,
I KNEW IN A MOMENT IT MUST BE ST. NICK..

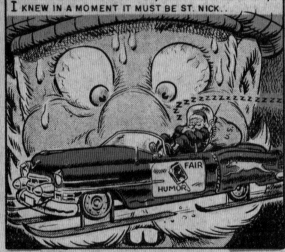

MORE RAPID THAN EAGLES HIS COURSERS THEY CAME,
AND HE WHISTLED, AND SHOUTED, AND CALLED THEM BY NAME;

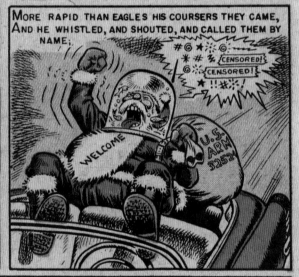

"NOW, DASHER! NOW, DANCER! NOW, PRANCER! AND VIXEN! ON, COMET! ON, CUPID! ON, DONNER AND BLITZEN!
TO THE TOP OF THE PORCH, TO THE TOP OF THE WALL! NOW, DASH AWAY, DASH AWAY, DASH AWAY ALL!"

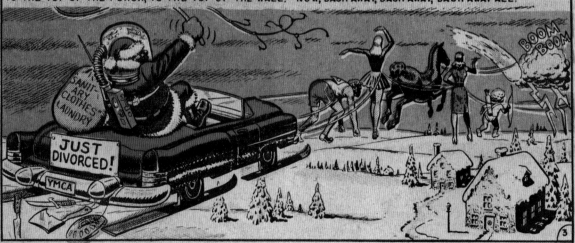

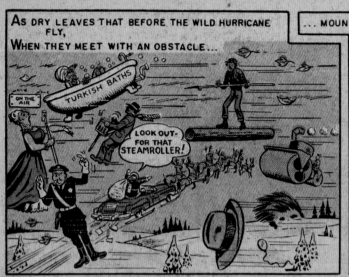

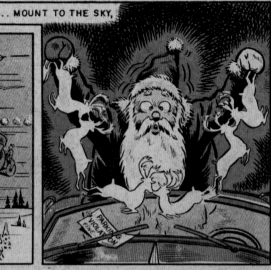

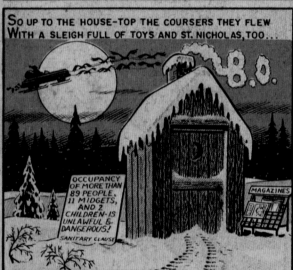

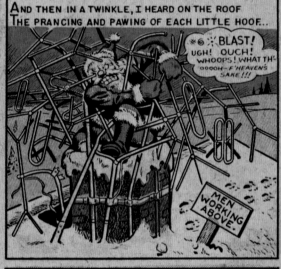

A BUNDLE OF TOYS HE HAD FLUNG ON HIS BACK, AND HE LOOKED LIKE A PEDDLER JUST OPENING HIS PACK...

HIS EYES HOW THEY TWINKLED! HIS DIMPLES HOW MERRY!

HIS CHEEKS WERE LIKE ROSES, HIS NOSE LIKE A CHERRY...

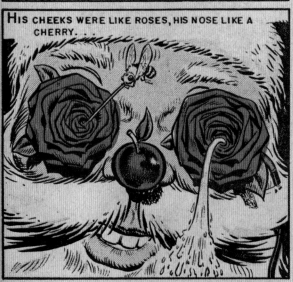

HIS DROLL LITTLE MOUTH WAS DRAWN UP LIKE A BOW, AND THE BEARD ON HIS CHIN WAS AS WHITE AS THE SNOW...

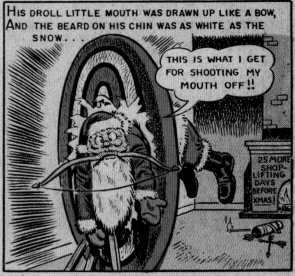

THE STUMP OF A PIPE HE HELD TIGHT IN HIS TEETH.

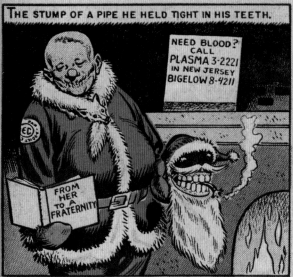

AND THE SMOKE, IT ENCIRCLED HIS HEAD LIKE A WREATH.

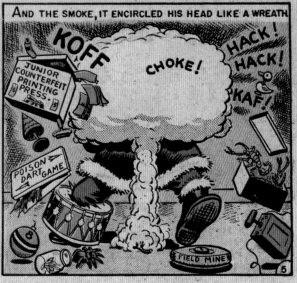

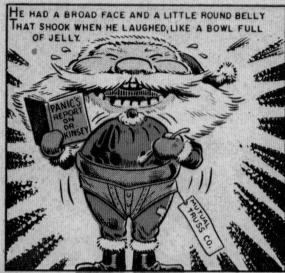

He had a broad face and a little round belly
That shook when he laughed, like a bowl full of jelly.

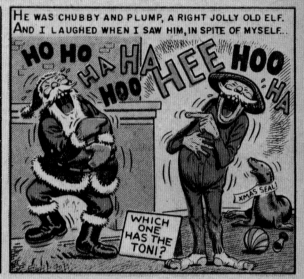

He was chubby and plump, a right jolly old elf.
And I laughed when I saw him, in spite of myself...

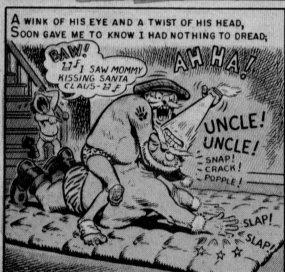

A wink of his eye and a twist of his head,
Soon gave me to know I had nothing to dread;

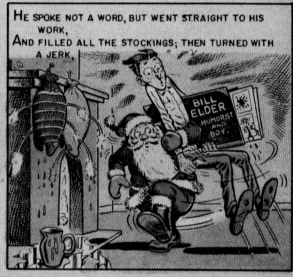

He spoke not a word, but went straight to his work,
And filled all the stockings; then turned with a jerk,

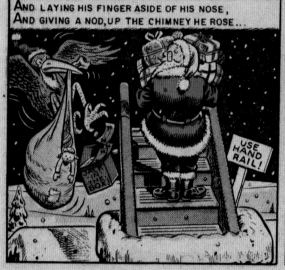

And laying his finger aside of his nose,
And giving a nod, up the chimney he rose...

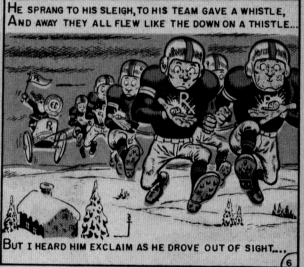

He sprang to his sleigh, to his team gave a whistle,
And away they all flew like the down on a thistle...

But I heard him exclaim as he drove out of sight....

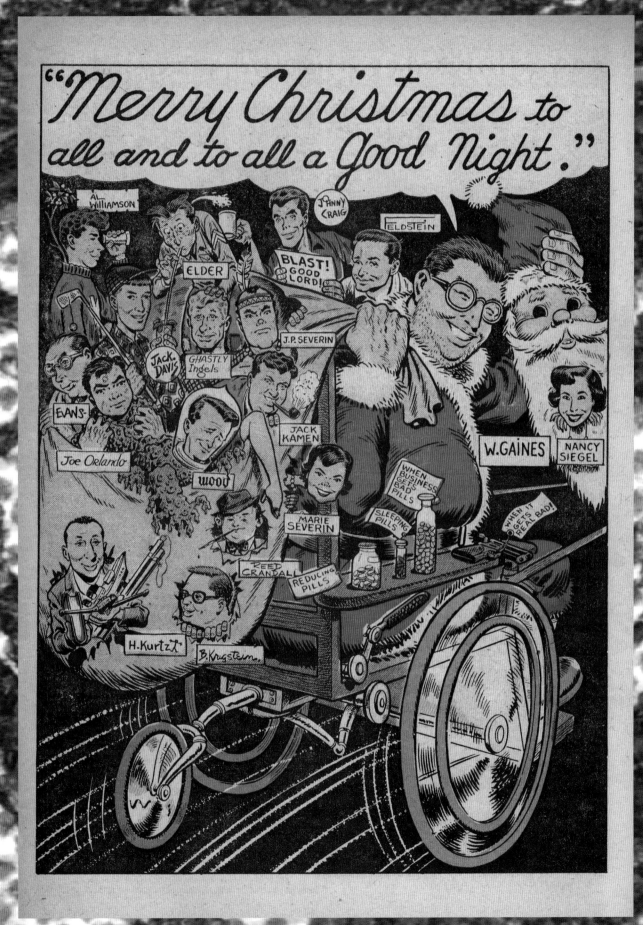

JOHN SEVERIN!

"A VERY *TRADITIONAL* GUY WHO ALWAYS BELIEVED IN *THANKSGIVING* AND *MOTHERHOOD!*" –HARVEY KURTZMAN

John Powers Severin was born in Jersey City, New Jersey on December 26, 1922. He attended the High School of Music and Art in New York City, where he met Harvey Kurtzman, Will Elder, Al Jaffee, Al Feldstein, and Colin Dawkins, who would later collaborate with Severin as a writer. He worked as a machinist in the year after his high school graduation, and then enlisted in the Army.

After his discharge from the Army, Severin rented studio space in the Charles William Harvey Studio, working alongside Kurtzman and Elder. Strangely enough, Severin was not a fan of comic strips or comic books; he'd purchased only a single comic book as a youngster. One day, however, he saw Kurtzman over in the corner working on a comic-book page. Severin asked, "How much do you get paid for doing a page like that?" He was told, and Severin replied, "Gee, that's not bad. How do you get into this stuff?" He got his first job in the comics in November 1947, a story for Joe Simon and Jack Kirby at Crestwood. The story was penciled by Severin and inked by Will Elder— working together at the Charles William Harvey Studio—and the team of Severin and Elder was born. The pair began doing a number of stories for Crestwood, most importantly a long run of covers and stories for *Prize Comics Western*, doing a feature called "American Eagle." The team worked well, said

Severin, because "we both supplied what the other guy needed. He couldn't draw and I couldn't ink."

Severin has a penchant for realism that is matched by few comics artists, with a special interest in the Old West and in various battles from foreign wars. "I try to be accurate about almost anything," Severin told John Benson in a 1970 interview published in *Graphic Story Magazine*. "So if it's authentic about the West, it's just because that's the way I work. And if I get it wrong I'm in trouble with me, if not with anybody else."

Severin and Elder followed Kurtzman over to E.C. at the end of 1950 to work on *Two-Fisted Tales*, and later on *Frontline Combat*. Kurtzman said of the duo that "they complemented each other, and they did some of the finest stuff in that partnership that was ever done in the genre of war books." With Severin's flair for authenticity, he fit in very well with the detail-obsessive Kurtzman. The pair also did a number of science fiction stories for Al Feldstein at E.C., including several important Ray Bradbury adaptations. Bradbury said of the duo in a letter to E.C. dated Easter

Above: Severin/Elder cover to *Prize Comics Western* #85, January–February 1951.

Copyright © 1951 by Feature Publications

Left: Severin's cover to *The New Two-Fisted Tales* #37, April 1954.

Below: Severin self-portrait, 1940s.

Right: Frontline Combat #10, January–February 1953.

le Comte Jean de Severin

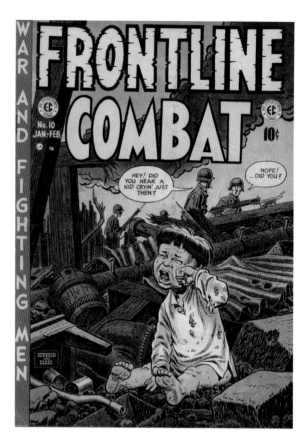

Sunday 1953: "I was delighted to hear you will use the two artists who worked on 'King of the Grey Spaces' to do 'The Million Year Picnic.' I look forward to this." In time, however, the Severin/Elder partnership broke up. "Eventually," Severin told Benson, "both of us were about set to go on our own, so we tried it. It was a friendly sort of thing. We never broke, it's just that we stopped getting jobs together."

Severin was also a significant early contributor to Kurtzman's *MAD* comics, appearing in nine of the first ten issues. Kurtzman loved what Severin did with a pen, but hated the way he used a brush. "John Severin disagreed markedly with my views, and I think his disagreement was unfortunate," Kurtzman has said. "He would want to do brush technique, and I'd tell him to leave the brush alone. So I tried to make him stay with the pen technique, but he'd get angry."

In spite of their disagreements on technique, the two men seemed to have somewhat of a sense of humor about it: in the unreproduced margin on the original art of the splash page to a *MAD* story called "Bop Jokes!" (*MAD* #9, February–March 1954) is this note:

"Harvey,

You thought you'd seen my worst job. Well, you *ain't*, until you've seen *this*!

–J.S."

Severin did no work for Gaines and Feldstein on the E.C. horror comics, basically because he had told Gaines he didn't want to do them. One day in the office someone threw down the gauntlet in front of Gaines, saying, "It's because you *can't* do them." So Severin went home and worked up a couple of

Above middle and bottom: Severin art done as gifts for Bill Gaines in the 1950s.

Above: Severin/Elder splash page to "The Million Year Picnic," *Weird Fantasy* #21, September–October 1953.

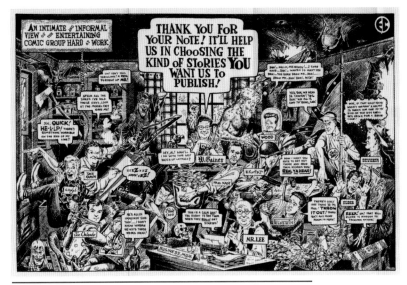

Above: Severin "Thank You for Your Note" flyer, 1952.

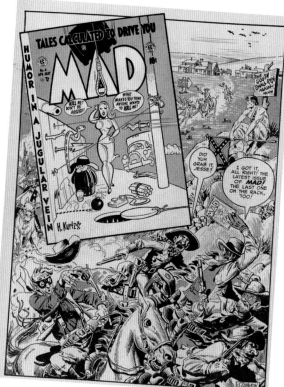

Above: Severin "house ad" for *MAD* #4, which appeared in various E.C. comics in 1953.

drawings. "I took a head, and split it with an ax, and I had all the things dribbling out," he said in *Graphic Story Magazine*. "And I had a guy drop an ax on his foot and cut it, through the shoe and all. Gaines said he threw up when he got the head in the mail. I said, 'It serves you right. You said I couldn't do it.' Hell, I got sick when I *drew* it. I just couldn't do that kind of stuff, with intestines running around the baseline and so forth."

By the end of 1953, Kurtzman was feeling like he had spread himself too thin and wanted to concentrate only on *MAD*. He offered Severin the editorship of *Two-Fisted Tales*, and, anxious to tackle a new challenge, he readily accepted. This would mean, however, that Severin would have to give up his regular slot in the *MAD* comic book. "Sure," Severin said (without the benefit of hindsight), "*MAD* won't last another six months." Severin called in his old friend Colin Dawkins to help with the scripts, and Severin handled what turned out to be the final six issues of *Two-Fisted Tales*.

Severin did some very striking work on the E.C. New Direction newspaper/adventure title *Extra!*, which was edited by Johnny Craig; Severin did five installments of the continuing adventures of "Steve Rampart."

Above: Severin study, done to prove to Bill Gaines that he could do horror.

Copyright © 1953 by E.C. Publications

Above: Severin splash page from "Melvin!," a *Tarzan* parody from *MAD* #2, December 1952–January 1953.

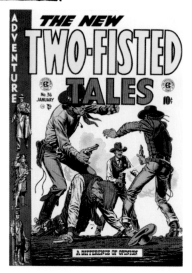
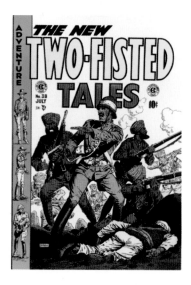
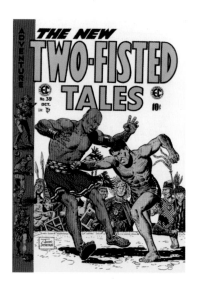

Above: Severin covers for *Two-Fisted Tales* (1954) and three panels from "War Dance!," *Frontline Combat* #13, July–August 1953.

Left: Severin drawing of "Sylvester P. Smythe," *Cracked* magazine's mascot.

When Kurtzman left *MAD* in 1956 and Al Feldstein took over as its editor, Feldstein called Severin to see if he could work on *MAD* Magazine, but the timing was bad, as Severin had just accepted a staff position with Stan Lee at Atlas. "I went to see Stan Lee," Severin said, "and he sympathized with me." But then Lee told him: "Unfortunately, we can't have you working for the competition." Severin initially worked primarily on western stories for Atlas (notably *Kid Colt, Rawhide Kid,* and *The Ringo Kid*), but when Atlas became Marvel in the early 1960s, Severin worked on a wide variety of material, including *The Hulk* and a long run inking Dick Ayers's pencils on *Sgt. Fury and His Howling Commandos.*

Severin was the main artist for *Cracked* (the most successful of the *MAD* imitations) from the first issue in 1958 up until very recently when the magazine changed ownership. He was also the magazine's chief cover artist (doing nearly all of them), and has done literally hundreds of covers for the publication over the years.

In the 1960s, Severin also freelanced for a number of other publishers. For D.C. he regularly worked on *Sgt. Rock.* For Warren, he did beautiful work in *Creepy, Eerie,* and on the short-lived but critically acclaimed war book *Blazing Combat.*

In the early 1970s, he teamed up with his younger sister Marie to work on Marvel's *Kull the Conqueror,* a spin-off of the company's

successful *Conan the Barbarian*. More recently, Severin has worked on Marvel's much-publicized "gay" spin on *Rawhide Kid* and on D.C.'s *Desperadoes* series.

Asked by Benson what his most favorite work had been, Severin replied that it had been for "*Cracked*, Warren, and E.C. And the main reason for that is simply that you have the most free expression with them."

After a long, successful career spanning fifty-six years, John Severin was inducted into the Will Eisner Hall of Fame in 2003. •

Below: Severin covers to *Cracked* #11 (October 1959) and #33 (December 1964).

Left: "Steve Rampart" splash page, *Extra!* #1, March–April 1955.

Above: Severin/Elder splash page to "Counter-Clockwise," a science fiction story from *Weird Fantasy* #18, March–April 1953.

Above: Severin "thank you" notes for Bill Gaines.

Right: Severin book cover for *The Adventures of Lewis and Clark* (Random House, 1968).

173

... FOR US the LIVING

ON THE MORNING OF MAY 12, 1953, TWO AGENTS OF THE FEDERAL BUREAU OF INVESTIGATION ENTERED THE ATOMIC ENERGY COMMISSION'S BUILDING IN WASHINGTON, D.C., STRODE SILENTLY ACROSS THE LOBBY, AND CLIMBED THE MARBLE STAIRS TO A SECOND-FLOOR OFFICE. A GREY-HAIRED, MIDDLE-AGED MAN LOOKED UP FROM HIS DESK STACKED HIGH WITH CONFIDENTIAL FOLDERS, GLANCED AT THE GLEAMING BADGE ONE OF THE MEN HELD IN HIS HAND, AND ROSE SLOWLY, ALMOST RESIGNEDLY, TO HIS FEET...

DOCTOR RUSSELL CROMWELL. YOU ARE UNDER ARREST.

I...I WAS EXPECTING THIS. IT WAS INEVITABLE THAT I'D BE DISCOVERED. IT WAS ONLY A MATTER OF TIME. I'LL... GET MY THINGS.

THE GREYING ATOMIC SCIENTIST WENT TO A CLOSET, TOOK OUT A SMALL SUITCASE, AND TURNED TO THE F.B.I. MEN...

YOU'LL WANT TO SEE THIS... WHAT I HAVE IN THIS SUITCASE. SHALL WE... GO?

WE HAVE A CAR DOWNSTAIRS, DOCTOR CROMWELL.

THEY DROVE HIM TO F.B.I. HEADQUARTERS. THEY LED HIM INTO A SMALL WINDOWLESS ROOM AND SAT HIM IN A CHAIR. THEY TOLD HIM WHY HE'D BEEN ARRESTED. HE NODDED...

YES, GENTLEMEN. YES! EVERYTHING YOU SAY IS TRUE! MY IDENTIFICATION PAPERS ARE FALSE! MY BIRTH CERTIFICATE HAS BEEN FORGED! MY RECORD IS A FAKE! I ADMIT ALL YOUR CHARGES.

THEN YOU ADMIT BEING A SPY... A SABOTEUR... BENT ON STEALING ATOMIC SECRETS FOR A FOREIGN POWER?

SEVERIN AND ELDER

"... For Us the Living," from *Weird Fantasy* #20 (July–August 1953).
Penciled by John Severin, inked by Will Elder. Written by Bill Gaines and Al Feldstein.

DOCTOR CROMWELL SHOOK HIS HEAD SLOWLY. HE HELD UP HIS THIN SENSITIVE HAND...

NO! NO, THAT IS WHERE YOU ARE *WRONG!* I DO *NOT* ADMIT WORKING FOR A *FOREIGN* POWER! I AM WORKING FOR THE BENEFIT OF *MANKIND...* FOR THE *REPUBLIC OF EARTH!*

PLEASE, DOCTOR. WE ARE NOT DISCUSSING YOUR *SOCIOLOGICAL BELIEFS!* SPECIFICALLY *WHICH* NATION ARE YOU *WORKING* FOR?

I WORK FOR *NO PRESENT NATION ON EARTH!* I WORK FOR A *DIFFERENT* EARTH... A *UNITED, PEACEFUL* EARTH... AN EARTH THAT EXISTED IN AN *ALTERNATE TIME-BRANCH.*

IN *OTHER* WORDS, YOU *REFUSE* TO *COOPERATE...* TO GIVE US THE *FACTS!*

GENTLEMEN, I *AM* GIVING YOU THE FACTS. I AM *NOT* FROM *YOUR* WORLD... *THIS WORLD.* I AM A *CASTAWAY* IN YOUR WORLD. I AM FROM A WORLD THAT *EXISTS NO LONGER* BECAUSE I HAVE *DESTROYED* IT... *ERASED* IT...

THE F.B.I. MEN LOOKED AT EACH OTHER AND GRIMACED...

GUESS THERE ISN'T ANYTHING *WE* CAN DO WITH HIM, PERRY!

I'D BETTER GET THE *CHIEF*, SOL.

GET YOUR CHIEF! LET ME TELL YOU ALL WHAT *HAPPENED!* LISTEN TO MY *STORY!*

THE F.B.I. CHIEF ENTERED THE SMALL ROOM. DOCTOR CROMWELL POINTED TO HIS SUITCASE...

OPEN THE *SUITCASE! SEE* FOR *YOURSELF!* THE *CURSED MACHINE* IS THERE... THE MACHINE THAT *CAUSED* ALL OF THIS...

OPEN IT, PERRY.

OKAY, SIR.

THE AGENT NAMED PERRY UNLATCHED THE SUITCASE AND LIFTED THE LID. INSIDE, CAREFULLY WRAPPED IN EXCELSIOR, WAS A SMALL COMPLICATED-LOOKING APPARATUS...

ALL RIGHT, DOCTOR CROMWELL. WHAT *IS* IT?

THAT, GENTLEMEN, IS A *TIME-MACHINE.*

A *WHAT?!*

A *TIME-MACHINE.* A MACHINE THAT *I* BUILT. A MACHINE THAT CAUSED THE DESTRUCTION OF *MY* WORLD AND THE *CREATION* OF *YOURS!* A MACHINE THAT COULD *EVENTUALLY RE-CREATE MY* WORLD AGAIN... AND, GOD WILLING, *DESTROY* YOURS...

LOOK, DOCTOR. YOU'RE TALKING *PRETTY WILDLY!* SUPPOSE WE DON'T *WANT* YOU TO DESTROY *THIS* WORLD!

2

OH, *YOU WOULD!* YOU'D *WANT* ME TO IF YOU *KNEW* OF *MY WORLD*... THE *WONDERFUL* WORLD *I CAME* FROM! LET ME *TELL* YOU ABOUT *MY WORLD!* LET ME TELL YOU WHAT *HAPPENED!*

HE'S *SICK,* SIR.

GIVE HIM A CHANCE. START *TALKING,* DOCTOR...

DOCTOR RUSSELL CROMWELL LEANED BACK IN HIS CHAIR AND STARED OFF INTO SPACE. A LIGHT SEEMED TO SUDDENLY COME INTO HIS SAD EYES. HIS GRIM MOUTH RELAXED...SMILED. HIS VOICE WAS SOFT...ALMOST REVERENT...

MY WORLD WAS A WORLD OF *PEACE*... OF *BROTHERHOOD*...OF *FREEDOM.* IT WAS A TRULY *UNITED* WORLD...

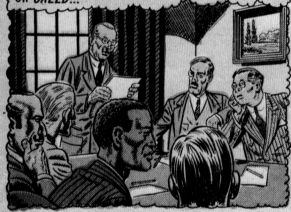

'IT WAS A WORLD WHERE *ALL* OF THE RACES OF MAN LIVED IN *HARMONY*...WHERE *NO SUCH THING* AS *PREJUDICE* EXISTED BECAUSE OF A MAN'S *COLOR* OR *CREED*...'

'IT WAS A WORLD OF *PEACE* AND *UNDERSTANDING*... A WORLD WHERE *ALL NATIONS* HAD *LONG BEFORE* LAID DOWN THEIR *ARMS* AND *JOINED TOGETHER* IN A *COMMON GOVERNMENT* KNOWN AS *THE REPUBLIC OF EARTH*...'

'MY WORLD WAS A WORLD OF *SCIENTIFIC ADVANCEMENT* BEYOND YOUR *WILDEST DREAMS,* A WORLD OF *GLEAMING CITIES*...!'

'...OF *TECHNOLOGICAL COMFORTS* FAR IN ADVANCE OF *YOUR* SOCIETY...'

'...A *UTOPIA* OF *PLENTY* FOR *ALL!*'

'MEDICINE HAD LONG-SINCE CONQUERED THE ILLS THAT STILL PLAGUE YOUR WORLD. CANCER... HEART DISEASE...'

'SPACE-TRAVEL HAD BEEN ATTAINED. GLEAMING ROCKETS SPED AWAY FROM PEACEFUL EARTH TO THE TWINKLING DISTANT STARS...'

'ATOMIC POWER BELONGED TO MANKIND... AS AN INSTRUMENT OF CONSTRUCTION, NOT DESTRUCTION.'

WARNI
THIS EN
FOR EMPI

DOCTOR CROMWELL POINTED TO THE COMPLICATED APPARATUS IN THE OPEN SUITCASE...

AND IT WAS IN AN ATOMIC LABORATORY OF MY WORLD THAT I DEVELOPED THAT CURSED TIME-MACHINE.

SO YOU CAME BACK HERE... TO VISIT US?

DOCTOR CROWELL SHOOK HIS HEAD...

I'M AFRAID YOU DON'T UNDERSTAND! I COULDN'T COME BACK TO VISIT YOU. YOUR WORLD DIDN'T EXIST. I CREATED IT WITH THAT MACHINE.

HOW?

FIRST LET ME TELL YOU ABOUT THE MAN WHO WAS RESPONSIBLE FOR THE GLORIOUS WORLD I CAME FROM. LET ME TELL YOU OF HIS WORK... HIS DREAMS... HIS TEACHINGS. HE WAS LIKE A SHINING LIGHT, LEADING HIS NATION THROUGH A STRUGGLE FOR FREEDOM... A WAR...

'IT WAS A HORRIBLE WAR WHERE BROTHER KILLED BROTHER ...A WAR THAT ALMOST DESTROYED THE NATION HE LOVED...'

4

'BUT WHEN THE WAR WAS *OVER*, HE *BOUND UP* THE NATION'S WOUNDS, AND USHERED IN AN ERA OF *PEACE* AND *BROTHERHOOD*. THE NATION *REBUILT* ITSELF, AND THE WORLD *WATCHED*...'

'AND THE GREAT MAN'S TEACHINGS *SPREAD* THROUGHOUT THE WORLD, AND *OPPRESSED PEOPLES EVERYWHERE* WERE FREED FROM THEIR *POVERTY* AND *SLAVERY*...'

'AND EVEN AFTER HE HANDED OVER THE REINS OF *HIS* GOVERNMENT TO ANOTHER, HE *STILL CONTINUED* TO *ADVISE* AND *GUIDE* UNTIL THE *WORLD* WAS *UNITED* UNDER *ONE* GOVERNMENT...'

'HE WAS THE *FOUNDER* AND THE *FATHER* AND THE *GUIDING LIGHT* OF MY WORLD. AFTER HIS DEATH, AT AGE 87, HIS DREAMS AND HOPES WERE *CARRIED ON BY OTHERS*. HE BECAME AN *UNIVERSAL HERO*... AN *IDOL*. I REMEMBER, AS A CHILD, VISITING HIS FINAL RESTING PLACE IN THE WORLD CAPITAL, PARIS...'

'WASN'T IT ONLY *NATURAL*, THEN, THAT WHEN I *INVENTED* MY TIME-MACHINE, I SHOULD WANT TO GO *BACK* TO THE ERA DURING WHICH THIS GREAT MAN LIVED... TO *SEE* HIM AS HE *WAS*... AT THE VERY *INCEPTION* OF THE WORLD I KNEW...'

YES, *YES! BEFORE* I MAKE MY REPORT... BEFORE I TURN THIS MACHINE OVER TO *MANKIND*, I WILL USE IT *ONCE*...FOR *MY PERSONAL PLEASURE*.

DOCTOR CROMWELL CLEARED HIS THROAT. THE F.B.I. MEN AND THE F.B.I. CHIEF WAITED, APPREHENSIVELY...

AND SO YOU *CAME BACK HERE*..?

NO...NO! I WENT BACK INTO *MY* WORLD'S PAST! IT WAS *FOOL-ISH!* IF I HADN'T *DONE* IT, I WOULDN'T HAVE *CHANGED* EVERY-THING. I DRESSED MYSELF IN THE *CLOTHING* OF *THE GREAT MAN'S ERA*...

'I SET MY MACHINE. I PLACED THE CORRECT AMOUNT OF *ATOMIC FUEL* INTO THE ENERGIZING UNIT. I ATTACHED THE WRIST BANDS WITH NERVOUS FINGERS. THEN I PRESSED THE CONVERTER SWITCH...'

'I WENT *BACK*...INTO THE *PAST*...BACK TO *THE TIME OF THE GREAT MAN*...TO *WASHINGTON, D.C.*...TO AN *APRIL EVENING*. I STOOD IN AN ALLEY, WATCHING... THE TIME-MACHINE IN A SUIT-CASE...'

'THE *GREAT MAN* WAS ATTENDING THE THEATER. I MINGLED WITH THE CROWD. I LONGED FOR JUST *ONE LOOK* AT HIM...'

'SO I SLIPPED INTO THE *STAGE-ENTRANCE* OF THE THEATER, MADE MY WAY TO THE BOX WHERE HE WAS SEATED...'

'THE BOX WAS GUARDED BY *TWO MEN*.* THEY *SAW* ME IN THE SHADOWS...*RUSHED* TO ME... *SEIZED* ME...'

ALL RIGHT, YOU...

'THEY WERE *PROTECTING* HIM... *THE GREAT MAN*. THEY THOUGHT I MEANT TO DO HIM *HARM*. I *STRUGGLED*, DENYING THEIR CHARGES...'

AN ASSASSIN!

NO! NO!

*APPARENTLY DOCTOR CROMWELL HERE REFERS TO JOHN F. PARKER, THE *GREAT MAN'S* BODYGUARD, AND TO CHARLES FORBES, HIS VALET! — ED.

'THEY FORCED ME DOWN THE CORRIDOR, *LEAVING THE BOX UNGUARDED*...'

COME WITH *US!*

YOU'RE ALL WRONG!

'SUDDENLY, A SHOT RANG OUT...'

GOOD LORD!

WHAT WAS THAT?

POW! EEEEEEEEEE...

6

'A FIGURE LEAPED TO THE STAGE OF THE THEATER, SHRIEKING...'

SIC SEMPER TYRANNIS! *

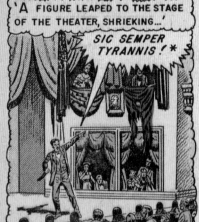

*SO MAY IT ALWAYS BE WITH TRAITORS!

'THE *GREAT MAN* SLUMPED, *MORTALLY WOUNDED*, A *DER-RINGER PISTOL-BALL* IN HIS *BRAIN*...'

HE'S BEEN SHOT...

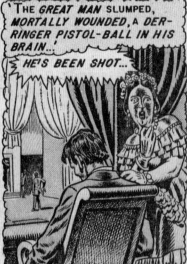

'AND IN THE CONFUSION I ESCAPED WITH MY MACHINE...'

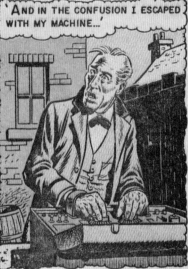

DOCTOR CROMWELL'S VOICE FALTERED, HIS EYES FILLING WITH TEARS...

YES, GENTLEMEN. IT WAS *MY FAULT*...ALL *MY FAULT*. IF *I* HADN'T *CAUSED THE ATTENDANTS TO LEAVE THE GREAT MAN'S BOX UNGUARDED*, HE'D *NEVER* HAVE BEEN *ASSASSINATED* BY *JOHN WILKES BOOTH*...

HE...HE WAS *ABRAHAM LINCOLN?*

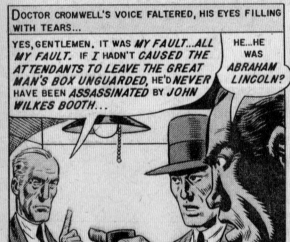

DOCTOR CROMWELL NODDED...

YES. *ABRAHAM LINCOLN.* YOU SEE, IN THE WORLD WHERE *I* COME FROM... THAT *OTHER* WORLD IN AN *ALTERNATE TIME-BRANCH*... ABRAHAM LINCOLN *LIVED*, AND BROUGHT TO THAT WORLD *PEACE* AND *BROTHERHOOD* AND *FREEDOM*...

...AND *YOU CHANGED HISTORY*...

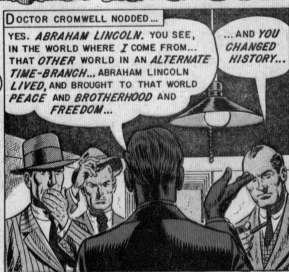

EXACTLY! I HAD *COME* FROM THE YEAR *1953* OF *MY* WORLD... A WORLD IN WHICH LINCOLN *ESCAPED ASSASSINATION!* BECAUSE I *CHANGED HISTORY*, I COULD ONLY RETURN TO THE *1953* OF *YOUR* WORLD... A WORLD THAT RESULTED BECAUSE LINCOLN HAD BEEN *SHOT.* THAT'S WHY I WAS *WORKING* FOR THE ATOMIC ENERGY COMMISSION. I WAS TRYING TO DEVELOP THE *ATOMIC FUEL I NEED.*

THE TIME-MACHINE IS *USE-LESS WITHOUT IT.* ONCE I *HAVE* IT, I WILL BE ABLE TO *RETURN* TO APRIL 14, 1865, AND *RE-*CHANGE HISTORY ...CHANGE IT *BACK AGAIN*... MAKE SURE LINCOLN WAS *NOT* SHOT...SO THAT *MY* WORLD WILL *EXIST ONCE MORE*...

THE F.B.I. CHIEF LOOKED AT HIS TWO ASSISTANTS. HE STOOD UP... SMILING...

DON'T YOU...*DON'T YOU BELIEVE ME?*

IT'S AN *INTER-ESTING STORY*, DOCTOR. *VERY INTERESTING.* CAN YOU *PROVE* IT? *ANY* OF IT?

7

DOCTOR CROMWELL POINTED TO THE TIME-MACHINE IN THE SUITCASE...

IF I HAD THE *FUEL*...

THEN YOU *CAN'T* PROVE IT!

THE SAD-EYED DOCTOR SHOOK HIS HEAD...

N-NO! I... CAN'T!

THEN I'M AFRAID WE'LL HAVE TO *HOLD* YOU, DOCTOR!

DOCTOR CROMWELL WAS LED FROM THE SMALL WINDOWLESS ROOM...

PRETTY *FAR-FETCHED* YARN, *EH*, SIR?

DON'T BE TOO *SURE*, SOL.

THE F.B.I. CHIEF TURNED TO HIS ASSISTANT...

YOU *KNOW*, SOL, IT'S LUCKY FOR US WE *DISCOVERED* THE DOCTOR BEFORE HE *DEVELOPED* HIS ATOMIC FUEL.

YOU *BELIEVE* THAT RIDICULOUS NONSENSE, SIR?

THE CHIEF SHRUGGED...

I DON'T KNOW! BUT WHAT'S *IMPORTANT* IS THAT *THIS* IS *OUR* WORLD. *GOOD* OR *BAD*, IT'S *OURS*. WHAT'S *DONE* IS *DONE*. WE HAVE TO MAKE THE *BEST* OF WHAT WE'VE *GOT*. WHY, *WE* PROBABLY WOULDN'T EVEN *EXIST* IN 'HIS WORLD'!

GOOD THOUGHT, SIR! OH...WHAT SHALL I DO WITH *THIS* GADGET?

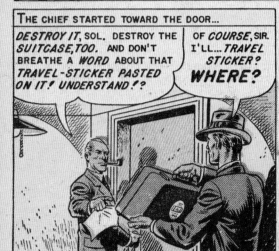

THE CHIEF STARTED TOWARD THE DOOR...

DESTROY IT, SOL. DESTROY THE *SUITCASE*, TOO. AND DON'T BREATHE A *WORD* ABOUT THAT *TRAVEL-STICKER* PASTED ON IT! UNDERSTAND!?

OF *COURSE*, SIR. I'LL... *TRAVEL STICKER*? *WHERE*?

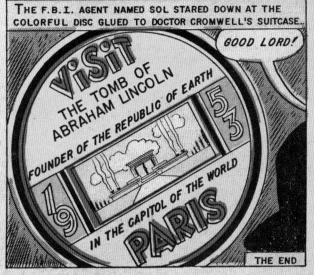

THE F.B.I. AGENT NAMED SOL STARED DOWN AT THE COLORFUL DISC GLUED TO DOCTOR CROMWELL'S SUITCASE...

GOOD LORD!

VISIT THE TOMB OF ABRAHAM LINCOLN FOUNDER OF THE REPUBLIC OF EARTH

53

19

IN THE CAPITOL OF THE WORLD

PARIS

THE END

GEORGE EVANS!

"YOU WOULD NEVER *DREAM* THAT THIS MAN WAS *CAPABLE* OF SUCH *BRILLIANT* DEPICTIONS OF *BRUTALITY!*" —BILL GAINES

George Evans was born on February 5, 1920 in Harwood, Pennsylvania. His earliest art training came from a correspondence course he sent away for at the age of fifteen. He also spent a year at the Scranton Art School. At a young age, Evans developed a dual fascination with art and airplanes, and by the age of sixteen he was contributing illustrations to the aviation pulps.

Evans spent three years in the Army Air Corps during World War II, and when he came out in 1946 he became a staff artist at Fiction House. He started out as an assistant, and worked his way up the ranks into doing feature stories, including "Tigerman" in *Fight Comics*, "The Lost World" in *Planet Comics*, and "Jane Martin" in *Wings Comics*. Evans also had work published in some of Fiction House's pulp magazines.

He freelanced for at time at Better Publications, but didn't particularly like the people he was working with. Evans's good friend Al Williamson suggested that Evans try Fawcett (the home of *Captain Marvel),* and Evans began to work there in 1949, where he drew for such titles as *Captain Video* and *When Worlds Collide.* Evans found a nice, family atmosphere with the people at Fawcett, and was very content with his situation. In 1952, however, Fawcett was nearing the end of a lawsuit brought by D.C. Comics over

alleged similarities between *Superman* and *Captain Marvel.* Finally throwing in the towel, Fawcett decided to cease publication of comic books altogether. "I loved working at Fawcett's," Evans told Paul Wardle in a 1992 interview published in *The Comics Journal.* "I would never have left them, but they went under."

Again Al Williamson stepped up for his friend, suggesting that E.C. had the same "family" feel that Evans was used to, and encouraged him to go meet Gaines and Feldstein. They gave him an assignment right away ("All Washed Up!," *The Haunt of Fear* #15, cover dated September–October 1952). Gaines and Feldstein loved what Evans came back with, and they kept him busy from then on. Evans did consistently good work in E.C.'s horror, science fiction, crime, shock, and war titles. Evans told interviewer Andy Lee in *Comic Book Marketplace*: "When Fawcett went under and I lost those friends up there and they scattered to different places, I stepped into another family: E.C. To the day Bill died, he was a

Below: Evans's splash page from *Captain Video* #1, February 1951.

Left: Detail from Evans's cover to *Shock SuspenStories* #18, August–September 1953.

Copyright © 1951 by Fawcett Publications

183

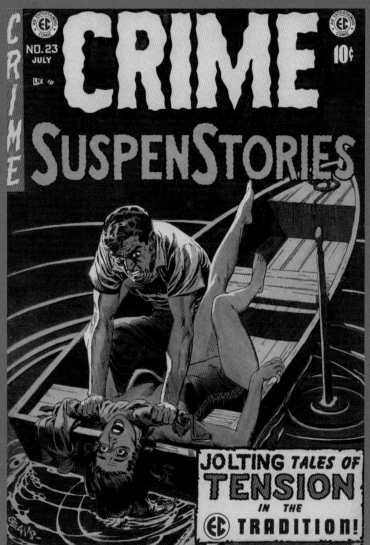

Left: Splash page from Evans's first E.C. story, "All Washed Up!," *The Haunt of Fear* #15, September– October 1952)

Left: Evans's cover to *Crime SuspenStories* #23 (June–July 1954) caught the attention of the Senate Subcommittee to Investigate Juvenile Delinquency. Here is an excerpt from Bill Gaines's April 21, 1954 testimony before them:
Senator Kefauver: This is the July one. It seems to be a man with a woman in a boat and he is choking her to death here with a crowbar. Is that in good taste?
Mr. Gaines: I think so.
Senator Kefauver: How could it be worse?

friend." Bill Gaines said of Evans in *E.C. Lives!* that "George was another sweet, lovable guy; quiet and gentlemanly. He could do the most ghastly stuff in the *Crime* and *Shock* books. This sweet little fella looked like an accountant, and you would never dream that this man was capable of such brilliant depictions of brutality." Al Feldstein said that "George was a professional. His work was realistic and controlled, and we would therefore give him the 'slicker' things to do. His work was like his character." Comic historian Michelle Nolan has referred to Evan's work as "vivid, exacting, and highly realistic." Evans usually played down the horrific elements in his stories, saving the gruesome or shocking element for the final panel. "I'm not bringing anyone out of the sewer who is putrid and decaying," Evans told *The Comics Journal.* "Al

Feldstein would tailor the stories to fit the artist that would be drawing them. For me, he generally had some plot where ordinary, naive guys get mixed up in horrific situations."

Evans regularly worked on Harvey Kurtzman's war comics. More than any of the other E.C. artists, Evans hated working with Kurtzman's tissue-paper layouts, feeling that Kurtzman was stifling his creativity. "I did a lot of work for him, and I still wonder if he was pleased with anything I did," Evans said in *E.C. Lives!* If Evans varied from Kurtzman's layouts–which Evans would invariably do, not out of spite, but to make what he thought was a better illustration–Kurtzman would ultimately tell Evans that he had "desecrated his story." On the other hand, Evans loved working for Gaines and Feldstein. Evans said in *The Comics Journal*: "When you brought in

the finished art, Al would say, 'Oh geez, I never imagined a picture like that. Look at this, Bill.' And Bill would look and say, 'Holy cripes! Here's another one, Al.' This was a delight. You'd work for them for free."

When E.C. ceased publication of their horror and crime comics in 1954, Evans did the covers and all the interior stories for all five

HENRY GRINNED DOWN INTO THE BLOODY KITCHEN SINK, AND LISTENED WITH RAPTURE AND RELIEF AS THE BRAND NEW GARBAGE DISPOSAL UNIT STOPPED GRINDING AND SUCKING AND CHATTERING AND BEGAN TO HUM SMOOTHLY. IT HAD DONE ITS JOB WELL. HENRY SIGHED WITH SATISFACTION, STOOPED, OPENED THE CABINET DOORS BELOW THE SINK, AND SWITCHED THE UNIT OFF. THE SILENCE OF THE HOUSE CLOSED IN AROUND HIM. HE TURNED AND KNELT AND BEGAN SPONGING UP THE POOL OF SCARLET ON THE KITCHEN FLOOR...

GOOD-BYE, RITA! AND GOOD RIDDANCE...

GEORGE EVANS

Above: A panel from "Indisposed!," *The Haunt of Fear* #25, May–June 1954.

issues of the New Direction title *Aces High.* Feldstein recalled that "George was a World War I airplane buff, and we did *Aces High* because we knew that George was great at that stuff and would do well." In the opinion of many E.C. buffs, Evans not only did "well" on *Aces High*, but produced some of his best work ever. Nolan referred to Evans's art on these books as "classically beautiful," and the cover art "so realistic and cinematic you virtually feel you are in the middle of an air battle."

The highly versatile Evans also had work in two other New Direction titles, *M.D.* and

Impact, and did several stories for three of the E.C. Picto-Fiction magazines: *Shock Illustrated, Crime Illustrated,* and *Terror Illustrated.* Of the E.C. comics and his association with them, Evans told Lee: "They were very successful comic books and they dominated each field—science fiction, horror, shock-suspense. The scripts were intelligent; they didn't write down to readers. Everybody at E.C., knowing that this was stuff that was a little better than the run of the mill stuff, worked a little harder and tried to capture what Al Feldstein was writing about."

When E.C. stopped publishing comics, Evans took his portfolio down to see Bob Kanigher, the editor of the war titles at D.C. Comics. Evans told *The Comics Journal* that Kanigher looked at him and said: "Oh, you're one of those bastards from E.C. who ruined the whole industry, and now you think you're going to move in here, and we're going to pay you?" Evans packed up his portfolio and walked out.

Evans did land work at Gilberton, publisher of *Classics Illustrated*, doing comic adaptations of such classics as *The Hunchback of Notre Dame, Romeo and Juliet, The Three Musketeers,* and *Lord Jim,* often working in collaboration with Reed Crandall. He stayed with them until 1962. For

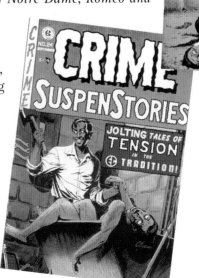

Above: Evans's *Crime SuspenStories* and *Shock SuspenStories* covers had a very realistic feel to them, settings where, said Evans, "ordinary, naive guys get mixed up in horrific situations."

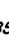

GEO.EVANS.

Right: Three panels from "Last Resort," *Crime SuspenStories* #23 (June–July 1954).

Above: Evans snuck in a little tribute to Al Williamson in this panel from "As Ye Sow . . . ," *Shock SuspenStories* #14 (April–May 1954).

Dell/Gold Key, Evans did some nice work in the early 1960s on their long-running *The Twilight Zone* comic, and on the movie tie-in one-shots *Edgar Allan Poe's Tales of Terror* and *Hercules Unchained.* He also did a number of stories that were very much in the E.C. tradition for James Warren's mid-1960s black-and-white magazines *Creepy* and *Eerie.*

In spite of his earlier experience at D.C., Evans finally did do some attractive work for the company in the late 1960s, primarily in their "supernatural" titles, their war comics, and on *Blackhawk.*

In 1960, Evans began ghosting the daily syndicated strip "Terry and the Pirates" for George Wunder, a position he held until 1972. Not being able to sign his work was a drawback, but what the job lacked in notoriety it made up with a steady paycheck. Evans also did some comic-related parodies in the 1970s for the *National Lampoon.* And at Al Williamson's request, in the early 1980s Evans took over the "Secret Agent Corrigan" syndicated strip. "I wrote and illustrated it," he told Lee. "It wasn't making a great deal of money, but I enjoyed the heck out of doing it."

Nolan has referred to Evans as one of the comic art field's "most under-rated artists." No doubt the low-profile (but high-quality) work Evans has done over the last several decades didn't help matters. But to E.C.'s fans, Evans remains one of its most highly regarded artists. Evans, who passed away on June 22, 2001 at the age of eighty-one, summed up his career approach to Andy Lee with a message to his fans: "I hope they know I always did my best. Even in the *Classics Illustrated* days, with those very low rates, Reed Crandall and I (working together) did our best. If it required research, we did it. In everything I did, both working with others and solo, I did my darndest to give the fans the best interpretation I could give and the most enjoyment I could provide for them. In doing that, I enjoyed it just as much as they did. So, to those fans: 'Hi guys! We're all one tribe!'" •

Left: George Evans at the 1972 E.C. Fan-Addict Convention in New York City.

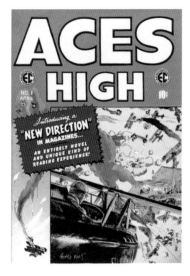
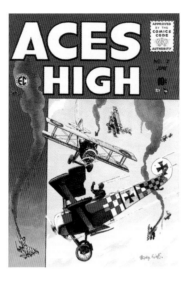

Above: Evans's covers for E.C.'s New Direction line were breathtakingly realistic. As a long-time aviation buff, he prided himself on getting every detail of the vintage aircraft on the *Aces High* covers correct. And on the *Piracy* cover he perfectly captured the feeling of being underwater.

<div style="writing-mode: vertical">*Aces High* sketches courtesy of Charlie Roberts</div>

"The Hun in the Sun"

Barber Basting

Left: Evans's concept sketches for an *Aces High* cover commission. The final artwork is shown on the following page.

AN ENTERTAINING COMIC

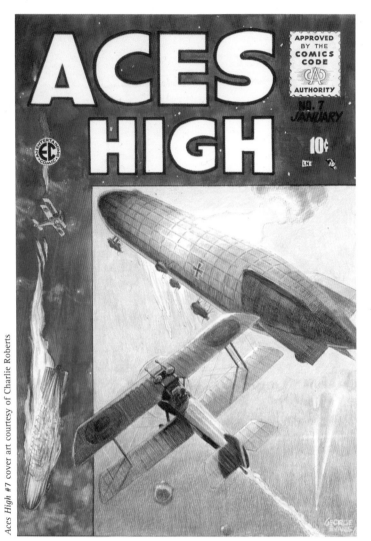

Aces High #7 cover art courtesy of Charlie Roberts

Left: The "non-existent" cover to *Aces High* #7, which Evans did on a commission from a fan. (There were only five issues of *Aces High*.)
Below: A World War I–era dogfight, done by Evans in 1994.

THE VAULT OF HORROR!

HEH, HEH! AND NOW THAT *C.K.* HAS *CURDLED* YOUR *ANEMIC BLOOD*, IT'S TIME FOR YOUR *HOST* IN *THE VAULT OF HORROR*, THE *VAULT-KEEPER*... NAMELY, *ME*...TO *ENTERTAIN* YOU WITH A *SPINE-TINGLING*, *NAUSEATING NOVELETTE* FROM *MY CREEP COLLECTION*. LET'S *SEE!* OH...LET'S *NOT* SEE! YES! *THIS* IS A *GOOD GORY ONE!* IT'S CALLED...

BLIND ALLEYS

THE "HOME" WAS OLD AND PAINT-STARVED AND DRAFTY AND BADLY IN NEED OF REPAIR. THE ROOF LEAKED AND THE WINDOWS RATTLED AND WERE COVERED WITH YEARS OF DUST AND GRIME. THE INMATES OF THE HOME WALKED GRIM-FACED AND SILENT THROUGH CRACKED PLASTER HALLS, OR SAT IN DINGY ROOMS ON CRAWLING BEDS. THEY SHIVERED IN THE COLD WHEN WINTER CAME...WHEN THERE WAS NO STEAM TO WARM THE RUSTED RADIATORS...

...AND THEY SWELTERED IN THE HEAT WHEN SUMMER BURNED...WHEN LONG-BROKEN FANS LAY IDLE AND UNREPAIRED AND UNABLE TO WAFT A BREATH OF COOLING RELIEF...

"Blind Alleys," from *Tales from the Crypt* #46 (February–March 1955).
Illustrated by George Evans. Written by Bill Gaines and Al Feldstein.

BUT THEY COULD NOT *SEE* THE PAINT-PEELED WALLS...THE DIRT CLOUDED WINDOWS... THE DUSTY AND COB-WEBBED HALLS OF THIS, THEIR HOME...THESE INMATES. THEY COULD NOT *SEE* THE ROACHES AND THE RATS SCAMPERING ACROSS THE UNWASHED FLOORS...

... AS *THIS* WAS A "HOME" FOR THE *BLIND*...FOR *WRETCHED SOULS* WHO *LIVED* IN WORLDS OF *DARKNESS*...WHO STARED WITH *UNSEEING* EYES AT THE MISERY AROUND THEM... AND YET *KNEW* AND *HATED* ALL OF IT...

FOR THE LOSS OF *ONE* SENSE ONLY TENDS TO *SHARPEN* THE *OTHERS*...TO *TUNE* THEM MORE *FINELY*...TO MAKE THEM MORE *ACUTE*. THE IN-MATES *KNEW* BECAUSE THEY COULD *TASTE*...AND *TOUCH*...AND *SMELL* AND *HEAR*. THEY COULD *TASTE* THE *SPOILED* AND *ROTTED FOOD* PLACED BEFORE THEM AT MEALTIMES...

THEY COULD *TOUCH* THE *STICKY, FILMY COBWEBS*...THE *DUST LAYERS* COVERING EVERYTHING...

THEY COULD *SMELL* THE FOUL ODORS OF *MILDEW* AND *FAULTY PLUMBING* AND *POOR SANITA-TION* AND *NEGLECT*...

THEY COULD *HEAR* THE *RATS* SCAMPERING AND THE *ROACHES* CRAWLING AND THE *TERMITES* BURROWING AND THE *LICE* AND *BED-BUGS* AND *FLIES* AND A THOUSAND *OTHER* CREATURES OF FILTH THAT MOVED...

AND THEY COULD HEAR *OTHER* CREATURES *TOO*... *OTHER* CREATURES OF FILTH THAT MOVED. THEY COULD HEAR *MR. GRUNWALD*, THE HOME'S DIRECTOR, IN HIS OFFICE-APARTMENT DOWNSTAIRS, ENTERTAINING HIS LATEST LADY-FRIEND WITH THE MONEY HE'D SAVED ON THEM...THE INMATES...

THEY COULD HEAR HIS ALMOST MANIACAL LAUGHTER AND THE CLINKING OF CHAMPAGNE GLASSES. THEY COULD SMELL THE MOUTH-WATERING ODORS OF THE LAVISH SUPPER HE WAS ENJOYING, AND THEY COULD SEE, IN THEIR MINDS' EYES, THE LUXURIES WITH WHICH HE'D SELFISHLY SURROUNDED HIMSELF AT THEIR EXPENSE...

GUNNER, *PLEASE*...

COME, NOW, HONEY! DON'T YOU *LIKE* GUNNER...

HERE, BEAUTIFUL! HAVE ANOTHER *DRINK!*

MMM! THIS IS MORE *LIKE* IT!

YES, GUNNER GRUNWALD HAD *INDEED* SURROUNDED HIMSELF WITH LUXURIES...PAID FOR WITH THE *ALLOTMENTS* GIVEN HIM FOR EACH BLIND INMATE. WHY *PAINT* AND *PLASTER DREARY HALLS* THAT *THEY'D* NEVER *SEE*, WHEN *HE* COULD HAVE AN *AIR-CONDITIONER* FOR THOSE BLISTERING SUMMER DAYS?...

WHY *LAUNDER SHEETS* AND *BLANKETS* AND *CLOTHES* OF DIRT-SMEARS AND SWEAT-STAINS THAT *THEY'D* NEVER SEE WHEN HE COULD HAVE A *HEATER* FOR THOSE BITING WINTER NIGHTS?...

WHY GIVE THOSE POOR MISERABLE BLIND FOOLS *BEAUTY* IF THEY COULD NOT *APPRECIATE* BEAUTY? GUNNER GRUNWALD'D *FELT* THAT WAY! SO HE'D *SKIMPED* ON THE INMATES...*CUT CORNERS HERE*...*DENIED THERE*...AND WITH THE *SURPLUS*, HE'D SUPPLIED *HIMSELF* WITH BEAUTY. . .

FINE *FURNITURE*...GOOD *BOOKS*...PLUSH *RUGS*...EXPENSIVE *DRAPES*...AN OCCASIONAL EVENING OF *FEMALE COMPANIONSHIP*...THEY WERE *ALL* GUNNER'S TO ENJOY. HE'D EVEN BOUGHT A *DOG*...A *VICIOUS* DOG. HE'D HAD A *GOOD REASON*...

FOR GUNNER'D KNOWN THAT *ANOTHER* SENSE HAD REPLACED THE INMATES' SENSE OF SIGHT... A *DEEP-SEEDED* SENSE...*GROWING* EACH DAY. HE'D SEEN IT IN THEIR WEBBED-BLIND *EYES*, IN THEIR SILENT GRIM *FACES*. HE'D SEEN THEIR GROWING *HATE*. SO HE'D BOUGHT THE DOG FOR *PROTECTION*...

AND WITH THE DOG AT HIS SIDE, GUNNER'D WALKED *SELF-CONFIDENTLY* BEFORE THEM, KNOWING THAT HIS SIGHT AND THE DOG'S STRENGTH WOULD KEEP HIM FROM *HARM*.

AND SO, HE'D BEEN ABLE TO *CONTINUE* TO ENJOY HIS FIENDISH LITTLE AMUSEMENTS...LIKE *TRIPPING* HELPLESS UNSUSPECTING INMATES AS THEY'D TOTTER BLINDLY BY HIM...

OOOPH!

HEH!

..OR *REMOVING* SOMETHING THAT THEY'D COME TO *KNOW* WAS THERE AND *COUNTED* ON...

THE *BANNISTER!* WHERE'S THE ..BA YAAAAA..GGGHHH..

HEH! HEH!

...OR *ADDING* SOMETHING NEW...

OWWWW!

HEH, HEH,

... OR BEING JUST *MEAN*...

HAW, HAW!

YES, GUNNER'D *AMUSED* HIMSELF WITH HIS CHARGES' INABILITY TO SEE. HE'D BEEN *SADISTIC* WITH HIS TORTURES. AND HE'D GROWN *FAT* ON HIS DENIALS. AND HIS CHARGES HAD SAT IN THEIR WORLD OF DARK- NESS AND *WAITED.* *LISTENING.*

GUNNER... *PLEASE!* IT'S THE *DOG!* HE MAKES ME *NERVOUS!* I'M *AFRAID* OF DOGS!

I'M SORRY, BABY! *HERE, BOY! HERE!*

..*LISTENING* FOR THEIR *OPPORTUNITY*...

YOU STAY OUT THERE TILL GUNNER IS *THROUGH!*

GRUNWALD DIRECTOR IVATE

...AND *TONIGHT*...THEIR *OPPORTUNITY* CAME...

HUNGRY, DOGGY? *NICE,* DOGGY? *HERE,* DOGGY! HERE'S SOME *MEAT!*

...SO THEY LURED THE DOG DOWN INTO THE OLD MUSTY CELLAR OF THE HOME WITH SOME MEAT-SCRAPS THEY'D SAVED FROM THEIR SCANT MEALS...

IN *HERE,* DOGGY! *COME,* BOY!

QUICKLY! LOCK HIM UP!

AND THEN THEY WAITED. THEY WAITED FOR GUNNER'S FRIEND OF THE EVENING TO LEAVE...

GOODNIGHT, GUNNER! AND *THANKS*...

THANK *YOU*, MY DEAR...

THEY WAITED FOR GUNNER TO MISS HIS DOG...

BRUTUS!? WHERE *ARE* YOU? *BRUTUS?* BRU-...

...AND THEN THEY STRUCK! BLINDLY... UNSEEING...THEY SURROUNDED THEIR HATED ENEMY...

WHAT *IS* IT? WHAT DO YOU *WANT?* GO BACK TO YOUR *ROOMS*... ALL *OF YOU!*

...AND DRAGGED HIM TO THE CELLAR TOO...TO ANOTHER WAITING CUBICLE...

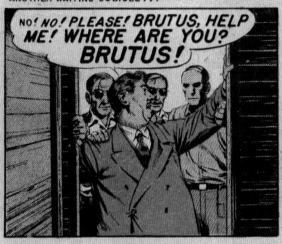

NO! *NO! PLEASE!* BRUTUS, HELP ME! WHERE ARE YOU? *BRUTUS!*

BUT GUNNER'S ONLY ANSWER WAS THE SOFT WHINE OF THE DOG IN THE ADJOINING CUBICLE...

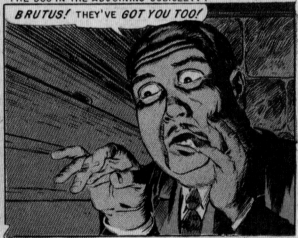

BRUTUS! THEY'VE *GOT YOU TOO!*

THEN THEY BEGAN TO WORK. THEY DRAGGED OUT OLD HAMMERS AND RUSTY NAILS AND LONG-IDLE SAWS...

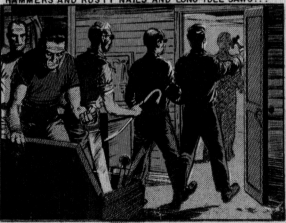

AND THEY WENT THROUGH THE HOME AND CUT AND RIPPED AND CHOPPED THE LUMBER THEY NEEDED...

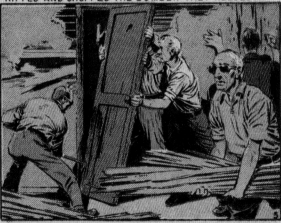

GUNNER LISTENED TO THE HAMMERING ECHOING THROUGH THE CELLAR. HE LISTENED TO THEIR GIGGLES AND CHATTER, AND HE WONDERED...

WHAT ARE THEY *UP* TO? WHAT ARE THEY *MAKING*?

AND HE LISTENED AS THE NIGHT PASSED AND DAWN CAME AND THE DOG IN THE CUBICLE NEXT DOOR GREW HUNGRY AND PACED AND GROWLED AND SCRATCHED AS ITS STOMACH GNAWED...

FEED BRUTUS, YOU FOOLS! HE'LL GET *WILD* IF YOU DON'T! HE'LL BE *DANGEROUS*!

WE *KNOW*, MR. GRUNWALD!

THE DAY PASSED AND NIGHT CAME AGAIN. GUNNER'S OWN STOMACH ACHED WITH HUNGER. AND STILL THEY HAMMERED AND SAWED AND LAUGHED AND TALKED...

WHAT ARE YOU MAKING? WHAT ARE YOU GOING TO DO?

YOU'LL *SEE*, MR. GRUNWALD!

PRIVATE KEEP OUT

THE DOG IN THE NEXT CUBICLE HOWLED ALL THAT NIGHT, SLOBBERING AND SNARLING AND SCRATCHING. GUNNER SHUDDERED. THE DOG WAS A BEAST, NOW... A HUNGER-CRAZED BEAST. AND THE HAMMERING WENT ON...

FOOD! GIVE ME SOME *FOOD! PLEASE...*

DO YOU *CALL* WHAT YOU'VE BEEN FEEDING *US* FOOD, MR. GRUNWALD?

DAWN CAME AGAIN AND THE SECOND DAY PASSED. NEXT DOOR, THE DOG WAS FIGHTING WITH ITSELF, THROWING ITSELF AGAINST THE CUBICLE SIDES AND HOWLING MADLY...

BRUTUS WILL *KILL* ANYONE THAT SETS *FOOT* IN THERE NOW!

GUNNER HIMSELF WAS HALF-CRAZED WITH HUNGER AS THE THIRD NIGHT CAME. AND THEN, TOWARDS MIDNIGHT, THE HAMMERING STOPPED. THE CELLAR WAS SUDDENLY FLOODED WITH LIGHT. EVEN BRUTUS STOPPED SNARLING IN ANTICIPATION...

THEY'RE... THEY'RE *OPENING* MY CUBICLE...

THEY STOOD BEFORE HIM...DIRTY, SWEATED, TIRED FROM LONG HOURS OF LABOR... THE INMATES... THE BLIND UNSEEING CARPENTERS. GUNNER BLINKED OUT AT THEM...

COME, MR. GRUNWALD! YOU ARE *FREE TO GO!*

FOLLOW US, MR. GRUNWALD! WE BUILT THIS *JUST FOR YOU!* IT LEADS TO THE *CELLAR STEPS*...AND *FREEDOM!*

GUNNER STOOD UP AS THEY DARTED OFF. HE COULD HEAR THEIR FOOTSTEPS FADE AS THEY ROUNDED CORNERS AND RAN DOWN LONG CORRIDORS THAT TURNED AND TWISTED AND DOUBLED BACK. GUNNER STARED...

THEY... THEY BUILT A *MAZE!* A *PUZZLE!* I HAVE TO *FIGURE IT OUT!*

AND THEN GUNNER SAW THE GLEAMING GLITTERING SLIVERS OF STEEL EMBEDDED IN THE MAZE WALLS...

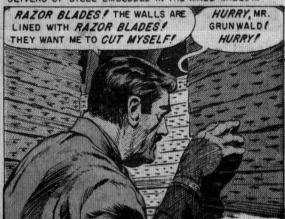

RAZOR BLADES! THE WALLS ARE LINED WITH *RAZOR BLADES!* THEY WANT ME TO *CUT MYSELF!*

HURRY, MR. GRUNWALD! HURRY!

GUNNER LAUGHED TO HIMSELF AS HE STARTED OUT OF HIS CUBICLE...

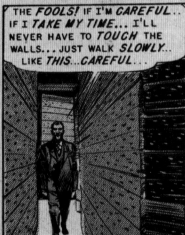

THE *FOOLS!* IF I'M *CAREFUL*.. IF I *TAKE MY TIME*... I'LL NEVER HAVE TO *TOUCH* THE WALLS... JUST WALK *SLOWLY*.. LIKE *THIS...CAREFUL...*

A SOUND BEHIND GUNNER FROZE HIS BLOOD! A SNARL AND A SQUEAK OF A DOOR OPENING...

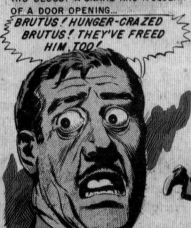

BRUTUS! HUNGER-CRAZED BRUTUS! THEY'VE FREED HIM, TOO!

GUNNER BEGAN TO RUN. HE *HAD* TO REACH FREEDOM BEFORE THAT STARVED DOG *CAUGHT* HIM! HE RAN DOWN THE TWISTING MAZE CORRIDORS...THE SOUND OF THE LOPING SNARLING DOG BEHIND HIM...

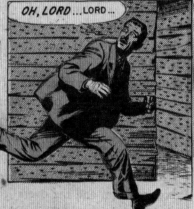

OH, *LORD*...LORD...

HE BRUSHED AGAINST THE RAZOR BLADES, SLASHING HIS FLESH. HE STUMBLED AND GOT UP...RAN ON...FRIGHTENED...WILD...DOWN THROUGH THE TWISTING, DOUBLING-BACK MAZE CORRIDORS WITH THE RAZOR-LINED WALLS AND THE SLOBBERING HOUND CLOSE BEHIND...

AND THEN SOME IDIOT TURNED OUT THE LIGHTS!

OOPS! WRONG TURN, GUNNER! *NOW, NOW!* DON'T GO TO *PIECES!* AFTER *ALL!* IT'S *ALMOST* LIKE BEING *BLIND!* WELL, KIDDIES. THAT'S MY *SICKENING-STORY* FOR THIS *FIRST ISSUE* OF C.K.'S *NEW MAG!* NOW IT'S TIME TO CLOSE *THE VAULT OF HORROR* AND TURN YOU BACK TO HIM. AS THE *DISMEMBERED PARTS* OF A *CORPSE* SAID WHEN THEY WERE SHIPPED TO THE *UNDERTAKER'S*... "WE'LL GET *TOGETHER AGAIN!*" BYE!

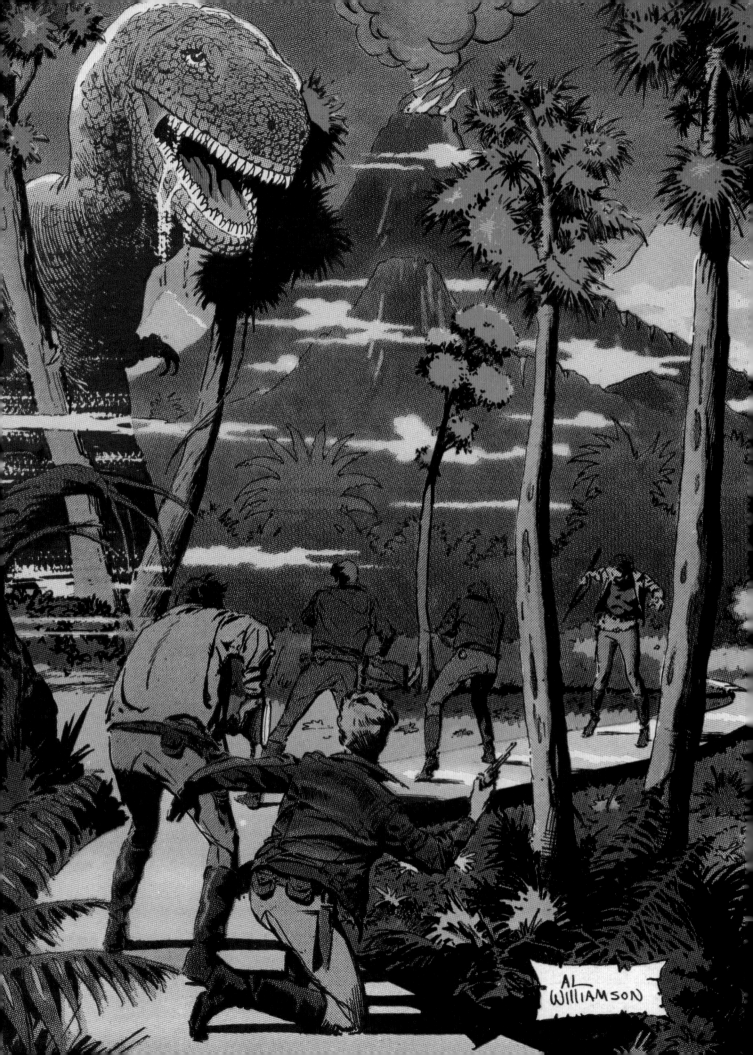

AL WILLIAMSON AND THE FLEAGLE GANG!

"WILLIAMSON WAS JUST A *NUT*, PART OF THE FLEAGLE GANG WITH FRAZETTA, TORRES, AND KRENKEL. THEY'D JUST AS SOON PLAY *BASEBALL* AS ANYTHING ELSE!" -BILL GAINES

Al Williamson, the youngest artist on the E.C. staff, was born in New York City on March 21, 1931. At the age of two his family moved to Columbia, South America, where his father owned a coffee plantation. Williamson grew up in the capital city of Bogota, and was fluent in both English and Spanish.

Williamson became interested in comics around 1939 when he discovered Spanish language reprints of American comic strips such as "Terry and the Pirates." He was also inspired by a strip called "The Undersea Empire," which was written and drawn by an Argentinian artist named Carlos Clemen. "That was the stuff that hooked me into drawing," Williamson told comics historian and fanzine publisher James Van Hise in *The Art of Al Williamson*. "He was my first inspiration to do comics."

Around 1941, Williamson's mom took him to see the movie serial *Flash Gordon Conquers the Universe*. "I couldn't believe they'd made

a movie like that," Williamson told Van Hise. "I rushed home that evening and found some pages of 'Flash Gordon' that I knew I had. I had about five pages, tabloid-size and in Spanish, and boy, that did it. I was hooked on 'Flash Gordon.'" "Flash Gordon" was illustrated by Alex Raymond, a superb craftsman whose work cast a very long shadow of influence on his fellow artists, and Williamson was greatly influenced by him, as well as two other legendary artists of the era, Hal Foster and Burne Hogarth.

In 1943, when Williamson was twelve, he returned to New York. Between 1945 and 1947, Williamson attended Saturday morning classes at Burne Hogarth's

Copyright © 1948 by Famous Funnies

Left: Detail from Williamson's cover to *Weird Science-Fantasy* #25, September 1954.

Above: Williamson's first comic-book work, spot illustrations from *Famous Funnies* #169, August 1948.

197

Cartoonists and Illustrators School (later called the School of Visual Arts).

In 1948, Williamson began assisting Hogarth on the Sunday newspaper strip "Tarzan." During this period Williamson met Wallace Wood and Roy Krenkel. Williamson said of Wood in an interview published in the *Wally Wood Sketchbook*: "In the Fall of 1950, I'd seen his *Captain Science*, and it was just wonderful work. I knew him enough to give him a call, and told him his stuff was great; I loved it." Wood told him that he was sharing a studio with Joe Orlando, so Williamson went over for a visit. Wood ended up helping Williamson on a few jobs, then encouraged him to go to E.C. "Both Wally and Joe insisted that I go up there. I kept saying 'No, I wasn't ready.' I didn't think I could handle it, because you really had to be on the ball." Under the weight of substantial peer pressure, Williamson eventually made the plunge. "Finally, after they kept insisting," Williamson continued, "I did a sample page and went up to E.C. They hired me."

The first job he did for E.C. was a Gaines/Feldstein horror story entitled "The Thing in the 'Glades!" (*Tales from the Crypt* #31, August–September 1952). "They had two scripts available, a science fiction story and a

horror story that took place in the Everglades," Williamson said in *The Art of Al Williamson*. He decided to take "The Thing in the 'Glades!" because it seemed like an easier assignment. He brought the job back, and Gaines and Feldstein liked it. His second assignment was "Mad Journey!" (*Weird Fantasy* #14, July–August 1952), the science fiction story they had showed him originally. Of that job, Williamson told Van Hise that "I got chicken on some of the stuff, and I had Frank [Frazetta] ink some of it. I was always afraid that I would screw up my penciling with the inking." Williamson also regularly had help from Roy Krenkel—and later Angelo Torres—on the stories he did for E.C.

One day, not long after Williamson started doing work for E.C., he and a bunch of his artist cronies—including Frank Frazetta, Roy Krenkel, Angelo Torres, and future *MAD* staffer Nick Meglin—stopped by the E.C. office. They entered Harvey Kurtzman's office to say hello, and Kurtzman looked up and exclaimed, "Good Lord! It's the Fleagle Gang!" Everybody broke up, and the name stuck. From then on, Nick Meglin said in *Tales of Terror! The E.C. Companion*, "Everyone referred to us as the Fleagles." (Another member of the Fleagle Gang was

Right: Williamson's first two jobs for E.C., "The Thing in the 'Glades!" (*Tales from the Crypt* #31, August–September 1952) and "Mad Journey!" (*Weird Fantasy* #14, July–August 1952).

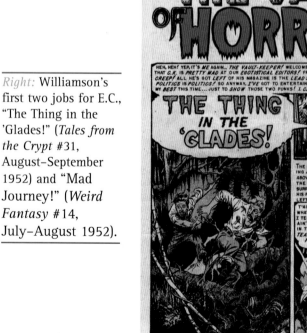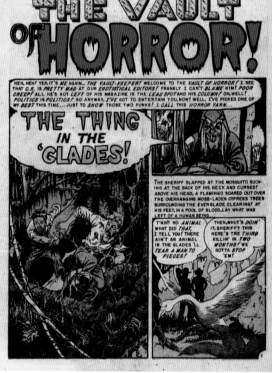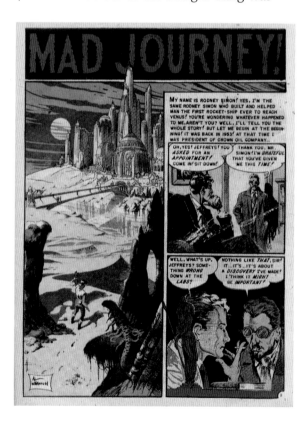

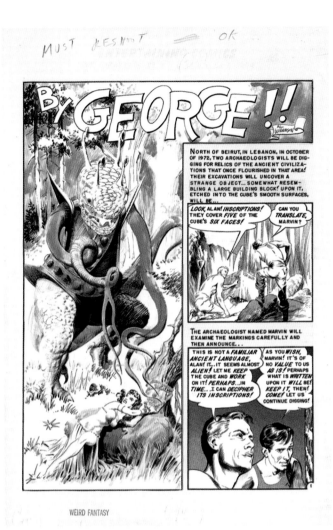

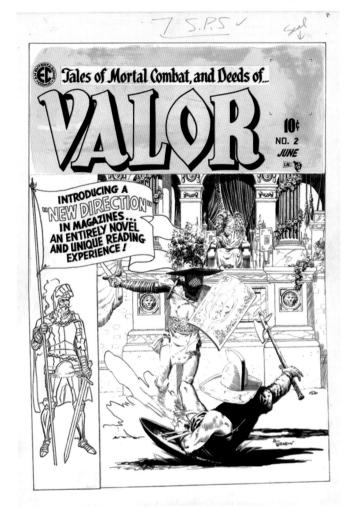

George Woodbridge, who attended the School of Visual Arts with Torres and Meglin. Although friends with Williamson, Woodbridge did no work on his E.C. stories.)

As they did with all the artists, Gaines and Feldstein tailored the stories they gave to Williamson for the best fit. Williamson would come in, and, Feldstein recalled in *Tales of Terror! The E.C. Companion*, "We'd sit and read it and chat about it, and he'd take it off and finish it up." Williamson would bring the job back in, having been aided and abetted by Frazetta, or Torres, or Krenkel, and, said Feldstein, "I would be *wild* about the artwork. What the heck did they call those guys?—the Fleagle Gang. I was aware of all that, but they were turning out a nice product." Bill Gaines was aware of the outside help Williamson had as well, but he didn't care either, because the completed jobs were absolutely stunning.

Feldstein said in *E.C. Lives!* that "Al couldn't work unless he had people standing over him, giving him encouragement. Al always did such a spectacular job on his art, but it was with such tremendous pain, personal pain. Tremendous anxiety, self examination, incrimination. He went through the tortures of the damned developing his art." Gaines said in the same publication that

Above left: The original art and printed splash page from "By George!!" (*Weird Fantasy* #15, September–October 1952). *Above right:* The original art and printed cover to *Valor* #2 (May–June 1955).

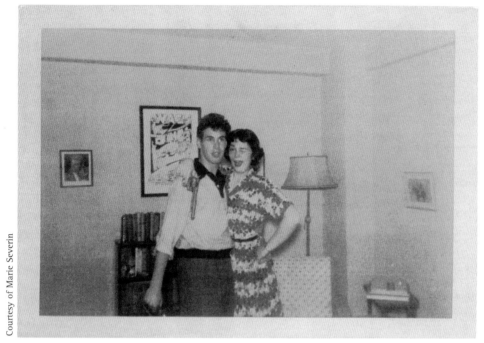

Courtesy of Marie Severin

Left: Al Williamson and E.C. colorist Marie Severin, clowning around in Williamson's apartment, circa 1953. Severin said recently that Williamson usually struck a pose in his photos, but in this shot he was taken by surprise.

Above: A spectacular Williamson/Frazetta collaboration adorns this cover to *Weird Fantasy* #21, September–October 1953.

"Al Williamson was a problem. He was so undisciplined, and was such a nut in those days. You never knew where to find him or whether he was working on your art or not; he was just a lovable nut." Also in *E.C. Lives!*, Wallace Wood recalled him as being "like a hippie of his time, always doing strange things, dressing in wild clothes. He used to be irresponsible and had such a terrible time getting work in on time. He would get hung up on each panel, and he might finish an entire story except for the last panel, and spend a week just on the single panel."

Williamson said in the *Wally Wood Sketchbook* that "I got along famously with everybody at E.C., they were all the nicest people in the world. But I was very young." Marie Severin said of Williamson in *E.C. Lives!* that "he was in the process of growing up at the time, which was very pleasant to see—like a breath of fresh air. It may have been Moon air or Mars air, but he had a nice freshness about him." Williamson's friend George Evans said of him in *E.C. Lives!*, "Al has the biggest talent of anybody, and always did. At that time he was working almost strictly on raw talent."

Williamson and company did three of E.C.'s adaptations of Ray Bradbury's stories: "The One Who Waits" (*Weird Science* #19, May–June 1953), "I, Rocket" (*Weird Fantasy* #20, July–August 1953), and "A Sound of Thunder" (*Weird Science-Fantasy* #25, September 1954). Bradbury wrote in a letter to E.C. dated Easter Sunday 1953 that "I must give a special nod this time out to Al

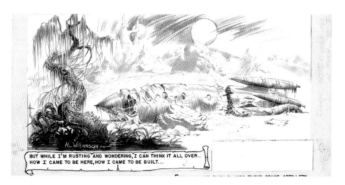

Above: The original art (left) and the printed splash panel (right) from the Ray Bradbury adaptation "I, Rocket" (*Weird Fantasy* #20, July–August 1953).

Williamson for his delicate and sensitive evocation of 'I, Rocket.' A superb job."

Williamson did a few other horror stories for E.C., but he never really liked doing them. One such story ("Saved," *Weird Fantasy* #21, September–October 1953), although set in space and published in one of the science fiction comics, had a vampire motif. Williamson said to Van Hise, "Oh yes, the vampire in space. I hated that with a passion. I hated that! You can throw vampires in the garbage, but they gave it to me. I really carried on like a prima donna. I'd say, 'No, no, no, I can't do this. I don't feel it.'" (See page 204 for Williamson's humorous take on his own "prima donna" behavior.)

It must be noted that, although they were working in a commercial environment for E.C., Williamson and the Fleagle Gang were nonetheless doing "art for art's sake." The final result was the important thing, not how long it took, for example, or who contributed what. On "Food for Thought" (*Incredible Science Fiction* #32, November–December 1955), they packed a phenomenal amount of fine-line detail into the story, knowing all the while that the cheaply printed comic books could never really do the artwork justice. The story is a tour-de-force masterpiece of comic art.

Interestingly, Williamson's cohorts in the Fleagle Gang, Frank Frazetta, Roy Krenkel, and Angelo Torres, did very few solo jobs for E.C. Frazetta did two stories on his own. The first, "Squeeze Play," appeared in *Shock SuspenStories* #13 (February–March 1954). Frazetta drew himself as the main character. When the original art for this story was first sold at auction in 1984, it fetched $15,000, a record high for E.C. art at the time. Frazetta's second solo story for E.C. remains unpublished. Entitled "Came the Dawn," the story was intended for one of the Picto-Fiction magazines. When E.C. dropped these titles, Gaines called Frazetta and told him he could finish the job and be paid for it, or keep the art and not be paid. Frazetta choose the latter. (This unfinished story will likely never be published, as it has since been sold and dispersed among private collectors.) Roy Krenkel—who usually supplied the cityscapes and other

exotic backgrounds for Williamson's E.C. stories—did one solo outing for E.C., a curiously uninspired effort entitled "Time to Leave" (*Incredible Science Fiction* #31, September–October 1955). And Angelo Torres did a story called "An Eye for an Eye," which was intended for *Incredible Science Fiction*

#33, January–February 1956). This story, which dealt with mutants, was rejected by the Comics Code Authority and remained unpublished until 1971, when it finally appeared in the coffee-table book *The E.C. Horror Library* (Nostalgia Press).

When E.C. started the New Direction comics, Williamson and the Fleagles did splendid work in *Valor*, and for the Picto-Fiction title *Shock Illustrated*. (Another

Above: Perhaps the most finely detailed splash page in comics history, by Williamson and Krenkel, from "Food for Thought" (*Incredible Science Fiction* #32, November–December 1955).

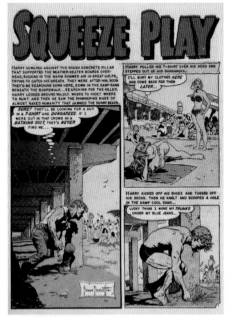

Below: Solo E.C. efforts by Fleagle Gang members Frazetta ("Squeeze Play," *Shock SuspenStories* #13, February–March 1954), Krenkel ("Time to Leave," *Incredible Science Fiction* #31, September–October 1955), and Torres ("An Eye for an Eye," intended for *Incredible Science Fiction* #33, January–February 1956).

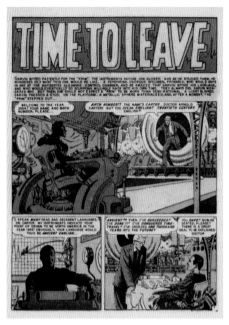

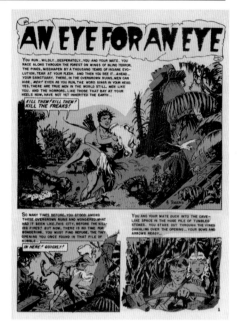

Above: Frank Frazetta cover to *Weird Science-Fantasy* #29 (May–June 1955). This was originally done for *Famous Funnies* as a Buck Rogers cover. Rejected as being too violent, Gaines licensed the image from Frazetta. *Right:* Williamson's cover to King Comics's *Flash Gordon* #5 (May 1967).

Picto-Fiction story, "Wanted for Murder," was done for *Crime Illustrated* #3, which was never published. This story appears in its entirety on page 258.)

In 1956, after E.C. ceased publication of everything but *MAD*, Williamson hit the freelance trail, finding work with Stan Lee at Atlas, where he worked on the company's various western, war, mystery, and romance titles. During this period, he also freelanced for such companies as A.C.G., Charlton, Classics Illustrated, and Dell.

In 1961, Williamson began to work as an assistant to John Prentice on the syndicated newspaper strip "Rip Kirby," a position he held until 1964. After leaving "Rip Kirby," Williamson did some beautiful black-and-white artwork for James Warren's *Creepy*, *Eerie*, and the war magazine *Blazing Combat*.

In 1966, Williamson did four covers and a number of stories for King Comics's *Flash Gordon* comic book. He likely would have done more work for the book, but King Features called and asked him to do the "Secret Agent X-9" syndicated strip (the name was later changed to

"Secret Agent Corrigan"); he did the strip from 1967 until 1980. (The feature was written by E.C.-fan-turned-comics-professional Archie Goodwin.)

In 1980, Goodwin, who had been writing the "Star Wars" syndicated strip, called Williamson and asked if he would do the Marvel Comics adaptation of *The Empire Strikes Back*. Williamson said in the July–August 1980 issue of *Mediascene Prevue*, "I think the ninety-six pages of my *Empire* adaptation are at least as good as the work I did for E.C., and better than my *Flash Gordons*. I've done a lot of drawing since then, have a better feel for composition and storytelling, and a more flexible attitude for the work. Over twenty-five years of experience is really paying off." Williamson later took over the "Star Wars" daily syndicated strip, after the death of artist Russ Manning. (Actually, Williamson had been George Lucas's first choice to draw the "Star Wars" strip, but he was busy with "Secret Agent Corrigan" at the time.) It was a perfect fit, which stands to reason, because Lucas—a longtime E.C. fan—was said to have

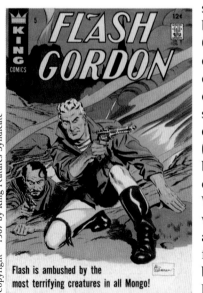

Flash is ambushed by the most terrifying creatures in all Mongo!

Copyright © 1967 by King Features Syndicate

been influenced by Williamson's art for the look of *Star Wars*. After the "Star Wars" strip finally wound down, Williamson went to Marvel, where he soon became the company's top inker.

Williamson's fellow Fleagle Gang members all went on to successful careers. Frank Frazetta began concentrating on doing oil paintings (starting with a number of covers for Edgar Rice Burroughs's novels), and eventually became perhaps the most popular fantasy illustrator of the twentieth century. Roy Krenkel (who died on February 24, 1983) also did a number of illustrations for the works of Edgar Rice Burroughs, and he became somewhat legendary among his friends as one of the world's great eccentrics. Nick Meglin joined the staff of *MAD* as an "idea man" in 1956, thinking it would be just a short-term position. Fat chance; he only just recently retired from the magazine, having been there longer than anyone else, including Bill Gaines

(who died in 1992). Angelo Torres did work for Stan Lee at Atlas, and later settled in for a long run at *SICK*, an inferior competitor to *MAD* Magazine. At Meglin's urging, Torres joined "The Usual Gang of Idiots" at *MAD* in 1971, and he is still a regular contributor to the magazine. George Woodbridge also did work for Atlas, primarily on their western comics. He joined the staff of *MAD* in 1957 (also at Meglin's urging), and remained an important contributor until declining health forced him to slow down his output. Woodbridge died on January 20, 2004.

Williamson told Van Hise, "Looking back, I must say that I was quite privileged to work with the most talented men in the field. I learned a lot from all of them. There's Frank (Frazetta), Angelo (Torres), Roy (Krenkel), Reed Crandall, George Evans. Thanks for making me look good. I love all of you." Al Williamson was inducted into the Will Eisner Hall of Fame in 2000. •

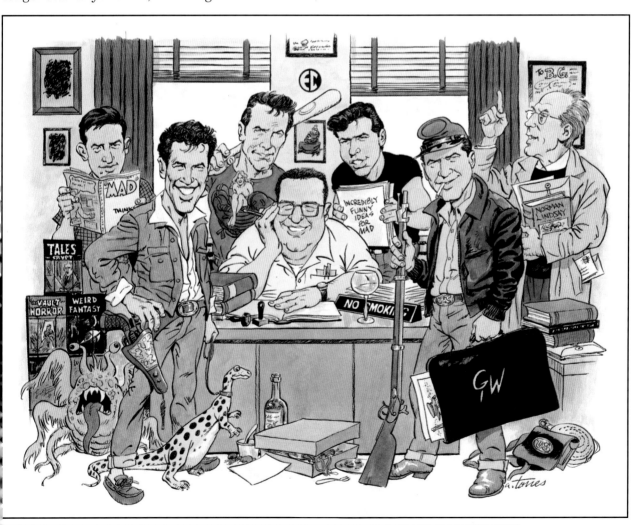

Above: The 1950s Fleagle Gang hangs out in Bill Gaines's office in this piece done by Angelo Torres especially for this book. From left to right: Torres, Williamson, Frazetta, Gaines, Meglin, Woodbridge, and Krenkel.

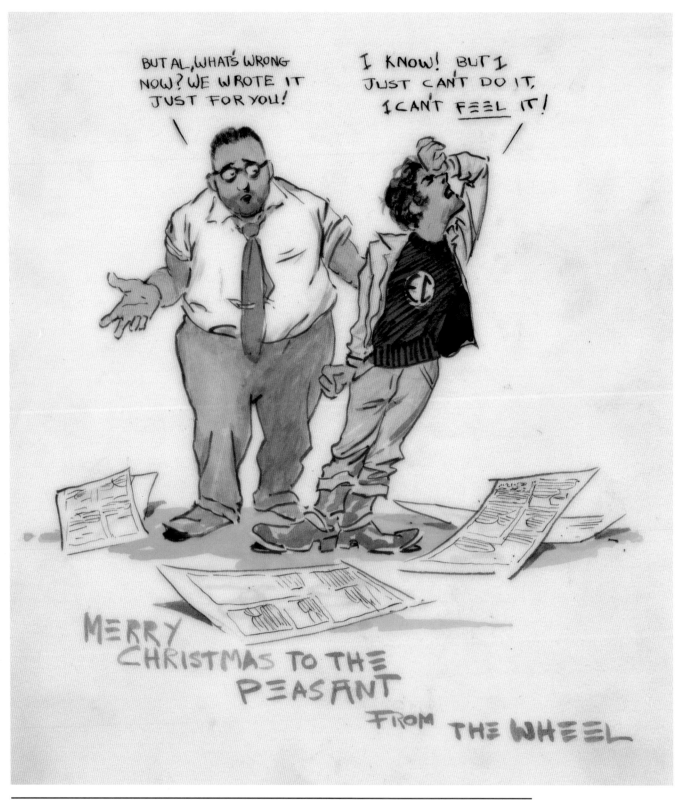

Above: By his own admission, Williamson sometimes behaved like a "prima donna" if he didn't like a story. Shown is a piece Williamson did as a Christmas present for Gaines, circa 1953.

50 GIRLS 50

I HAVE TO *LAUGH!* EVEN THOUGH MY FINGERS ARE GROWING NUMB AND I LIE PARALYZED IN MY DEEP-FREEZE SUSPENDED ANIMATION CHAMBER, FEELING THE INCREASING COLDNESS CREEPING OVER MY BODY AND KNOWING THAT *I AM GOING TO DIE,* I HAVE TO LAUGH. I WAS *FOOLED.* *I KNOW* THAT NOW. AND YET, WHEN MY BODY GROWS RIGID IN THE SUB-ZERO TEMPERATURE AND MY FLESH BECOMES BRITTLE AND THE LIFE LEAVES MY BODY, THERE WILL BE A *SMILE* FROZEN ON MY FACE. ONE YEAR AGO, I LAY LIKE THIS IN THIS VERY CHAMBER. ONLY THINGS WERE *DIFFERENT* THEN. THE COLD WAS *RECEDING* THEN. THE GROWING DARKNESS WAS VANISHING AND A WARMTH AND LIGHT WAS COMING OVER ME. FOR I WAS *THAWING.* I WAS *COMING TO.* I REMEMBER HOW I OPENED MY EYES AND SAT UP, PUSHING THE TRANSPARENT LID OPEN AND LOOKING AROUND AT THE TIERS OF OTHER D-F S.A. CHAMBERS WITH THEIR PALE-BLUE-FLESHED CONTENTS...

WE...WE'RE *TWO YEARS OUT OF EARTH.* PERFECT. *PERFECT.* JUST THE WAY I *PLANNED* IT.

I CLIMBED FROM MY CHAMBER, LISTENING TO THE SILENCE OF THE SHIP. I MOVED DOWN THE AISLE BETWEEN THE STACKED D-F UNITS AND PEERED INTO EACH, SMILING AT THE SCULPTURED STATUE-LIKE FACES OF THE WOMEN, AND SNEERING AT THE CLEAN-SHAVEN WHITE FACES OF THE MEN...UNTIL I CAME TO WENDY'S...

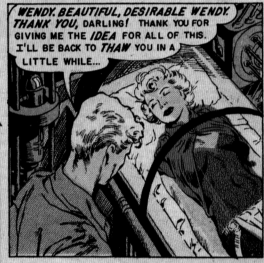

WENDY. BEAUTIFUL, DESIRABLE WENDY. THANK YOU, DARLING! THANK YOU FOR GIVING ME THE *IDEA* FOR ALL OF THIS. I'LL BE BACK TO *THAW* YOU IN A LITTLE WHILE...

THIS WAS WHAT I WANTED. THIS WAS THE BEGINNING OF MY PLAN. WENDY HADN'T ACTUALLY SUGGESTED IT, BUT SHE'D GIVEN ME THE IDEA. I PUT THE FIRST PHASE OF MY SCHEME INTO OPERATION AND RETURNED TO HER CHAMBER. I REACHED FOR THE TEMPERATURE CONTROL RELAY...THE SWITCH THAT WOULD SEND LIFE AND WARMTH INTO HER RIGID BODY. BUT THEN I HESITATED...

NO, DARLING! NOT *YET!* NOT *YOU...FIRST!* SOMEONE *ELSE.* AN *APPETIZER* TO THE *MAIN COURSE.* A *TEMPTER...*

"50 Girls 50," from *Weird Science* #20 (July–August 1953).
Illustrated by Al Williamson and the Fleagle Gang. Written by Bill Gaines and Al Feldstein.

I STEPPED TO THE NEXT TIER OF D-F UNITS AND SURVEYED THE FACES... THE FROZEN MASKS OF BEAUTY WITHIN. I FELT WILD AND ELATED AND MY BLOOD POUNDED THROUGH MY BODY. *FIFTY WOMEN!* AND I COULD *HAVE MY PICK*...

LAURA MASTERS. SHE'S... LOVELY. *LOVELY!* ALL RIGHT, LAURA. YOU WILL BE MY *FIRST CONQUEST...* MY *FIRST*...

I SHOVED THE RELAY FORWARD TO 'THAW'. THE REFRIGERATION UNIT KICKED OFF AND ANOTHER MOTOR CLICKED ON. I HURRIED BACK TO THE CONTROL ROOM AND SAT DOWN. IT WOULD TAKE A WHILE FOR LAURA TO COME TO...

FIFTY WOMEN. LET'S SEE. I'M *TWENTY-SIX* NOW. SAY I LIVE TO BE *SEVENTY*-SIX. THAT WOULD BE *ONE WOMAN EACH YEAR.* HARDLY ENOUGH TIME TO *TIRE* OF HER. HEH, HEH. WHAT A *LIFE* I'LL LEAD. WHAT *HEAVEN*...

WHILE I WAITED FOR LAURA'S THAW-ING TO BE COMPLETED, I THOUGHT OF HOW ALL THIS HAD COME ABOUT. MY VOLUNTEERING FOR THIS TRIP. I REMEMBER HOW WE ASSEMBLED, I AND THE FORTY-NINE OTHER MEN AND THE FIFTY WOMEN, AND LISTENED TO OUR FIRST BRIEFING...

LADIES AND GENTLEMEN. YOU HAVE BEEN CAREFULLY SCREENED AND PICKED FROM OVER *TWENTY-THOUSAND VOLUNTEERS* FOR THE *FIRST JOURNEY TO A DISTANT STAR*...

I REMEMBER HOW WE GASPED WHEN THE GENERAL TOLD US...

THE SOLAR SYSTEM WE HAVE CHOSEN, THE ONE THAT SEEMS MOST LIKELY TO CONTAIN AN INHABITABLE PLANET, WILL TAKE EXACTLY *ONE HUNDRED YEARS* TO REACH.

BUT... BUT WE WON'T *LIVE* THAT *LONG*...

...AND HOW HE FIRST EXPLAINED ABOUT THE D-F S.A. UNITS...

AFTER CAREFUL EXPERIMENTATION, WE HAVE DISCOVERED A METHOD OF *QUICK-FREEZING THE HUMAN BODY AND KEEPING IT IN A STATE OF SUSPENDED ANIMATION INDEFINITELY.* THUS, IN THIS HUNDRED-YEAR-JOURNEY, NO ONE WILL *AGE*...NOT *ONE DAY*...FROM THE MOMENT THE SHIP *LEAVES* EARTH UNTIL IT *REACHES* ITS DESTINATION AND YOU ARE *AUTOMATICALLY THAWED.*

A SOUND BEHIND ME STARTLED ME FROM MY REVERIE. LAURA STAGGERED INTO THE CONTROL ROOM. SHE STARED AT THE CALENDAR-CLOCK. I ACTED SHOCKED AT SEEING HER...

OH, LORD! AT LAST! SOME-ONE TO *TALK* TO! I THOUGHT I'D GO OUT OF MY *MIND* FROM *LONELINESS.*

WHAT *HAPPENED?* WE'RE *ONLY TWO YEARS* OUT! WE WERE SUPPOSED TO BE FROZEN FOR A *HUNDRED YEARS!*

I DREW HER TO ME, FEELING HER WOMANLY WARMTH, AND AMAZED AT MY ACTING ABILITY...

I'VE BEEN THAWED FOR *SIX MONTHS,* GOING *CRAZY* ALL BY MYSELF. MY *RELAY* FAILED. THAT'S WHAT HAPPENED TO *YOURS* TOO.

WE'LL... WE'LL HAVE TO *LIVE OUT OUR LIVES* ON THE SHIP...*DIE* OUT HERE IN SPACE...

2

THE GENERAL HAD MADE IT VERY CLEAR AT THE BRIEFING...

THIS *QUICK-FREEZE PROCESS* CAN *ONLY* BE DONE *ONCE*. THE *HUMAN BODY* CAN STAND *ONLY ONE FREEZE* AND *ONE THAW*. IF, FOR SOME UNFORSEEN REASON, ONE OF THE D-F UNITS *FAILED*, AND ONE OF YOU *CAME TO*, THERE WOULD BE *NO GOING BACK!* YOU WOULD LIVE YOUR LIFE OUT ON THE SHIP.

LAURA TREMBLED IN MY ARMS. MY FINGERS TINGLED, LONGING TO CARESS HER. BUT THAT WOULD COME. THIS WAS WHAT I WANTED. THE CHASE. THE CAPTURE. AND THEN, THE DELIGHTFUL ENJOYMENT OF SURRENDER...

OH, SID. WHAT WILL WE *DO?*

AT LEAST THERE'S THE *TWO* OF US, LAURA. WE CAN SEE IT THROUGH *TOGETHER!*

HOW MANY TIMES DOES A MAN DREAM OF BEING MAROONED ON A DESERT ISLAND WITH A BEAUTIFUL WOMAN? NOW, FOR ME, THE DREAM HAD COME TRUE. MAROONED ON A ROCKET-SHIP-ISLAND... IN SPACE... WITH LAURA...

SID... I'M *FRIGHTENED.* HOLD ME TIGHTER. KISS ME!

BABY...

INSTEAD OF THE ROAR OF BREAKERS ON A SILVERY BEACH, THERE WAS THE HUM OF NINETY-EIGHT D-F UNITS. INSTEAD OF SWAYING PALMS, THERE WERE NINETY-EIGHT FROZEN BODIES, TIERED ONE OVER THE OTHER DOWN THE AISLE. BUT WE WERE *ALONE* ON OUR ROCKET-SHIP-ISLAND. *ALONE AND UNINHIBITED...*

OH... DARLING!

SWEET...

BUT SOON, THE SILVERY BEACH TURNED GREY AND FLOTSAM-STREWN. THE BEAUTIFUL WOMAN TURNED UGLY. THE TINGLING LEFT ME. I WAS *TIRED* OF LAURA. IT WAS *TIME...*

SID. WHAT *IS* IT? WHAT'S THE *PARALYZER* FOR?

I'M *THROUGH* WITH YOU, LAURA. IT'S BEEN ALMOST A *YEAR* AND I'M *SICK AND TIRED* OF YOU. I WANT *SOMEONE ELSE...*

I REMEMBER HOW SHE LOOKED AT ME, AND THE REALIZATION CAME TO HER...

YOU... *YOU* THAWED ME! YOU DID IT ON *PURPOSE.* YOU WANTED *COMPANY.* YOU WANTED ...*OH, GOD*... AND NOW YOU'RE *BORED*...

THAT'S *RIGHT*, LAURA. AND AFTER YOU'RE *BACK* IN YOUR FREEZE-CHAMBER... *DEAD*... I'LL THAW ONE OF THE *OTHERS!*

SHE CURSED ME AS THE PARALYZER BLAST MADE HER BODY GROW RIGID. I CARRIED HER BACK TO HER D-F UNIT AND SET THE RELAY BACK. SHE WOULD NEVER WAKE UP. THE REFREEZING WOULD KILL HER...

THANKS, LAURA! THANKS FOR THE *APPETIZER*.

I DUMPED HER IN AND SHUT THE LID...

3

I WAITED UNTIL THE COLOR DRAINED FROM HER FACE AND THE BLUENESS STIFFENED HER AND SHE LOOKED LIKE A FINELY CHISLED PIECE OF SCULPTURE. ONE COULD NOT TELL THAT SHE WAS NO LONGER IN THE SUSPENDED-ANIMATION STATE, BUT ACTUALLY DEAD. THAT IS, IF ONE DIDN'T LOOK TOO CLOSELY AT WHERE THE TEARS HAD TURNED TO ICE ON HER CHEEKS...

I STARED IN AT DESIRABLE WENDY...PALE AND DEATH-LIKE, WITH SENSUOUS BLUISH LIPS, WENDY...WHOSE HOT BLOOD HAD BEEN STOPPED COLD AND NOW LAY AS RIGID RED ICE-WIRES ENCASED IN SUB-ZERO HARDENED VEIN AND ARTERY AND CAPILLARY WALLS. WENDY... WHO I WANTED SO MUCH THREE YEARS AGO. WENDY, WHO NOTICED MY HUNGRY LOOKS AND CAME TO ME ONE DAY...

PERFECT! NOW...FOR YOU, WENDY! THE... MAIN COURSE!

YOU'RE NAME IS SID, ISN'T IT? I'VE BEEN WATCHING YOU FOR SOME TIME...

I'VE BEEN WATCHING YOU TOO, WENDY! YOU'RE... VERY BEAUTIFUL!

I REMEMBER THE GENERAL'S WORDS. I REMEMBER HOW HE'D PREDICTED WENDY'S AND MY MEETING...

YOU ARE FIFTY MEN AND FIFTY WOMEN. YOU HAVE BEEN CHOSEN CAREFULLY. YOUR MENTALITY... YOUR PHYSICAL ATTRIBUTES... ALL OF YOUR QUALITIES HAVE BEEN CONSIDERED. BUT WHAT IS MORE IMPORTANT...EACH OF YOU HAS A PERFECT MATE IN ONE OF THE OPPOSITE SEX GROUP...

THE GENERAL WENT ON TO EXPLAIN... ABOUT PSYCHOLOGICAL FACTORS... TEMPERAMENT RATIOS...INTELLIGENCE LEVELS. I LOOKED AROUND, LAUGHING TO MYSELF. ANY ONE OF THEM...

ONCE YOU REACH YOUR DESTINATION AND BEGIN BUILDING YOUR COLONY, YOU WILL FIND YOUR MATE. IT IS INEVITABLE.

I PUSHED THE RELAY OF WENDY'S D-F UNIT TO 'THAW'...

WENDY...MY MATE!

THE GENERAL HAD BEEN RIGHT! IN FACT, WENDY AND I HAD GOTTEN TOGETHER BEFORE THE TAKE OFF...SHE WAS CRAZY ABOUT ME...

YOU'RE IN CHARGE OF THE D-F UNITS, AREN'T YOU, SID? INSTALLING THEM... SETTING THE RELAYS? NO ONE CAN TAMPER WITH THEM?

NO ONE... EXCEPT ME! WHY?

IT WAS TRUE. EACH OF US HAD BEEN ASSIGNED TO SOME PART OF PREPARING THE SHIP FOR THE TRIP. MY ASSIGNMENT HAD BEEN THE DEEP-FREEZE SUSPENDED ANIMATION CHAMBERS...

COULD YOU SET A RELAY TO THAW SOMEONE BEFORE THE HUNDRED YEARS ARE UP, SID, DARLING?

I'D HAVE TO REWIRE IT... MAKE SOME ADJUSTMENTS... BUT IT COULD BE DONE! WHY?

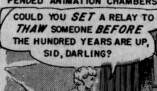

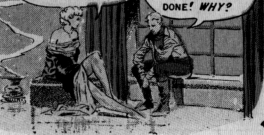

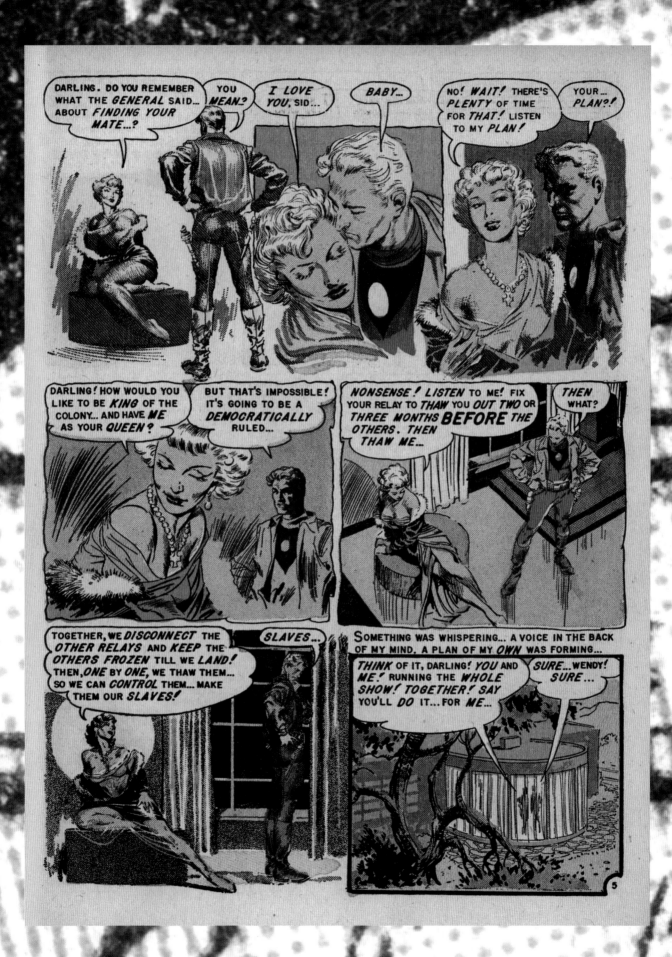

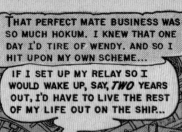

THAT PERFECT MATE BUSINESS WAS SO MUCH HOKUM. I KNEW THAT ONE DAY I'D TIRE OF WENDY. AND SO I HIT UPON MY OWN SCHEME...

IF I SET UP MY RELAY SO I WOULD WAKE UP, SAY, *TWO* YEARS OUT, I'D HAVE TO LIVE THE REST OF MY LIFE OUT ON THE SHIP...

... BUT THERE'D BE *WENDY!* AND *AFTER* HER...THE *OTHERS*. *FIFTY WOMEN*. I COULD HAVE THEM *ALL*. TIRE OF *ONE*...ON TO *ANOTHER*...

...AND IT WOULD BE SUCH A *SIMPLE* LIFE. I'D TAP THE *FOOD-STORES* THAT WE'LL BE CARRYING...THAT ARE SUPPOSED TO FEED THE COLONY...UNTIL IT CAN GROW IT'S OWN. AND *ONE BY ONE*, UNTIL I GREW *OLD* AND *SENILE*, I'D TASTE *FRESH LOVE*...

THE COLOR WAS COMING INTO WENDY'S CHEEKS NOW. SHE WAS THAWING. SUDDENLY I THOUGHT OF IT. SHE'D BE FURIOUS, KNOWING THAT I HADN'T WAITED TILL TWO MONTHS BEFORE ARRIVAL-DATE...

BUT *WHY?* WHY *MAKE* HER ANGRY? SHE WANTS TO BE *QUEEN OF THE COLONY!* WHY LET HER *KNOW* WE'RE ONLY *THREE YEARS OUT*?

I WENT BACK TO THE CONTROL-ROOM AND CHANGED THE CALENDAR-CLOCK TO *98 YEARS OUT*...

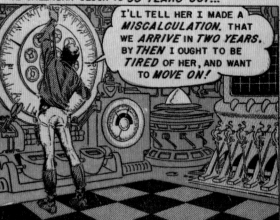

I'LL TELL HER I MADE A *MISCALCULATION*. THAT WE *ARRIVE* IN *TWO YEARS*. BY *THEN* I OUGHT TO BE *TIRED* OF HER, AND WANT TO *MOVE ON!*

I SAT DOWN TO WAIT. IT WOULDN'T BE LONG BEFORE WENDY WAS IN MY ARMS. I GRINNED...

WENDY WAS STANDING AT THE DOORWAY TO THE CONTROL ROOM. SHE HAD A PARALYZER IN HER HAND...

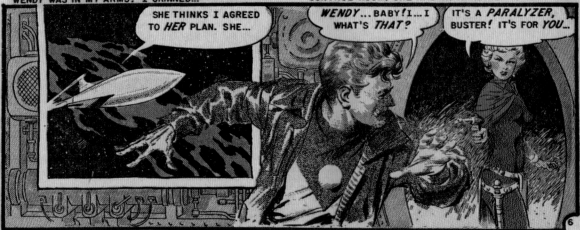

SHE THINKS I AGREED TO *HER* PLAN. SHE...

WENDY...BABY!I...I WHAT'S *THAT*?

IT'S A *PARALYZER*, BUSTER! IT'S FOR *YOU*...

6

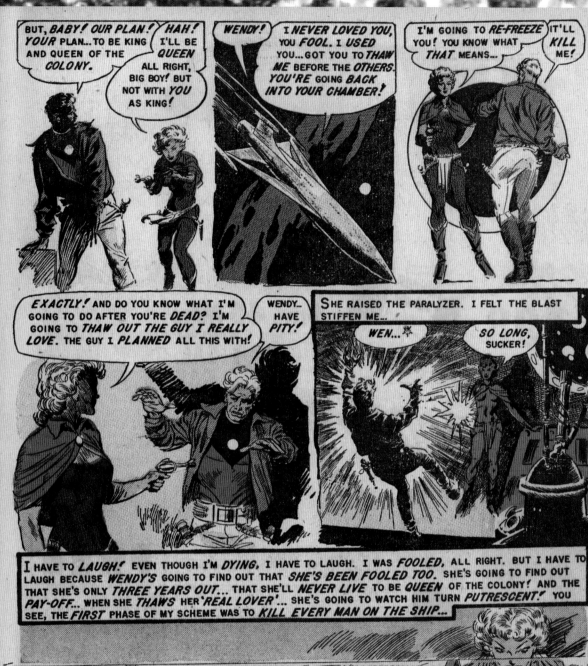

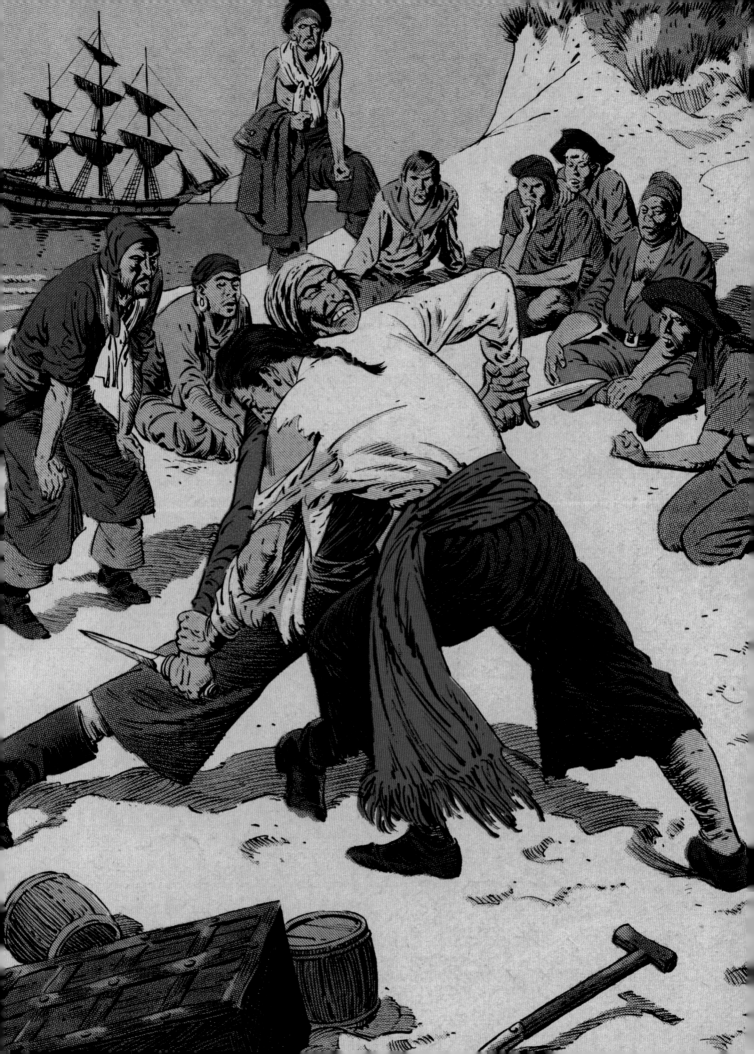

REED CRANDALL!

"WHEN *REED CRANDALL* WALKED INTO THE LOOKING FOR WORK, I FELL ON MY KNEES BECAUSE I ALWAYS *WORSHIPED* HIS STYLE!"
-AL FELDSTEIN

Unlike many of the other E.C. artists, Reed Crandall was an established veteran of the comic-book industry long before he worked for E.C. Bill Gaines said of Crandall in the fanzine *E.C. Lives!* that "he came walking in one day, and of course we all had heard of Reed Crandall. We were just as impressed with him as he was with us, so we fell on each other's necks and he became part of the group immediately."

Crandall was born in Winslow, Indiana on February 22, 1917. E.C. artist George Evans (a longtime friend), quoted Crandall in *Squa Tront #3* (1969) as saying: "I was drawing with anything I could get my hands on ever since I can remember." When Reed was thirteen his family moved to Newton, Kansas. Refining his artistic talent all through high school, he was awarded a scholarship upon graduation to the Cleveland School of Art, where he studied from 1935 through 1939. Here he was exposed to and profoundly influenced by the work of such classic illustrators as Howard Pyle, N.C. Wyeth, Henry C. Pitz, and James Montgomery Flagg.

He arrived in New York in 1940, and quickly found work at Will Eisner and Jerry Iger's shop—the entry point into the comic-book industry for many of the artists of the period. Much of Crandall's work was packaged by Eisner and Iger to appear in Everett "Busy" Arnold's Quality line of comics, and for Fiction House. Soon after, he began a long stint working directly for Arnold at Quality. Arnold held Crandall's work in high esteem, and hired him to be exclusive to Quality, a position he would hold for the next twelve years. Ron Goulart quotes Busy Arnold in *The Great Comic Book Artists* as saying that Crandall was "the best man I ever had." Crandall worked on a variety of features for Quality, including covers and stories for such titles as *Doll Man*, *Hit Comics*, *Police Comics*, *Buccaneers*, and *Military Comics* (later to become *Modern Comics*). *Military Comics* and *Modern Comics* both carried a feature that many aficionados consider Crandall's best work for the company, *Blackhawk*. Crandall carried the feature forward when Blackhawk was given his own title, and his attention to detail and meticulous, almost "classical" draftsmanship went a long way in making

Left: Detail from Crandall's cover to *Piracy #2* (December 1954–January 1955), an homage to Howard Pyle's famous 1911 painting *Who Shall Be Captain?* (shown above right, from *Howard Pyle's Book of Pirates*, 1921).

Copyright © 1942 by Comic Favorites

Copyright © 1947 by Comic Magazines

Right: Crandall splash page from "The Doll Man," *Doll Man Quarterly* #2 (Spring 1942), and Crandall cover from *Modern Comics* #64 (August 1947).

Copyright © 1948 by Comic Magazines

Copyright © 1950 by Comic Magazines

the book the success it was. Crandall drew the feature from 1942 to 1944, when he joined the Air Force and served in World War II. Upon his discharge in 1946 he returned to Quality, where he was the main *Blackhawk* artist until 1953 when Quality began winding down their operations.

Crandall's first work for E.C. appeared in 1953 ("Carrion Death!," *Shock SuspenStories* #9, June–July 1953), and it was immediately embraced by the fans. From this point on, Crandall regularly had work in E.C.'s horror, science fiction, crime, and shock titles. Bill Gaines said in *E.C. Lives!* that "he was a fine, fine craftsman and did some of our very best stuff. I only regret that he came to us so late. We didn't have him for the first half, so we only got half as much out of him as we would have if he had started in 1950."

What Crandall's output for E.C. might have lacked in quantity was more than made up in quality, and he did some of his best work for the company. When E.C. dropped their horror and

crime comics, Crandall had work in nearly all their New Direction comics, including *Piracy, Impact, Valor, Extra!,* and *M.D.* He also contributed stories (and three covers) to E.C.'s short-lived Picto-Fiction magazines *Shock Illustrated, Crime Illustrated, Terror Illustrated,* and *Confessions Illustrated.*

As good as he was, Crandall was not without personal problems; he was another of E.C.'s artists that was no stranger to the

Above: Crandall covers to *Modern Comics* #77 (September 1948) and *Buccaneers* #21 (May 1950).

214

Above: Crandall's first E.C. story, "Carrion Death!," *Shock SuspenStories* #9 (June–July 1953).

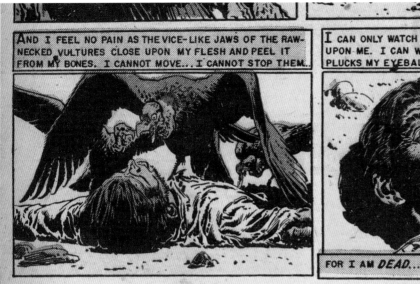

AND I FEEL NO PAIN AS THE VICE-LIKE JAWS OF THE RAW-NECKED VULTURES CLOSE UPON MY FLESH AND PEEL IT FROM MY BONES. I CANNOT MOVE... I CANNOT STOP THEM.

I CAN ONLY WATCH IN SILENT HORROR AS THEY FEED UPON ME. I CAN WATCH ONLY UNTIL ONE OF THEM PLUCKS MY EYEBALLS FROM MY SKULL...

FOR I AM *DEAD*...

THE END...

Left: The horrific final two panels from "Carrion Death!," *Shock SuspenStories* #9 (June–July 1953).

bottle. Al Feldstein, who knew Crandall from back in the days at the Eisner and Iger shop, recalled in his interview in *Tales of Terror! The E.C. Companion* that "Reed was an extremely talented artist. Unfortunately, when he came to work for me he was already pretty alcohol destructed." It must be said, however, that his drinking didn't seem to affect his work at E.C., and there are no reports of Crandall having any deadline problems at the time.

After E.C. stopped publishing comics, Crandall did two stories for *MAD*

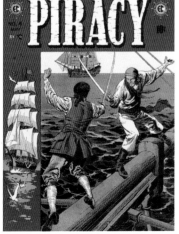

Magazine—a Goodyear Tire ad parody (*MAD* #30, December 1956) and a piece on palm reading (*MAD* #35, October 1957), but it was clear that he wasn't a "funny" artist and ultimately wouldn't be fitting in with "The Usual Gang of Idiots." Gaines told Rich Hauser in 1969 that "Crandall is not funny. He can do most anything, but I don't think he'd be effective in *MAD*."

Crandall found himself freelancing for a variety of companies, including jobs for Stan Lee at Atlas and a long stint illustrating for *Treasure Chest*, an educational comic published by the Catholic Church. He also had a long run of work in the giveaway comic *Buster Brown*, produced for the Buster Brown Shoe Stores. In the early 1960s he teamed up with George Evans for some memorable work on Gold Key's *The Twilight Zone* comics, and for *Classics Illustrated*. Some of this work was low paying, so the artists would need to bash it out quickly to make any money. On one such Crandall/Evans collaboration for *Classics Illustrated*, the script was sent out for Crandall to pencil, and the finished

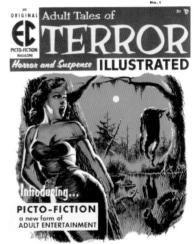

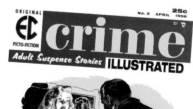

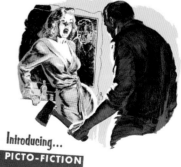

Above left: Crandall covers to *Piracy* #3 and #4 (1955). *Above right:* Crandall covers to the Picto-Fiction magazines *Terror Illustrated* #1 (1955) and *Crime Illustrated* #2 (1956).

215

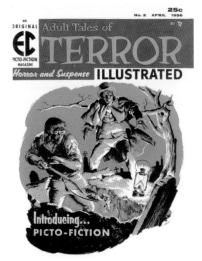

Above: Crandall cover to the Picto-Fiction magazine *Terror Illustrated* #2 (Spring 1956).

pencils were sent back to Evans for the final inking. Evans recalled in *Squa Tront* #3 that "there in meticulous tight penciling was the most beautiful comic art I ever saw. In common sense I should have lumped mob scenes into silhouettes, slashed out backgrounds, and cut all the beautiful shadow modeling into straight outlines." Evans in all good conscience couldn't allow himself to ruin such beautiful art, so he "sat on my tail, [inked it properly], and lost money like a fool." The work did get noticed, however, and both artists got better offers on the strength of it.

Starting in 1965 Crandall worked on Wallace Wood's *Thunder Agents* and *Dynamo* comics for Tower Comics, and (at the recommendation of Al Williamson) did a cover and several stories for King Comic's *Flash Gordon* comic book. Crandall enjoyed a late career renaissance in the mid-1960s with some lovely work in James Warren's black-and-white magazines *Creepy* and *Eerie*, which were unabashed attempts on the part of Warren to duplicate the previous success of E.C.'s horror comics. He also did some very attractive work with a series of

book illustrations for the works of Edgar Rice Burroughs (published by Canaveral Press), holding his own against the likes of such other important Burroughs artists as Frank Frazetta and Burne Hogarth.

Above: Crandall's Edgar Rice Burroughs–related painting from *Squa Tront* #3 (1969).

Artist/author Jim Steranko said this of Crandall in the *History of Comics, Volume 2*: "Crandall unquestionably was the finest artistic talent to emerge from the world of comic illustration in the 1940s. His attention to detail was never less than scrupulous. No matter how much drawing went into a story or how many figures were required on a page, the art was never slack, careless, or indulgent. As a draftsman, he was every bit as proficient as [Hal] Foster, [Alex] Raymond, or [Milton] Caniff."

In later years Crandall's health problems finally began to take their toll, and his drawings—while still meticulously detailed—began to exhibit an odd distortion of both anatomy and perspective. He suffered a debilitating stroke in 1974, and in his final years he was unable to produce any work. After a period of steadily declining health, Reed Crandall passed away in Wichita, Kansas on September 13, 1982. •

Above: Painted cover to *The Twilight Zone* #1288 (February–April 1962), a collaboration between Crandall and George Evans.

THE VAULT OF HORROR!

HEH, HEH! IT'S SO *NICE* TO SEE YOUR *PUTRID PUSSES* AGAIN, *CREEPS*, PEERING INTO *THE VAULT*. WELL, YOUR *HAPPY HOST IN HOWLS*, *THE VAULT-KEEPER* (THAT'S *ME*, IN THE *LIVID FLESH*) IS READY TO RELATE ANOTHER *REVOLTING TALE* FROM MY *APPETIZING ASSORTMENT*. SO, *COME IN*... CURL UP ON THAT *DISSECTION TABLE THERE*, AND I'LL *BEGIN* THE *SCREAM-STORY* I CALL...

The HIGH COST of DYING!

OUR STORY BEGINS IN PARIS ON A SWELTERING SUMMER NIGHT IN 1867. A CART RATTLES THROUGH DESERTED COBBLE-STONED STREETS...PAST DARKENED STORES AND SHUTTERED HOUSES...DOWN WINDING ALLEYS ALIVE WITH SCAMPERING GREY SHADOWS...AND FINALLY UP ONTO ONE OF THE COUNTLESS BRIDGES THAT SPAN THE RIVER *SEINE*. THE SHABBILY DRESSED FIGURE, PULLING THE NOISY CART, GASPS AND STRAINS AS HE LABORS UP THE INCLINE OF THE BRIDGE TOWARD ITS CENTER. HIS TORN AND SHREDDED SHIRT IS WET WITH PERSPIRATION, AND HIS GRIMY FACE IS STREAKED BY THE TEARS THAT FILL HIS EYES AND OVERFLOW THEIR LIDS...

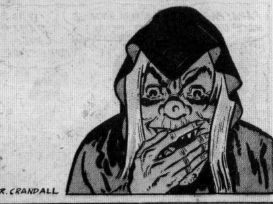

R. CRANDALL

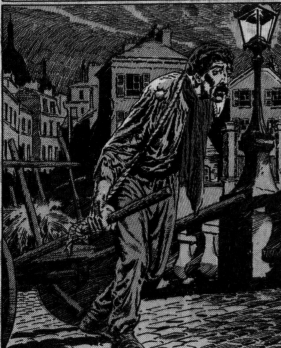

HIS NAME IS HENRI COURBET. HE STOPS NOW, RESTING... WIPING HIS WET EYES WITH THE BACK OF HIS HUGE HAND. HE TURNS AND GLANCES BEHIND HIM...AT THE CART...AT THE BODY LYING UPON IT, WRAPPED IN BURLAP, LYING STILL AND SILENT AND NEVERMORE TO MOVE OR LAUGH OR TALK OR CRY, AS NOW HENRY IS CRYING...

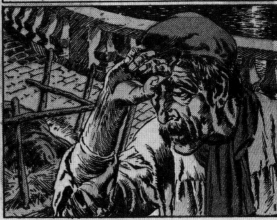

"The High Cost of Dying!," from *The Haunt of Fear* #21 (September–October 1953). Illustrated by Reed Crandall. Written by Bill Gaines and Al Feldstein.

FOR A WHILE, HENRI STARES DOWN AT THE MUDDY FOG-BLANKETED RIVER, SHAKING HIS HEAD, HATING HIMSELF FOR THIS...THIS HORRIBLE THING THAT HE IS DOING...

BUT SOMETIMES A MAN IS FORCED TO DO THINGS THAT ARE HATEFUL AND REVOLTING TO HIM. SOMETIMES, HE CANNOT HELP HIMSELF. HENRI STARES DOWN AT THE SLOW MURKY RIVER AND NODS...

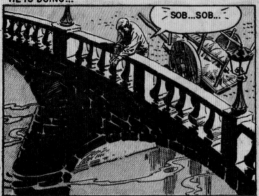

SOB...SOB...

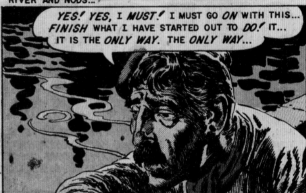

YES! YES, I MUST! I MUST GO ON WITH THIS... FINISH WHAT I HAVE STARTED OUT TO DO! IT... IT IS THE ONLY WAY. THE ONLY WAY...

THE RIVER BELOW THE BRIDGE FLOWS ON...LIKE TIME... CEASELESSLY... UNENDING... NEVER COMING BACK...GOING DOWNSTREAM INTO THE PAST...LOST FOREVER. HENRI GAZES DOWNSTREAM INTO THE FOG...INTO THE PAST. AND HE SEES HIMSELF WAKING THAT MORNING TO THE CHILDREN'S HYSTERICAL CRIES...

HENRI SEES IT ALL SO CLEARLY...HIS HUNGRY CHILDREN, PALE AND WAN AND RAGGED...SOBBING...

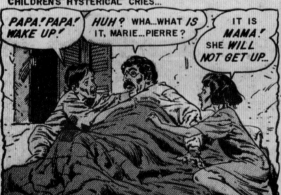

PAPA! PAPA! WAKE UP!

HUH? WHA...WHAT IS IT, MARIE...PIERRE?

IT IS MAMA! SHE WILL NOT GET UP...

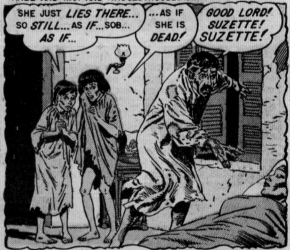

SHE JUST LIES THERE... SO STILL...AS IF...SOB... AS IF...

...AS IF SHE IS DEAD!

GOOD LORD! SUZETTE! SUZETTE!

AND HE REMEMBERS HOW HE HAD LEAPED FROM HIS STRAW COT AND RUSHED TO HIS WIFE'S SIDE...TO SUZETTE...BEAUTIFUL, SILENT SUZETTE...

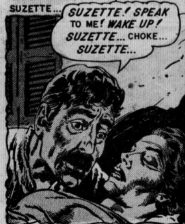

SUZETTE! SPEAK TO ME! WAKE UP! SUZETTE...CHOKE... SUZETTE...

HE REMEMBERS SENDING THE BOY, PIERRE...

HURRY, CHILD! RUN TO M'SIEUR LE DUCART... THE DOCTOR. BRING HIM HERE! HURRY!

YES, PAPA!

HE REMEMBERS DOCTOR LE DUCART COMING TO THE SQUALID CELLAR-APARTMENT AND PUTTING DOWN HIS LITTLE BLACK BAG AND TAKING SUZETTE'S LIMP WHITE HAND IN HIS AND SHAKING HIS HEAD...

SORRY, COURBET! SHE IS DEAD, FOR SURE. FROM MAL-NUTRITION, IT APPEARS...

NO...SOB... NO...

2

THE OFFICER LEERED AT HENRI...

DO YOU KNOW WHAT *THAT* MEANS, M'SIEU COURBET? IT MEANS THAT IF YOU CAN'T AFFORD TO *BURY* YOUR WIFE, HER *BODY* IS TURNED OVER TO *MEDICAL STUDENTS* FOR *DISSECTION!*

IT ISN'T *FAIR!* OH, *GOD!* IT ISN'T FAIR. THERE ISN'T ENOUGH *TIME!*

HE SNEERED...

DO YOU KNOW WHAT MEDICAL STUDENTS *DO* TO BODIES, M'SIEU COURBET? THEY TAKE *SHARP LITTLE SCALPELS*...AND THEY CUT THEM *OPEN* AND TAKE OUT THE *INSIDES* AND CUT *THEM* OPEN...

PIECE BY *PIECE*... INCH BY *INCH*... THEY *PROBE* AND *SLICE* AND *CUT* AND *STUDY* AND *CUT SOME MORE*...

...AND DO YOU KNOW *WHY* THE COMMISSIONER OF HEALTH *ISSUED* THIS DECREE, M'SIEU COURBET. *NOT* IN THE INTERESTS OF THE CITY'S *HEALTH!* HE GETS *SEVENTY-FIVE FRANCS* FOR EACH BODY... FROM THE *CONSERVATORY*... WHICH HE *POCKETS!*

STOP IT! STOP IT! HAVE *PITY!*

THE OFFICER LOOKED AROUND. HE LOOKED AT SUZETTE'S STILL WHITE FORM...

SHE IS *YOUNG* AND *PRETTY.* THE MEDICAL STUDENTS WILL *ESPECIALLY* WELCOME *HER* BODY. SO I SUGGEST YOU *RAISE* THE MONEY, M'SIEU...*QUICKLY. BURY HER!*

I...CHOKE...I *CAN-NOT! I HAVE TRIED!* I CANNOT EVEN BUY *FOOD* FOR THE *CHILDREN!*

THE OFFICER LOOKED AT THE POVERTY AND SQUALOR... AT THE PALE THIN STARVING CHILDREN WHO STARED AT HIM WITH WIDE FRIGHTENED EYES...

THEN DON'T BE A *FOOL,* COURBET. *TAKE* HER TO THE CONSERVATORY *YOURSELF..TONIGHT!* LINE YOUR *OWN* POCKETS WITH THE *SEVENTY-FIVE FRANCS!* AT LEAST YOU WILL BE ABLE TO *FEED YOUR CHILDREN*...

KNOWING WHAT THEY WILL *DO* TO SUZETTE... SOB. HOW *CAN I?*

THE OFFICER TURNED TO GO. HE SHRUGGED...

SHE IS *DEAD,* M'SIEU. *SHE* WILL NEVER *KNOW!* GOOD-EVENING! TILL TOMORROW... THEN...

TILL TOMORROW...

221

HENRI STARES DOWN AT THE RIVER. HE THINKS OF THE MEDICAL STUDENTS...GATHERED AROUND THE BODY... THEIR SHINING SCALPELS IN THEIR UPRAISED HANDS... THEIR GRINNING FACES...

AND THEN HE THINKS OF THE CHILDREN...MARIE AND PIERRE...THEIR BLOATED STOMACHS CRYING FOR FOOD... THEIR BONY FINGERS SEARCHING FOR CRUMBS IN THE FLOORBOARD CRACKS...

AND THEN HE LOOKS AT THE BODY WRAPPED IN BUR- LAP LYING ON THE OLD CART, AND HE KNOWS THAT WHAT HE IS DOING IS RIGHT...

THE CART RUMBLES DOWN AND OFF THE BRIDGE, THE STIFF BODY BOUNCING UPON IT...

YES! YES! I MUST GO *ON* WITH THIS! I *MUST!*

...RUMBLES ON THROUGH COBBLE-STONED STREETS, DOWN WINDING ALLEYS, TOWARD *THE PARIS CONSERVATORY OF MEDICINE...*

FOOTSTEPS APPROACH IN ANSWER TO HENRI'S FRANTIC KNOCK. THE DOOR SWINGS OPEN. A FACE PEERS OUT...

THE DOOR SWINGS WIDE. A SHAFT OF LIGHT KNIFES INTO THE FOGGY SUMMER NIGHT, FALLING ACROSS THE BURLAP-WRAPPED FORM...

THE OLD MAN HOBBLES OUT INTO THE NIGHT...OUT TO THE CART...LIFTS THE BURLAP COVER AND PEEPS AT THE STILL WHITE FACE...

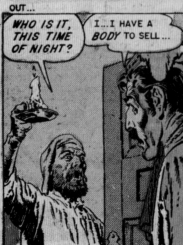

WHO IS IT, THIS TIME OF NIGHT?

I...I HAVE A *BODY* TO SELL...

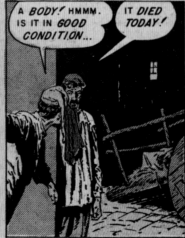

A *BODY!* HMMM. IS IT IN *GOOD* CONDITION...

IT *DIED* TODAY!

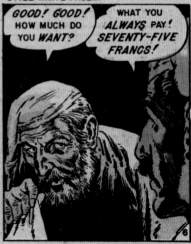

GOOD! GOOD! HOW MUCH DO YOU *WANT?*

WHAT YOU *ALWAYS* PAY! SEVENTY-FIVE FRANCS!

EARLY THE NEXT MORNING, PIERRE AND MARIE ATE HEARTILY...THE FIRST GOOD FOOD THEY'D HAD IN MONTHS...

SLOWLY, CHILDREN! SLOWLY...

YES, PAPA!

AND THEY DRESSED IN THEIR NEW CLOTHES...THE CLOTHES HENRI HAD BOUGHT WITH PART OF THE SEVENTY-FIVE FRANCS...

THIS IS THE MOST BEAUTIFUL DRESS IN THE WHOLE WORLD, PAPA!

AND THIS... THE HANDSOMEST SUIT!

YES, CHILDREN...

...AND, TOGETHER, THEY WALKED OUT INTO THE SUNLIGHT...

IT'S A BEAUTIFUL DAY, PAPA!

MAMA ALWAYS LOVED BEAUTIFUL DAYS!

YES, CHILDREN!

AT EXACTLY THAT MOMENT, IN *THE PARIS CONSERVATORY OF MEDICINE*, EAGER CURIOUS PROSPECTIVE DOCTORS CUT AND SLICED AND PROBED THE NEW BODY THAT HAD ARRIVED THAT NIGHT...

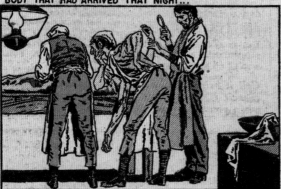

AND LATER, JUST OUTSIDE PARIS, HENRI AND THE CHILDREN STOOD BEFORE THE GAPING OPEN GRAVE, WATCHING THE COFFIN BEING LOWERED SLOWLY INTO IT...

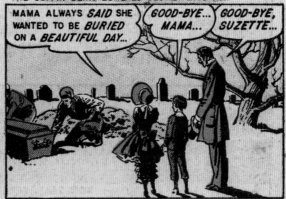

MAMA ALWAYS SAID SHE WANTED TO BE BURIED ON A BEAUTIFUL DAY...

GOOD-BYE... MAMA...

GOOD-BYE, SUZETTE...

WHILE AT THAT PRECISE MOMENT, THE DEAN OF *THE PARIS CONSERVATORY OF MEDICINE*, ON HIS DAILY TOUR OF THE ANATOMY CLASSES, STOPPED BEFORE THE NEWLY PURCHASED BODY THAT NOW LAY COMPLETELY DISSECTED...AND SHRIEKED...

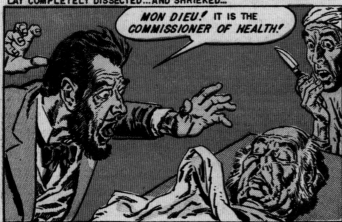

MON DIEU! IT IS THE COMMISSIONER OF HEALTH!

HEH, HEH! YEP! THAT'S MY *YELP-YARN*, FIENDS! HENRI TOOK A *WALK* THAT NIGHT TO TRY AND DECIDE WHAT TO *DO*... AND THE *SOLUTION*, SHALL WE SAY, *DROPPED* INTO HIS LAP. OF COURSE, HE HAD TO *COAX* THE COMMISSIONER TO *DROP* (DEAD, THAT IS) BY... WELL... I'LL *SPARE* YOU THE *GORY DETAILS*. JUST USE YOUR LIL' OL' *IMAGINATIONS*. AND NOW IT'S TIME TO *CLOSE* THE DOOR OF THE *VAULT* TILL *NEXT* WE MEET...WHICH WILL BE IN *THE CRYPT-KEEPER'S MAG...TALES FROM THE CRYPT*. TILL THEN...AS THE *UNDERTAKERS* SAY...'HAVE A *NICE MOURNING!*'

...THE END...

BERNIE KRIGSTEIN!

"KRIGSTEIN WAS AN *EXTREMELY* TALENTED GUY, AND HAD E.C. LASTED, HE WOULD HAVE CRACKED *WHOLE NEW GROUND* IN COMICS!" –AL FELDSTEIN

Bernard Krigstein, the most consciously "artistic" of all E.C.'s artists, was also one of the last to join the stable. He was also perhaps the only artist of the time to approach comic art as a serious art form.

Krigstein was born in Brooklyn, New York, on March 22, 1919. Like many aspiring young artists, he developed an early fascination with the Sunday comic section, being especially fond of *Mutt and Jeff, Toonerville Trolley, Slim Jim,* and *The Katzenjammer Kids.* Krigstein graduated in 1940 with a degree in art from Brooklyn College. Even then, Krigstein was interested in pursuing fine art, but finances were low. "I had always looked at comics with contempt, but a friend of mine who worked in the field had repeatedly asked me to try drawing for it," Krigstein said in the 1962 interview fanzine *Bhob Stewart and John Benson Talk with B. Krigstein.* "Finally it did come about that I needed the money, and I took a job." Forced to examine the possibilities inherent in the field, Krigstein became seduced by it. "It became the only serious field for me at that time." It should be noted, however, that Krigstein kept up his own personal "fine art" work going, even while busily working in comics.

Krigstein's first job in the field was for Bernard Baily's assembly-line-style shop. He worked there for about four months, but in March 1943 he received his draft notice. Krigstein served a two-year stretch in the Army, and when he got out he "went back into comics the same day." And by being in comics, Krigstein said in Greg Sadowski's excellent 2002 book, *B. Krigstein,* "I became no longer embarrassed about the so-called limitations of working in black and white, and so forth. I shed all the criticism of the form as I worked in it." He got his old job back at the Baily shop, but soon moved on to various other work, including stints at Lloyd Jacquet's Funnies, Inc. shop, Fawcett (*Nyoka the Jungle Girl, Master,* and *Whiz Comics*), Novelty (*Target Comics*), D.C. (*Sensation* and *Flash*), Rae Herman's shop, and Hillman Publications. His work at the latter sufficiently impressed Harvey Kurtzman, who called Krigstein in 1951 and asked him to come work on the E.C. war comics. "I had heard of E.C., but I didn't know much about them," Krigstein said in an interview published in *Squa*

B. Krigstein

bhob stewart and John Benson

TALK

with

B. Krigstein

Left: Detail from Krigstein's cover to *Piracy* #6, August–September 1955. Krigstein's original concept for this cover had the corona of the sun scaled even larger, which would have made for an even more powerful image.

Above: Bhob Stewart and John Benson Talk with B. Krigstein, a rare 1963 fanzine.

Above: *The E.C. Press* #4, an extremely rare August 1954 mimeographed fanzine that contained the first serious critique of Krigstein's E.C. comic work, written by Bhob Stewart.

Tront #6, (1975). "I knew Kurtzman was doing interesting work, but I felt that the rates he was able to pay didn't satisfy me. So I turned Harvey down. But I think if I knew more at that time about what E.C. *meant*, I simply would have accepted Harvey's invitation." Instead, he went on to stints working for Ziff-Davis, D.C., and with Stan Lee at Atlas.

At the end of 1951, Krigstein became passionate about forming a union, the Society of Comic Book Illustrators, to organize and ultimately provide three vital services for its members: provide a group health plan, lobby for the return of all artwork to the artists, and establish a minimum page rate. Needless to say, the industry was not ready at that time for what seemed like such a radical idea, and largely because of resistance from the publishers, the Society had died on the vine by the middle of 1953.

At that point, Krigstein called Kurtzman to see if there was still an opening at E.C. There actually wasn't, as Gaines then had a full compliment of artists he was perfectly happy working with. Kurtzman lobbied on Krigstein's behalf, and the door was opened. "I could see that Harvey's recommendation had great force with Gaines," Krigstein said in *B. Krigstein*, "and it was strictly on that basis that I came to E.C." Oddly, he didn't do any work for Kurtzman for quite a while, instead working on the comics produced under Feldstein's editorship.

Krigstein's first job for the company was inking Al Williamson's pencils on a story called, ironically, "A New Beginning" (*Weird Science* #22, November–December 1953). This pairing proved to be disastrous, with neither artist happy with the work; Williamson actually got the job back and re-inked a fair portion of it. From then on, Krigstein flew solo; his first such outing was "Derelict Ship" in *Weird Fantasy* #22 (November–December 1953).

His second solo job for the company was "The Flying Machine" (*Weird Science-Fantasy* #23, March 1954), Feldstein's adaptation into comics form of Ray Bradbury's now-classic short story. It would be hard to imagine artwork that more perfectly suits the prose; here Krigstein's art has a delicate, Eastern-influenced style. Bradbury, after seeing an advance proof of the story, had this to say in a letter to E.C., dated July 18, 1953: "'The Flying Machine' is the finest single piece of art-drawing I've seen in the comics in years. Beautiful work; I was so touched and pleased by the concern for detail." (This story appears in its entirety at the end of this chapter.)

Interestingly, sometime prior to 1962, Krigstein had approached Ballantine Books about doing a full-length comic adaptation of Bradbury's novel *Fahrenheit 451*. "I spoke to his editor; I spoke to [Ian] Ballantine himself, and, unfortunately, he nixed the idea." (Ballantine Books did subsequently come out with two paperback collections of E.C.'s Bradbury adaptations, *The Autumn People* in 1965 and *Tomorrow Midnight* in 1966.)

Krigstein would go on to produce a total of forty-three stories for the company, work that is now widely considered to be some of

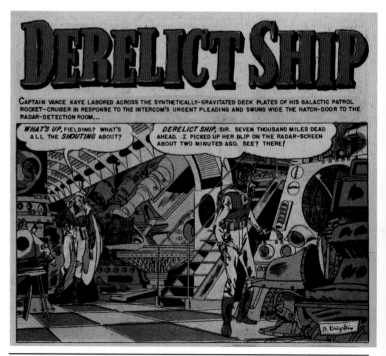

Above: The splash panel from "Derelict Ship" (*Weird Fantasy* #22, November–December 1953).

the best art ever done in comics. Some fans at the time, however, were not so sure. Bhob Stewart, in the very first critical essay of Krigstein ever published, "B. Krigstein: an Evaluation and Defense" (published in *The E.C. Press* #4, August 1954) had this to say: "Krigstein is a great artist. But somehow the fans can't take him. Perhaps the style is a bit too radical, a bit too different." He ended his essay by appealing to Krigstein's detractors to give him a chance.

Comics historian Michelle Nolan has said of Krigstein that he was "well known for the extremely innovative, often cinematic use of

panels, and for stubbornly standing by his own code of artistic conduct." More so than any other artist of the time, Krigstein was fascinated with the emotion, drama, and mood that could be conveyed by the arranging or

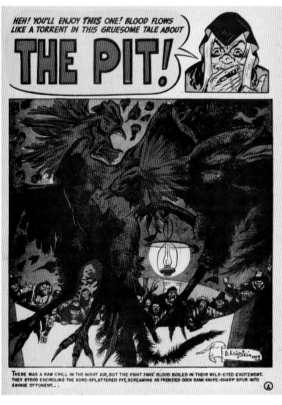

rearranging of the panels. Krigstein told Stewart and Benson that "I didn't feel there was any real difference between a play and a movie as far as inspiration for a comic-book artist was concerned." Krigstein's layouts and stop-motion panels have often been likened to the quick jump-cuts used in film. "I wanted panels; I was desperate for panels," Krigstein told Stewart and Benson. "So, out of desperation, I began subdividing the panels. The point came where it was simply absurd to have six panels for a certain amount of text. I began to see these people doing all sorts of things, and it just became ridiculous to have them doing all this stuff in six panels." Amazingly, Krigstein broke down one six-page E.C. story, "Key Chain" (*Crime SuspenStories* #25, October–November 1954), into sixty-three separate panels.

Above: Six-panel detail from "Key Chain" (*Crime SuspenStories* #25, October–November 1954).

We would be doing Krigstein a disservice to discuss his work only in terms of multiple-panel breakdowns; sometimes the opposite approach was taken if it worked best for the story. "The Pit!" (*The Vault of Horror* #40, December 1953–January 1954) is a good example of this. The splash page consists primarily of just one huge panel, the better to

Above: The splash page and a detail from the original art to "The Pit!" (*The Vault of Horror* #40, December 1953–January 1954).

focus on the senseless mayhem of the cock-fight and the bloodlust of the crowd.

Most devotees feel that Krigstein's crowning achievement in story breakdown was "Master Race," a story originally intended to appear in *Crime SuspenStories* #26 (December 1954–January 1955). Written and laid out by Feldstein as a six-page story, Krigstein envi-

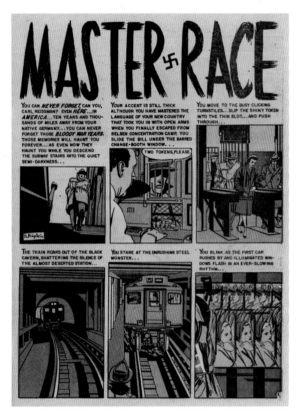

Right: The splash panel from "Master Race" (*Impact* #1, March–April 1955).

sioned something else entirely. "It was just the most explosive story that I had ever come across in the field," he told Stewart and Benson. He called Gaines and told him he wanted to expand it to a twelve pager. Gaines replied, "Twelve pages? It's impossible," and went on to say that he couldn't do it because it would be an extra expense to have the story sent out and relettered. Krigstein volunteered to cut up the pages himself and paste the existing lettering down onto new pages. "This was such a ridiculous thing for any artist to do," Krigstein told Stewart and Benson, "but I felt the story was worth anything."

They finally settled on eight pages, which meant the story had to be bumped out of its slot in *Crime SuspenStories* and held over for some later issue. (Jack Kamen's "falling off a subway platform cover," intended to tie in with this story, ran anyway as the cover to *Crime SuspenStories* #26; this cover appears in this book on page 114.) Midway through the story, Gaines and Feldstein called to say that they were worried about it, and that they had made a mistake. Krigstein assured them that they hadn't. "When I brought the pencils in," Krigstein told Stewart and Benson, "Bill and Feldstein agreed that it was well worth the expansion." "Master Race" finally appeared in the New Direction title *Impact* #1, March–April 1955. "If only," Krigstein continued, "they would have allowed me to continue on this track, I felt I could have done something new and different. All these years, frankly, I have been nursing that frustration. I always nurtured this feeling that something tremendous could have been done if they had let me do it." Al Feldstein said of "Master Race" in *Tales of Terror! The E.C. Companion* that "he really improved the story. The story was good, but he improved the art end of the story so much that I thought we were really breaking new ground. He was right in the end."

Krigstein and E.C. finally parted ways over an assignment called "Fall Guy for Murder" (published in the Picto-Fiction title *Crime Illustrated* #1, November–December 1955). To Krigstein's way of thinking, the ideological philosophy of the book—and the story he was given—was that "crime pays." Not liking that philosophy, Krigstein made a change in the story's ending. "I felt that as the artist I would simply employ my

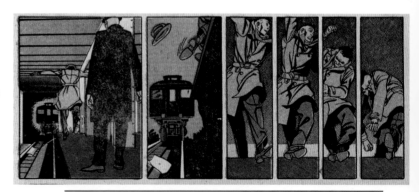

Above: A series of stop-motion panels from "Master Race" (*Impact* #1, March–April 1955).

prerogative, which I had always employed, making certain changes that suited me," Krigstein told Stewart and Benson. "In the last panel I did something that indicated that there was a moral reckoning insofar as the criminal was concerned." Krigstein handed in the story, and Feldstein reportedly read it very happily until the end. "What's this, Bernie?," said Feldstein. Krigstein replied: "Well, I changed the story. I don't like the way you ended the story." Feldstein told Krigstein that he couldn't do that, and that he would have to change it back. Krigstein said he wouldn't change it. It was a standoff. "I let them know that I didn't want to be credited for it," Krigstein told Stewart and Benson. "And that was the end between me and E.C."

Gaines told E.C. aficionado Rich Hauser, "Krigstein left in the middle of that story and Reed Crandall—who's more philosophical about these things—came in. He finished off Krigstein's unfinished story, and that was that." And in *E.C. Lives!*, Gaines said of Krigstein that "Bernie was the most difficult to work with, because he was so strong minded. He'd take the stories as we did them and would chop them up into little pieces, and re-paste them down into other shapes and formats. In retrospect, he was right and we were wrong, I suppose, but from a point of view of trying to get the thing out in a standardized position he drove us crazy."

After leaving E.C., Krigstein went back and did a number of stories for Atlas. Here he reached his personal best of a whopping seventy-five panels packed into the four-page story "They Wait Below" (*Uncanny Tales* #42, April 1956). "I really feel as if I stumbled upon an important way to tell stories, to break down stories," he told Stewart and Benson. "As things worked out, I was unable to continue. Soon after that, I had to leave the field."

By the late 1950s, Krigstein began to get work as an illustrator, landing numerous assignments for book covers, record album jackets, and magazine illustrations. In 1962 he also began teaching at the New York High School of Art and Design, a position he would hold for two decades. And as he always had, he pursued his own "fine art," enjoying a

number of one-man shows at various galleries and winning a number of awards for his canvases.

Pulitzer Prize–winning comics artist/writer Art Spiegelman is quoted in *Between the Panels* as saying, "I used to daydream about

the possibility that Krigstein might be lured back into the field now that *maybe* the medium was beginning to catch up with his work in the 1950s." It was not to be; Krigstein never returned to comics.

"I belong to low culture," Krigstein told comics fans at an appearance at the 1978 NewCon in Boston. "Not only do I belong to low culture, I don't think low culture *is* low culture." Bernard Krigstein died on January 8, 1990. He was inducted into the Jack Kirby Hall of Fame in 1992, and to the Will Eisner Hall of Fame in 2003. •

Above: Krigstein in Central Park, October 1963.

Below: Krigstein's final self-portrait, circa mid-1980s.

Copyright © 1959 by Harcourt, Brace and Company

Copyright © 1959 by McGraw-Hill

Above: Krigstein's front cover and spine for *The Buffalo Soldiers* (Harcourt, Brace and Company, 1959), along with a cover rough for the same title. *Left:* The original line art from a Krigstein book illustration.

Above: Krigstein-illustrated dust jacket for *The Manchurian Candidate* (McGraw-Hill, 1959). This book was made into a 1962 feature film starring Frank Sinatra, and re-made in 2004 as a feature starring Denzel Washington.

Above: Recurrent Nightmare, one of Krigstein's "fine art" paintings. This image was completed on September 19, 1956.

The FLYING MACHINE

IN THE YEAR A.D. 400, THE EMPEROR YUAN HELD HIS THRONE BY THE GREAT WALL OF CHINA, AND THE LAND WAS GREEN WITH RAIN, READYING ITSELF TOWARD THE HARVEST, AT PEACE, THE PEOPLE IN HIS DOMINATION NEITHER TOO HAPPY NOR TOO SAD. EARLY ON THE MORNING OF THE FIRST DAY OF THE FIRST WEEK OF THE SECOND MONTH OF THE NEW YEAR, THE EMPEROR YUAN WAS SIPPING TEA AND FANNING HIMSELF AGAINST A WARM BREEZE WHEN A SERVANT RAN ACROSS THE SCARLET AND BLUE GARDEN TILES, CALLING...

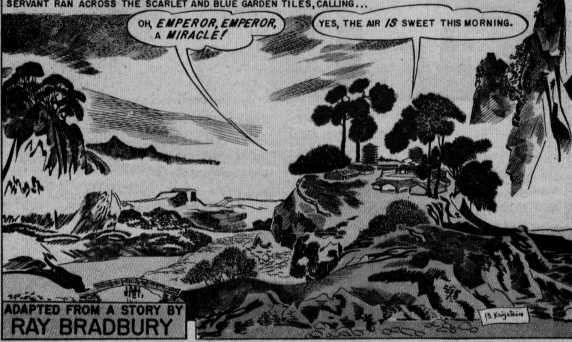

OH, EMPEROR, EMPEROR, A *MIRACLE!*

YES, THE AIR *IS* SWEET THIS MORNING.

ADAPTED FROM A STORY BY
RAY BRADBURY

B. Krigstein

THE SERVANT SHOOK HIS HEAD, BOWING QUICKLY...

NO, NO, A *MIRACLE!*

AND THIS *TEA* IS GOOD IN MY *MOUTH.* SURELY *THAT* IS A MIRACLE.

COPYRIGHT, 1953, BY RAY BRADBURY

NO, *NO,* YOUR EXCELLENCY.

LET ME GUESS, THEN. ER... THE *SUN* HAS RISEN AND A *NEW DAY* IS UPON US. OR THE *SEA* IS *BLUE. THAT,* NOW, IS THE FINEST OF *ALL* MIRACLES.

EXCELLENCY, A *MAN* IS *FLYING!*

WHAT?

THE EMPEROR STOPPED HIS FAN... ①

"The Flying Machine," from *Weird Science-Fantasy* #23 (March 1954).
Illustrated by Bernie Krigstein. Story by Ray Bradbury, adaptation by Al Feldstein.

"I SAW HIM IN THE AIR, A MAN FLYING WITH WINGS. I HEARD A VOICE CALL OUT OF THE SKY, AND WHEN I LOOKED UP, THERE HE WAS, A DRAGON IN THE HEAVENS WITH A MAN IN ITS MOUTH, A DRAGON OF PAPER AND BAMBOO, COLORED LIKE THE SUN AND THE GRASS."

"IT IS EARLY, AND YOU HAVE JUST WAKENED FROM A DREAM."

"IT IS EARLY, BUT I HAVE SEEN WHAT I HAVE SEEN! COME, AND YOU WILL SEE IT, TOO."

"SIT DOWN WITH ME HERE. DRINK SOME TEA. IT MUST BE A STRANGE THING, IF IT IS TRUE, TO SEE A MAN FLY. YOU MUST HAVE TIME TO THINK OF IT, EVEN AS I MUST HAVE TIME TO PREPARE MYSELF FOR THE SIGHT."

THEY DRANK TEA. THE EMPEROR ROSE THOUGHTFULLY AS THE SERVANT PLEADED...

"PLEASE. OR HE WILL BE GONE."

"NOW YOU MAY SHOW ME WHAT YOU HAVE SEEN."

THEY WALKED INTO A GARDEN, ACROSS A MEADOW OF GRASS, OVER A SMALL BRIDGE, THROUGH A GROVE OF TREES, AND UP A TINY HILL...

"THERE!"

THE EMPEROR LOOKED INTO THE SKY...

AND IN THE SKY, LAUGHING SO HIGH THAT YOU COULD HARDLY HEAR HIM LAUGH, WAS A MAN, AND THE MAN WAS CLOTHED IN BRIGHT PAPERS AND REEDS TO MAKE WINGS AND A BEAUTIFUL YELLOW TAIL, AND HE WAS SOARING ALL ABOUT LIKE THE LARGEST BIRD IN A UNIVERSE OF BIRDS, LIKE A NEW DRAGON IN A LAND OF ANCIENT DRAGONS...

"I FLY! I FLY!"

"YES! YES..."

THE EMPEROR YUAN DID NOT MOVE. INSTEAD HE LOOKED AT THE GREAT WALL OF CHINA NOW TAKING SHAPE OUT OF THE FARTHEST MIST IN THE GREEN HILLS, THAT WONDERFUL WALL WHICH HAD PROTECTED THEM FOR A TIMELESS TIME FROM ENEMY HORDES AND PRESERVED PEACE FOR YEARS WITHOUT NUMBER...

"TELL ME, HAS ANYONE ELSE SEEN THIS FLYING MAN?"

"I AM THE ONLY ONE EXCELLENCY."

THE EMPEROR WATCHED THE HEAVENS ANOTHER MINUTE AND THEN SAID...

"CALL HIM DOWN TO ME."

"HO, COME DOWN, COME DOWN! THE EMPEROR WISHES TO SEE YOU!"

2

THE EMPEROR GLANCED IN ALL DIRECTIONS WHILE THE FLYING MAN SOARED DOWN THE MORNING WIND. HE SAW A FARMER, EARLY IN HIS FIELDS, WATCHING THE SKY, AND HE NOTED WHERE THE FARMER STOOD...

THE FLYING MAN ALIT WITH A RUSTLE OF PAPER AND A CREAK OF BAMBOO REEDS. HE CAME PROUDLY TO THE EMPEROR, CLUMSY IN HIS RIG, AT LAST BOWING BEFORE THE OLD MAN...

WHAT *HAVE* YOU DONE?

I HAVE *FLOWN* IN THE *SKY*, YOUR EXCELLENCY.

WHAT HAVE YOU *DONE*?

I HAVE JUST *TOLD* YOU!

YOU HAVE TOLD ME *NOTHING* AT ALL.

THE EMPEROR REACHED OUT A THIN HAND TO TOUCH THE PRETTY PAPER AND THE BIRDLIKE KEEL OF THE APPARATUS. IT SMELLED COOL, OF THE WIND...

IS IT NOT *BEAUTIFUL*, EXCELLENCY?

YES, *TOO* BEAUTIFUL.

IT IS THE *ONLY* ONE IN THE *WORLD*! AND I AM THE *INVENTOR*!

THE *ONLY* ONE IN THE WORLD?

I *SWEAR* IT!

WHO ELSE *KNOWS* OF THIS?

3

"NO ONE. NOT *EVEN* MY *WIFE*, WHO WOULD THINK ME *MAD WITH THE SUN.* SHE THOUGHT I WAS MAKING A *KITE.* I ROSE IN THE NIGHT, AND WALKED TO THE CLIFFS FAR AWAY. AND WHEN THE MORNING BREEZES BLEW AND THE SUN ROSE, I GATHERED MY COURAGE, EXCELLENCY, AND LEAPED. I *FLEW!* BUT MY *WIFE* DOES NOT *KNOW* OF IT."

"WELL FOR *HER,* THEN. *COME ALONG.*"

THEY WALKED BACK TO THE GREAT HOUSE. THE SUN WAS FULL IN THE SKY NOW, AND THE SMELL OF THE GRASS WAS REFRESHING. THE EMPEROR, THE SERVANT, AND THE FLIER PAUSED WITHIN THE HUGE GARDEN. THE EMPEROR CLAPPED HIS HANDS.

"HO, GUARDS!"

THE GUARDS CAME RUNNING...

"HOLD THIS MAN."

"CALL THE *EXECUTIONER!*"

"WHAT'S *THIS?* WHAT HAVE I *DONE?*"

THE FLIER BEGAN TO WEEP, SO THAT THE BEAUTIFUL PAPER APPARATUS RUSTLED...

"*HERE* IS A MAN WHO HAS MADE A CERTAIN *MACHINE,* AND YET HE *ASKS* US WHAT HE HAS *CREATED.* HE DOES *NOT KNOW HIMSELF.* IT IS ONLY NECESSARY THAT HE *CREATE,* WITHOUT KNOWING *WHY* HE HAS DONE SO, OR *WHAT* THIS THING WILL *DO.*"

THE EXECUTIONER CAME RUNNING WITH A SILVER AX. HE STOOD WITH HIS NAKED, LARGE-MUSCLED ARMS READY, HIS FACE COVERED WITH A SERENE WHITE MASK...

"ONE MOMENT..."

THE EMPEROR TURNED TO A NEARBY TABLE UPON WHICH SAT A MACHINE THAT HE HIMSELF HAD CREATED. HE TOOK A TINY GOLDEN KEY FROM AROUND HIS OWN NECK. HE FITTED THIS KEY TO THE TINY, DELICATE MACHINE AND WOUND IT UP...

THEN HE SET THE MACHINE GOING...

4

235

THE MACHINE WAS A GARDEN OF METAL AND JEWELS, SET IN MOTION. BIRDS SANG IN TINY METAL TREES, WOLVES WALKED THROUGH MINIATURE FORESTS, AND TINY PEOPLE RAN IN AND OUT OF SUN AND SHADOW, FANNING THEMSELVES WITH MINIATURE FANS, LISTENING TO THE TINY EMERALD BIRDS, AND STANDING BY IMPOSSIBLY SMALL BUT TINKLING FOUNTAINS...

THE EMPEROR SAID...

IS *IT* NOT BEAUTIFUL? IF YOU ASKED ME WHAT *I* HAVE DONE HERE, I COULD *ANSWER* YOU *WELL*. I HAVE MADE *BIRDS* SING, I HAVE MADE *FORESTS* MURMUR, I HAVE SET *PEOPLE* TO WALKING IN THIS WOODLAND, ENJOYING THE LEAVES AND SHADOWS AND SONGS. *THAT* IS WHAT *I* HAVE DONE.

THE FLIER, ON HIS KNEES, THE TEARS POURING DOWN HIS FACE, PLEADED...

BUT *I* HAVE DONE A *SIMILAR* THING! I HAVE FOUND *BEAUTY*. I HAVE *FLOWN* ON THE *MORNING WIND*. I HAVE LOOKED DOWN ON ALL THE SLEEPING HOUSES AND GARDENS. I HAVE SMELLED THE SEA AND EVEN *SEEN* IT, BEYOND THE HILLS, FROM MY HIGH PLACE. AND I HAVE SOARED LIKE A BIRD. OH, I CANNOT *SAY* HOW BEAUTIFUL IT IS UP THERE, IN THE SKY, WITH THE WIND ABOUT ME, BLOWING ME LIKE A FEATHER. *THAT* IS *BEAUTIFUL*, EMPEROR, THAT IS *BEAUTIFUL*, *TOO!*

YES. I KNOW IT *MUST* BE *TRUE*. FOR I FELT MY *HEART* MOVE WITH YOU IN THE AIR AND I *WONDERED*: WHAT IS IT *LIKE*? HOW DOES IT *FEEL*? HOW DO THE DISTANT POOLS LOOK FROM SO HIGH? AND HOW MY HOUSES AND SERVANTS? LIKE ANTS? AND HOW THE DISTANT TOWNS, NOT YET AWAKE?

THEN *SPARE ME!*

BUT THERE ARE TIMES WHEN ONE MUST *LOSE* A LITTLE BEAUTY IF ONE IS TO *KEEP* WHAT LITTLE BEAUTY ONE *ALREADY* HAS. I DO NOT FEAR *YOU, YOURSELF*, BUT I FEAR *ANOTHER MAN*.

WHAT MAN?

SOME *OTHER* MAN WHO, SEEING YOU, WILL BUILD A THING OF BRIGHT PAPERS AND BAMBOO LIKE THIS. BUT THE *OTHER* MAN WILL HAVE AN *EVIL FACE* AND AN *EVIL HEART*, AND THE *BEAUTY* WILL BE *GONE*. IT IS *THIS* MAN I *FEAR!*

WHY? WHY?

WHO IS TO SAY THAT SOMEDAY *JUST* SUCH A MAN, IN *JUST* SUCH AN APPARATUS, MIGHT NOT *FLY IN THE SKY AND DROP HUGE STONES UPON THE GREAT WALL OF CHINA?*

⑤

NO ONE MOVED OR SAID A WORD...

OFF WITH HIS HEAD!

THE EXECUTIONER WHIRLED HIS SILVER AX...

BURN THE KITE AND THE INVENTOR'S BODY AND BURY THEIR ASHES TOGETHER...

THE GUARDS RETREATED TO OBEY...

THE EMPEROR TURNED TO HIS SERVANT WHO HAD SEEN THE MAN FLYING...

HOLD YOUR *TONGUE.* IT WAS *ALL A DREAM,* A MOST *SORROWFUL* AND *BEAUTIFUL DREAM.* AND THAT *FARMER* IN THE DISTANT FIELD WHO *ALSO* SAW, TELL HIM IT WOULD *PAY* HIM TO *CONSIDER* IT *ONLY A VISION.* IF *EVER* THE *WORD* PASSES AROUND, *YOU AND THE FARMER DIE WITHIN THE HOUR.*

YOU ARE *MERCIFUL* EMPEROR.

THE OLD MAN SAW, BEYOND THE GARDEN WALL, THE GUARDS BURNING THE BEAUTIFUL MACHINE OF PAPER AND REEDS THAT SMELLED OF MORNING WIND. HE SAW THE DARK SMOKE CLIMB INTO THE SKY...

NO, *NOT MERCIFUL.* NO, ONLY *VERY MUCH BEWILDERED* AND *AFRAID.*

HE SAW THE GUARDS DIGGING A TINY PIT WHEREIN TO BURY THE ASHES...

WHAT IS THE LIFE OF *ONE* MAN AGAINST A *MILLION OTHERS?* I MUST TAKE *SOLACE* FROM THAT THOUGHT.

HE TOOK THE KEY FROM ITS CHAIN ABOUT HIS NECK AND ONCE MORE WOUND UP THE BEAUTIFUL MINIATURE GARDEN. THE TINY GARDEN WHIRRED ITS HIDDEN AND DELICATE MACHINERY AND SET ITSELF INTO MOTION; TINY PEOPLE WALKED IN FORESTS, TINY FOXES LOPED THROUGH SUN-SPECKLED GLADES, AND AMONG THE TINY TREES FLEW LITTLE BITS OF HIGH SONG AND BRIGHT BLUE AND YELLOW COLOR, FLYING, FLYING, FLYING IN THAT SMALL SKY. AND THE EMPEROR SAID, CLOSING HIS EYES...

OH, *LOOK* AT THE *BIRDS,* *LOOK* AT THE *BIRDS!*

THE END

6

home to stay!

PROLOGUE: THE CHILD'S NAME IS JIMMY...JIMMY FAWCETT! HE STANDS BESIDE HIS MOTHER, ELAINE FAWCETT, IN THE GARDEN OF THEIR TWENTY-FIRST CENTURY SOLAR-HOME! ABOVE THEM, THE NIGHT SKY HANGS LIKE A GIGANTIC BLACK UMBRELLA, FLECKED WITH COUNTLESS STAR-HOLES! THE MOTHER'S FACE IS ANXIOUS AS SHE GAZES UP AT THE TWINKLING DIAMOND-SUNS! THE BOY'S EYES SHINE IN CHILDLIKE ADORATION...

THEY STAND IN SILENT AWE SURVEYING THE CELESTIAL MAGIC ABOVE THEM! SUDDENLY THE BOY GASPS! A CHUBBY HAND POINTS! ACROSS THE WHITE-DOTTED BLACK, A METEOR PLUMMETS EARTHWARD... ITS FLAMING TRAIL A FAINT LINE OF LIGHT STRETCHING OUT BEHIND IT...

MOMMY! WHEN...WHEN IS DADDY COMING HOME? HE'S BEEN GONE SO LONG THIS TIME!

I...I DON'T KNOW, JIMMY! SOON...I HOPE! VERY SOON!

LOOK, MOMMY! LOOK! A FALLING STAR!

QUICKLY, JIMMY DEAR! MAKE A WISH... MAKE A WISH!

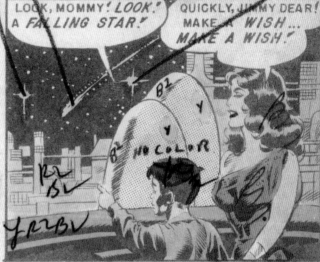

THE BOY'S FACE BRIGHTENS! HE SMILES AS HE WATCHES THE FLASHING STAR STREAK ACROSS THE NIGHT SKY! A CHILDISH GIGGLE ESCAPES FROM HIS TINY LIPS! HE SIGHS...

HURRY, JIMMY! MAKE A WISH!

I WISH...I WISH...

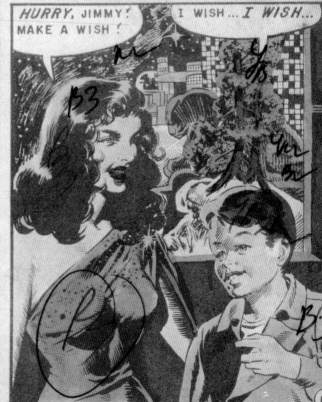

THE BEST OF THE REST!

MARIE SEVERIN!
"THE CONSCIENCE OF E.C.!"
—BILL GAINES

Marie Severin, colorist for most of the E.C. comics, was born on August 21, 1929 in Oceanside, New York, and is the younger sister of John Severin.

Before Severin came aboard in 1951, E.C.'s stories were routinely being colored by anonymous colorists at the engraving plant; as one might imagine, all too often the results were less than inspired. Marie Severin said in the E.C. fanzine *Horror from the Crypt of Fear #9* (1997) that "when 'kelly green' suits and yellow cars—or just 'Mickey Mouse–type' coloring on realistic stories—would appear, the E.C. boys would have a fit. They wanted some control, so that the coloring would help tell the story along with the text and art."

As the only woman actively involved in E.C. (apart from the secretaries), Severin had a very important role. Bill Gaines said in *E.C. Lives!* that "whenever we, as males, would tend to go off the deep end, sex-wise, it was Marie who would come in and stamp on our heads, and refuse to allow it to be done. Marie was about the only one we'd allow to trample on our creative efforts."

Feldstein said in *Tales of Terror! The E.C. Companion* that "she was our Catholic conscience, there was no question about it. In a kind of gentle way, she would chide us when we went overboard."

And if she found a panel too gruesome to color in the "traditional" way, she would often opt to color the whole thing blue as a way to tone down the gore. Feldstein also credits Severin's coloring on E.C.'s covers with helping the comics move off of the newsstands. "You have to give Marie Severin credit for selling a lot of the covers that were done in black and white, but were really brought to life by her color," he said in *E.C. Lives!*

When Gaines narrowed his operation to just the black-and-white magazine version of *MAD*, Severin was out of a job. She soon found work as a colorist for Stan Lee at Atlas (later to become Marvel). By the late 1960s, Severin had graduated from doing just coloring to doing artwork. She worked on a variety of titles, including *The Incredible Hulk, Tales to Astonish, Strange Tales,* and *X-Men.*

Left: Marie Severin's original hand-colored silverprint to the splash page of "Home to Stay!," *Weird Fantasy* #13, May–June 1952.

AN ENTERTAINING COMIC

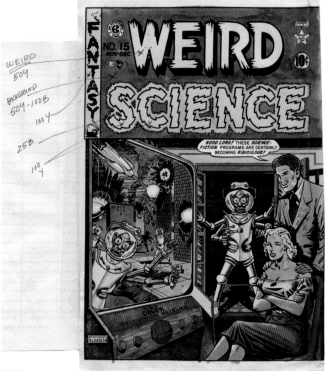

Above: Severin hand-colored silver-print of Al Feldstein's cover to *Weird Science* #15, done in 1979 for Russ Cochran's *Complete E.C. Library* reprint series.

She got to fully indulge her humorous bent on *Not Brand Ecch*, a Marvel comic that primarily satirized their own characters; for this book she contributed both cover art and stories. *Not Brand Ecch* ran for thirteen issues between August 1967 and May 1969.

She teamed up with her brother, John, in 1972 for a number of issues of *Kull the Conqueror*, a series based on the stories of Robert E. Howard. Severin also worked on Marvel's later humor comics *Spoof*

Below: Severin "thank you" note to Gaines.

(1970–1973), *Crazy!* (1973), and *Arrgh!* (1974–1975). When Marvel morphed *Crazy!* from a comic book into a magazine in 1973 to better compete with *MAD*, Severin made the jump, and she remained associated with the title until the plug was finally pulled on it in 1982.

From the late 1970s through the 1990s, Severin got a chance to re-color virtually all of the old E.C. covers for Russ Cochran's *Complete E.C. Library*, a high-quality series of hardcover reprints that consisted of the entire output of the E.C. comics that were published by Bill Gaines.

Gaines summed up his feelings on Severin in *E.C. Lives!*: "She was probably the best damn colorist in the history of the comics industry. She's gone on to much better and greater things today, but I'll always think of Marie as *my* colorist."

Marie Severin was inducted to the Will Eisner Hall of Fame in 2001. •

Above: Marie Severin cartoon done for Gaines, dated "12/6/51."

Above: Marie Severin at the 1951 E.C. Christmas party.

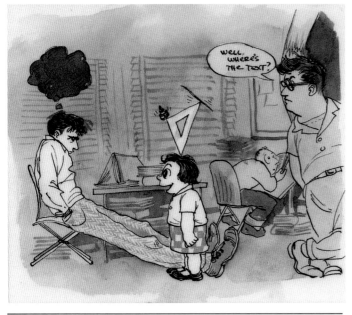

Above: Harvey Kurtzman's assistant, Jerry DeFuccio, also wrote many of the E.C. "text" pieces. (The Post Office required two pages of text—usually fiction—in every comic book to maintain a second-class mailing permit.) In this mid-1950s Marie Severin cartoon, Severin tries to cheer up a funked-out DeFuccio, while Gaines testily inquires about a text story that is obviously overdue.

Above: Severin "Happy New Year" card to Gaines ("Unca Binky"), 1953.

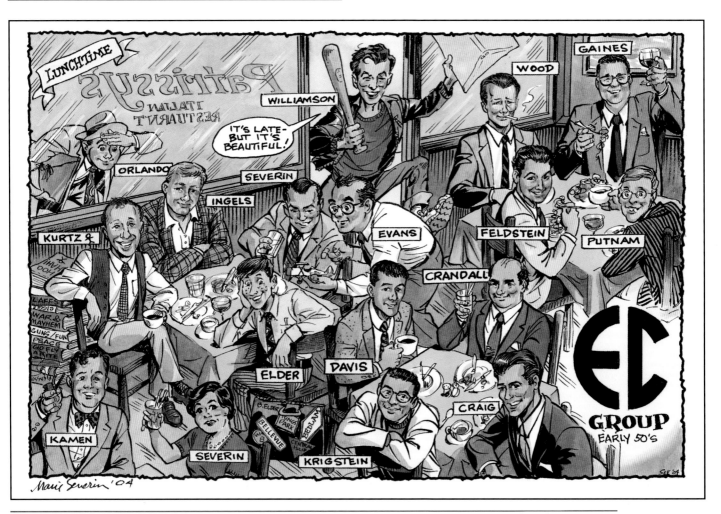

Above: The E.C. gang at Patrissy's, created especially for this book by Marie Severin. E.C. "gal Friday" Nancy Gaines (née Siegel) recalled that "every day, Bill would take all of the office staff—and any of the artists that were in delivering jobs—to lunch at Patrissy's, an Italian restaurant near the office in Little Italy."

SHELDON MOLDOFF!

Sheldon "Shelly" Moldoff was born in New York City on April 14, 1920. Moldoff first worked for M.C. Gaines on his All-American line of comics, where he regularly contributed covers for (and was the main artist on) *Hawkman*. He also did numerous covers for both the D.C. and the All-American sides of the Gaines/Donenfeld companies.

"I got along very well with M.C. Gaines," Moldoff said in *Tales of Terror! The E.C. Companion*. "He was a very talented man; he knew the field and he had definite ideas." Moldoff said in an interview published in *Alter Ego* #4 (2000) that "M.C. Gaines took a shine to me. He liked my style; he liked the realism." When Gaines sold his share of All-American and established E.C., Moldoff worked for him there as well, primarily on *Moon Girl*, a *Wonder Woman* redux begun in 1947.

Above:

Moldoff cover from *Moon Girl* #4, Summer 1948.

Max Gaines was killed in August of 1947, and when Bill Gaines took over the company, Moldoff continued to work on *Moon Girl*.

Sometime prior to March 1948, Moldoff approached Bill Gaines with an idea for a new comic book, something that—according to Moldoff—had never been done in comics before. Moldoff recounted his conversation with Gaines in *Tales of Terror! The E.C. Companion*: "I said to him, 'Bill, if I brought you an idea, would you give me a percentage?' And he said, 'Absolutely.' So I said, 'I've got an idea. Let me work it up, and I'll bring it in. If you like it, then I expect a percentage.' He said, 'No problem.'"

Moldoff brought in his idea, a proposal for a comic book called *Tales of the Supernatural*. The idea must have impressed Gaines, because he had E.C.'s attorney, Dave Alterbaum, draw up a contract.

What happened from here on out has never been completely clear, because Bill Gaines—who died in 1992—never went on the record with his version of events. However, the original legal documents and lawyer's notes regarding *Tales of the Supernatural* have recently been uncovered in the files of the Gaines estate, and at last Gaines's side of the story can be told.

The contract that Alterbaum drafted called for E.C. to publish the title "not less than six months" from the date of the signing of the agreement, which was duly executed on March 25, 1948. The contract specified that Moldoff would deliver "a minimum of twenty-nine pages and a cover," or one complete issue. The contract called for Moldoff to receive a royalty, tiered as follows: for sales of less than 75% of the print run, no royalty was due. For sales between 75% and 79%, a 15% royalty was due. For sales between 80% and 84%, a 20% royalty was due. And for sales between 85% and 100%, a 25% royalty was due. Included was a standard deduction from royalties of the cost of creating the magazine, including the scripts, art, engraving, printing, binding, et cetera. In a way, this royalty structure amounted to what in the film industry is referred to as "monkey points," royalties that are highly unlikely ever to be paid out. Truthfully, it would be very hard for a brand-new title to hit even a 75% sale, but it nonetheless was a legitimate royalty structure that, had it been in place for Siegel and Shuster (the creators of *Superman*),

Above: Sheldon Moldoff self-portrait from *Moon Girl* #6, March–April 1949.

Shelly

READ THIS MAGAZINE AT YOUR OWN RISK !!

TALES OF THE SUPERNATURAL

TALES OF THE SUPERNATURAL

At last a magazine dealing entirely
with stories of ghosts and spirits that
walk in the night. Weird tales of the living
dead, ghouls, vampires.. superstitions,
curses and primitive voodoos. A book filled
with stories of suspense, mystery and
physchic phenomenom, well calculated
to make your blood run cold..
A magazine dealing with a
subject as old as life
itself.. Never done in
comic book form before...

Above: Sheldon Moldoff's original proposal for *Tales of the Supernatural,* submitted to Bill Gaines in March 1948.

AN ENTERTAINING EC COMIC

Introducing one of the
most exciting and sensationly
different comic strips..

MR. DESTINY

In the summer of the
year 1945, the United States
loosed the most powerful force
ever uncovered in the form
of an Atomic Bomb... the
world trembled.. and the
great powers took a hand..

Mr. Destiny was sent to
the earth, third planet
from the sun, in a last
desperate effort to bring
peace and good will to
mankind.......

Above: The back cover of Moldoff's original *Tales of the Supernatural* proposal, regarding a continuing character called Mr. Destiny.

for example, would have made them very wealthy men.

Moldoff delivered the book, which contained the following stories: "Vampire of the Bayous!" (a "Moon Girl" story illustrated by Moldoff), "Zombie Terror!" (illustrated by Johnny Craig), "The Werewolf's Curse!" and "The Hanged Man's Revenge" (both illustrated by Howard Larsen), and a two-page text story (title unknown, but research has suggested that it was possibly called "Out of the Grave"). No one involved can remember what the cover looked like, but some E.C. historians speculate that it might have appeared later as the cover to the first issue of *The Haunt of Fear* (#15, May–June 1950).

We continue the story directly from Dave Alterbaum's original case notes:

"To all the producers other than Moldoff, we made payments directly.

"Subsequently, before the plates were engraved, Moldoff suggested that we use the title *Haunted* as the title for the magazine, and we corrected the cover and put that word on it. We sent the cover over to Chemical Engraving Company. Tarshes of Chemical phoned that Ben Sangor, another publisher [American Comics Group], had sent over a cover with the same title a month previously. Sangor phoned Gaines and accused him of stealing the title, and Gaines said that he had obtained it from Moldoff. Gaines then told him that he would check with Moldoff.

"When Moldoff was consulted by Gaines, he denied the theft, but admitted that he had done a supernatural story for

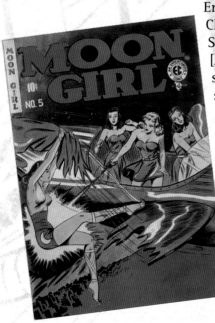

Above: The original hand-colored silverprint to Moldoff's cover for *Moon Girl* #5, Fall 1948.

Sangor before approaching us with this deal, which he had called a 'new idea.' He tried to convince Gaines that the 'supernatural' idea was his from back in 1946 by showing him a carbon copy of a letter purporting to be a previous offer of the idea to Fawcett Publications.

"Our distributor, Macfadden Publications, refused to take on this book for distribution. Gaines told Moldoff of this, and the parties mutually agreed to drop the contract. At the same time, since the artwork had been paid for, he agreed that it could be used in other titles and in other books at a future date, without accounting to him.

"We had on hand four stories, or a complete book and a two-page [text] story. One of these stories was a 'Moon Girl' vampire story, which we used in our *Moon Girl* ['Vampire of the Bayous!,' *Moon Girl* #4, Summer 1948]. The other three 'supernaturals' were used in three different 'crime' books."

"Subsequently, we had only two crime books. [This is a reference to the fact that *Moon Girl*, which had since been dropped, was titled *Moon Girl Fights Crime!* for its last two issues.] In order to bolster sales [on *War Against Crime!* and *Crime Patrol*], the new assistant editor, Feldstein, taking off on the 'suspense type' of program on television, evolved two features: 'Vault of Horror' and 'Crypt of Terror,' which he ran as single stories in the crime books. These stories were suspense types, and not supernatural, as were Moldoff's.

"While this new book was in process, Moldoff was drawing *Moon Girl*. From time to time, Gaines told him of the difficulty to get distributors to take it on. Eventually Gaines was definitely turned down by Macfadden, and he told Moldoff of that fact. We agreed to drop the contract.

"About eight months ago he called to see us, and accused us of stealing his ideas and kicking him out. He threatened suit."

Alterbaum's notes acknowledge that Gaines published stories that were "fantastic," although they took the position that the stories were "suspense type" at the beginning, and that they "later adopted supernatural and horror to compete." Alterbaum also notes that

other publishers had preceded E.C. in publishing "supernatural" material, including "Sangor's *Adventures into the Unknown* and [Atlas publisher] Martin Goodman's *Suspense, Marvel Tales,* and *Captain America's Weird Tales.*" A reference is also made to *Weird Comics,* published in 1940 by Victor Fox. He did acknowledge that Moldoff's idea was "occasionally encompassed in [E.C.'s] scripts."

Around January 1950, Moldoff consulted with a Madison Avenue lawyer named Maurice V. Seligson, and shortly afterwards they filed a lawsuit against Gaines and the five corporations that collectively formed E.C. comics.

According to Alterbaum's notes, he and Seligson met on January 23, 1950 to discuss the case. Alterbaum's position was that the parties "had mutually abandoned the contract when Macfadden refused to distribute." Seligson then stated that he "had no reason to doubt his client's veracity." They took up the issue of Moldoff's idea being "new and novel," and Alterbaum showed Seligson a number of comics that pre-dated the concept. Alterbaum stated that "the idea of supernatural long antedated [Moldoff's proposal], and was neither new or novel." Alterbaum also mentioned to Seligson that he would "hate to see his client become embroiled in litigation, that the field is a small one, and once it becomes known that his client claims originality for stories and ideas and is a litigant, publishers will be hesitant in engaging his services."

They went forward with the suit, and Alterbaum went into the "discovery" phase. Time passed. On January 17, 1951 Alterbaum met with Ben Sangor, who confirmed Gaines's version of events. He also examined Sangor's payment book, which revealed that on February 10, 1948 Moldoff was paid $140 for penciling seven pages of a "ghost story" titled "The Castle of Otranto," which appeared in the first issue of *Adventures into the Unknown,* Fall 1948.

Alterbaum apparently made overtures toward a settlement, and on February 2, 1951 Alterbaum got a call from Seligson saying that his client and Alterbaum "spoke the same language." At 12:30 P.M. the same day,

Moldoff went to see Alterbaum, complaining that Gaines never cancelled the contract, and that he had been assured that "when the idea revived," he would be called in.

To this day, Moldoff maintains that his contract with Gaines pre-dated the work he did for Sangor and that his original idea extended beyond supernatural to include horror. Nevertheless, the case was settled on May 25, 1951 for $250, which is what Moldoff figured he was personally owed for delivering the book's cover and the four complete stories. (This was actually nothing to sneeze at in 1951 dollars.) On the same day, Moldoff signed a general release. On May 28, 1951 Dave Alterbaum sent over to Maurice Seligson E.C.'s check for $250, and the suit was officially settled.

We will never know, but it's interesting to ponder what E.C.'s history would have looked like if Moldoff hadn't asked for the title of the book to be changed at the last minute to *Haunted* from *Tales of the Supernatural.*

In 1951, Moldoff sold Fawcett on a comic book called *This Magazine is Haunted.* He later went to work at D.C., and from 1953 to 1967 he ghosted virtually all of the *Batman* stories that were credited to *Batman* creator Bob Kane.

In 1967, along with several other artists from the Golden Age, Moldoff was summarily dismissed from D.C. He went into animation, producing storyboards for numerous cartoons, including *Courageous Cat* and *Minute Mouse.* He also drew comics produced as giveaways for such restaurant chains as Bob's Big Boy, Red Lobster, and Burger King.

In recent years, Moldoff has been a frequent guest at various comic-book conventions around the country, where he obligingly produces nicely crafted re-creations of his vintage covers and comic-book characters. •

Above: The original hand-colored silverprint to Johnny Craig's splash page of "Zombie Terror!" (*Moon Girl* #5, Fall 1948). *Below:* The original hand-colored silverprint to Moldoff's cover of *Moon Girl Fights Crime!* #7, May–June 1949).

ALEX TOTH!

Alex
Toth

Below: The Toth/Kurtzman splash page from "Dying City!"

Below: Toth's splash page from "F-86 Sabre Jet!"

If it hadn't been for the fact that Alex Toth was also busy on other projects during the time he worked for E.C.—and his induction into the Army—Toth would likely have his own chapter in this book.

Toth was born on June 25, 1928 in New York City. He broke into comics in 1944 at Famous Funnies, doing spot illustrations for text stories and two- and three-page fillers for *Heroic Comics.*

In 1947, Toth was hired at All-American Comics by Shelly Mayer, M.C. Gaines's editor. Here he worked primarily on super-heros, notably "Green Lantern," "Dr. Mid-Nite," and "The Atom."

In 1951, Toth did the first of three stories for Kurtzman at E.C. His initiation to working with Kurtzman was on "Dying City!" September–October 1952. Toth said in an interview in *Graphic Story Magazine* #10 (published in 1969) that the story was "inked by Kurtzman because of my rushed schedule at the time. I remember the weekend that I did that first story for Kurtzman. I was working on three stories at the same time; one for D.C., another for Standard, and Kurtzman's."

The other two Toth stories for Kurtzman were "Thunderjet!" (*Frontline Combat* #8, September–October 1952) and "F-86 Sabre Jet!" (*Frontline Combat* #12, May–June 1953).

Of Kurtzman's method of working, Toth told *Graphic Story Magazine* that "a Kurtzman story assigned to the artist consisted of sheets of Strathmore with inked panel and page borders; Ben Oda [E.C.'s letterer for Kurtzman's stories] had already lettered in all the copy. Taped over the Strathmore was the vellum sheet that held the panel layouts. That's the way Kurtzman wrote, via visual breakdowns. In this sense he held considerable control over the story."

Toth worked in a bold, clean, open style that was markedly different from the other comic-book artists of the period. Some even feel that Toth was ahead of his time, and this notion does seem to be supported: his early work looks and feels contemporary even today.

Many of his peers have considered him to be an "artist's artist," a kind of sideways compliment that can often mean that one's art doesn't quite click with the great unwashed masses. While this may have been true at one time, Toth has now achieved legendary status, especially among younger Baby Boomers who fondly remember his post-E.C. work in the mid-1960s on *Hot Wheels* and *The Witching Hour* for D.C., and his highly regarded character designs for such Hanna-Barbera animated cartoons as *Space Ghost* and *Herculoids.*

Alex Toth was inducted to the Will Eisner Hall of Fame in 1991. •

Right: The final panel from "Thunderjet!," *Frontline Combat* #8, September–October 1952.

BASIL WOLVERTON!

Basil Wolverton, the leading proponent of what *Life* magazine once famously described as the "spaghetti and meatball school of design," was born July 9, 1909 in Central Point, Oregon. Unlike virtually all of his fellow comic-book artists, Wolverton did not live in the greater Manhattan area, but rather remained in the Pacific Northwest and relied on the mail to deliver his assignments. "No one else lived as

far away as I did. Publishers liked to have artists under their thumbs at all times," Wolverton told Dick Voll in an interview published in an all-Wolverton issue of *Graphic Story Magazine* (#14, Winter 1971–1972).

"That had advantages for the artists," Wolverton said, "but I would rather have forgone those things and have more freedom otherwise."

He began in the business in 1926 by selling a cartoon to *America's Humor*. His earliest work in comics was two features that appeared in *Circus* #1 (Globe Syndicate, June 1938). One of them, "Disc Eyes," is now obscure, even to his fans. The other, a strip called "Spacehawks," indirectly led to a later series called "Spacehawk," which appeared regularly in *Target Comics*. "Spacehawk" is still highly revered among the cognoscenti.

In 1942, he created "Powerhouse Pepper," a wacky, off-the-wall humor strip for Timely Comics. To complement his antic art, Wolverton took his personal penchant for alliteration and internal rhyme schemes to a place bordering on the ridiculous, which, of course, was just the point. Joe Brancatelli, writing in *The World Encyclopedia of Comics*, called the strip "one of the most cherished features of the 1940s."

In 1946, United Features—which syndicated Al Capp's "Li'l Abner" strip—sponsored a contest inviting readers to create and submit images of the ugliest woman in Lower Slobovia, "Lena the Hyena." The entries were judged by Salvador Dali, Boris Karloff, and Frank Sinatra; Wolverton's entry won hands down, resulting in a tremendous amount of notoriety for the artist. All of this led to Wolverton doing numerous caricatures of celebrities for ad campaigns sponsored by assorted movie studios, the NBC radio network, and various advertising agencies.

In August 1953, Harvey Kurtzman contacted Wolverton about doing some work for *MAD*. "I'd always been aware of Basil. I was aware of Wolverton from way back, from when we were both appearing in Stan Lee's books," Kurtzman has said. "For me, Wolverton always had an integrity of style and effort," Kurtzman said in *Graphic Story*

Top left: A panel from "Powerhouse Pepper." *Bottom left:* A splash panel from "Spacehawk."

was always consistent, always pure Wolverton. He never borrowed, never hacked, and he never shortchanged the public. This is a good deal of the reason why he was what few of his contemporaries could claim: Wolverton was an original."

Kurtzman used Wolverton for several specialty pieces in the *MAD* comic book.

Wolverton's first appearance in *MAD* was a "Lena the Hyena" lookalike that appeared in the final panel of "The Face upon the Floor," a Jack Davis–illustrated piece in *MAD* #10 (March–April 1954). For the cover of *MAD* #11 (May 1954), a *Life* magazine cover parody, Kurtzman asked Wolverton to create "the Beautiful Girl of the Month." This cover so horrified the suits at *Life* magazine that they threatened legal action. To diffuse the situation, Bill Gaines had to send *Life* a letter promising not to do it again (one of many such similar promises to various offendees that he broke in later years with subsequent articles in *MAD*). Al Feldstein also used stats of this art in several issues of *PANIC*, most notably on the cover of issue #4 (August–September 1954).

In *MAD* #17 is another classic Wolverton article, "Meet Miss Potgold" (November 1954). Some of Wolverton's drawings for this article had to be retouched for fear that they were too phallic. Curiously, Wolverton—a deeply religious Christian—always claimed naiveté when it came to anything untoward in his work, though Sigmund Freud would surely have had a field day with it.

Wolverton continued to do infrequent appearances in *MAD* over the years. Wolverton said in *Graphic Story Magazine* that "having material published in *MAD* has always been like getting a shot in the liver."

Macabre cartoonist Gahan Wilson said in the Wolverton collection *Wolvertoons: The Art of Basil Wolverton* that "Basil Wolverton pushed me over the edge." And Marvel Comics creator Stan Lee said of Wolverton in *Graphic*

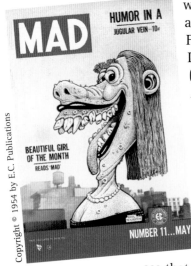

Copyright © 1954 by E.C. Publications

Above: Wolverton's cover to *MAD* #11 (May 1954). *Below:* Wolverton's art recycled on *PANIC* #4 (August–September 1954).

Story Magazine, "Basil was one of the most original, unpredictable talents in the field. His style was unique and virtually inimitable, and I've never known anyone who didn't get a kick out of Basil's far-out artwork." Well, maybe there was one. Bill Gaines said of Wolverton in *Wolvertoons*: "I know this will upset you, but I have never been a fan! I find his work disagreeable. Sorry! It's also ugly. Wolverton drew ugly." Ugly work or not, Basil Wolverton (who died on December 31, 1978) was inducted to the Will Eisner Hall of Fame in 2000. •

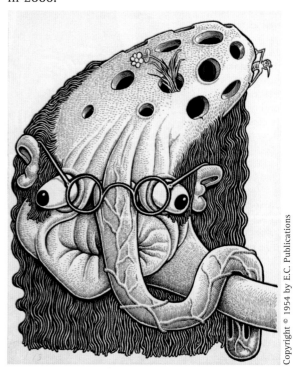

Copyright © 1954 by E.C. Publications

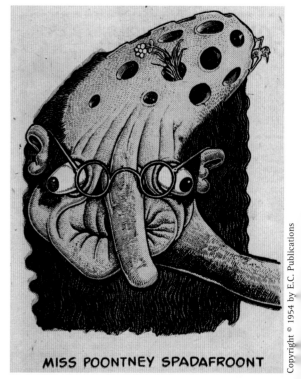

MISS POONTNEY SPADAFROONT

Copyright © 1954 by E.C. Publications

Right: The original art and retouched, published version from "Meet Miss Potgold" (*MAD* #17, November 1954).

JOE KUBERT!

Joe Kubert was born on September 18, 1926 in Brooklyn, New York. Although considered one of the giants in the comics field, Kubert did only three stories for E.C., all of them in Harvey Kurtzman's war comics: "Tide!" (*Two-Fisted Tales* #32, March–April 1953), "Pearl Divers!" (*Two-Fisted Tales* #33, May–June 1953), and "Bonhomme Richard!" (*Frontline Combat* #14, October 1953).

The ever-finicky Kurtzman always had a certain vision for his stories, and sometimes the artist assigned to any given story just didn't live up to Kurtzman's exacting standards. Kurtzman said in the October 1981 issue of *The Comics Journal*, "Joe Kubert, of course, was a great, swift professional, but there was something about his work where he lacked the authenticity that I needed. Kubert is one of the best there is in comic books, but I just couldn't get it." Uncharacteristically, Kurtzman did allow himself some of the blame, saying "I didn't try all that hard. We did no more than two [three] stories together. Joe was always very busy, he always had other things to do."

Kubert has enjoyed a long, successful career in comics. At the time he did the stories for Kurtzman, his main account was with St. John. His best-known work at this time was on a prehistoric comic book of his own conception entitled *Tor*. During the short-lived 3D comic book craze of 1953–1954, St. John produced several issues of *Tor* in 3D ("glasses included!").

During the 1960s, Kubert moved over to D.C., where he has worked on a variety of titles over the years, including *Hawkman*, *Our Army at War* (featuring "Sgt. Rock"), *Star-Spangled War Stories* (featuring "Enemy Ace"), and in the early 1970s, *Tarzan*.

In 1976, Kubert founded the successful Joe Kubert School of Cartoon and Graphic Art (located in Dover, New Jersey), with a curriculum designed to pass along his formidable knowledge to a younger generation of artists.

Joe Kubert was inducted to the Will Eisner Hall of Fame in 1998. •

Above: Kubert's splash page to "Pearl Divers!" (*Two-Fisted Tales* #33, May–June 1953). *Left:* Kubert's splash panel to "Bonhomme Richard!" (*Frontline Combat* #14, October 1953).

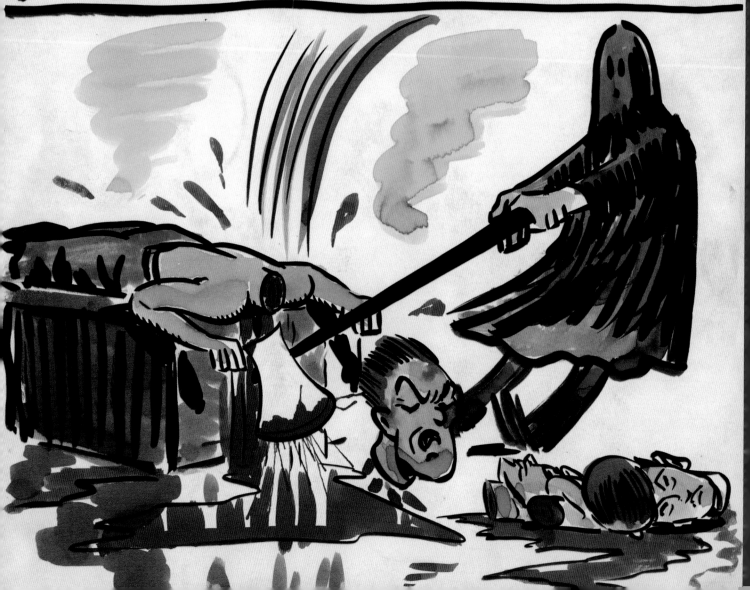

E.C. CHRISTMAS PARTY ART!

"REMARKABLY *UNINHIBITED* AND UNABASHEDLY *CYNICAL!*" –JOHN BENSON

The E.C. New Trend and New Direction eras spanned six Christmases. At the end of each year, humorous posters were made by Al Feldstein, Marie Severin, Harvey Kurtzman, or *MAD* Magazine art director John Putnam to be hung up in the office at the annual E.C. Christmas parties. Comics historian John Benson, writing in the E.C. fanzine *Squa Tront* #9 (1983), called the 1950 cover parody posters "remarkably uninhibited and unabashedly cynical." The other posters deal with the various personality traits or foibles of the E.C. gang.

The Feldstein posters that were done for 1951 could not be immediately located in the Gaines archives; these posters, however, do appear in *Squa Tront* #9 (1983). The Marie Severin posters for the 1952 Christmas party were sold several years ago, and are now dispersed into private collections; these posters appear in *E.C. Lives!*, the program book done for the 1972 E.C. Fan-Addict Convention. (Some of the art seems to be missing from the 1953 and 1954 sets, as not all of the artists are present.) •

Left: E.C. secretary Nancy Gaines (formerly Nancy Siegel, and newly married to Bill Gaines) in the E.C. office in December 1955. Note the posters for the 1955 Christmas party, including the Marilyn Monroe poster for production man Ric Doonan (whose name is misspelled). The framed artwork above the bookcase is by Al Williamson. In the rack at the left are the latest E.C. comics, Picto-Fiction magazines, and copies of *MAD* #26.

251

Art by Al Feldstein

CHEMICAL LOVE
2¢
EC
LN
IN THIS ISSUE
My Conception!

APHRODISIAC LOVE
25¢
LN.
EC
I WAS A SPANISH-FLY (BY NIGHT)

MODERN SEX ADVENTURES
LN
3¢
EC

GET THOSE DIRTY JEW COMICS
LN
FREE
EC
IN THIS ISSUE MY HOBBY BY ADOLPH SCHICKELGRUBER

THE CRYPT OF CRAP
LH
7¢
EC
MEN

1953

WHAT SANTA SHOULD GIVE...
UNLIMITED RESOURCES
BILL GAINES

WHAT SANTA SHOULD GIVE...
POWER TO CLOUD MEN'S MINDS
MURPHY
AL FELDSTEIN

WHAT SANTA SHOULD GIVE...
JIM DANDY EXTRA ARM
WALLY WOOD

Art by Harvey Kurtzman

AN ENTERTAINING COMIC EC

WHAT SANTA SHOULD GIVE...

MORTGAGE PAID

GRAHAM INGELS

WHAT SANTA SHOULD GIVE...

SANE

BILL ELDER

WHAT SANTA SHOULD GIVE...

LIVING SPACE

JACK KAMEN

WHAT SANTA SHOULD GIVE...

(WHAT ELSE)?

GEORGE EVANS

WHAT SANTA SHOULD GIVE...

SEASON PASS FOR ALL BROWNS LINES... Berg

REED CRANDALL

WHAT SANTA SHOULD GIVE...

EXTRA PANELS

BERNIE KRIGSTEIN

WHAT SANTA SHOULD GIVE...

PUTTY PUTTY PUTTY

TZING

(ONE THAT WORKS)

NANCY SIEGAL

WHAT SANTA SHOULD GIVE...

LYLE STEWART

WHAT SANTA SHOULD GIVE...

ASSISTANT STUFFER

DICK POLLENBERG

AN ENTERTAINING EC COMIC

1954

To ALL E.C. ARTISTS
Security is Yours!

HERE'S WHAT EACH OF YOU CAN DO IF E.C. FOLDS:

These are only suggestions! You can always STARVE!!

HARVEY KURTZMAN

HUSTLER OF FRENCH POST-CARDS AND FEELTHY EASTER-EGGS

I UNDERMINE MORALS!
(HAVE LARGE FOLLOWING AMONG CHILDREN!)

WALLY WOOD

PROFESSIONAL LIFE-OF-THE-PARTY!

I RAISE HELL FOR YOU!

NOISY EVENING...$5.00 —EXTRA NOISY..$10.00
BRAWLS... $15.00 and up!
SQUARE-DANCING MY SPECIALTY!

JACK DAVIS

CARPET-BAG MANUFACTURER

TOUR DIXIE WITH DAVIS'S BAG!
HOLDS PLENTY!

GRAHAM INGELS

MURAL PAINTER FOR CHILDREN'S NURSERIES!

GUARANTEED TO SOOTHE YOUR LIL'
DARLIN' TO SLEEP! GAY LIGHT SUBJECTS
AND HAPPY MOODS IN CHEERFUL COLORS!

BILL ELDER

PROFESSIONAL MOURNER!
ALWAYS AVAILABLE!
25¢ PER TEAR! THREE SOBS-$1.00
MAKE YOUR FUNERAL REAL SAD-LIKE!

JOHNNY SEVERIN

COMMUNIST ORGANIZER!

LET ME HELP PLAN YOUR PARTY!

BIG CELLS-$10.00... LITTLE CELLS-$1.00

Have Literature — Will Travel!

PAUL KAST

MAIL SERVICE

WHAT IS THE % RETURN ON THE XMAS
CARDS YOU SEND OUT? 5%.?.. 10%?
LET ME GUARANTEE YOU 100% RETURNS!

JUST GIVE ME YOUR CHRISTMAS CARD LIST!
I WILL SEND YOU...FROM EVERY PERSON ON
YOUR LIST... A COMPLETELY DIFFERENT XMAS
CARD, ALL WITH AUTHENTICLY FORGED
SIGNATURES! SHOW YOUR NEIGHBORS AND
FRIENDS AND RELATIVES HOW POPULAR
YOU ARE! SEVERAL YEARS MAILING
EXPERIENCE!

Art by Al Feldstein

First came **KINSEY**...
and
"The Sexual Behavior of the Human Male"
—
Now comes **E.C.** ...
and
"The Special Behavior of the Inhuman Artist"
OR
"WHAT OUR BOYS WOULD DO
IF THEY WERE ALONE WITH
**MARILYN
MONROE** →

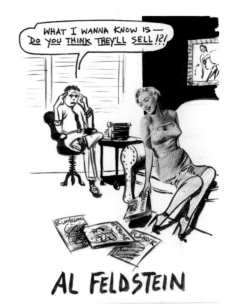

AL FELDSTEIN

BILL ELDER

GRAHAM INGELS

JACK DAVIS

WALLY WOOD

JOE ORLANDO

JACK KAMEN

Art by Al Feldstein and John Putnam

REED CRANDALL

JOHN PUTNAM

HARRY CHESTER

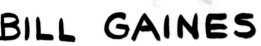

BILL GAINES

HARVEY KURTZMAN

WANTED FOR MURDER!

"PICTO-FICTION WAS A GREAT CHALLENGE! I'M SORRY IT DIDN'T GO OVER BETTER THAN IT DID!" –JOHNNY CRAIG

The piece that follows, "Wanted for Murder," is an unpublished story from 1956 that was originally intended for the never-released E.C. Picto-Fiction magazine *Crime Illustrated #3*.

When Bill Gaines dropped all of his publications except *MAD*, E.C. was all but broke. The paternalistic Gaines felt an obligation to his regular artists, and he called each one and told them to finish up the last stories they were working on, with the assurance that they would be paid for the work no matter what happened to the company.

Since the Picto-Fiction magazines weren't selling anyway, Gaines decided not to throw good money

Above: Detail from the second page of the story.

after bad, and the books were never printed. (The exception to this is *Shock Illustrated #3*, which was on the press when the end came. Lacking the money to bind it, Gaines ordered the entire print run destroyed, apart from 100 to 200 copies, which were hand-bound for E.C.'s files, and to give to the artists or to fans who had requested the issue.)

"Wanted for Murder" is reproduced here from the original production paste-ups, recently pulled from the Gaines family archives.

The piece is signed by Al Williamson, but in the true "Fleagle Gang" tradition, Angelo Torres had a hand in illustrating this story as well. •

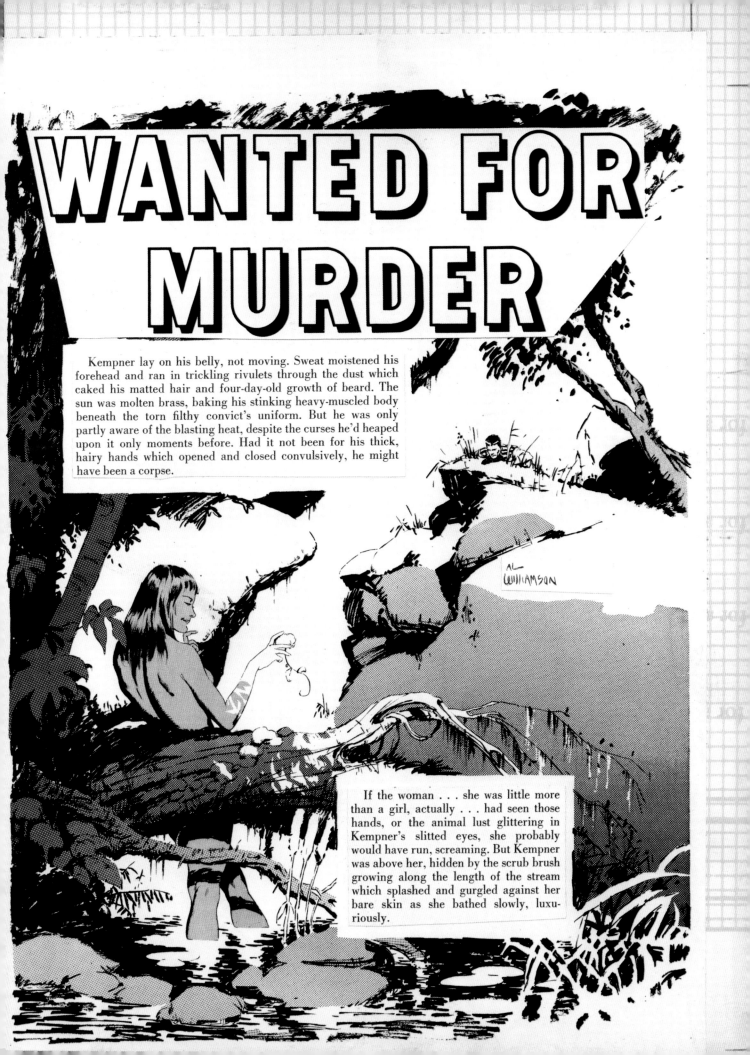

WANTED FOR MURDER

Kempner lay on his belly, not moving. Sweat moistened his forehead and ran in trickling rivulets through the dust which caked his matted hair and four-day-old growth of beard. The sun was molten brass, baking his stinking heavy-muscled body beneath the torn filthy convict's uniform. But he was only partly aware of the blasting heat, despite the curses he'd heaped upon it only moments before. Had it not been for his thick, hairy hands which opened and closed convulsively, he might have been a corpse.

If the woman . . . she was little more than a girl, actually . . . had seen those hands, or the animal lust glittering in Kempner's slitted eyes, she probably would have run, screaming. But Kempner was above her, hidden by the scrub brush growing along the length of the stream which splashed and gurgled against her bare skin as she bathed slowly, luxuriously.

Kempner's tongue flicked out, moistened his dry lips. He had come upon the girl only moments before, and it had been a long time since Kempner had seen a woman. A long, long time. Finding one here in the Dakota hills, thirty odd miles from the nearest town, was almost impossible good luck. Yet Kempner did not move.

That appetite could wait. Now, there was another, even more pressing appetite to be assuaged. The muscles in Kempner's empty stomach writhed.

When the woman finished her toilet, dressed herself in jeans which hugged her smooth hips, donned a tight-fitting sweater, and moved off up the streamside trail, he followed her.

Ten minutes later, Kempner was smiling. He had been right! The girl wasn't alone! From behind a tree, he watched as a man took her in his arms, and kissed her gently. Almost, Kempner laughed aloud. That wasn't the way *he* would kiss a dame like her!

But again . . . that could wait. Kempner's eyes picked out two haversacks, a rifle, a supply of canned food, a fishing rod. This was almost too good to be true! A pair of campers, miles from nowhere, who had everything he needed. Easy pickings. He waited only until the two had their backs to him.

It was the man who turned . . . just as Kempner was stooping to pick up the rifle. The man moved instinctively, and Kempner's hairy fist caught him on the side of the jaw.

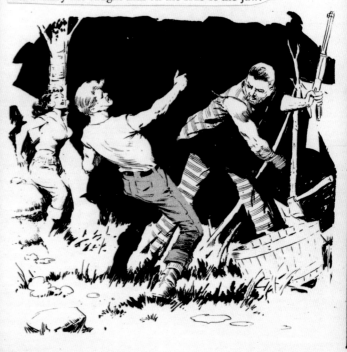

2B

The blow spun the man around so that he fell in a limp tangled heap, like a rag doll.

The woman moved then, perhaps to go to the still figure on the ground. It wasn't important. Kempner cuffed her hard across the mouth and she sprawled too.

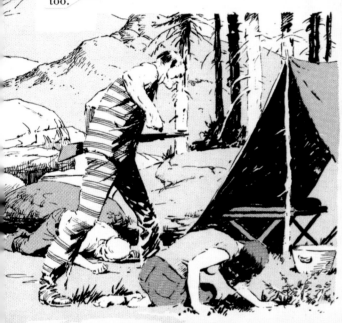

She remained on the ground, supporting herself on her hands, staring in open-mouthed terror while he ate greedily, sitting crosslegged with the rifle on his lap.

"What's your name, honey?" he asked when the first sharp pangs of hunger had been dulled.

No answer. The rag doll stirred. Then there were two pairs of terrified eyes staring at him.

"Your wife?" Kempner's grin was a leer. "Not bad. Not bad at all . . ."

Still no answer. Kempner shrugged, went on eating, the food clinging in tiny particles to the stubble of his beard. It was not until he was completely sated that he walked to where the man still lay on the ground.

"Now," he said, "we'll talk. Who are you? What are you doing out here?" The grin creased his brutal face again. "So I'll know if you'll be missed . . ."

Nothing. The man's lips moved but no sound came. Kempner raised his foot, set the heavy heel of his prison boot down on the man's hand, and shifted his weight.

He could hear the bones crack as he ground the heel downward, even above the man's sudden shrill scream of agony.

"Well?" he snarled.

The man was crying, tears of pain welling from his eyes as he clutched his injured hand. He was young. Kempner noted. Maybe twenty-four. White-faced and scared. Like the girl.

"I'm H-Harry Baird," he sobbed. "This is my wife . . . Susan . . ."

"We're just on a camping trip," he sobbed on. "Please. Who . . . who are you? What do you want? We have nothing . . ."

"Susan, eh?" Kempner looked her over. "Pretty." The girl shrank away as he bent to touch her. "Don't worry. You've got what I want! In spades!"

"Don't! D-don't . . . please!" That was the man. Kempner ignored him. He bent to the girl again.

The man was sneaking toward him, shaking, fighting his own fear, when Kempner turned.

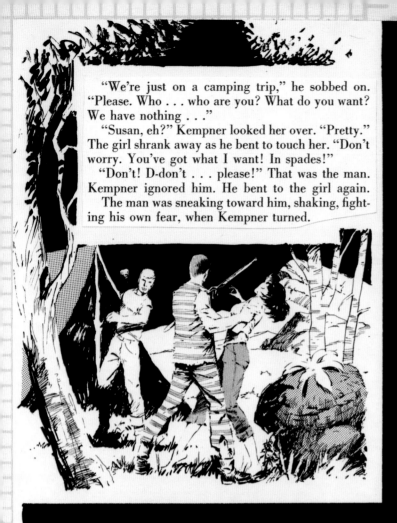

Kempner kicked him in the groin and then stood over him while he writhed, moaning.

"Okay," Kempner hissed. "Okay. So you're a hero! There was another hero, four days ago. A guard in the prison where I was doing time. I left him with a smashed skull when I took off. You're luckier than he was . . . so far . . ."

The rifle barrel came up, pointing at the agonized body.

"No . . . Oh, no . . ." The words seemed to gasp from the girl of their own volition.

Kempner turned. "All right, beautiful," he said. "Maybe we can make a deal, eh? You be nice to me, and I'll be nice to you."

His hand jerked out and caught her by the hair as she attempted to run. "Why settle for a boy, when you can have a man?" he grinned.

His mouth closed on hers. The girl fought, but Kempner bent her back, his body straining against hers. It had been a long time. A long, long time.

"No . . ." the man cried. "Please . . . don't! I . . . I'll give you money! Lots of money! Please . . ."

The movement must have cost the man a torment, but he was dragging himself forward, clawing at the ground, as he gasped out his plea.

Kempner laughed at him, and held the girl tighter. "Money? I guess you're rich, eh?"

"N-no," the man whined. "We . . . we don't have any money of our own. But we . . . we *do* know where there's *lots* of money! *A fortune!*"

Kempner turned to the man, but still held the girl. "Don't kid me, mister . . ." he sneered.

"We do! It's true!" the man insisted. "Four years ago there was a holdup near here. A bank! The money was never recovered. But we know where it is! We'll tell you! If you'll let us go . . . without . . ."

"Holdup? Yeah . . ." Kempner was remembering. Something he'd heard in prison. "Yeah," he grinned. "Some mob got away with better'n twenty grand. The cops got 'em in the hills. But nobody ever found the dough . . ."

"That's it," the man cried eagerly. "We found it! Only a few days ago. In an abandoned prospector's shack. Back in the hills. We . . ."

"Sure!" Kempner's voice was a snarl. "And I'm Santa Claus!" He'd released the girl, and now his foot drew back and cracked against the man's ribs. "Who do you think you're conning?" he growled.

"Leave him alone! He's telling the truth!" The girl was on her knees, holding the man.

"Yeah?" Kempner grimaced. "Okay, show me."

"We . . . we will! If you promise to let us go . . . afterward . . ." Every word was a gasp, but the man went on. "We're not lying! Honest! We'll take you to the money! It's all there! Every dollar! We were on our way back to town to tell the sheriff! When we found it, we got scared! We're respectable people! We . . . we don't want any trouble! We didn't touch the money! You can have it! All of it! If . . . if you promise not to . . . not to harm us!"

Respectable? Yeah, they sure were! Two of a kind! A pair of nice, respectable people who didn't even know that there were men like Kempner in the world. That was what decided him. They were too scared to be lying!

"You know," Kempner said, "there's just a chance that you're leveling with me. Okay. Twenty grand is a nice chunk of change. And right now, I can use a nice chunk of change. But get this . . ." He leaned over, so that his bearded face was close to theirs and the stink of his body was heavy in their nostrils. "If you're lying, what I'll do to both of you will be artistic! Real artistic!"

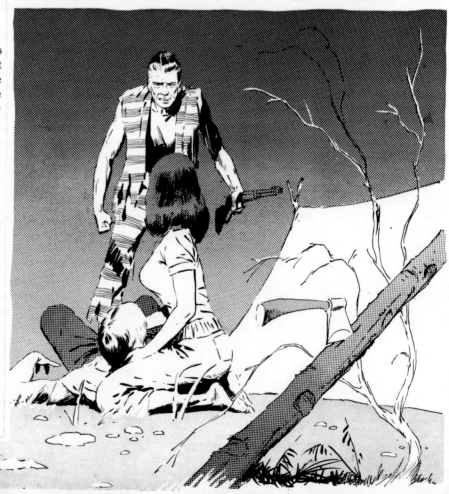

It had to be a gag. It almost *had* to be. It was too pat . . . too convenient. But what had Kempner to lose? Only the woman. And twenty grand would buy a lot of women. Kempner's kind. Not like this pasty-faced girl-woman who clung so tightly to her pasty-faced husband.

That night, he tied them up, back to back. He needed sleep. That way, they wouldn't be trouble.

Nor were they. In the morning, Kempner made the woman cook breakfast. He tormented the man by pulling her into his arms and fondling her, then grinning across the barrel of his rifle when the man stumbled toward him, his bandaged right hand limp beside him, his left clenched into a weak ineffective fist.

"Just giving you an idea of what happens . . . to her . . . if you're trying to outsmart me!" he smiled.

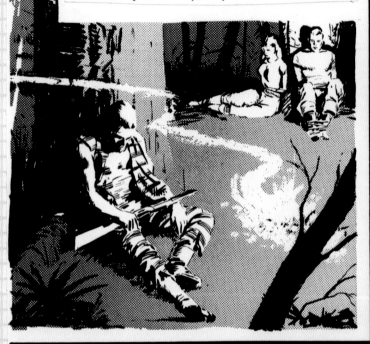

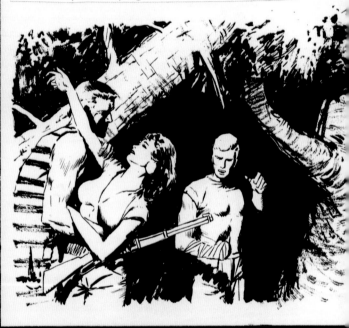

"What happens to you will be a lot different," Kempner concluded.

The man lowered his fist. "We'd better get started," he said coldly. "We'll have to get some water, first. The canteens are almost empty and there's no water where we're going . . ."

The three of them went to the stream. But it was Kempner who took the canteens after they'd been filled. That was all he carried. The canteens . . . and the rifle.

That was why, after the first few hours, he still walked easily, while the others dragged their feet. The country they passed through was almost completely barren. Rocks and sunbaked earth. After a while, Baird pulled up.

"Please," he whined. "Can't we rest? My wife can't keep up this pace. That sun . . ."

"It *is* hot, *isn't* it?" Kempner put one of the canteens to his mouth, tilted back his head so that the water spilled down his chin and darkened his shirt already stained with perspiration, and drank long and full.

When he'd finished, he screwed back the cap and snarled. "We keep going! Every cop and every hick sheriff in this state is probably out looking for me, so we don't waste time!"

"But . . . she's tired! Won't you even let her have a drink?" the man pleaded.

"She'll get a drink. After we reach that shack," snapped Kempner. "If you've got any other ideas . . ." The muzzle of the rifle moved up, centered on Baird's chest.

By sundown, Baird and his wife were staggering. Camp was made at the foot of a huge basalt rock which pointed skyward like a giant finger. The woman cooked over a tiny fire of canned heat, while Kempner smoked the last of Baird's cigarettes.

And almost, watching the woman in the last light of day, Kempner forgot. When she bent over the tiny fire, there was a glimpse of smooth white flesh. *Respectable flesh*, Kempner grinned, checking himself. *To hell with it! She'd keep! Why spoil things now?*

If the story about the stolen cash was true, there would be plenty of time for that . . . afterward. And after that . . . two respectable corpses in two shallow, un-marked graves. Kempner was not such a fool as to leave witnesses behind to tell the police even the little that these two would be able to tell.

After supper, he tied them up again. He slept well that night.

But respectable or not, Baird was not altogether a fool. He must have suspected what Kempner planned. Otherwise, he would not have tried what he did.

Kempner caught him whispering to his wife, next day. Thereafter, he saw to it that they walked a few yards apart. But those few words they'd spoken had been enough.

In the afternoon, there was a trail that led along the side of a steep hill, and around a curve at a sharp right angle. Baird was in the lead, his wife behind him, and Kempner was in the rear.

When Kempner rounded the turn, the woman clutched at the barrel of the rifle, and in that moment, Baird swung downward with the sharp rock he held in his uninjured hand.

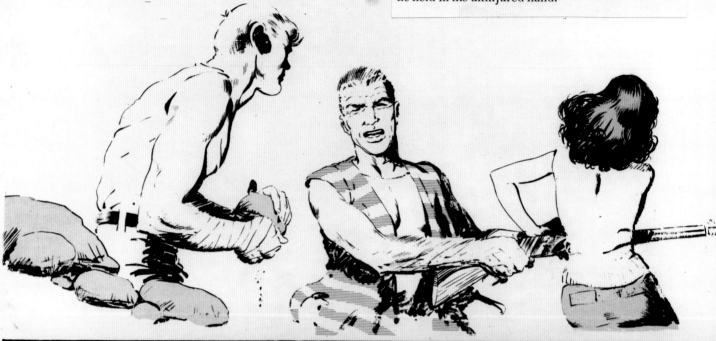

Only the fact that Baird had to use his left hand rather than his right saved Kempner! Baird was clumsy! Yet even so, the rock tore a jagged rip in Kempner's cheek and crashed down on his shoulder with agonizing impact.

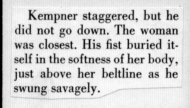

Kempner staggered, but he did not go down. The woman was closest. His fist buried itself in the softness of her body, just above her beltline as he swung savagely.

She fell just as the man charged Kempner, sobbing. Kempner grabbed him by the throat and held him while his struggles became more and more feeble.

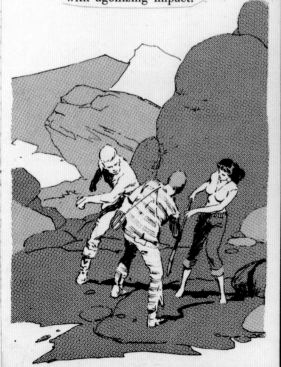

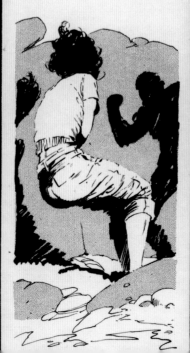

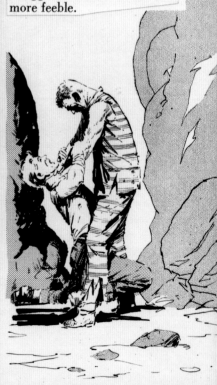

But it was no part of Kempner's plan to kill Baird. Not yet, anyway. When he sagged, Kempner drew back a fist and slammed it again and again into that pale, respectable face, until the lips were pulp, and the nose streamed blood, and the eyes were almost closed by swollen, livid flesh.

When they went on, Baird's wife had to lead him by the hand. He could barely see. Her gaze, when it rested on Kempner, was filled with hate. But beneath the hate, there was still the fear, just as the fear was still present in her husband's battered face. Yeah, they were a pair, all right!

They saw the shack that afternoon, from a rise. Even then, Kempner didn't really believe them.

An hour later, they stood outside it. It was weatherbeaten, ruined, dwarfed by the towering rocks which surrounded it. But it was there!

And the money was there, too! Under the rotted floor, in a metal box, wrapped in oilskin. When they took it from its hiding place, Kempner counted it. Carefully. There was more than he'd hoped for! Thirty-three thousand dollars!

"We'll spend the night here," he snapped. "In the morning, you two can take off."

In the morning! That was a laugh! Kempner enjoyed their uneasiness as they watched him. He let an hour go by, two, while he counted and recounted the money. Then he tired of that pastime. Both of them knew what was coming when he raised the rifle. They didn't even move. The clung to each other. Like frightened rabbits. What a pair! Two of a kind!

"You . . . you never intended to let us go," Baird whispered.

"That's right!" Kempner gestured with his rifle. Toward the woman. "You," he barked. "Get away from him . . ."

Pasty-faced or not, it'd been a long time! Kempner was trembling as he looked at her. All that stood in his way was Baird. His finger tightened on the trigger.

And that was when the door behind him burst inward on rusty hinges, and men poured in. He had just time to whirl and get off one ineffective shot before the men were on him and something slammed against his skull.

He was dazed when he came to, when he tried to brush a hand over his eyes and found that for some reason he could not.

"That's *him* all right, Sheriff," one of the men was saying. "Lou Kempner! His picture's plastered all over the post office wall!"

Kempner shook his head to clear the cobwebs. And then he saw why he had not been able to raise his hand. He was handcuffed! To Baird!

"Pretty smart," he mumbled. "You must have been trailing me all this time!"

There was only one thing he didn't quite get. Why he was handcuffed to *Baird*. Why one of the men had a firm grip on the woman's arm. But the sheriff explained all that.

"Trailing you?" The sheriff laughed. "You're a bit mixed up, mister! We weren't trailing you! We didn't even know you were here until we busted in! We were trailing *them!*"

Kempner's eyes focused. "Them? The Bairds? You were trailing them?"

"That's right," the sheriff nodded. "Only they ain't married! *His* name's Baird, all right! But *hers* is Williams! Sue Williams."

He picked up the tin box filled with green bills.

"So you don't know 'em, eh?" he shook his head. "Funny! You sure found your own level, mister! We've been trailing 'em around these hills for weeks, hoping they'd lead us to this money!"

"You . . . you mean that . . . that isn't the bank job loot?" Kempner was confused.

"Shucks, no," the sheriff laughed.

"Seems that Harry Baird and Sue, here, wanted to get married up, real bad. Only Sue's Pa objected. So they cleaned out his office safe, and they stashed the money here till it'd be safe to pick up, and hightail it out of these parts."

The sheriff pursed his lips. "But first, Harry here *killed* Sue's Pa! Pretty messy, too! The kind of a job *you* did on that prison guard! Like I said, you sure found your own level! You and Harry . . . you're *two of a kind!*"

THE END

"R.I.P."!

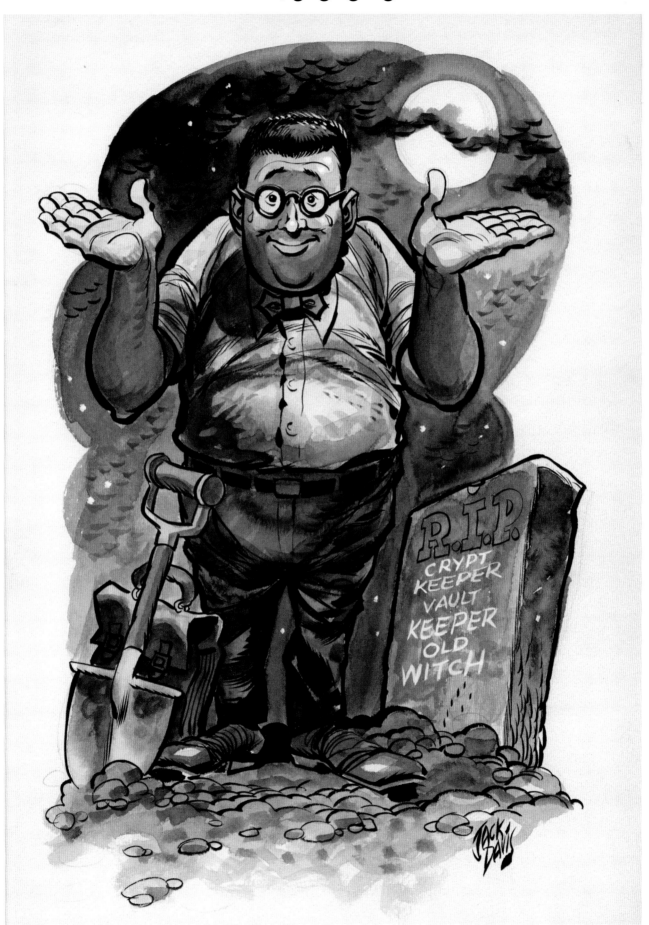

Above: Bill Gaines buries his beloved horror comics in this 1954 Jack Davis piece, done as a gift for Gaines.